IMPRESSIONIST PAINTERS

GUY JENNINGS

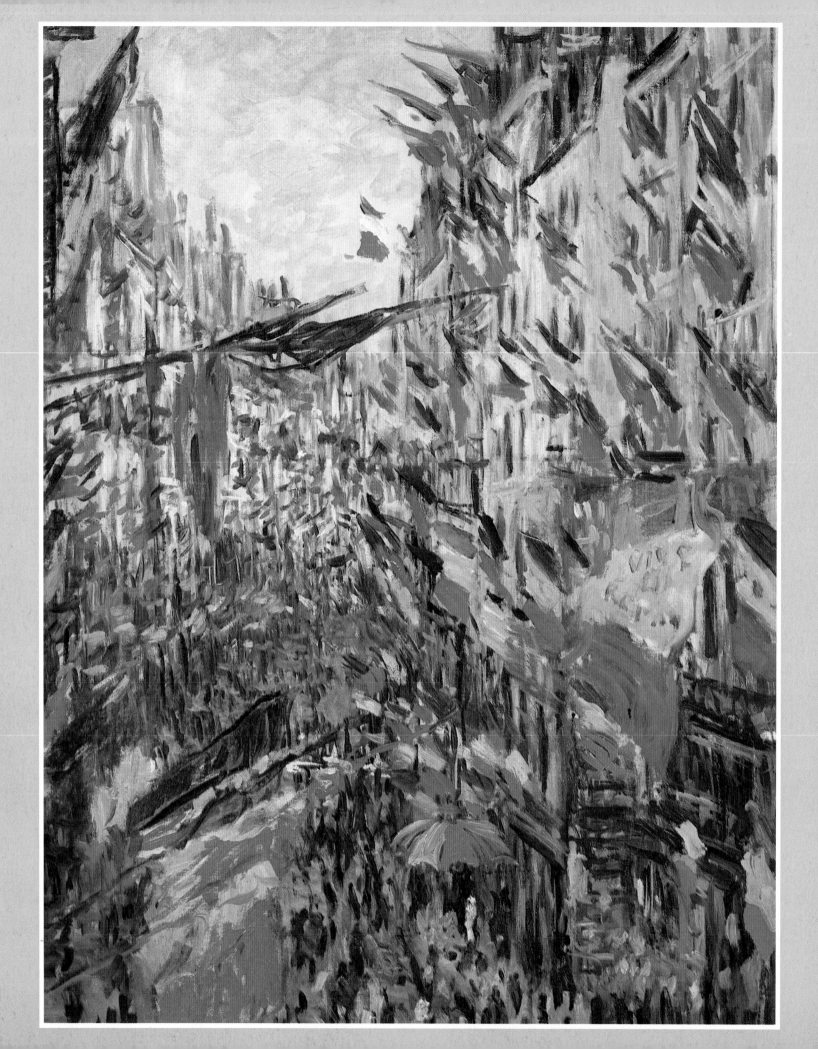

IMPRESSIONIST PAINTERS

GUY JENNINGS

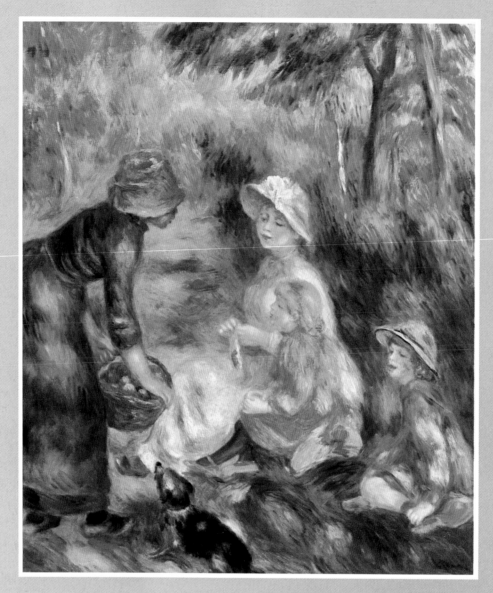

First published in 1990 by Pyramid Books,
an imprint of the Octopus Publishing Group

This edition published 2005 by Bounty Books,
a division of Octopus Publishing Group Ltd,
2-4 Heron Quays, London E14 4JP

This edition copyright © 2005 Octopus Publishing Group Ltd

ISBN 0 7537 1073 0
ISBN 13 9780753710739

Printed and bound in China

The apple seller, 1890

48 × 53 cm (19 × 21 in)

PRIVATE COLLECTION

*This charming and informal scene is
typical of Renoir's return to the use of
full rich colour and bright dappled
sunlight, after the uncertain period of
the late 1880s (see page 181). The
rapid brushwork loosely models the
foreground figures and creates a
patterned background unconnected
with realistic detail.*

CONTENTS

IMPRESSIONISM IN PERSPECTIVE

The body of work known as Impressionism enjoys the distinction of being not only historically significant, but also one of the best known and most popular cultural movements of modern times. Indeed, Impression can be regarded as the beginning of modern art.

The fact that we call the group of artists who produced this work, the Impressionists, presupposes that they were motivated by common aims. Yet in looking at the paintings it is only too obvious that the work of each of the artists in the group is distinct and independent. Close study of Impressionism supports this by outlining their personal and stylistic differences. In one sense it is the rich

diversity of Impressionism and its associations which makes it such a fascinating study, not the possibility of categorizing all the artists into a convenient group identification.

There were, of course, various shared aims and principles which held them together: the study of light and colour applied to depicting a subject as the eye perceived it, and not as the mind interpreted the forms; a determination to free art from the rigid discipline of academicism and to breathe fresh air into the methods and techniques of the artist; and interest in the changing face of a society being tranformed by scientific and industrial progress.

It is as if at certain times in history a variety of

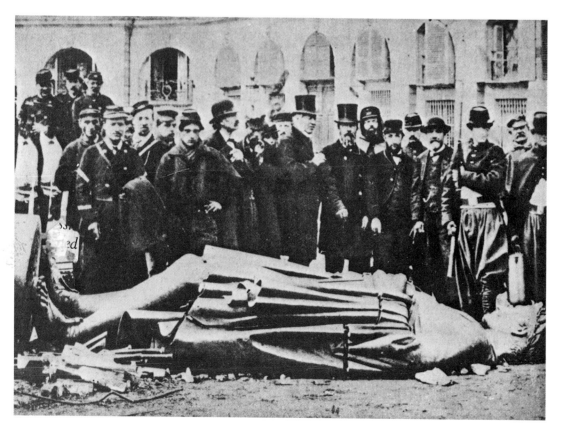

The collapsed statue of Napoleon I from the Vendôme Column
After the short-lived period of the Paris Commune in 1871, in which he was closely involved, the artist Gustave Courbet was imprisoned for the destruction of the Vendôme Column, a monument to the successes of Napoleon I, although he claimed to have had no direct hand in the violence.

factors are assembled which make a new departure possible. Impressionism was one such departure and, to this day, the reverberations have been widespread, even outside the boundaries of art itself.

A background of change

The painters who became the initiators and inheritors of the Impressionist movement were born and grew up in a climate of significant political and social change in France. The French revolution of 1789 and the subsequent restless years before the rise of Napoleon set a pattern of continual political unrest and constitutional change in France which continued throughout the nineteenth century.

There was revolutionary activity in 1830 and again in 1848, first restoring the monarchy and then reintroducing republicanism. This was swiftly followed by the establishment of the Second Empire under Napoleon III, grandson of the great Napoleon. His government collapsed in 1871 as a result of the ill-advised and ill-prepared Franco-Prussian war, an event which directly affected the lives of all the major Impressionist artists. That year also saw the brief phase in which Paris was declared an independent commune and only in the last quarter of the century did the Third Republic establish a period of relatively stable and peaceful government.

As the century progressed, the old aristocratic values that had dominated France for centuries under the monarchy were gradually eroded by populist movements and the emergence of the bourgeoisie. Seizing the advantages of commercial success offered by the Industrial Revolution, the bourgeoisie soon became the dominant force in French society.

Accompanying these constant shifts of social and political power, the landscape of France was changing as a result of industrial development. People were leaving the rural areas in vast numbers to flock to the new industrial cities in search of better wages. Vast urban sprawls developed and the countryside became filled with factories and mills. Railway lines spread out from Paris, stretching the influence of the new modernity into the furthest corners of the country. It was this changing society of urban development that provoked demands for a new iconography, a fresh style of painting appropriate for a modern, emerging country.

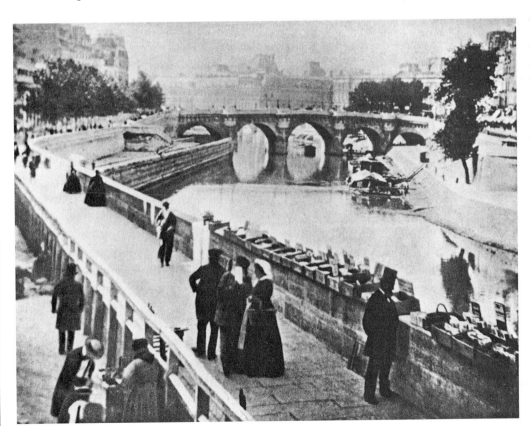

The Quai des Grands-Augustins, Paris

Impressionism is often regarded as an art of pure landscape, but an important background to its development was the emergence of modern Paris, a city of industry and commerce newly reorganized by the architect Baron ᵃᵃmann. The Seine remai. ᵗʰe dazzling heart of the city, but by the nineteenth century it was surrounded by broad boulevards linking the railway stations and conducting the increased traffic.

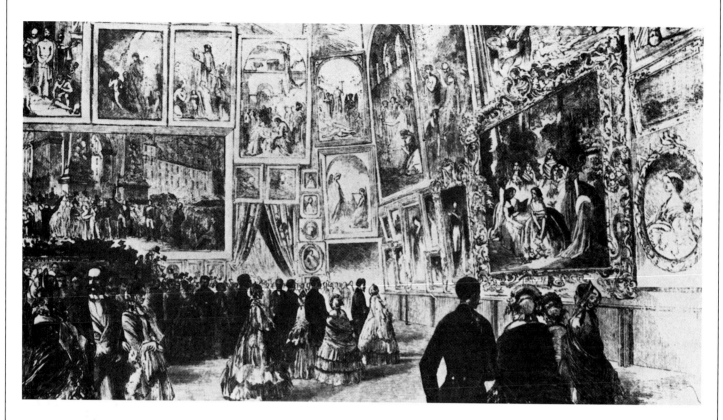

The interior of the Salon of 1885
The official exhibition of the Ecole des Beaux Arts, the Salon was the marketplace for awards, sales and commissions for the artists of nineteenth-century France. Although the pictures were hung several deep, it was necessary to exhibit there to gain recognition.

The traditions in art

The visual arts have always played an important part in the public life of France and in nineteenth-century Parisian society painting was very much in the public domain, avidly viewed and discussed by the middle and upper classes. The Ecole des Beaux Arts was the principal academy of painting and the masters of this school dominated artistic taste. Every two years there was an official Salon, a major exhibition, in which young painters would be invited to show their works alongside their established elders. A jury composed of some of these established painters would select work for the exhibition and it was what they regarded as suitable that formed the style of the Salon and thereby the public standards of French art. Thus the officially approved styles were perpetuated and it was difficult to effect change. Young artists were trained into this system and with regard to pupils of the Ecole des Beaux Arts, the great romantic painter Delacroix complained: 'They are taught the beautiful as one teaches algebra.' Only one notion of beauty was tolerated and it was taught by formula.

At the beginning of the nineteenth century classical art had reached its highest point. After the hedonism of the eighteenth century and the predominance of such lavish painters as Boucher and Fragonard, the climate of revolution had caused a return to a disciplined and stylistically pure classicism, based on the standards of ancient Greece and Rome and serving, in this later context, to glorify the successes of the Napoleonic Empire. It was not considered anachronistic if French art of the early nineteenth century dealt with classical heroes clad in togas and suits of armour. History painting was considered the most noble form of art and training for young artists consisted of long preparation, learning to draw from busts and statues, progressing to live models in classical poses and continuing with standard and highly organized forms of pictorial composition.

Classical principles of strong linear drawing and subdued colouring were most finely expressed by the major exponent of classicism, Jacques Louis David, but his followers and the lesser talents who followed the genre could not rival his abilities. Only Ingres,

Alfred Sisley

Berthe Morisot

with his feeling for line and pure form, provided justification for the continuing development of the classical style. This genre was challenged and thrown on the defensive, however, by the emergence of the romantic movement, represented by the leading painters Géricault and Delacroix. Delacroix, particularly, tended to emphasize colour and movement in painting in preference to the restrained, dry skill of the classical line, and argued that the classical school 'did not contain that dash of truth, the truth which comes from the soul.'

At the same time the marketplace for art had changed. As the bourgeoisie rose in political importance, they also took their place as patrons of the arts. Strict aesthetic values were being replaced by the artistically ignorant assessment of new buyers who wanted paintings that pleased and flattered the eye. These qualities they found in the development of the *juste-milieu* school, essentially a compromise between the austerity of classicism and the warmth of romanticism. Painters such as Paul Delaroche and Thomas Couture applied the principles of both movements to their literary and historical scenes.

Anecdotal paintings, competently executed but entirely unexceptional, became the normal fare of the picture-viewing public. The Salons became picture bazaars and the enthusiastic response was scathingly criticized by the writer Baudelaire: 'Our public wants to be astonished by means alien to art and the obeying artists conform themselves to its taste.' Baudelaire was one of the most powerful and influential of the voices crying out for new painters prepared to deal with the modern life of France, to abandon the historical for views of the boulevards of modern Paris and real people dressed in the fashions of the age going about their usual business.

THE BARBIZON SCHOOL At the same time as the *juste-milieu* was occupying the attentions of the Salon-going public, a new group of painters loosely attached to the romantic school were competing for a position in the public eye. Landscape painting had been traditionally regarded as an inferior genre by the Ecole des Beaux Arts, recognized mainly as having a place in forming the background for heroic figure paintings. But during the middle years of the

Pierre Auguste Renoir in his old age
Camille Pissarro and Paul Cézanne

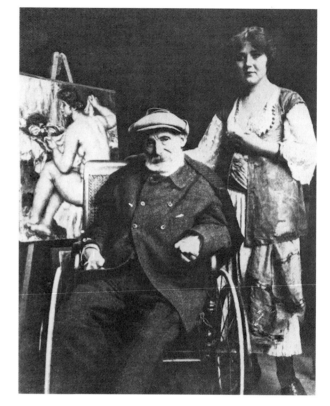

nineteenth century a number of painters, among them Théodore Rousseau, Constant Troyon and Jean Baptiste Camille Corot, began to paint out of doors in the wilder and less developed parts of the countryside. They sought to capture the landscape in its natural condition, studying the dramatic effects of dawn and dusk and the changing appearances of the seasons. Many of these landscapists gathered at the village of Barbizon in the forest of Fontainebleau, which was the nearest area of truly unspoiled countryside within easy reach of Paris. Their work was accepted for exhibition at the Salon, though regarded as belonging to an inferior category, and the artists gradually came to be known as the Barbizon school.

The Barbizon school was of great importance in the development of Impressionism. These painters were pointing the direction away from classical idealism towards a freer and more realistic approach, and at the same time were slowly beginning to attack and break down the prejudices of the Salon jury. There was an element of social realism in the work, especially that of Gustave Courbet and of Jean François Millet, who became the central figure of the Barbizon school. The declining condition of the peasants in an industrial age, and the rigours of rural life gave Millet much of his subject matter, which was later to be an important icono-

graphic influence on Pissarro and van Gogh.

The Salon jury were confronted with increasing regularity by works which were unfamiliar to them and unappealing to their tastes; despite the slowly growing influence of the Barbizon school, most jury members became more conservative and less flexible in their judgement. To be an artist in France was a highly respected profession. Artists who won fame at the Salon would receive commissions from the government, even medals and decorations. The successful painters could become very wealthy and enjoy the respect of society, but it all began at the Salon. Artists trying to challenge the conventions of the academic world attracted notoriety and public abuse, as happened to both Courbet and Manet, while other painters content to conform to required standards received the wealth, accolades and decorations. It was the persistent inability of the Impressionist painters to gain access to the Salon which prompted them to organize their own exhibitions in which their work could be made available to the public, but the Salons continued to be of consequence until the end of the century.

The emergence of Impressionism

It was from this tension between established tradition and new impulses in art that Impressionism as a movement grew, during the period of government

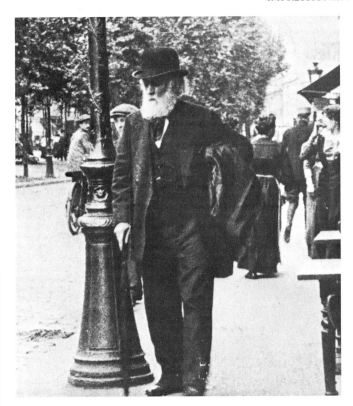

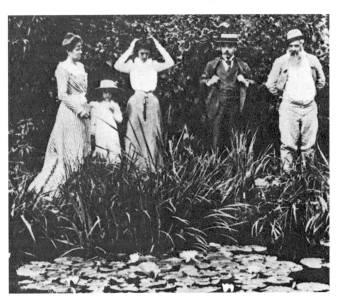

Edgar Degas in old age in a Paris street
Claude Monet with friends in his garden at Giverny

of Napoleon III lasting from 1851 to 1870. The first sign of a break in the power of the Salon, in fact, came from an action by Napoleon who in 1863, responding to the outrage of artists whose work had been rejected at the Salon, allowed them to set up an alternative exhibition known as the Salon des Refusés. It was not a particular success for those painters of merit who had suffered the jury's severity, because they were herded together with artists of meagre talent whom the jury had been right to reject; but it sowed the seed of the idea that there could be an alternative to the Salon.

The painters who came to be known collectively as Impressionists came together by various means and were not essentially connected by a simple, stylistic unity. Monet, Renoir and Sisley met as students in the studio of the academic teacher Charles Gleyre. Monet had already been acquainted with Camille Pissarro, the other leading figure of the Impressionist group, from working at the Académie Suisse in the early stages of his training. A focal point which brought these and other artists together was the habit of regular meetings at the Café Guerbois in Paris. These were dominated by Edouard Manet, a painter who had become notorious as a result of the Salon des Refusés through his painting 'Luncheon on the grass' (see page 105), an updating of a classical theme which had outraged

both the Salon jury and the picture-viewing public. Edgar Degas was also a frequenter of the Café Guerbois and these artists were to form the nucleus of the Impressionist group, together with other painters and sympathizers also looking for a progression from establishment tradition.

THE IMPRESSIONIST EXHIBITIONS The real identification of a new grouping of painters came with the decision of these artists, with the exception of Manet, to exhibit work together independently of the Salon. Frustrated by continual rejections at the hands of the Salon jury, they nevertheless felt that a repetition of the Salon des Refusés would do nothing to alter radically the system operated from the secure base of the Ecole des Beaux Arts. In 1867 the idea of an independent exhibition was discussed seriously by Monet and Pissarro, but it was not until 1874 that it became a reality. This immediately emphasized the individuality of the painters involved. Degas wanted to invite some of the more successful and established artists in order to give the exhibition credibility, but was overruled by Monet. Pissarro attempted to draw up rules and a proper constitution for the new grouping, but the easygoing Renoir opposed this proposition as being too bureaucratic and authoritarian. Pissarro did, however, create a joint stock company with shares,

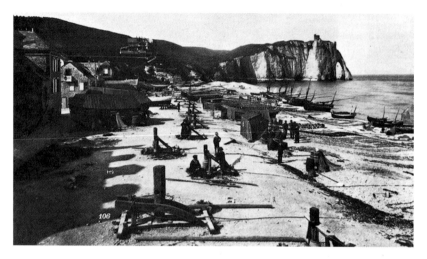

The beach at Etretat
The extraordinary rock formations of the cliffs at Etretat were a subject that attracted many painters, among them Courbet (see page 66) and Monet (see page 134).

The Seine at Argenteuil *(right)*
The river Seine was like the life force of early Impressionism, painted frequently by all the major artists.

subscriptions and monthly instalments. It was decided that each painter would contribute one-tenth of any income from sales of paintings and Renoir became treasurer for the group and chaired the hanging committee of the exhibition. The founding charter was drawn up in December 1873, witnessed by Monet, Renoir, Pissarro, Sisley, Degas and Berthe Morisot, among several other artists now less well-remembered than their colleagues.

The photographer Nadar volunteered his studio, free of charge, as the venue for the exhibition. This had large rooms on the second floor of a building on the boulevard des Capucines in Paris. When the problem arose of what the exhibition should be called Degas proposed the neutral title of La Capucine, after the street name, which incidentally means nasturtium. Eventually they agreed on a name for the group which seemed sufficiently anonymous, literally, being 'Société Anonyme des artistes, peintres, sculpteurs, graveurs etc'. Monet's friend and mentor Eugène Boudin was invited to join the group. Paul Cézanne was included on the insistence of Pissarro, although Monet and Degas were less sympathetic to Cézanne's work and personality. Manet steadfastly refused to be identified with this radical step, preferring to pursue his own private battle with the Salon whose recognition he

still desired and expected. In all, twenty-nine artists took part and the exhibition opened on 18 April 1874, in advance of the official Salon.

The exhibition was a disaster. All Paris laughed and the public attended to poke fun at the independent painters, responding to the hostile and abusive press criticism. It was from a press review that the title 'Impressionism' was born. The critic Louis Leroy, in a scathing article, seized on the title of one of Monet's paintings, 'Impression, sunrise' and headed his review 'The Exhibition of the Impressionists'. It was meant as a term of abuse and as it became common currency the artists themselves tried to resist being lumped together under this name. It gradually became a convenience, however, so that this event of 1874 is now generally referred to as the first Impressionist exhibition.

Apart from the derision which the Impressionists had to put up with, they also faced the disappointment of lack of sales or a useful introduction to the picture-buying public. The 360 franc profit from the exhibition barely covered the cost of the enterprise. But it signalled their determination to survive without the approval of the Salon and the independent exhibitions became regular events, seven more taking place in the years up to 1886. Each of these occasions served to emphasize the wide differences

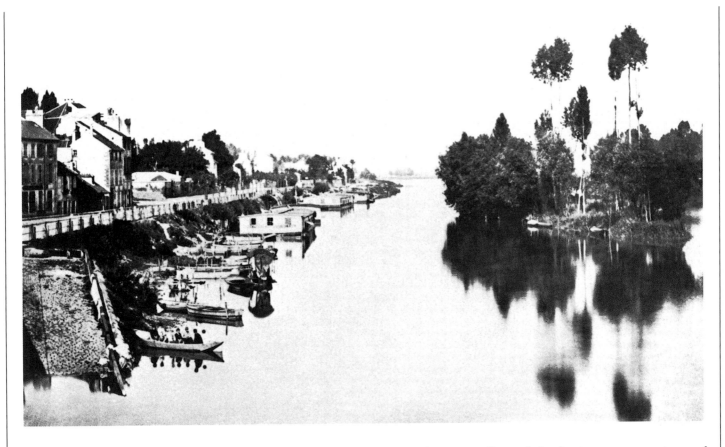

in approach of the participating artists. There were squabbles about the nature of the movement, the purpose of the exhibition, who should be involved and how the work should be presented. Only Pissarro took part in all eight of the exhibitions and it was he who invariably welcomed and fostered newcomers to the group despite their considerable stylistic variations, as in the case of Cézanne and later Seurat. Renoir eventually returned to the Salon, fearing the revolutionary associations attributed to the Impressionist group. Degas remained committed to the independence of the Impressionist exhibitions, despite his personal objections to the organization and, sometimes to the other participants. Monet and Sisley, arguably the painters who most represent the spirit of Impressionism exhibited only in five and four of the shows respectively. In actual fact, there was a curious lack of cohesion within the group which belies the simple historical categorization of this or that artist as 'an Impressionist'.

New perceptions

Aside from the common desire among certain artists to shake the rigidity of the art establishment, there were various other factors which contributed to the development of a new movement in painting at that

particular time. One of the basic preoccupations of Monet, Pissarro and Sisley was the idea of painting directly from nature, taking canvases into an open-air location and completing a picture on the spot, as opposed to the traditional practice of making sketches of a subject which could then be developed and refined into a large composition painted in the studio. In a simple technical sense, outdoor painting had been made much easier by the invention in 1840 of soft metal tubes for carrying paint, so that instead of mixing paints daily in the studio, an artist could carry prepared colours to the site of the subject and work in oils on a full-scale canvas.

The attempt to capture the effects of light and the full vibrancy of nature was also assisted by new advances in colour chemistry during the 1860s and the continuing development of colour theory, which between them made new synthetic paint colours available and suggested alternative ways of using them. The academic practices of working on a dark ground, building up a tonal interpretation before colour was added and using heavy blacks to create shadow were all dispensed with by the Impressionists. They placed their bright colours on a pure, white surface and tried to manipulate the hues to suggest light and shade in colourful ways, using small dabs of paint thickly amassed, not tamed

by the academics' habit of blending and smoothing the colours on the surface. The introduction to France in the 1860s of Japanese art, particularly clear-coloured prints with their formalized compositions, gave western artists a whole new way of perceiving pictorial forms.

THE INFLUENCE OF PHOTOGRAPHY Arguably the most important scientific development to have an influence on painting was the development of photography, which caused a temporary crisis of confidence among artists. The daguerrotype, the first rapid and successful method of fixing an image formed by light, was invented in France in the late 1830s. Once the principles of photography were established more efficient technical methods were continuously developed and, by the 1860s, commercial photographic studios were a going concern.

Suddenly there was a machine which could reproduce accurately all the elements of realism that a painter would strive long to depict. 'From today, painting is dead,' the anguished cry of Paul Delaroche, was a feeling shared by many figurative artists who felt their role as portraitists and picture-makers usurped by the new art of photography. To more imaginative minds, however, it was clear that photography would not replace painting; rather it freed artists from the tedious chores of patient and detailed recording of a view or object. The painter could put expression and mood into a composition, still being truthful to what was seen, but going well beyond the capabilities of contemporary photography. Degas, in particular, was alive to the aesthetic innovations and limitations of photography.

The Impressionist artists
The years between 1870 and 1880 were the heroic decade of Impressionism, the period when disagreements were minor and there was a strong sense of cohesion within the movement. But the disparate forces leading up to and following that momentous decade are all part of the history of Impressionism.

THE PRECURSORS Various artists contributed to the appearance of a completely new style of art. Camille Corot, the earliest of the painters included in the biographical studies following this chapter, was an established figure who, by his devotion to landscape and understanding of the effects of light and colour, showed part of the way forward to the coming generation of painters. Gustave Courbet, a monumental figure both personally and artistically, broke away from conventions and made a dramatic challenge to the cosy traditionalism of the Salon. In this

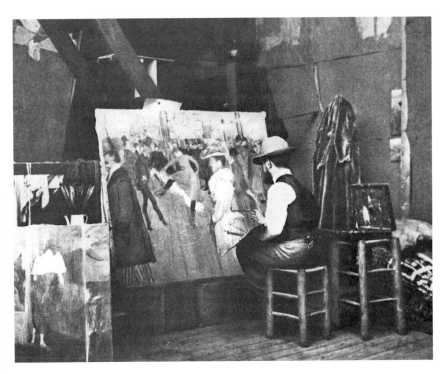

View of Pontoise (*far left*)
Many of Pissarro's finest landscapes were painted in and around Pontoise, a village on the Oise, a tributary of the Seine.

Toulouse-Lautrec working in his studio
Henri de Toulouse-Lautrec, in a brief but prolific career, followed in the wake of Impressionism as a chronicler of the busy night-life of Paris.

way he, like the Barbizon artists, weakened the academic hold on French painting which the Impressionists were eventually to break. Eugène Boudin and Johann Barthold Jongkind were both quiet but pervasive influences: never fully associated with the Impressionist group, both were dedicated to their vision of landscape as a true and important contribution to artistic style. In conveying this to the young Monet, they were unwittingly opening the way for an artistic revolution which neither would have consciously intended to create.

THE LEADING FIGURES The catalyst at the centre of the development of Impressionism was Edouard Manet. Paradoxically, it was his very struggle for acceptance by the art establishment which inspired the younger artists gathered around him to make their move for independence. Stylistically, Manet's work represented a modernist approach interpreted through a technique sufficiently non-academic to enrage the Salon and the conservative arts patrons. Yet he remained aloof from the development of Impressionism as an alternative force and it was his challenge to the Salon and his persistence that he should be accorded proper respect for a new style of painting that was of such great influence and encouragement to the Impressionists.

The choice made by both Manet and Courbet to exhibit work in private pavilions at the Exposition Universelle, the World's Fair held in Paris in 1867, was the kind of independent gesture that opened the way to establishing the Impressionist exhibitions as an alternative to the Salon.

Of the major artists involved with the actual founding of the independent Impressionist exhibitions, the three landscapists Monet, Pissarro and Sisley most consistently reflect in their work the Impressionists' fascination with light, colour and atmospheric effects. Renoir, essentially a figure painter, applied the lessons of Impressionism to his work while retaining a distinctive connection with French art of the past, a tendency which came through more strongly as Renoir grew older and more apart from his former colleagues. Degas, by inclination a crusty and independent figure, followed more the tradition of Manet in his work, with a feel for linearity and pictorial organization that was unique among his peers. He was responsible for inviting the American artist Mary Cassatt to join the Impressionist group. The paintings of Cassatt and the other major female painter, Berthe Morisot, contributed to Impressionism themes generally absent from the male-dominated world of nineteenth-century art.

Pierre Bonnard

The art dealer Paul Durand-Ruel

THE POST-IMPRESSIONISTS The many offshoots of Impressionism, created by individuals involved with or influenced by the leading painters of the group, have for historical convenience been put together under the title 'Post-Impressionism'. This term has been forced to encompass the individualistic output of van Gogh and Gauguin; of Cézanne, who wanted 'to make of Impressionism something solid and durable, like the art of the museums'; and the analytical colour science of the divisionist theory developed by Seurat and Signac. These all, in their way, showed a move away from Impressionist principles, yet as the term Post-Impressionism implies, they form a bridge by which the revolution in art went forward into the extraordinary creativity of the early years of the twentieth century. The significance of Impressionism lies not only in the stylistic innovations of its major artists but in establishing the opportunity to make new kinds of art.

The marketplace for painting

A result of Impressionism which is not often remarked on, but which was of the greatest importance to the progress and public recognition of new styles in painting, was the emergence of independent dealers as a vital force in publicizing and distributing the works of individual artists. By breaking the stranglehold of the official Salon, they opened the way to various alternatives. The dealer Paul Durand-Ruel, who consistently championed the work of the Impressionists to the point of bankrupting himself in their support, is in his way one of the important figures of the period. Private patrons, such as Victor Chocquet and the painter Gustave Caillebotte, saved the Impressionists' work from extinction in the face of public disapproval. It was the loyalty of such men that served to found the important collections of Impressionist art, in France and elsewhere, though many early works were lost through lack of support.

One other development of note was the founding of an alternative Salon, known as the Salon des Indépendants. This was based on and followed in the wake of the independent exhibitions first organized by Monet, Pissarro, Renoir and Degas. Seurat and Signac were the principal architects of the Salon des Indépendants and it remained the major alternative showcase for artists until World War I, becoming the point of departure for the new avant-garde painters of the early twentieth century.

The bequest of a large collection of his colleagues' paintings to the French nation by Gustave Caillebotte formed the nucleus of the many great works now belonging to the Louvre in Paris, housed, at the time of writing, in the Jeu de Paume. These will be a substantial feature of the museum of the nineteenth century, housed at the old Gare d'Orsay which has been adopted for this purpose.

There are fine collections of Impressionism in the United States particularly in Boston, Chicago and New York. The museums of Moscow and Leningrad also contain many remarkable examples, as do the Courtauld Institute and the National Gallery in London. A list of the more important museums containing Impressionist works is at the back of this book.

BAZILLE

Frédéric Bazille could have been one of the greatest painters of the late nineteenth century, but his brilliant career was cut short in 1870 when, at the age of 28, he was killed fighting in the Franco-Prussian war. Before his early death, however, he had worked closely with Monet, Sisley and Renoir throughout the 1860s, a period which, with hindsight, can be marked as the important first phase of Impressionism.

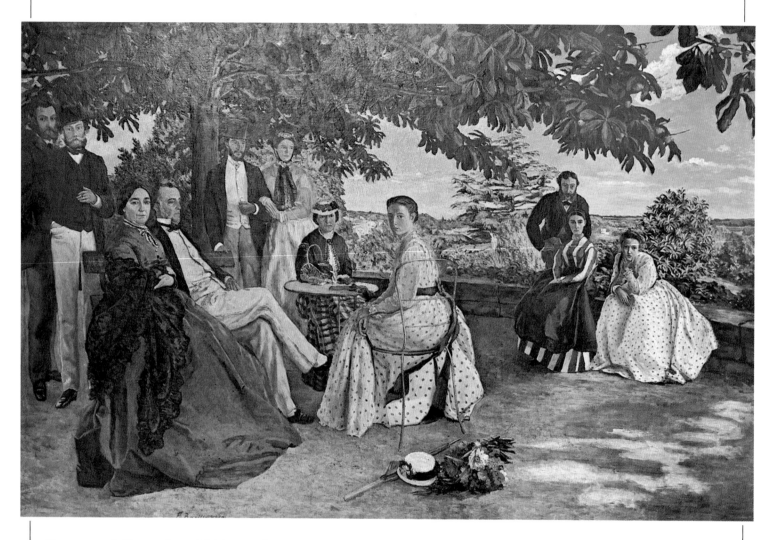

Born on 6 December 1841, in the same year as Renoir, Frédéric Bazille was the son of a wealthy *haut-bourgeois* family from Montpellier in the south of France. At school he was no more than competent but when he left, despite wanting to become a painter, he acceded to his father's wishes and entered the famous medical school at Montpellier. There was nothing in the family background that would have disposed the young Bazille to become an artist, but he was a frequent visitor to the museums in his home town which had been well-endowed by local patrons, and in particular by Alfred Bruyas, who had been a patron of Courbet and of the romantic painters.

In 1862, Bazille managed to persuade his father to let him go to Paris, where he entered the studio of the painter Charles Gleyre and found himself a fellow pupil with Monet, Sisley and Renoir. The four young painters shared a common interest in the

Barbizon school and this made them impatient with the studio teachings of Gleyre, although he was in fact one of the more liberal of the teachers in Paris at that time.

With Monet and his other companions, Bazille took up the practice of painting in the open air and at first they visited a locality made famous by the Barbizon painters, amid the natural beauty of the Forest of Fontainebleau near Paris. Bazille was particularly influenced and encouraged by Monet at this stage, as were the other members of the group, because Monet, having been taught the vivid experience of open-air painting by Boudin and Jongkind, passed it on to his friends with great practical enthusiasm.

In 1864 Bazille failed his medical examinations, which came as no surprise and meant that he was free to devote his full attention to painting. That summer he travelled with Monet to the Normandy

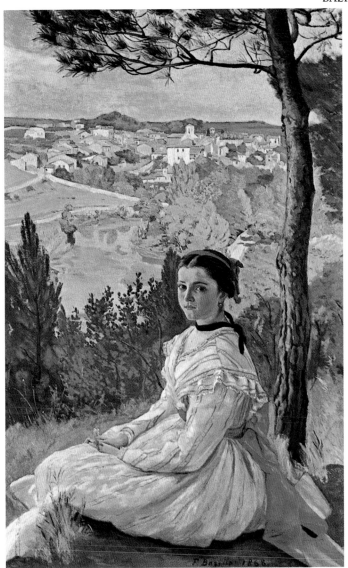

The family reunion, 1867 (far left)

152 × 227 cm (60 × 89 in)

LOUVRE, PARIS

This large group portrait was painted entirely out of doors. It bears an interesting comparison to Monet's 'The terrace at Sainte-Adresse' (see page 124) of the same year, each composition showing the painter's family and exploiting the bright colours of an outdoor setting. Bazille's mother and father are the seated figures to the left; the others are his aunt, uncle and cousins on his mother's side.

The view of the village, 1868 (left)

130 × 89 cm (51 × 35 in)

MUSEE FABRE, MONTPELLIER

Bazille's friends were full of praise for this work, although it was ridiculed by critics at the Salon of 1869. Berthe Morisot wrote: 'He is seeking what we have all so often sought; how to place a figure in outdoor surroundings. This time I think he has really succeeded.'

Black woman with peonies, 1870 (overleaf)

60 × 75 cm (24 × 30 in)

MUSEE FABRE, MONTPELLIER

This is one of Bazille's last paintings. The composition with the black model and lush flowers is strongly reminiscent of Manet's 'Olympia' (see page 106).

coast and stayed at the St Siméon farm, a well-established guest-house patronized mainly by artists. Bazille was more fortunate than his colleagues in that he was supported by his family and could easily afford to occupy his time with painting. On his return to Paris he rented a studio in the rue de Furstenberg, in which Monet also worked throughout the 1860s. Bazille's wealth was to support Monet and Renoir in many times of need; he willingly provided them with paints and studio space when they were unable to provide for themselves. Bazille's studio was a sociable place; he had an upright piano moved in and often held small gatherings to which writers as well as artist friends were freely invited.

Bazille's work at this time, like that of his contemporaries, was moving towards the Impressionist style which was soon to burst forth on a startled art world. He painted large-scale figure portraits and that of his family at Montpellier shows more confidence than Monet's similar outdoor figure group 'Women in the garden', a work which Bazille eventually bought from Monet to help him out of recurring financial difficulties. Bazille also worked in the spirit of Delacroix, using the great romantic's inspiration for works such as 'Black woman with peonies' and 'La toilette' which was rejected by the Salon jury in 1870. In these Bazille was more in tune with Manet's work of the period, which concentrated on indoor figure scenes and the flattened spaces of contrasting light and shade. But as well as these figure compositions he was also working on open-air themes, though not of the subject matter seen along the Seine and on the Normandy coast, like his colleagues. Instead Bazille depicted the landscapes of southern France around his home town in Montpellier – in 'The view of the village', for example.

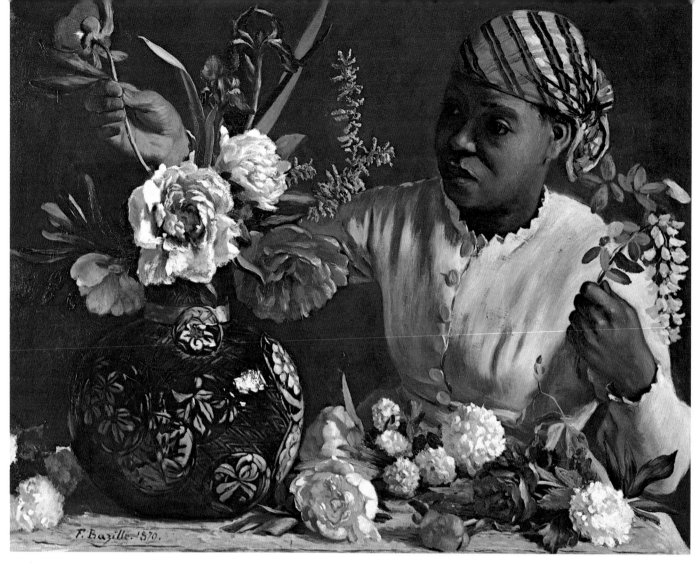

Bazille was an integral member of the group of young painters who later became known as the Impressionists. He was a frequent attender and eloquent speaker at the Café Guerbois where, equal to Manet and Degas by virtue of his wealthy background and good education, he was able to play a more prominent role than Monet or the other less articulate friends of his student days. Towards the end of the 1860s, as he was growing in confidence, his conversation and correspondence became peppered with ambitious plans for the future. It would be rash to speculate how these might have turned out; despite his closeness to the younger Impressionist painters, he seemed more to follow the example of Manet than Monet as far as the style of his paintings was concerned.

In 1870, at the outbreak of the Franco-Prussian war, Bazille was quick to volunteer and he joined the Third Infantry Regiment which soon saw active service. The young painter was killed in the battle of Beaune-la-Rolande on 20 November 1870, shortly before his birthday on which he would have been 29 years old. In a letter to his own father, the writer Edmond de Maître wrote: 'Bazille enlisted in the infantry, he was killed at Beaune-la-Rolande, just below Orléans and was buried under the snow; after ten days his father was able to find his body and bring it back to Montpellier on a cart.'

Bazille's early death was a very great tragedy in artistic as well as human terms. The collapse of the Second Empire following the war and the emergence of the Third Republic in France heralded a time of change, making room for the heroic decade of Impressionism in which, on the evidence of the 1860s, there is no doubt that Frédéric Bazille would have played an important part. His influence and his role as colleague, friend and supporter of the major Impressionist painters have kept his name alive, however, and are testimony to a man who had only just begun to challenge in the aesthetic debates of the late nineteenth century and whose talents might have added yet another unique contribution to that extraordinarily fertile period of French art.

BONNARD

Bonnard once described himself as the last
of the Impressionists. He was much
younger than the other artists involved in
the Impressionist group and the
movement was already beginning to
change and fragment by the time Bonnard
started his training as a painter. His
initial influences, in fact, came from the
offshoots of Impressionism and he did not
at first pay much direct attention to the
work of Monet, Renoir and others who
had led the field in developing a new style
of art. But later Bonnard described
Impressionism as having given him 'a
sensation of discovery'. It was he who in
a real sense brought Impressionism forward
into the twentieth century, detaching the
effects of shimmering light and colour
from the objective discipline which had
originally stimulated them, and creating
with these means his own subjective view
of the world around him, where every
surface and object became filled with the
brilliance of pure colour.

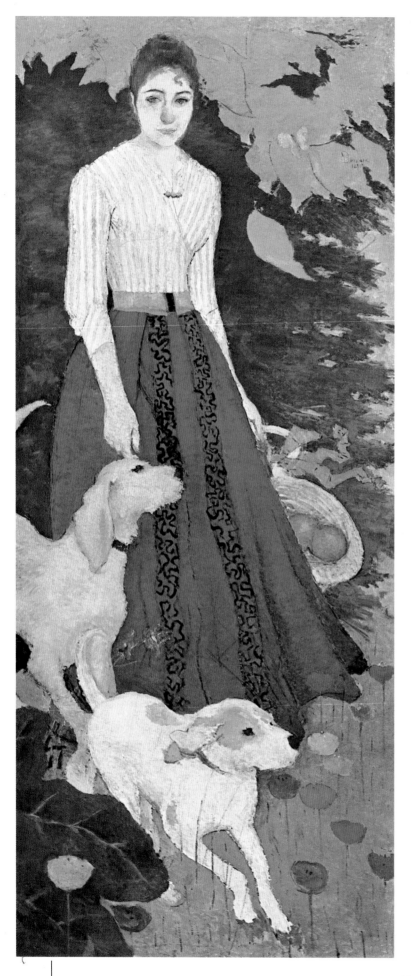

Mlle Andrée Bonnard and her dogs, 1890

188 × 80 cm (74 × 32 in)

PRIVATE COLLECTION

This early work by Bonnard is significantly free from traditional academic influences. The composition, which shows Bonnard's sister casually walking with her dogs, is not designed to construct a sense of time and space in the conventional manner. The flat planes of colour isolate the figure and the boundary of the picture frame is emphasized by the left-of-centre arrangement.

The croquet game, 1892 *(right)*

128 × 160 cm (50 × 63 in)

PRIVATE COLLECTION

The flattened view and complex arrangement of patterns in this picture give it a decorative quality wholly at odds with traditional treatment of colour and perspective. This formalized interest in the surface elements of a picture at the expense of realism was typical of work by members of the Nabis group formed in the early 1890s, among them Bonnard and his close colleague Edouard Vuillard. Bonnard gradually developed a more liberal manner of exploiting colour, characteristic of his later paintings, but this picture shows clearly the influence of oriental prints and paintings.

Born on 3 October 1867 at Fontenay-aux-Roses near Paris, Pierre Bonnard was the son of a senior civil servant in the war ministry. His father encouraged him to study law, but at the same time Bonnard was also allowed to attend art school. His father's hopes were thwarted when Bonnard failed his oral examinations and abandoned further law studies, but before he was allowed to pursue the career as a painter which he so much desired, he was made to work for a short time as a clerk in his father's ministry. Bonnard had entered the Ecole des Beaux Arts in 1885 and also studied at the Académie Julien, but like the Impressionist painters two decades earlier, he was not satisfied with this formal classical training and soon began to explore the work of contemporary avant-garde artists.

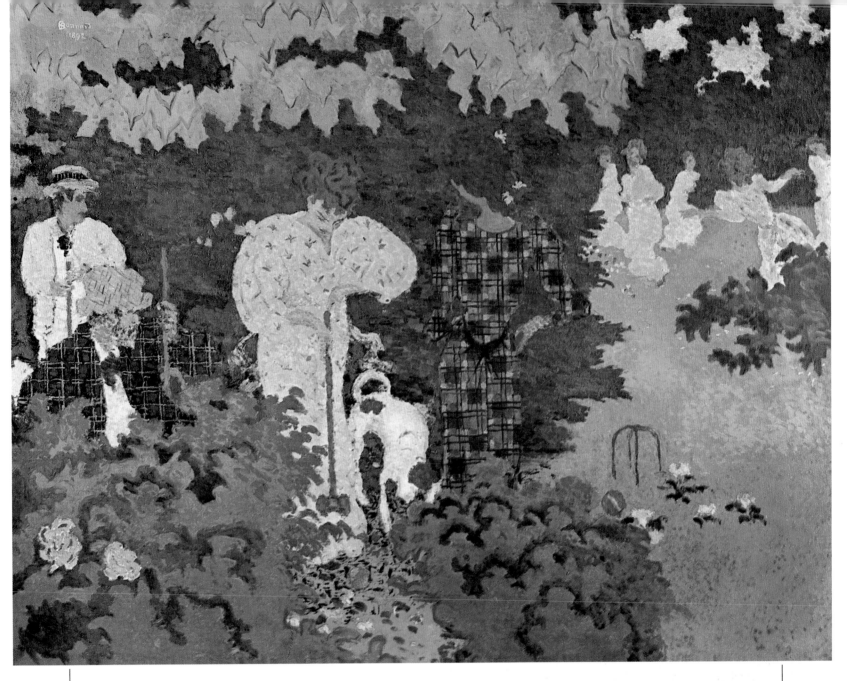

At the Ecole des Beaux Arts Bonnard met Edouard Vuillard and other young artists with whom in the 1890s he formed a group known as the Nabis, named from a Hebrew word meaning prophet. These painters were more indebted to Gauguin's work of the Pont Aven periods (see page 88) than to Impressionism. The liberation of colours effected by the Impressionists was of great importance to them but they applied this to non-naturalistic conventions of pictorial composition. The patterned qualities of Japanese printmaking were also an important influence; Bonnard, in particular, learnt much from this source, using the Japanese manner of flattening the picture plane and creating unusual perspectives. In working with the Nabis school Bonnard achieved almost immediate

success. He was lionized after the 1891 Salon des Indépendants, at which his colleagues were also highly successful, especially Vuillard.

At the age of 28, by now embarked on a full-time career as an artist, Bonnard set up home with Maria Boursin, a young French girl who also went by the name of Marthe de Meligny. From this time until her death in 1942, their relationship was a central feature of Bonnard's life and art, and over their long years together she became his most frequent model. Thadée Nathanson described Marie's curious presence in Bonnard's life: 'Close to him in exiguous quarters, we saw her fluttering, that young woman, then still a child, with whom he spent his life. She already had and kept always, her wild look of a bird, her movement on tiptoe as though winged.' She had

an obsessive concern with cleanliness and hygiene, which explains why Bonnard so often painted her either standing naked before a mirror or reclining in the bath. In other paintings she appears as an almost haunting presence, sometimes barely noticeable in the shadows of a corner, or peeking into a picture from the very edge of the frame.

Thadée Nathanson also wrote an intriguing description of Bonnard himself: 'This slim, active man seems tall, although he stoops a little and folds up on himself. He strokes his short beard which curls loosely on his obstinate chin. His nearsightedness is that of an observer, but it eliminates all useless details. Behind his spectacles, his unusually lively pupils glance at or fix on successive objects to make them his own.'

Pierre Bonnard, physically strong, was fond of the active life. He would take a long walk each day

Nude by lamplight, 1912 *(right)*
75 × 75 cm (30 × 30 in)
PRIVATE COLLECTION
Warm light bathes this intimate scene which owes much to Degas in its composition, although the encrusted paint layers and emotive use of colour are essentially Bonnard's own.

Street scene, c. 1906
35 × 47.5 cm (14 × 19 in)
PHILLIPS COLLECTION, WASHINGTON
Unlike Monet or Pissarro, who depicted Parisian crowds as seen from a high window, Bonnard has chosen a street-level viewpoint which gives a greater sense of involvement. The free brushwork heightens the sense of bustle as a fleeting moment is captured on canvas.

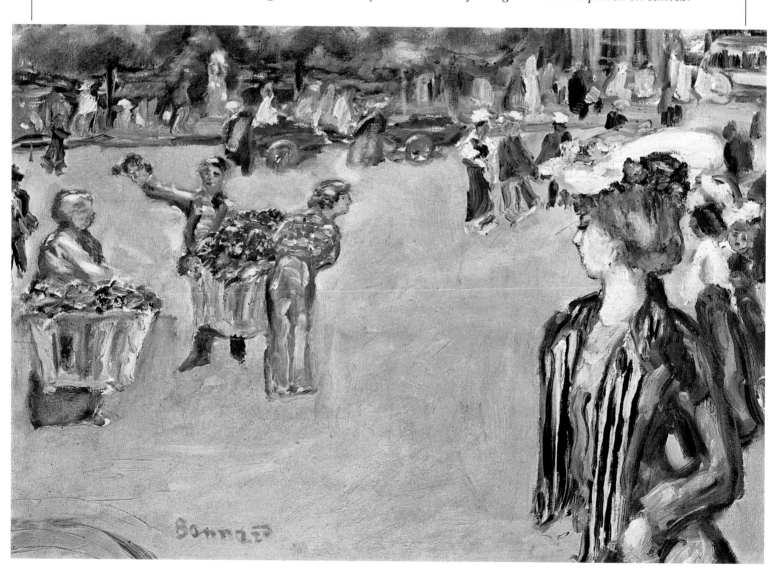

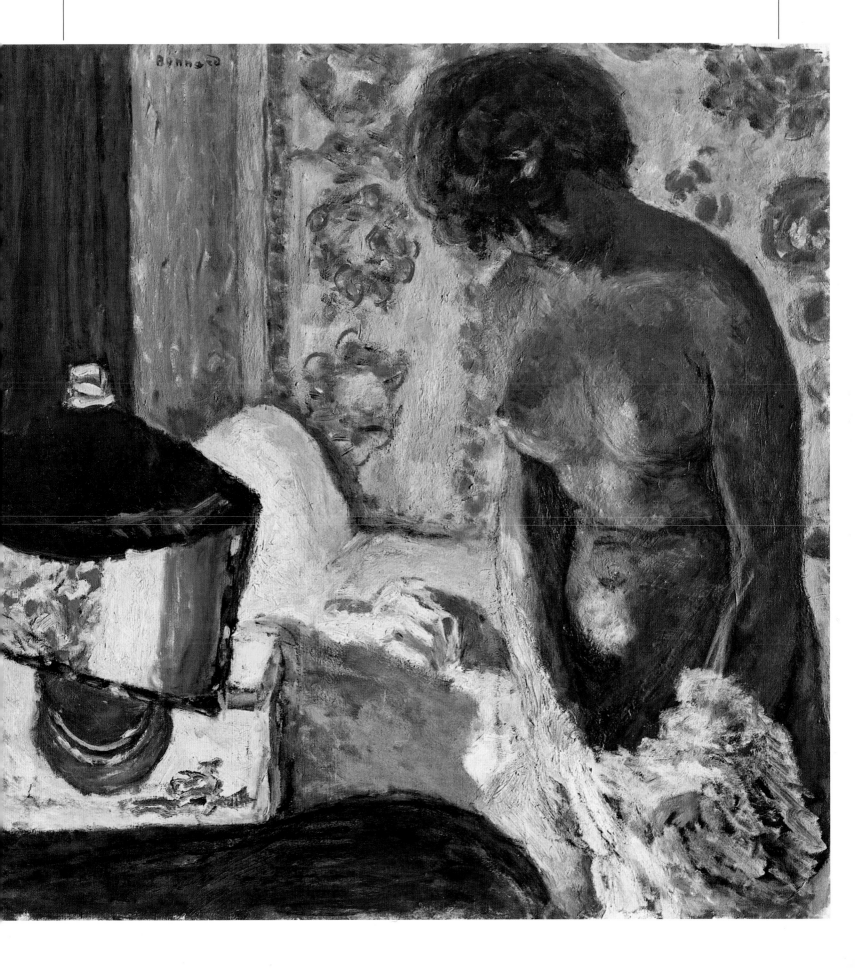

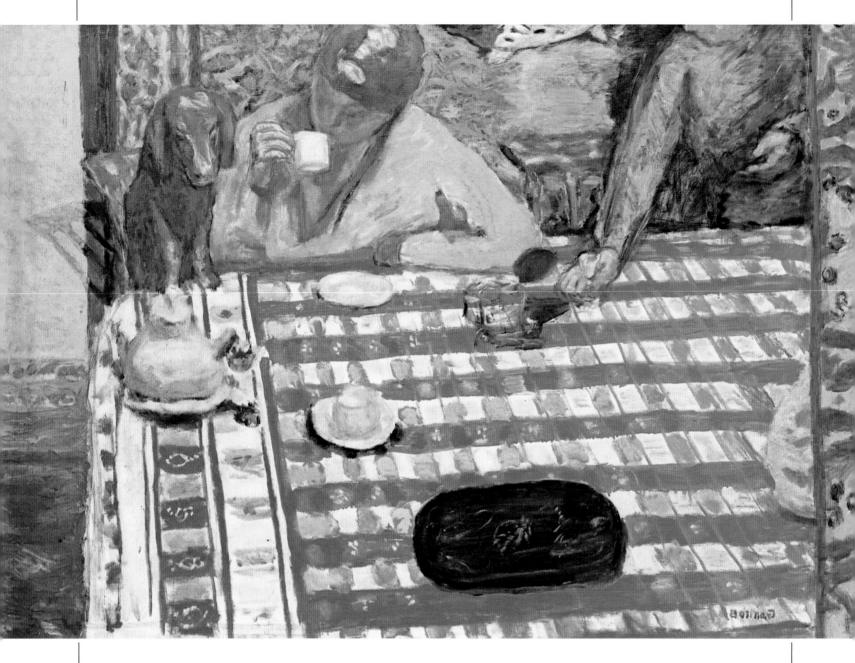

The coffee, 1914

73 × 106 cm (29 × 42 in)

TATE GALLERY, LONDON

Bonnard has deliberately played about with the framing of this composition in order to startle the viewer into looking more closely at a mundane domestic scene. If the subjects had been set out in the conventional manner, the painting would have lost much of its immediate impact. The perspective is deliberately confused by the broad band of pattern on the right-hand edge of the canvas and the way in which the figures are cut off at the top of the picture.

before breakfast and as a devout man would always attend Mass on Sundays and frequently also on weekdays. With his wife he was a constant and restless traveller, roaming widely in France and also taking 'study tours' throughout Europe and North Africa. The summer of 1908 was spent in Spain in the company of Vuillard. Bonnard also loved motoring and in the early days of the motor car would use it to find subjects for his paintings, driving at a leisurely pace through the countryside and stopping to picnic and paint when he found a scene that inspired him.

After 1900 Bonnard had emerged from the influence of his colleagues in the Nabis and from

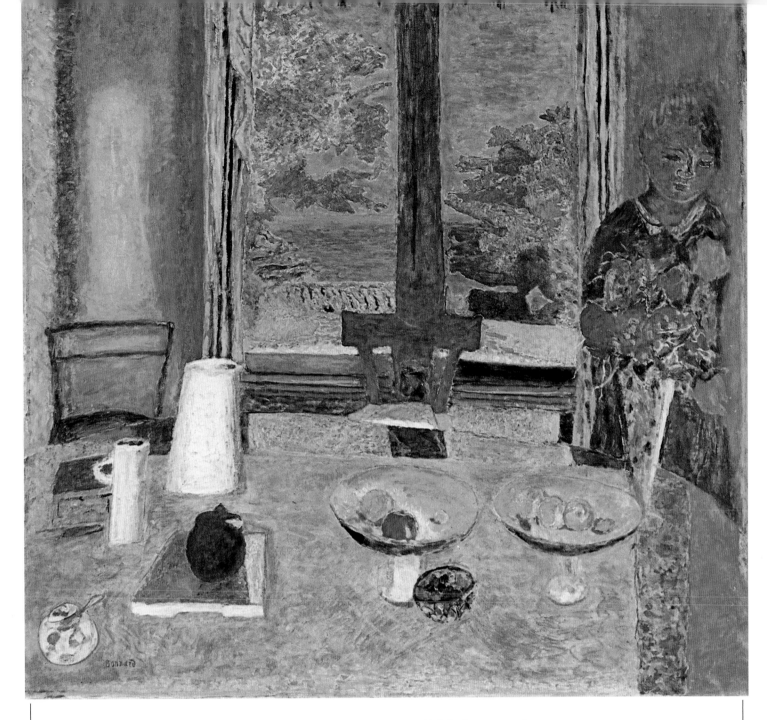

that of older contemporaries such as the Impressionists, and was pursuing his own experimentation with colour. 'A given colour is very different when you see it with other colours adjacent', he wrote in his diary. This document is full of telling remarks about his painting, which he always regarded as a process of development: 'A painter should have two lives, one in which to learn and the other in which to practise his art.' From his experiments a consistent style was already emerging, his paintings becoming a great riot of colour, generously applied. Although this treatment was subject to some variations, it was to remain essentially characteristic of all his work until his death in 1947.

Still life by a window, 1934
127 × 135 cm (50 × 53 in)
GUGGENHEIM MUSEUM, NEW YORK
This simple interior has an atmosphere of warmth and well-being, partly achieved by merging brushstrokes between one object and another, so reducing any linear emphasis.

Nude in the bath, 1937 (*overleaf*)
93 × 147 cm (37 × 58 in)
PETIT-PALAIS, PARIS
The nude was a constant theme of Bonnard's work, in particular the nude in the bath as he delighted in the unconventional viewpoint. His wife was usually the model.

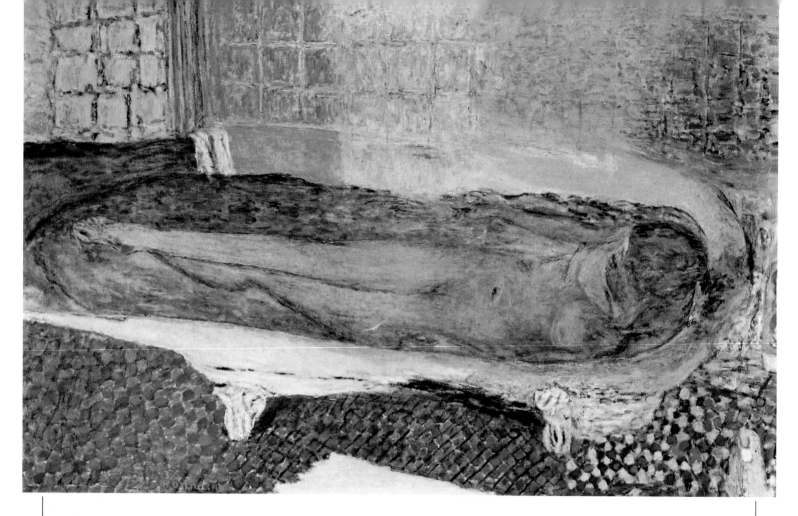

Sometimes Bonnard painted very swiftly but usually he would attach to the wall an enormous area of canvas on which he would begin several works at a time, returning each day to add to one painting and move on to the next without interruption. When all the separate works were complete they would be trimmed individually and mounted on wooden stretchers. Every part of the picture area was filled with strong and sumptuous colour and the vigorousness of the painting sometimes led to excess or awkwardness where the representational elements in the picture merged into abstraction.

Bonnard had enjoyed great early success and in his maturity, unlike Vuillard who began to fade, he pursued his own vision with a quiet tenacity. The hedonistic appearance of his work disguised a well-balanced and tempered life. He never lost the sense of economic responsibility which was the legacy of his bourgeois upbringing, so that although he was never in want of money, neither was he extravagant. From 1900 onwards he left Paris and lived increasingly in the countryside, buying several houses in succession in the Ile de France and eventually, in 1926, settling in Le Cannet in the south of France, where he lived into old age.

The brilliance of colour in Bonnard's work conveys the happiness and richness of his life and surroundings. Having found the course which he wanted to pursue, he did so untiringly although the artistic world around him was in ferment. By the time of his death he had witnessed a number of major changes in the development of the visual arts which would have seemed unthinkable to his contemporaries in the late nineteenth century. The heady succcess which he had enjoyed in the 1890s was because his work was very much the child of Impressionism, which had by then acquired the respect it deserved, and although his best work came through in the twentieth century, Bonnard was swiftly overtaken by more advanced aesthetic theories which shouldered his contribution into an isolated but by no means insignificant position.

After he moved to Le Cannet, Bonnard lived in quiet retirement from the world, almost unknown by the community around him. By the late 1930s his eyesight, which had never been good, was beginning to fail him and in the last years of his life he painted very little. Eventually he died peacefully at his house in Le Cannet, on 27 January 1947, one of the last representatives of a vanished age.

BOUDIN

The quiet and unassuming influence of
Eugène Boudin directly triggered the
development of Impressionism. This
painter of the great outdoors, who tried to
capture the wind, the clouds and the
movement of the sea with a freshness
previously unknown in French art, was
as a beacon to the young Claude Monet.
Boudin was an unpretentious man who
always feared that he could not paint
as well as he wished, but who at the same
time, through Monet, came to alter
forever the way landscape is
viewed and painted.

The Empress Eugenie on the beach at Trouville, 1863 (*right*)
34.5 × 57 cm (14 × 22 in)
BURRELL COLLECTION, GLASGOW
The groups of people crowding the beach at Trouville offered Boudin rich flashes of colour and movement which he could place against his ever-changing skies.

Beach scene, Trouville, 1863
18 × 35 cm (7 × 14 in)
PHILLIPS COLLECTION, WASHINGTON
Boudin painted beach scenes at Trouville over many years, capturing the atmospheric effects in brief and vivid sketches and also recording the fashionable pleasure-seekers. In this he was in tune with Baudelaire's call for painters of modern life.

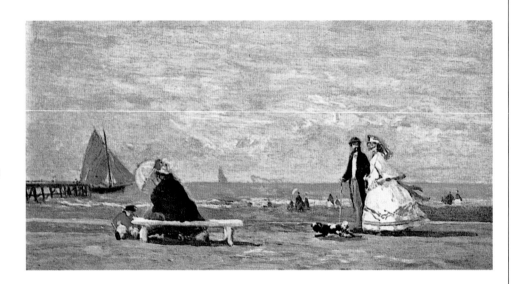

Eugène Boudin was born into a mariner's family on 12 July 1824, the first son of Léonard Sebastien Boudin and Marie Felicité Buffet. His birthplace was Honfleur on the Channel coast, and this coastal area remained Boudin's first love and most frequently painted subject throughout his career. His formal education was sparse and he was working as a cabin boy aboard his father's ship *La Polinichelle* even before he attended school. In 1835 the family moved from Honfleur across the mouth of the Seine to Le Havre, where Eugène was sent to a school run by priests; here, his talent for drawing was encouraged and he won a special prize for calligraphy. After only one year, however, he left the school and took up work as a clerk to a publisher and printer. His stay was brief and by the end of 1836 he was working for Alphonse Lemasle, a stationer who ran a shop in the rue des Drapiers. Lemasle was a kindly employer and noticing his young clerk's precocious talent, gave him a paintbox with which to experiment. All the while, Boudin's parents were much away from home; his father had a place on the steamship *Le Français* and his mother worked as a stewardess on various ships, as and when the

demand for money made it necessary. Boudin himself, although fascinated by the sea, was not attracted to the life of a sailor.

In 1844 Boudin left his job and set up his own stationery business in partnership with another former employee of Lemasle. More significant, however, was the sideline which Boudin developed of a small picture-framing business, acting for many of the artists who spent their summers on the Normandy coast, among them Jean François Millet, Eugène Isabey and Constant Troyon. They offered useful advice to the young Boudin, correcting his work and warning him of the perils of trying to make a living as an artist.

Regardless of this advice Boudin sold his share in the shop in order to be able to devote himself full time to painting. He spent days on end at the harbour, on the beach and on the cliffs. No early paintings survive but it is likely they were similar in subject to the later works, if less pure in technique. In 1847 Boudin travelled to Paris; feeling aware of the restrictions of his Le Havre existence he felt impelled to broaden his knowledge by visiting this centre of the arts. But he was not very happy in

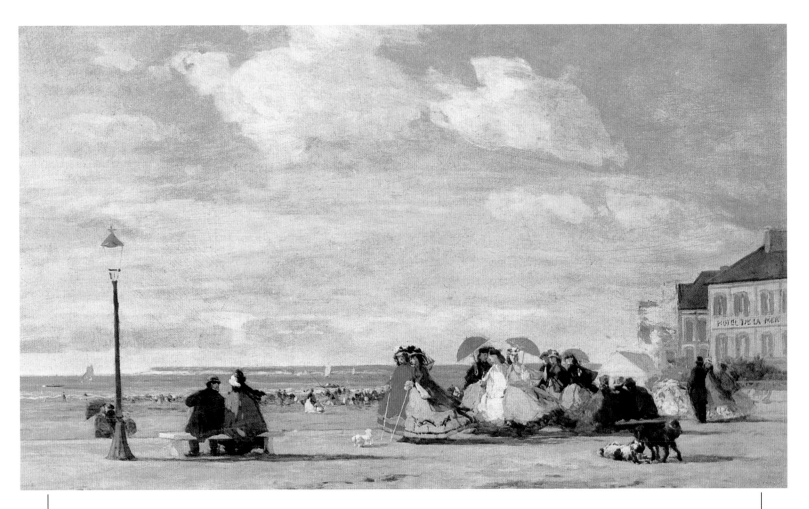

Paris and though he worked hard, studying in the Louvre, he was very lonely and acutely conscious of his limitations.

In 1849 Baron Taylor, a rich patron who had an eye for struggling young artists, sent Boudin on a visit to the Low Countries; here he became acquainted with the canals and harbours which he was often to revisit. In 1850 Boudin returned to Le Havre where the municipality, impressed with his work, gave him a grant for further study in Paris. He continued to find the city very claustrophobic and never really settled, though he worked hard copying old master paintings in pursuit of a formal art training. At the same time, he was much inspired by the contemporary Barbizon painters Corot, Troyon and Rousseau. Slowly, by following his own vision and instincts Boudin was moving towards what would later be recognized as the elements of Impressionism; but when he returned to Le Havre in 1854 after his grant had expired he was somewhat melancholic and lacking in confidence. He wrote wistfully in his diary, 'Sometimes when I am walking in a melancholy mood, I look at the light which bathes the earth, shimmers on the water and

plays on people's clothing and I feel positively faint at how much genius is necessary to overcome so many difficulties.' His poor self-assessment was certainly contradicted by his ability in later years, but his full capabilities did not really become manifest until the late 1860s.

The late 1850s were a period of gradual growth in confidence and ability. Boudin spent summers at the St Siméon farm on the estuary of the Seine, an inn run by a Madame Toutain at which Jongkind was also a frequent guest, among other distinguished artists such as Corot and Huet. This boarding house gave access to the open coastline and countryside and was popular as a summer venue where artists could gather to escape the heat of the city, exchange ideas and view the work of colleagues.

Boudin was only slowly beginning to achieve recognition but in 1858 the writer Alexandre Dumas bought two paintings. A visit to Brittany offered a broader range of subject matter which he explored with increasing skill. Boudin still frequented the shop in Le Havre which he had left behind so many years earlier. It was there that he one day met a promising young artist who lived

there in the town – Claude Monet – and offered to teach him about painting. Monet's original reluctance to follow Boudin in his dedication to painting out of doors was gradually overcome, and he later paid a handsome tribute to Boudin's influence when he wrote: 'I gave in at last and Boudin with untiring kindness undertook my education; my eyes were finally opened and I really understood nature. I learned at the same time to love it. If I have become a painter it is entirely due to Eugène Boudin.'

By 1859 Boudin had begun to receive the respect and appreciation of fellow artists and critics: Courbet sought him out to express admiration of his work and no less a person than Baudelaire wrote a critical appreciation of Boudin's paintings, describing them as having 'the eloquence of opium'. Progress,

however, was still slow in coming and the artist's moods fluctuated between depression and happiness. In 1859 his work 'The Pilgrimage to St Anne La Palud' was exhibited at the Salon but despite this acknowledgment, Boudin himself was not very pleased with the painting. 1860 was a year of important development for Boudin, the occasion of his first visit to the northern coastal resort of Trouville at the port of Deauville, which became, more than anywhere else, the place where his talent was really able to shine forth. He painted the beach in all sorts of weathers, crowded and uncrowded, at high tide and at low tide.

In the winter of 1861 Boudin was in Paris, employed in painting the backgrounds to pictures for Constant Troyon, so poor was he and desperate

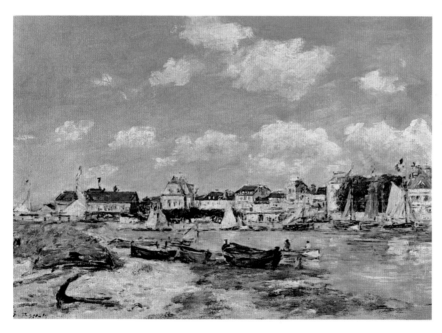

Boats at low tide on the estuary at Trouville, 1864
The daily life of the harbour and its fishermen was of great interest to Boudin. With his dry, loose brushwork he built from the most mundane subject matter up a picture shimmering with light and movement. It was this perception of the visual magic of life and nature that Boudin conveyed to Monet, as he showed the younger artist how to capture a house in the distance or the upturned hull of a boat with just a few judiciously placed strokes of colour.

On the beach at Trouville, 1869
(right)
31 × 48 cm (12 × 19 in)
LOUVRE, PARIS
As Trouville became more fashionable, Boudin grew ambivalent about the human intrusions upon the coastal landscape. 'The beach at Trouville which I used to love so much seemed no more than a hideous masquerade . . . the sight of the horde of gilded parasites with their triumphant airs seems somehow pitiful and one feels almost ashamed at painting the idle rich.'

''The romantics have had their day. Henceforth we must seek the simple beauties of nature . . . nature truly seen in all its varieties, its freshness.''

to make ends meet. But he was happy in other ways; he had fallen in love and was living with Marie-Anne Guedes. He continued to enjoy the esteem of his colleagues: a letter written to him by Corot included the words: 'Boudin, you are the king of the skies.' The pattern of his life was now beginning to develop. Boudin would spend the winters in Paris and the summers travelling along the Channel coast, in Brittany or in the Low Countries. In 1863 on the coast of Normandy he met and worked with Jongkind, who encouraged him to loosen his technique and become more relaxed; Boudin heeded this advice and it worked well for him.

By the mid 1860s Boudin was beginning to paint some of his best work, for example in 1864, 'The Empress Eugénie on the beach at Trouville', and the material success for which he longed was close at hand. His beach scenes were much in demand and patrons were beginning to seek him out to buy his works. In 1867 his work at the Exposition Universelle met with great acclaim and he began to exhibit in other European countries as the circle of his collectors spread. This meant that at last, in his middle age, Boudin was gaining financial security.

As well as the many beach scenes for which he was known and admired, Boudin painted port scenes of the high-masted vessels of the days of sail, pictures of rural isolation in Brittany and seascapes of falling tides through Brittany and as far south as La Rochelle. All these subjects and many more were captured on canvas by an artist at the height of his powers and maturity.

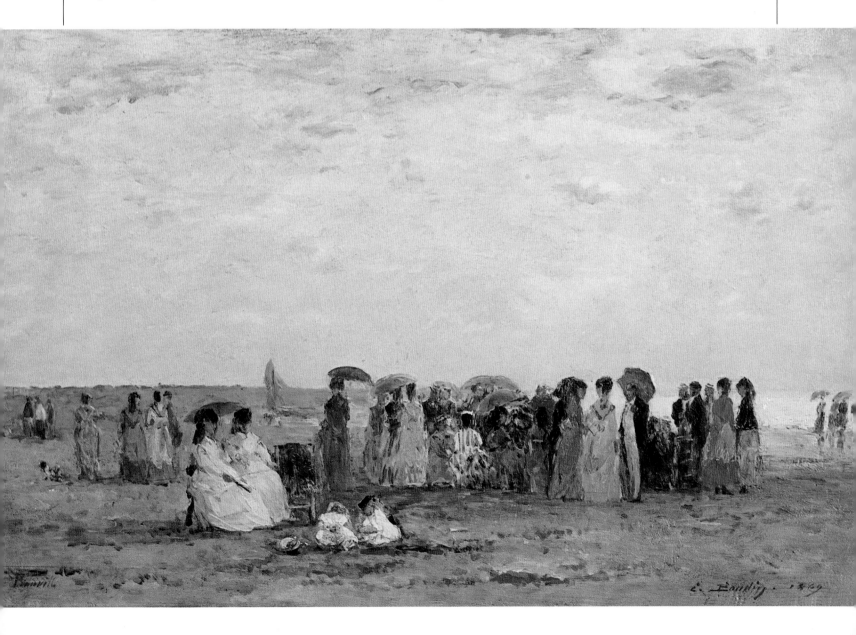

In 1874 Boudin exhibited at the first Impressionist exhibition but thereafter declined to exhibit with the young radicals. He was not genuinely an Impressionist, being set in the pattern of his working life earlier than others in the group, but he was by nature anti-academic, favouring the open-air school of painting which was to make much of the headway for the emerging Impressionists. His canvases have a looseness of brushstroke and a lightness of touch which Monet was not alone in admiring. Throughout the 1870s and 1880s, while critical scorn was being poured on the young Impressionists, Boudin was gaining critical praise. In 1883 the perceptive critic De Fourcauld wrote, 'If there is anyone who only trusts his immediate impression, immediately recorded to render what he sees, it is Eugène Boudin.'

In late middle age Boudin was at last able to paint in comfort; his reputation was secure and his finances sound. In the late 1880s he began to travel further afield, going south to Antibes and the Côte d'Azur and also visiting Venice. These trips were responsible for some wonderful, luminous works which increased his popularity. By the 1890s the dealer Paul Durand-Ruel was taking exhibitions of Boudin's work to London and New York and although his reputation has since been overshadowed by his more illustrious young colleagues, he remains, without a doubt, one of the most charming painters of the period.

In 1894 Boudin spent the winter on the Mediterranean at Beaulieu convalescing from stomach cancer, but was unable to overcome the sickness. He returned in August to die at Deauville, in his house on the cliffs above the beaches he had loved and immortalized in paint.

The port of Bordeaux, 1874
71 × 102 cm (28 × 40 in)
NATIONAL GALLERY OF SCOTLAND,
EDINBURGH
An untypically large canvas for Boudin, but made necessary by the scope of the painting, which takes in all the bustle and colourful life of the busy port. Boudin painted such scenes all around the Atlantic and Channel coasts of France, and on up to the Dutch ports of Amsterdam and Rotterdam. Human activity is shown amid the subtle changes of the sea and open sky.

CASSATT

Mary Cassatt was one of the most
remarkable characters of the
Impressionist movement. Both as a
woman and as an American it was
difficult for her to make a successful place
in nineteenth-century French society, and
her achievement as one of the leading
Impressionist painters is all the more
significant for this fact. She made her
mark as a woman painter and as a
painter of women. At a time when the
Impressionists were deliberately seeking to
portray the new elements of modernity in
their surroundings, she chose to focus on
the daily pleasures and chores of women
in modern society, using her feminine
sympathy and considerable painterly skill
to illuminate these often neglected
themes.

Mary Cassatt was born in Allegheny, near Pittsburgh in Pennsylvania, on 22 May 1844. She was the second daughter and fourth surviving child of Mr and Mrs Robert Cassatt, both of whom were of long-established upper-middle-class American stock. Robert Cassatt was a successful stockbroker who enjoyed a comfortable position in society; he was prepared to move from house to house, from town to country or even to a different continent as his work demanded, but always relentlessly travelling up the social scale. His wife was extremely well-read and well-educated, fluent in French and cosmopolitan in her tastes. She was loyal and supportive to her daughter when it became clear that Mary did not wish to follow the path normally mapped out for elegant young society ladies of the nineteenth century.

In the late summer of 1851 the Cassatt family moved to Paris, shortly before the *coup d'état* that established the Second Empire in France under Napoleon III. But after four years in Paris, where the children had quickly become used to the new environment, the family returned to Pennsylvania and resumed their former way of life. At the age of 17 Mary, who had shown a precocious interest in drawing and painting, was allowed to enter the Pennsylvania Academy of Fine Arts. She studied there for four years and in 1866 managed to persuade her parents that in order to complete her artistic education she must return to Europe.

Mary Cassatt travelled again to Paris and began to apply herself to the serious life of a dedicated artist. She worked briefly in the studio of the painter Charles Chaplin and received criticism and instruction from some of the more eminent classical artists of the day. During these years she took every opportunity to study not only the paintings of the old masters in the Louvre, as was expected of a young painter, but also to become well acquainted with the work of contemporary figures such as

Courbet and Manet, both of whom were subjects of public notoriety at that time. Manet, in particular, had already established a reputation as a leader of the avant-garde. Cassatt's studies were unfortunately interrupted in 1870, when the outbreak of the Franco-Prussian war forced her to return to Philadelphia.

In 1872, when her parents regarded Europe as once again a safe place for their daughter, Cassatt travelled back this time not directly to Paris, but to Parma in Italy where she settled for eight months, studying the works of Renaissance masters and taking drawing lessons and instruction in printmaking. Before returning to Paris she travelled to Madrid to view the great works on display in the Prado and went on to Antwerp in Belgium by way of Seville. In Antwerp she was able to see at first hand the paintings of the Netherlandish and Flemish masters. Meeting with her mother, who had travelled independently to Europe, Mary told her that she intended to take a studio and live permanently in Paris.

Since 1872 Cassatt had been sending work for exhibition at the Paris Salon, but her rather traditional style had received little attention. In 1874, however, the year of the first Impressionist exhibition, her work caught the interest of Degas who remarked of it, 'It's real, there is someone who feels like me'. The two artists were not to meet until 1877, when introduced by a mutual friend. In that year Cassatt's work was rejected from the Salon; she had become bored by the conventions of the academic world and had developed a keen interest in the new Impressionist movement, so she accepted with enthusiasm when invited by Degas to exhibit with the group. She was flattered that her work was taken seriously and developed a close friendship with Degas which lasted throughout his lifetime, though often put under strain by his irascible and pessimistic nature.

Reading *Le Figaro*, c. 1883
101 × 81 cm (40 × 32 in)
PRIVATE COLLECTION
Mary Cassatt's determination to become a painter was a bold and unusual step for a woman, even in the second half of the nineteenth century, and she appreciated the support of her family, particularly her mother who is the subject of this painting. By portraying her reading Le Figaro, Cassatt underlines her sense of women as educated and interested members of society.

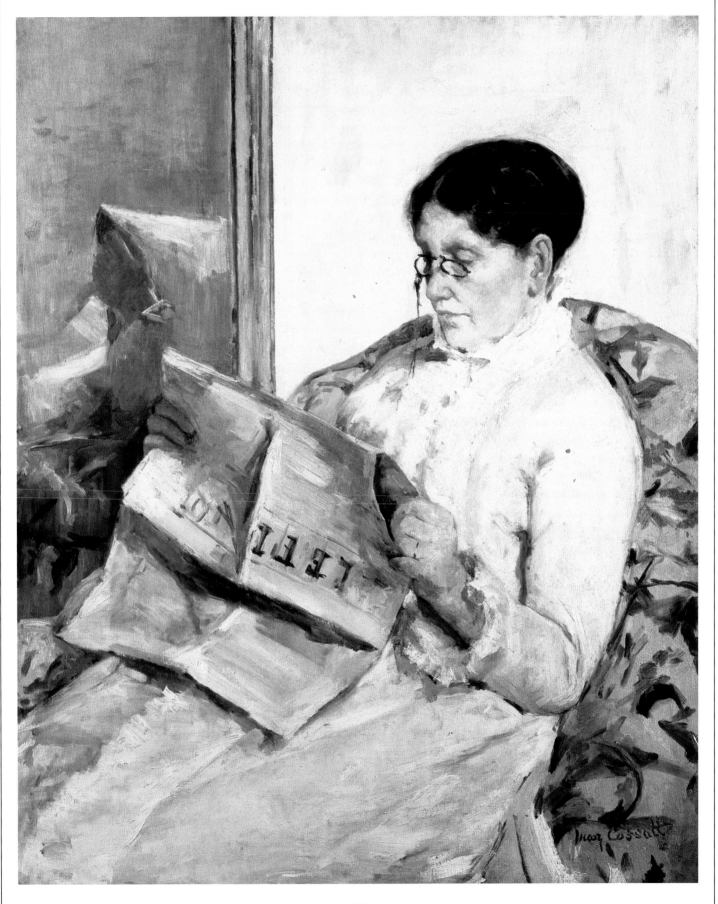

In this work the dazzling colour of the 1870s has been heavily subdued, the heavy blacks perhaps suggesting the influence of Manet. The picture has a subtle humour – as the young lady is engrossed in watching the performance through her opera glasses, she herself is as closely regarded by a man in a neighbouring box.

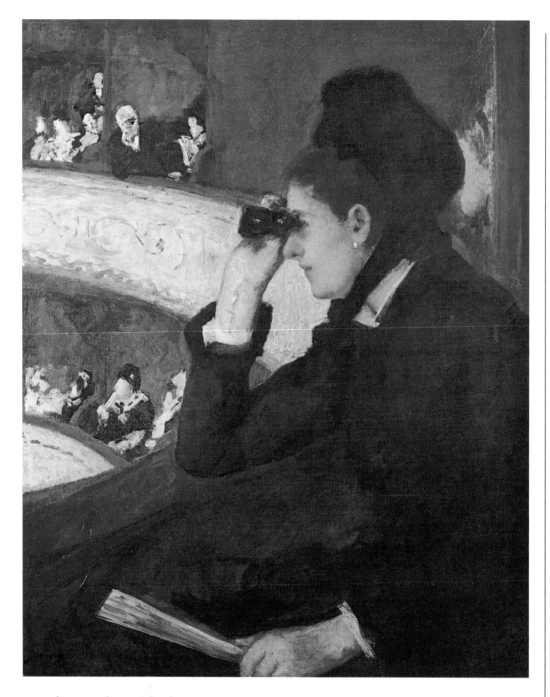

Later in life, Cassatt wrote to her mother, 'I had already recognized who were my true masters. I admired Manet, Courbet and Degas. I hated conventional art. I began to live.' The invitation to join the Impressionists was of crucial importance to Cassatt, giving her a sense of confidence and belonging to her environment that as an American woman living in Paris she had found very difficult to achieve. In the years after 1877 she produced the best of her work.

Cassatt is remembered above all for her paintings, prints and drawings depicting women and the family environment. Women were not allowed to attend life-classes where art students could draw from a live nude model and were therefore barred from an important aspect of art training. More important to Cassatt, as an artist seeking to avoid conventionality, was the fact that by her sex she was also denied access to the twilight world of the café, the music hall and the brothel, which provided so much subject matter for male painters such as Degas and Toulouse-Lautrec. But she contrived to make a virtue of these restrictions, turning to a theme which was freely available and which she understood intuitively. She frequently painted women in their maternal roles, washing and feeding their children, or enjoying their leisure and privacy, but also showed women at the theatre or reading newspapers and novels, underlining the fact that women could and did take the intelligent and

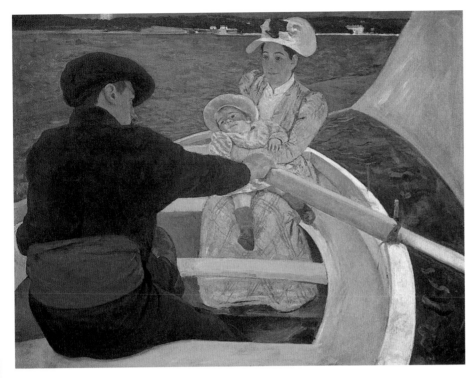

The boating party, 1893–4
90 × 117 cm (36 × 46 in)
NATIONAL GALLERY OF ART,
WASHINGTON
*The treatment in this highly
sophisticated composition is less
impressionistic than in Cassatt's
earlier paintings. The large blocks of
colour and the foreshortening of
perspective show the influence of
Japanese prints, while the overall
style bears comparison to Gauguin's
work of the Pont-Aven period,
showing that she was alert to the
development of Post-Impressionism.*

intellectual approach to life that was generally expected of men. Cassatt painted out of doors only occasionally: 'The boating party', a late work of the 1890s, repeats the motif of woman as mother but shows a formal approach strongly influenced by Japanese art, with the flattening of the picture plane and the use of patterned areas of strong colour.

At the fifth Impressionist exhibition in 1880 Cassatt submitted her work feeling confident and at ease with her new-found colleagues. Coming as she did from an affluent family, she was able to indulge her passion for painting without any financial worries. But she was commendably conscious of the great advantage she enjoyed over some of her colleagues in this respect and was also aware of the difficulties of some of the admirers who sought to help the Impressionists. In 1882 she gave money to the dealer Paul Durand-Ruel, who had almost bankrupted himself by his patronage of the Impressionist painters before they had become generally popular. Her generosity in turn was rewarded by Durand-Ruel when his prospects improved, as he arranged her first one-woman exhibition in 1891.

In 1898, after living in France for over 25 years, Cassatt returned to the United States where her work was known but had not gained her the respect she had achieved in Paris. The local newspapers in Philadelphia found little of interest to report in her homecoming: 'Mary Cassatt, sister of Mr Alexander Cassatt, President of the Pennsylvania Railroad, returned from Europe yesterday. She has been studying painting in France and owns the smallest Pekinese dog in the world.' Cassatt was sadly disappointed by the lack of appreciation of her paintings, as throughout her career she had constantly sent pictures back to America for exhibition, but in general they were poorly placed and little noticed. It was a particular disappointment in the context of the 1890s, as the first great American collections of Impressionist paintings were already being formed and prices for the works were at last beginning to rise. Cassatt returned to Paris in the spring of 1899 after only a few months in her native country and never again revisited the United States, though her reputation there was at last established in 1903 by an exhibition of her work in New York arranged by Paul Durand-Ruel.

As the new century progressed Cassatt was gradually painting less actively. The deaths of both her brothers within the same year, in 1910, brought on a nervous collapse and in common with her close friend Degas, she was suffering from failing eyesight. By 1914 the steady worsening of cataracts in the eyes had almost entirely prevented her from painting. The work of her later years took on a different manner from the earlier, vigorous period of Impressionism: she no longer painted in oils and used mainly pastel in broad, slashing strokes and strident, easily visible colour.

During World War I she lived alone in Grasse, in the south of France, where she had been evacuated from her own home which lay within the war zone.

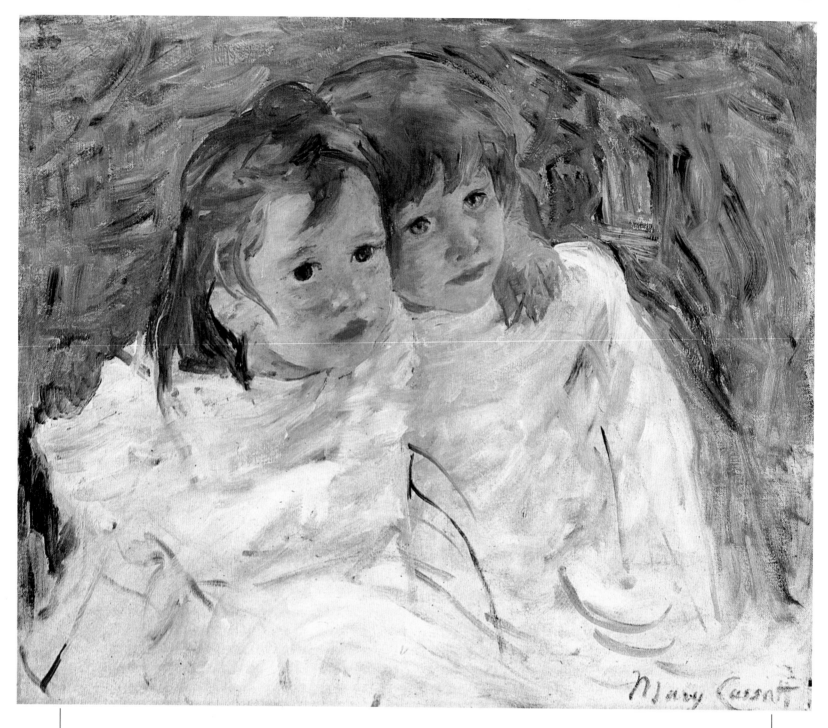

In 1921 an operation to remove the cataracts was a failure and Mary Cassatt remained virtually blind until her death on 14 June 1926.

In 1891 Cassatt's mother had written to her son: 'Mary is at work again, intent on fame and money, she says. After all, a woman who is not married is lucky if she has a decided love of work of any kind and the more absorbing the better.' But Mary Cassatt's love of work had not made her forget the choices she had made. Her devotion to art is often demonstrated with a special clarity in those intimate and tender works in which she depicted the motherhood she had knowingly sacrificed.

The little sisters, c. 1885
48 × 57 cm (19 × 23 in)
GLASGOW ART GALLERY
Cassatt's portrayals of mothers and children were not matched by any of her male colleagues, and only rivalled in similar works by Berthe Morisot. Here she has succeeded in capturing the shy confidence of youth in the children's cherubic faces, while avoiding sentimentality. The free brushwork and unfinished quality of this painting add to its charm.

CEZANNE

Paul Cézanne's artistic life was closely
involved with the Impressionist
movement. He was of the same
generation as its leading artists and yet his
work always remained curiously apart
from theirs. His use of colour, perspective
and the modelling of form reached the
very threshold of abstraction, and the
resulting style was a considerably greater
influence on succeeding generations than
on his contemporaries, who frequently
failed to understand his work. But it was
in the climate of change fostered by the
Impressionists that Cézanne was able to
develop and in time, although recognition
was slow in coming, provide the most
productive offshoot of Impressionism.

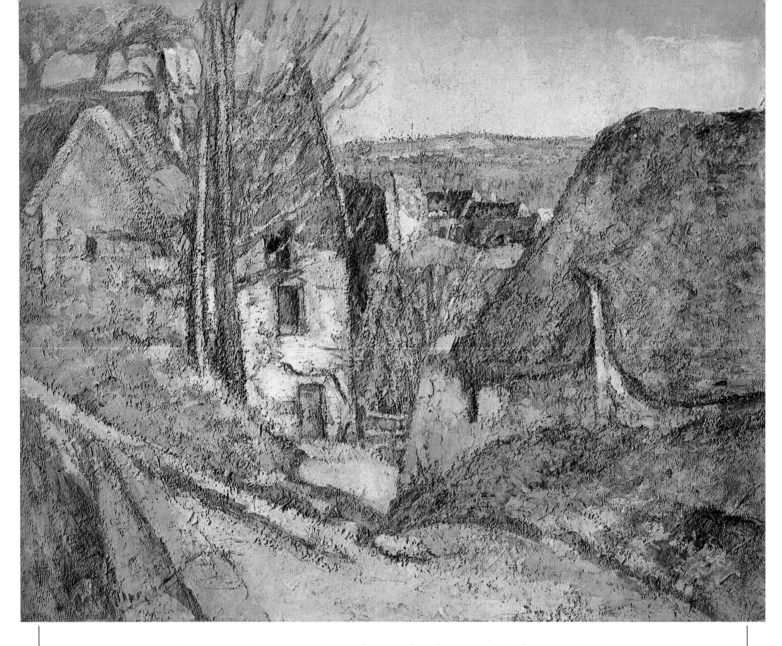

Paul Cézanne was born on 19 January 1839, the year before Monet's birth, in Aix-en-Provence in the south of France, the first of three children of a prosperous bourgeois family. In 1848 his father Louis Auguste purchased the local bank in Aix, when the former business was liquidated, and went on to make a substantial living as a banker. From 1849 Paul attended the Ecole St Joseph where he was allowed by his father to attend drawing classes but only on the condition that his other studies were not thereby interrupted. In 1852 he moved on to the Collège Bourbon, also in Aix, where he was a fellow pupil and close friend of the celebrated writer and critic Emile Zola.

Louis Auguste Cézanne was very keen for his son to study law when he had finished at school but Cézanne had no intention of being other than a painter. As well as attending the University of Aix he also attended classes at the drawing academy and dreamt continually of escaping to Paris to paint.

In 1861 his father allowed him to go to Paris where through Zola he soon met some of the young painters, in particular Pissarro, who was to remain a constant friend to him over the years. While in Paris, Cézanne studied at the Académie Suisse and also visited the Louvre and the Salon; but he apparently found the atmosphere discouraging and returned home, where he took up a job in his father's bank. The claustrophobic atmosphere of provincial Aix, in contrast with the busy life of Paris, soon proved too much for Cézanne who was constantly being encouraged by Zola to return. In 1862 he left the bank vowing to become a painter and made his way back to Paris to rejoin Zola. With intermittent visits to Aix, Cézanne was to remain in Paris until 1870.

The 1860s were a most difficult period for Cézanne. Year after year, every painting which he entered for the Salon was rejected. Although much praise came from Manet and Zola, almost everyone else found his work difficult to comprehend. His hostility to the academic establishment seemed to be visible in his work. In his portraits, landscapes and still lifes paint was applied heavily, using a palette knife as well as a brush, and the colours were dark and oppressive. Cézanne was seeking all the time to find a personal style and means of expression but, with a few notable exceptions, this seemed to elude him in the paintings of the 1860s and 1870s. Each time he was rejected by the Salon he made no effort to put forward paintings that would be less objectionable to the jury, but seemed to exercise a perverse delight in presenting works which would further shock and outrage the jury members.

Zola's house, 1879–81
59 × 72 cm (24 × 29 in)
BURRELL COLLECTION, GLASGOW
This picture of Emile Zola's country house demonstrates clearly Cézanne's preoccupation with the formal structure of a composition. The various elements are carefully balanced and knitted together by the slanted brushstrokes typical of this period of his work.

The house of the hanged man, 1873 (*opposite*)
55 × 65 cm (22 × 26 in)
LOUVRE, PARIS
Cézanne was working closely with Pissarro when he painted this work. It shows him in his most impressionistic phase. Although he was even more radically opposed to convention than the other Impressionists, this particular work was one of the few that found a buyer at the first Impressionist exhibition in 1874.

Cézanne was not without friends in Paris although his temperament and attitude were very much that of a loner. Zola brought him along to the Café Guerbois where he occasionally contributed to the conversations, but listened carefully and learnt much from the remarks that would fly in heated discussion. Whenever he felt the city was becoming too much for him, Cézanne would depart for Aix and stay there for a few months. Although not sharing all the opinions of the Impressionists, Cézanne was greatly won by the kindness and sympathy of Pissarro and through him began to take an interest in outdoor painting.

Coming from a wealthy family, Cézanne did not have to rely on selling paintings in order to make a living, but his father did not allow him unlimited funds. In 1870, to avoid conscription into the military services, Cézanne returned from Paris on the advice of his father to stay at the family home in Aix. He had left behind a young woman, Hortense Fiquet, whom he had met in Paris and was later to marry. As the Franco-Prussian war gathered pace and Paris was threatened, Cézanne moved on to L'Estaque on the coast south of Aix, where he sent for Hortense to join him. He was at this time concealing the relationship from his parents, for fear disapproval from his father would lead to the loss of his allowance.

When the war ended Cézanne moved back to Paris with Hortense and then on to Pontoise on the Seine north-west of Paris to stay with Pissarro. There in 1872 Hortense Fiquet gave birth to a son,

who was also named Paul. The visit to Pontoise lasted two years: often Pissarro and Cézanne would set out to work together, setting up their easels in front of the same view though their renderings of it on canvas usually differed dramatically. Pissarro's work showed an openness and harmony of colour that contrasted with Cézanne's continual efforts to contain his heavy brushwork within a complex pictorial structure. It was during this period that Cézanne's work came closest to being Impressionist, but as seen in a work such as 'House of the hanged man' the description 'Impressionist' is questionable. There is a deliberate foreshortening of the perspective which is not seen in any of the landscapes of the other painters at this time. However, in painting out of doors with a much brighter palette

than he had been accustomed to in the 1860s, and in the style of brushwork, designed to create a sense of light and shadow across the canvas, he showed the influence of Pissarro's technique.

With the support and encouragement of Pissarro, Cézanne exhibited three works in the first Impressionist exhibition in 1874 but they were greeted with even more scorn and derision than those of the other exhibitors although 'House of the hanged man' was bought by an Italian collector, Count Doria. Also in 1874 Cézanne left the hospitality of Pissarro's home at Pontoise and moved to Auvers near by. Here he was introduced to Victor Chocquet by Renoir and Chocquet became Cézanne's first patron, commissioning a portrait from him in the same year.

Poplars, 1879–82 *(left)*
62 × 78 cm (25 × 31 in)
LOUVRE, PARIS
Cézanne has made full use of colour to link the different areas within this image – the green foliage is full of touches of blue, and the predominantly blue sky is lightly tinged with green and pink.

Glass and pears, 1879–82
18 × 38 cm (7 × 15 in)
PRIVATE COLLECTION
In this simple arrangement of objects Cézanne was trying to transfer their volume and depth to the picture surface, not only with colour and tone, but by identifying the precise contours of the objects.

Cézanne decided not to show in the second Impressionist exhibition of 1876 and continued to send his most controversial and shocking works to the Salon; with their inevitable rejection, he railed all the more at the ignorance and prejudice of the jury. In 1877, however, Cézanne returned to the Impressionist group and at the third exhibition hung 16 works, which received hostile criticism even from those who were generally supportive of the new movement. His old friend Emile Zola tactfully avoided saying anything, but Cézanne received unexpected support from the critic Georges Rivière, in an article published in the review *L'Artiste*: 'M. Cézanne is a painter. Those who have never held a brush or pencil claim that he does not know how to draw, and have criticized him for imperfections which are actually a refinement gained through tremendous knowledge. His beautiful still lifes, so exact in tonal relationships, have a solemn quality of truth.'

Cézanne was unsettled during the 1870s, moving from location to location. In 1878 he returned to his native region, spending a lot of time at the Jas de Bouffan, the family house outside Aix. His father, who had come to terms with Paul's career as a painter but wished he could at least make it more of a success, did his best to make Cézanne abandon Hortense Fiquet and their son but had to tolerate them all living together under his roof.

Cézanne's work remained largely unnoticed until the late 1880s, largely for two reasons. First, it was far too radical even for the critics who supported Impressionism and was ignored because they could not understand it. Second, Cézanne spent less and less time in Paris, living in the south of France far away from the great aesthetic turmoil of the capital. In 1880 he settled at L'Estaque, where Renoir came to stay with him. At the official Salon of 1882, Cézanne at last had a painting accepted, but this was through the personal intervention of Antoine Guillemet, a mediocre artist on the fringes of Impressionism whose work was acceptable to the establishment. Cézanne was entered at the Salon as 'a pupil of Guillemet'.

In the 1880s, now in his forties, Cézanne was at last beginning to find confidence in his style and to develop the works of his mature period. 'Zola's

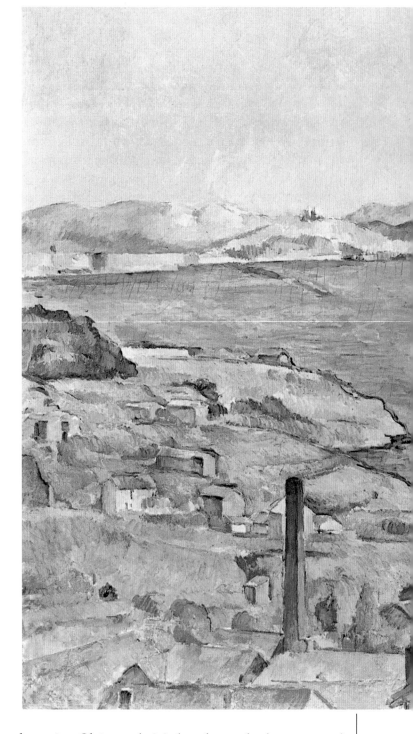

house' at Château de Médan shows the last traces of Pissaro's influence – something that he had struggled with over the past decade but found unsatisfactory. 'Poplars' shows the same iconographic inspiration later used to good effect by Monet, but handled very differently. The elements depicted begin to take on a form of their own with the wealth of colour modulations that Cézanne was able to introduce so subtly. By arranging the different relations of the picture planes within the space of the canvas a whole new pictorial imagery was created with the simple visual elements of hills, trees, sea and sky.

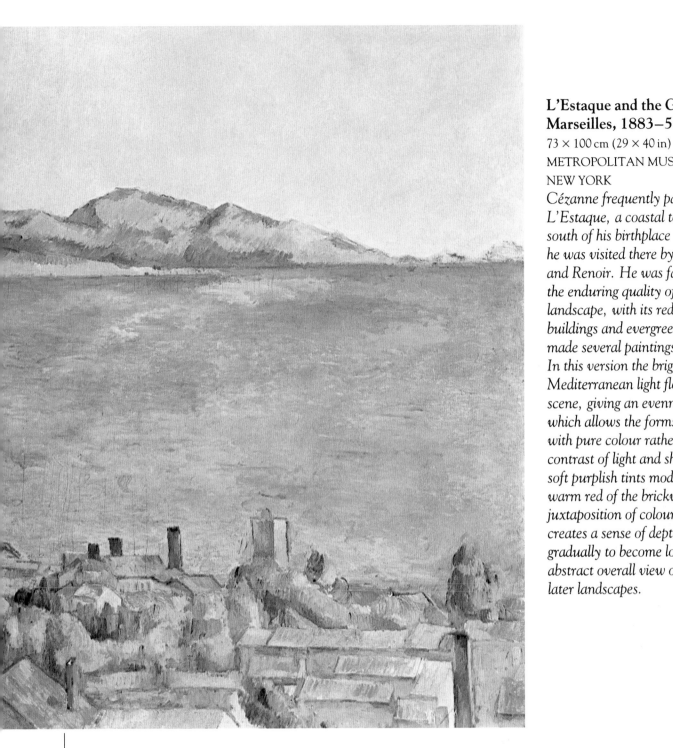

L'Estaque and the Gulf of Marseilles, 1883–5

73 × 100 cm (29 × 40 in)

METROPOLITAN MUSEUM OF ART,
NEW YORK

Cézanne frequently painted at L'Estaque, a coastal town situated south of his birthplace at Aix, and he was visited there by both Monet and Renoir. He was fascinated by the enduring quality of the landscape, with its red-roofed buildings and evergreen trees. He made several paintings of this view. In this version the bright Mediterranean light floods the scene, giving an evenness of tone which allows the forms to be built up with pure colour rather than with a contrast of light and shade, as in the soft purplish tints modifying the warm red of the brickwork. But the juxtaposition of colours here still creates a sense of depth which was gradually to become lost in the more abstract overall view of Cézanne's later landscapes.

''*The sun is so terrific here that it seems to me as if the objects were silhouetted not only in black and white but in blue, red, brown, and violet. I may be mistaken, but this seems to me to be to the opposite of modelling.*''

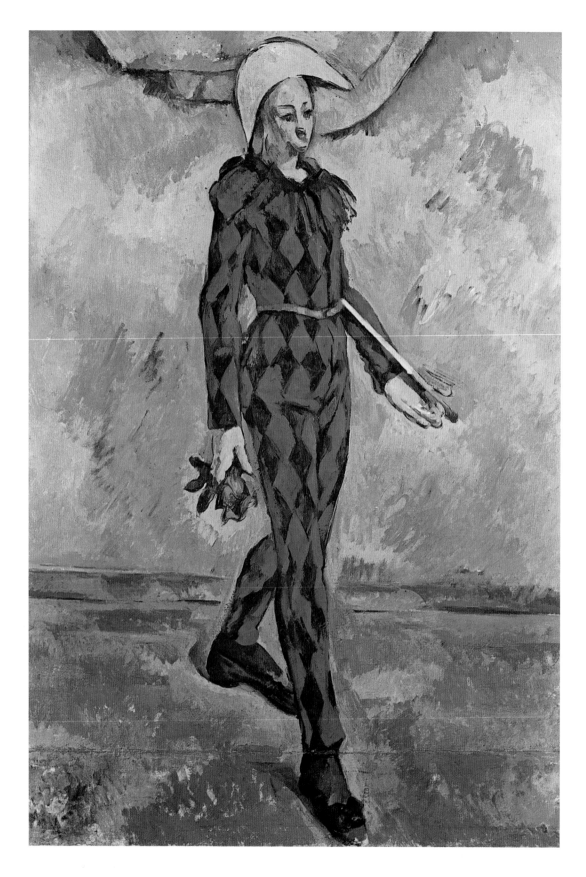

Harlequin, 1888
92 × 65 cm (37 × 26 in)
PRIVATE COLLECTION
This is one of a series of works which show Cézanne's son Paul dressed as a Harlequin.

The background is loosely structured and the junction between horizontal and vertical planes is flattened in order to thrust the figure forward, so that he fills the space leaving no sense of emptiness.

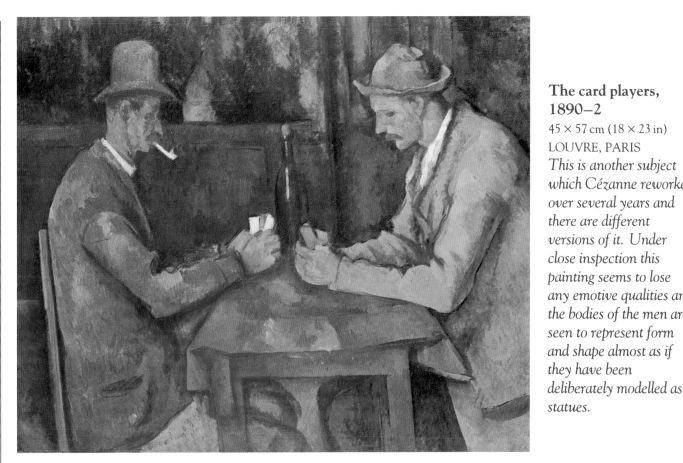

The card players, 1890–2

45 × 57 cm (18 × 23 in)
LOUVRE, PARIS
This is another subject which Cézanne reworked over several years and there are different versions of it. Under close inspection this painting seems to lose any emotive qualities and the bodies of the men are seen to represent form and shape almost as if they have been deliberately modelled as statues.

Shapes become interesting not merely because of what they represent but also because they begin to take on an abstract appeal of their own heightened by the attractions of colour. What Cézanne was slowly moving towards was the belief that a shape can be beautiful simply as a shape, as well as stimulating ideas or nostalgia, memory or familiarity by depicting mundane objects of everyday life.

1886 was a year of great personal significance for Cézanne. He at last married Hortense Fiquet in Aix, with his parents attending the wedding. In the same year Zola published his novel *L'Oeuvre* whose central character, a painter called Claude Lantier, was based quite closely on Cézanne. Zola denied the connection but Cézanne took great exception to the way he was depicted in the novel and was deeply hurt. Their close friendship, which had lasted for 30 years since their schooldays, ended abruptly. After the death of his father in October of 1886, Cézanne inherited a small fortune which gave him great freedom of movement. He began to travel more between Aix and Paris, renting studios or country houses as the mood took him.

In the early 1860s Cézanne had painted many figure compositions, in particular depicting the people close to him, his friends and parents. In the 1890s, having developed confidence in his mature style through work which showed mainly landscapes and still lifes, Cézanne turned once again to the human figure as his theme. 'The card players' is perhaps the most famous of these works and has about it some of the strengths of Degas's work 'Absinthe'. There was no social comment implied in showing the drunken men playing for small stakes; it was simply a scene which gave the artist an opportunity for striking composition – the polarization of the figures gathered around the table.

At the same time, Cézanne was beginning to work regularly in the Forest of Fontainebleau near Paris, not as Monet and Sisley had done in the early days of Impressionism but forming abstracted patterns based on the overhanging or arching trees. It was the kind of work, often in watercolour, that he continued in the quarry of Bibemus near Aix, and in the views of Mont St Victoire which he painted even more frequently after he had built a studio overlooking the mountain, at Les Lauves.

Although Cézanne had not achieved the popularity of Monet or Renoir, by the turn of the century he had at last begun to receive recognition and, perhaps more importantly, comprehension not only from his fellow painters but from poets and writers

"But you know all pictures painted inside in the studio will never be as good as the things done outside."

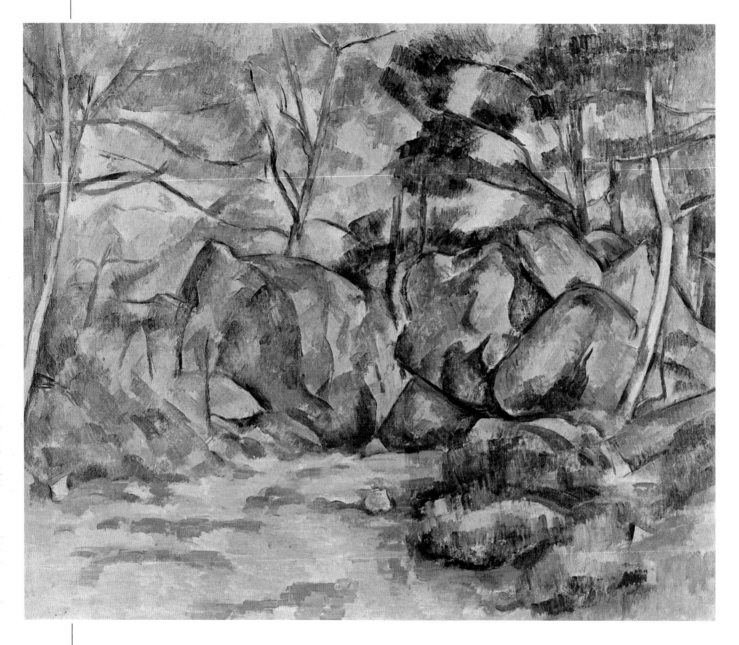

Landscape with rocks and trees, 1895
51 × 61 cm (20 × 24 in)
KUNSTHAUS, ZURICH
In this closely contained composition Cézanne uses long individual brushmarks to create an effect of mass and depth infused with light. In his search for structure and unity within an image he developed a purely personal vocabulary of form and technique far from the more instinctively realized landscapes of Pissarro and Sisley.

and above all from the dealer Ambroise Vollard, who had been introduced to Cézanne by the ever-thoughtful Pissarro. In 1895 Vollard gave Cézanne his first one-man show in Paris at which 150 works were exhibited. In 1897 Vollard bought the whole contents of Cézanne's studio at Fontainebleau and made an important sale of two works to the National Gallery in Berlin, although the Kaiser forbade them to be hung. Vollard made a strong

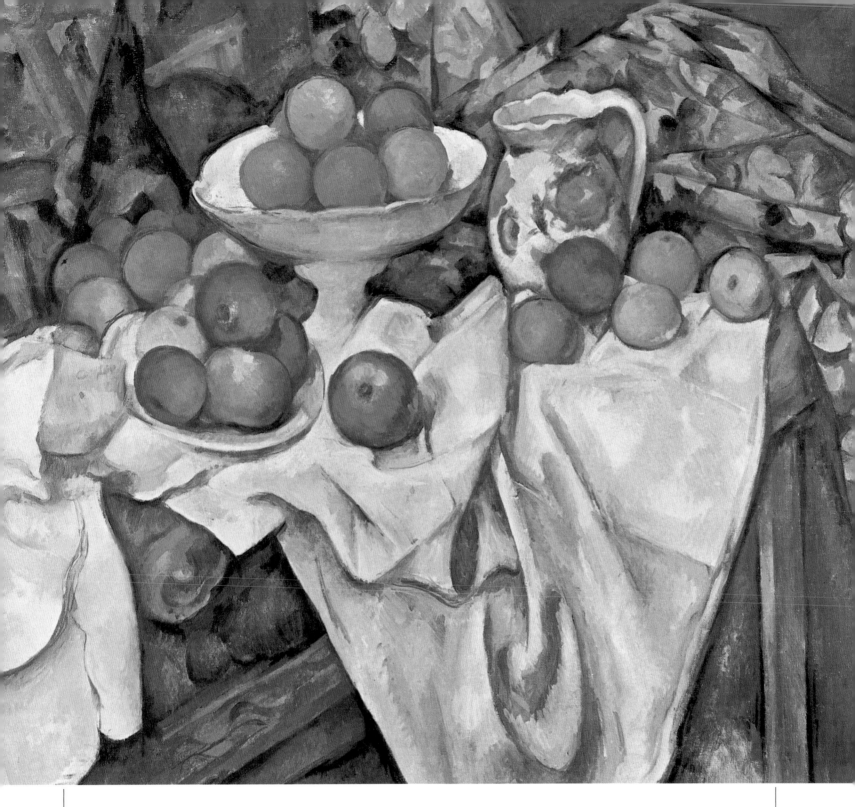

impression on Cézanne and in 1899 he commissioned a portrait which is in Cézanne's unique style, but shows echoes of the earlier work of Manet and Degas.

Finally, in the last years of his life, Cézanne found great success in contrast with the years of rejection. It would be some time before he was fully appreciated by the public but his work was at last understood by fellow artists and other colleagues.

Still life, 1895–1900
74 × 93 cm (29 × 37 in)
JEU DE PAUME, PARIS
The objects here are set out in a more complex pattern than in 'Glass and pears' (page 45). The shapes have a life of their own and the deliberate flouting of normal perspective shows Cézanne more interested in creating an image than in the faithful copying of his subject.

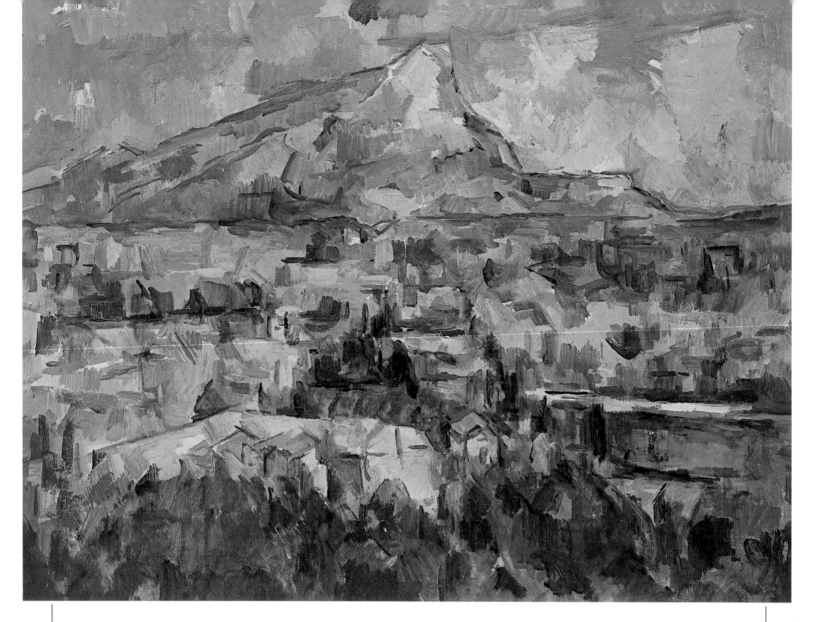

Monte Ste Victoire, 1904–6

73 × 92 cm (29 × 37 in)

PHILADELPHIA MUSEUM OF ART

Cézanne spent many years working on a series of paintings of Mont Ste Victoire, the dominant feature of the landscape surrounding his home at Aix. This very late painting from the series shows his move to suppress traditional landscape forms in favour of an almost abstract composition of colour and mass. The sky, containing both blues and greens and chequered with heavy brushmarks, appears to hold equal weight with the land below. The mountain itself is not invested with symbolic value but functions as a basic pictorial element. This picture shows clearly Cézanne's method of working all areas of the canvas together to achieve a cohesive texture and density in the richly applied colour.

Cézanne was, however, still working towards some goal of which he himself was unsure. As late as 1903 he wrote to Vollard, 'I am working obstinately. I am beginning to see the promised land.' His landscapes of this period have a much greater power and intensity, with the rocks and hills seeming almost isolated from humanity; no wind ruffles the leaves on the trees or casts ripples on the water. Cézanne had brought painting to the very fringe of abstraction.

In October of 1906 Cézanne was working out of doors near Aix, as was his habit. On 15 October he was caught in a very powerful thunderstorm; he collapsed and was carried home where pneumonia was soon diagnosed and on 22 October, aged 67, Cézanne died in his house at Les Lauves, overlooking his beloved Mont St Victoire which was to become one of the most important motifs of early twentieth century art.

COROT

Jean Baptiste Camille Corot was born at the end of the eighteenth century and, by the time the Impressionist painters had become locked in battle with the art establishment, was a respected elder statesman of French painting, a serene but notable influence. His gift to the new avant-garde was a sense of light and landscape unequalled by any of his contemporaries, but he barely lived to see what was made of his rich contribution since he died in 1875, the year following the first Impressionist exhibition.

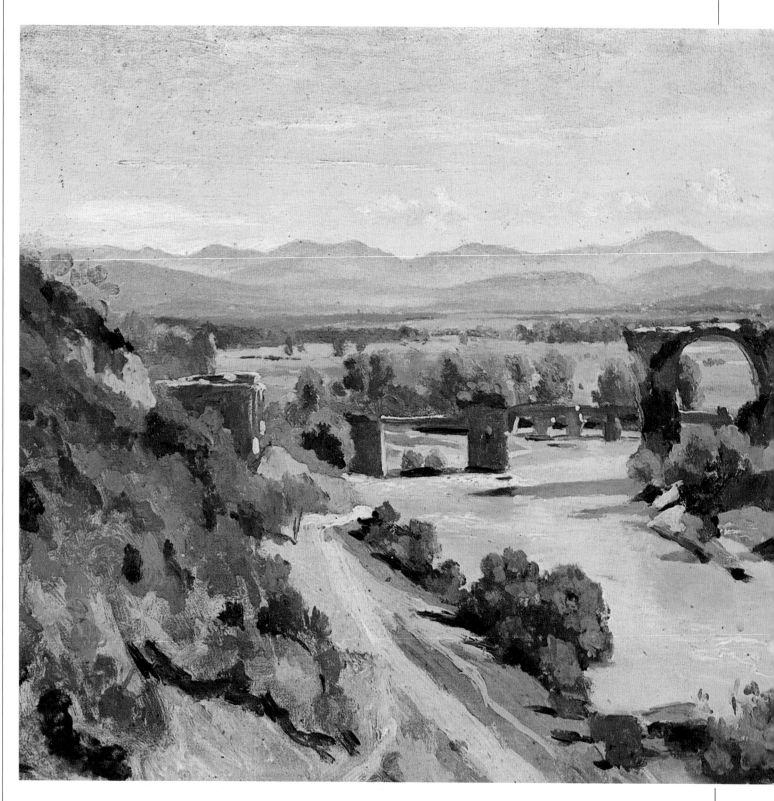

The Roman bridge at Narni, 1826
34 × 48 cm (14 × 19 in)
LOUVRE, PARIS
By the traditions of the time, a quickly executed painting of this type carried out in the open air was regarded as no *more than a useful reference to be used in a more considered composition. Corot's formal version, at double the scale, was executed in his studio and sent to the Salon of 1827. Yet the freshness in this original study show him to be one of the precursors of Impressionism.*

Corot was born on 16 July 1796, the second child of Louis Jacques Corot, a Parisian cloth trader. Immediately after his birth he was sent to a wet nurse, who looked after him throughout his early childhood until 1800 when he returned to his family. In 1807 he was sent away to school in Rouen, northwest of Paris, where he was a bad pupil by academic standards, concentrating on nothing except drawing. Louis Jacques Corot had always intended his son to follow him into the drapery trade and was not upset either by his lack of promise at school or his devotion to drawing. At the age of 18, Camille Corot was sent to work as a shop assistant for a fellow draper, M. Rutier, in the rue Richlieu, Paris. He found this work very dull indeed and constantly begged his parents for permission to leave and begin studies in painting. He used up all his spare moments, and a lot of his employer's time, in drawing and sketching. For five years, from 1817, his annual birthday gift to his father was a painting of a bunch of flowers, intended to persuade him that here was a talent worthy of encouragement. Eventually his father's resistance was worn down, perhaps finally by a softening of his attitude after the death of his elder daughter in 1822.

Corot learned to paint in the classical studios of the artists Michallon and Bertin. Both these artists had a sympathy for landscape, but used it as the background to literary or mythological scenes. Corot began to develop a feeling for landscape painting, independent of their tuition, but his real awakening as an artist did not come until he was in his late twenties, when he made his first trip to Italy in 1825. His father, by now totally resigned to the fact that his son had no aspiration or aptitude to become a draper, paid for this visit for at this time the artistic importance of Italy still dominated French painting. In Italy Camille Corot was received as an amateur by his colleagues. He painted the classical monuments of ancient Rome, in particular the Coliseum, as well as his early masterpiece 'The Roman bridge at Narni', of which he painted two versions.

The two versions of this painting demonstrate a principle which Corot understood early in his career and upheld throughout his life. He was finding his own way naturally towards a free, direct expression

of his observations of landscape and one version of the painting illustrates this direct approach. But Corot realized that this would not yet find acceptance with public taste and the official authorities of the Ecole des Beaux Arts and the Salon jury, so the second painting shows the more conventional style of academic composition. His fame during his lifetime was based not on the richly interpreted images which we now recognize as the natural expression of this artist but upon formal compositions, worked in the studio rather than in the open air, and including classical elements corresponding to established traditions.

On his return from Italy in 1828, Corot travelled around France. He painted the countryside freely and poetically, but continued to hide his early masterpieces from the public view. From 1827 he exhibited regularly at the Salon, showing the formal works approved by his masters and peers. His paintings became known and increasingly popular during the 1830s and 1840s and he settled into a routine common to painters of the period, of travelling during the summer and settling in France to work in his studio during the winter. He returned to Italy in 1834 and 1843, and made frequent tours through France in these middle years. He also visited Switzerland in the early 1840s and Holland in 1854. Despite the traditionalism of his publicly exhibited work, a sense of his personal, impressionistic interpretation was nevertheless visible in the shimmering colour of his landscapes.

Corot's life continued peacefully and without incident amid a crescendo of fame and popularity. He enjoyed considerable success at the Exposition Universelle in 1855 and reached the height of his fame between 1860 and 1870 when he was regarded with great respect, not only in established art circles but by the painters of the Barbizon school and the younger generation of avant-garde painters who,

reacting to established traditions in French art, felt that Corot was an early master who was showing a way they ought to follow. In the 1860s, his pupils included Berthe Morisot and her sister Edma, whom he encouraged to copy his works and to understand something of the effects of light and subtle use of greys and whites in the shadow areas, rather than the dark colours and heavy blacks more generally favoured by artists at this time.

Corot emerged from the neoclassical tradition where colour had been suppressed in favour of a strong linear definition, but only slowly came to discover the true potential of colour in landscape. In comparison with the later work of the Impressionists, his colours are still very muted. He laid great stress on the tonal values of his work, building up the overall sense of the painting with delicate and subtle contrasts. A house at Ville d'Avray in Normandy, bought by his father in 1817, became one of Corot's most frequently painted subjects, but in subject matter directly comparable to views painted by the Impressionists, such as 'Wheatfield' or 'Le Moulin de la Galette', it is easily seen that he had not yet reached complete freedom from the dominant classical influence of his earlier training. Some of his most beautiful work emerged from his journey to La Rochelle on the Atlantic coast of France in 1851, when his interpretation of the old harbour buildings and boats on the water formed a parallel to the work of Boudin and Jongkind who were beginning to develop that type of open-air scene. Corot's impressions are wonderfully fresh and there is a great joy in light and its reflection off water and onto trees and surrounding objects. The silvery grey which gave Corot his greatest popularity in the 1850s and 1860s was a lightening of the rather dead approach to landscape previously seen, tending towards the romanticism of the Barbizon painters' viewpoint and in its free and shimmering

Geneva, Quai des Paquis, 1842

45 × 34 cm (18 × 13 in)

MUSEE D'ART AND D'HISTOIRE, GENEVA

Here again, in a simple open-air study Corot's painting shows the qualities which made him a valuable teacher to

younger painters, including Pissarro and Berthe Morisot. The delicacy of the light, the balance between sky and water and the direct, unfussy brushwork are all elements which belong to the artistic vocabulary of Impressionism.

manner, a signal of what the new generation was about to produce.

In 1827 Corot had written to his parents from Italy to say, 'I have only one great goal in life, which I desire to pursue with constancy; that is to paint landscapes.' In fact, during his long and productive career he produced a wide and varied range of work. As well as his carefully contrived works for exhibition in the Salon, there were also a large number of figure paintings in which landscape plays no part, not even as background. Like much of his early landscape work these were only seen by fellow painters who visited him in his studio; they were never sold and never exhibited to the public in in his lifetime. A remarkable talent for portraiture

The gust of wind, c. 1867
46 × 58 cm (18 × 23 in)
MUSEE DES BEAUX ARTS, RHEIMS
The free brushwork and hazy colour enhance the sense of movement here. The blurred focus is accentuated by the silvery green grass and foliage – this muted yet luminous colouring became a hallmark of Corot's later work.

The church at Marissel, 1867 *(right)*
55 × 42 cm (22 × 17 in)
LOUVRE, PARIS
At the time of painting this rustic scene, Corot was at the height of his fame and influence, a respected member of the art establishment.

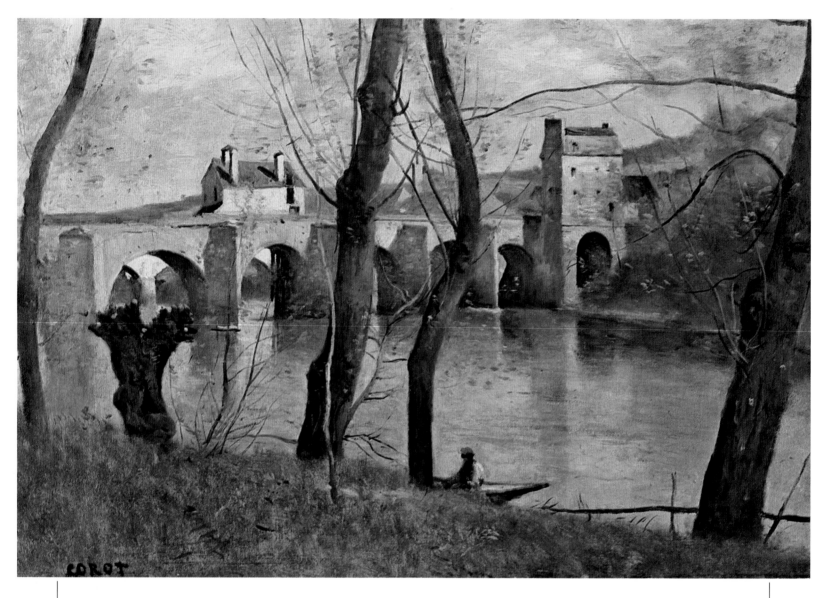

The bridge at Mantes, c. 1868–70
38 × 56 cm (15 × 22 in)
LOUVRE, PARIS

In this remarkable work, often considered one of Corot's greatest paintings, he has successfully captured the sense of a moment isolated in time.

and the attitude to colour in his painting of figures and interiors give an indication of the versatility and complexity of the man as an artist.

The life of Jean Baptiste Camille Corot was one of devoted attention to painting. In the biographical sense it was placid and uneventful. He never married nor, as far as we know, indulged in any flirtations or affairs. He travelled, often for long periods at a time, seeking to capture on canvas the beauty and tranquillity of the motif unhindered by theoretical interpretations. That he felt obliged to paint works specifically for the Salon was an indication of how much the success of a painter in the nineteenth century relied on being seen and

accepted in the official marketplace. The Impressionists of the next generation were not prepared to compromise their art in the same way to achieve recognition and struggled for many years as a result of their high-mindedness, but by the time of Corot's death in February 1875 both critics and fellow artists had realized that in this quietly spoken, dedicated old painter, they had seen an artist who had opened the way for a new form of art. He himself lived just long enough to witness a landmark for the future: the first Impressionist exhibition was held in 1874, unveiling the art of pure landscape to a startled and hostile public just one year before Corot's death.

COURBET

Gustave Courbet was the great radical painter of the nineteenth century. Like a great Colossus, he bestrode contemporary French society in a way that no painter had done before. He was alternately adored and despised, even by people who had never seen any of his pictures, because he brought to painting not only his ebullient and combative manner but also a heightened awareness of the social power that art could wield.

Gustave Courbet was born on 10 June 1819, the same year as Jongkind, the son of well-to-do landowners at Ornans in the region of Franche-Comté on the eastern borders of France. This was his mother's native region and the artist always had a deep pride in and attachment to the area. Many of his early works drew on his home town for inspiration and later in life Courbet was always returning to the nearby hills and wooded river valleys as subject matter for his paintings. As a noisy, lively youth he was educated first in Ornans and then in nearby Besançon, the capital of the region, where he learnt to draw under the instruction of the severely classical teacher Flajoulot.

At the age of 20, Courbet moved from the provincial comfort of his secure home to Paris where to begin with he led a quiet and studious life. In 1840, on his father's advice he contrived to avoid military conscription by making himself ill with a violent hangover. As a student Courbet flirted with various art schools; he was pleased that his master, Steuben, seemed impressed by his ability but in a letter to his father was dismissive of Steuben's teaching. He later, somewhat arrogantly, proclaimed that he knew no teacher but himself. From this early period he was very stubborn and convinced of his own ability, characteristics which were to become more prominent as he grew older.

Few early works survive as Courbet was later to re-use many of the canvases. From contemporary descriptions it appears that they were dark, romantic compositions. His entries for the Salon were rejected in 1841 and 1843 but he succeeded in exhibiting work in 1846 and 1848. Until 1849 he worked assiduously in Paris, leaving only to visit his family home in Ornans, except for one trip to Le Havre in Normandy where he had his first sight of the ocean. 'At last I beheld the sea, the real sea with no horizon; how strange it was to a denizen of the forests.' The influence of this first visit was profound and can be seen even in much later works, such as 'Immensity'.

Throughout the 1840s Courbet was very strongly motivated by the desire for success: 'I must make a name for myself in Paris in the next five years. There is no middle course, that is what I am working for.' In 1849 his first step towards the

success he looked for came when he won a medal at the Salon for 'After dinner at Ornans'.

From this time on Courbet began to emerge as an artist who by reputation and design had the effect of shocking the French art establishment. He deliberately painted subjects, such as 'Burial at Ornans' and 'The Winnowers', which were to do with day-to-day life and opposed to the historical and

After dinner at Ornans, 1849
195 × 257 cm (78 × 101 in)
MUSEE DES BEAUX ARTS, LILLE
*Courbet won his first Salon success in 1849
with this restrained but rather romanticized
composition of evening relaxation among
working men. The striking use of light and
shadow and the subtle traces of warm colour
among the neutral tones are in contrast to
the later light-filled and colourful works of
the Impressionists. The picture was admired
by the great painters Delacroix and Ingres
and much approved by the writer Charles
Baudelaire.*

*". . . to interpret the manners,
the ideas, the aspects of my time,
in terms of my own evaluations,
in a word, to produce living art."*

classical traditions of the Ecole des Beaux Arts. He
portrayed the drunken worthies of Ornans as though
they were of equal stature to the heroes of old or the
potentates of the Second Empire. In addition, his
paintings displayed in bold, broad, sweeping strokes
subjects which had already become popular among
the Barbizon painters: woodlands, seascapes, forests
and rural scenes.

Apart from his brilliance as a painter, Courbet was also a great showman and a sympathizer with anarchist politics. His style as an artist, and his personal aggression and arrogance swiftly gained him a reputation for being an anarchic, bellicose monster. His work of the early 1850s was undoubtedly shocking in conventional terms, and to the conservative Parisian art public, but he defended himself with the claim to realism: 'I am not only a socialist but a democrat and a republican; in short I am in favour of the whole revolution and above all I am a realist.' He became the subject of many caricatures in the press. Courbet adored the publicity, holding forth over pots of beer in the Brasserie Andler on his artistic, political and social opinions. 'I am the proudest man in France,' he was frequently heard to boast.

In 1855, in direct protest against the officialdom of the Ecole des Beaux Arts, Courbet erected his own private pavilion outside the Exposition Universelle in the Champs Elysées. It was a flamboyant and costly gesture, which was entitled 'Realism', although Courbet stated that this word had been foisted on him and was not a description that he would have chosen for himself. He expected his exhibition to be a great success, but in the event few people came and of those who did the majority came only to pour scorn. In the press he was much ridiculed for his vanity and his love of plebeian and ugly subject matter, as shown in the paintings.

Courbet remained undaunted. For the rest of the 1850s he continued to paint, regardless of his critics – so he maintained – though his approach was somewhat softened. The first of his hunting and country scenes began to appear, which in their open-air style and rural themes foreshadowed the interests of the Impressionists.

In fact, the early 1860s witnessed a great increase in Courbet's popularity as a painter. In spite of the bravado of his conversation, he had embarked on a highly productive period and the landscape and rural subjects were appealing to his public. In addition, his bold gesture of opening a 'free studio' endeared him to many of the young painters who were to form the avant-garde of the coming decade. The free studio allowed open admission and the model was more likely to be a tethered ox than a nude in classical pose. Though it survived for only three months, this was another act of opposition to the establishment and a gesture of middle-class provincial defiance to the smart Parisian world.

A different aspect of Courbet's personal anarchism was his association with seditious political movements. This was in almost ironic contradiction to the non-political and less aggressive style of his paintings of that period. His political development did not go unnoticed by his friends, and the critic Castagnary wrote to him complaining, 'Your true friends are concerned at the position you are taking up as a man and the status you are losing as a painter.'

Public opinion was fickle and Courbet's popularity fell away in 1863, but by 1865 his work was once again in demand. The summer of that year Courbet spent at Trouville on the Normandy coast, and he was much pursued by fashionable society for his portraits and seascapes. In the Salon of 1866 his works were hung in the most prominent positions and there was a chorus of praise in the press. In 1867 he again mounted his own pavilion outside the Exposition Universelle, as did Manet. It received little press criticism but appears to have been only moderately well received; however, Courbet's fame was still spreading and commissions continued to pour in. The pictures of the late 1860s are generally considered to be rather weaker and Courbet could be seen to be compromising himself to bourgeois taste; a very lucrative business. In 1869 his works were again hung in a place of honour at the Salon. In 1870 he painted seascapes at Etretat, on the Normandy coast, which proved very popular. Etretat was shortly to become a favourite haunt of Monet and other Impressionist painters.

Throughout his career Courbet's energies had been divided between his art and his politics and it was his political inclinations, combined with his not entirely justified intellectual arrogance, that led to his activities during the Paris Commune in 1871. As a result of the Franco-Prussian war and the fall of the Second Empire, France was in turmoil and Paris declared itself an independent commune. During this time Courbet was put in charge of the branch of the Commune appointed to protect the museums and works of art in Paris while the political turmoil

The winnowers, 1855

131 × 167 cm (56 × 66 in)

MUSEE DES BEAUX ARTS, NANTES

Courbet was frequently criticized for not painting pictures conforming to traditional ideals of figure painting, for at this time it was still not truly acceptable to celebrate the earthy, realistic qualities of peasant life, where a woman's place was to engage in tiring physical labour. This picture, however, is not realistic in the truest sense. The women, thought to be Courbet's sisters Zoé and Juliette, are posed in attitudes not typical of the actual work they seem to be doing in order to create a more dramatic effect. It is possible that Courbet was influenced by the style of Japanese prints which were only just being introduced to Europe and which were to have a much greater effect on the work of the major Impressionist and Post-Impressionist painters. The powerful lines and unusual pose of the central figure are elements which were taken up in the later works of Degas.

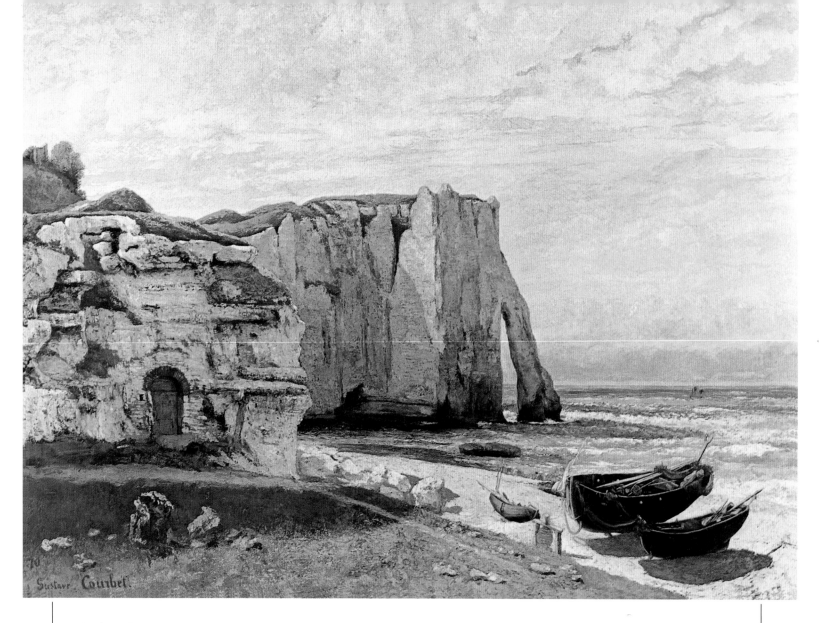

The beach at Etretat, 1870

130 × 157 cm (51 × 62 in)

LOUVRE, PARIS

The powerful coastal scenery at Etretat became an increasingly popular subject for the realist painters such as Courbet, and later for the leading Impressionists. This concentration on landscape for its own sake, which had been pioneered by Corot and the Barbizon school of painters as well as by Courbet, was gradually finding acceptance at the Salon. Courbet's picture of the Etretat cliffs is directly comparable with Monet's painting of 1883 (see page 134), but while Monet shows the turbulence of the pounding sea, Courbet has chosen a calm period following a storm in which the sunlight begins to break through over rocks and sea.

lasted. The Commune itself was an ill-fated and short-lived gesture, in the course of which Courbet became involved with the destruction of the Vendôme Column, a monument honouring the victories of Napoleon I. When peace was restored with the establishment of the Third Republic in France and the ending of the war with the Prussians, Courbet was arrested and tried. Although his actual part in events was confused, he was sentenced to six months imprisonment and fined 500 francs. In the event he served only three months before being released on medical grounds, but spent another three months in an army clinic. After his release in March 1872 he returned to Ornans almost penniless, forced to leave Paris where much of his property had been damaged or sequestered. In the winter of 1872–3, he suffered continual ill health – rheumatism and a liver disorder. In addition to these problems, he was also instructed to pay for the

reconstruction of the Vendôme Column. In 1873 he sought exile in Switzerland in order to escape the revengeful and rapacious government, who held him responsible for this massive debt and took no account of his useful work in protecting France's cultural heritage from the turbulence of the Commune period.

In exile Courbet became lonely and cantakerous. He drank heavily, rapidly grew corpulent, and his health began to decline. Though frequently visited by friends from France, he could not return to Paris as he was liable to pay over 300,000 francs for the reconstruction work. When he eventually died of dropsy in December 1877 he was buried in Switzerland, but in 1919 his remains were transferred to his home town of Ornans where there is now a museum in his honour.

Gustave Courbet's life as a painter is inextricably entwined with the colourful attraction of his radical

Still life, 1871

27 × 35 cm (11 × 14 in)

BURRELL COLLECTION, GLASGOW

During his period of imprisonment after the Paris Commune of 1871, the subject matter available to Courbet was very limited and he produced an untypical but highly accomplished series of still-life paintings, using as his models the flowers and fruit brought to him in prison by his sisters. The delicacy of the brushstrokes and the softness of the light show a sensitive side to the ebullient Courbet which was less apparent in his public life and better-known works.

Low tide, c. 1874

NATIONAL MUSEUM, WARSAW

Despite his aggressive political stance and defiant gestures against the art establishment, Courbet often endowed his paintings with a great charm and lyricism. He found beauty even in the simplest of subjects and treated them with surprising delicacy. He perfectly sets the mood of this almost empty beach scene by placing the horizon line low on the canvas and emphasizing the broad expanse of sky, a compositional device also frequently favoured by Boudin.

politics and robust personality. His arrogance and energy could be in turns attractive and repellent and he paid the price in his fluctuating status and popularity, and with the miserable exile of his final years. His importance to the Impressionists, however, lay not only in his bold and assertive use of paint but in his very hostility to the established society and artistic circles of his day. In this, like Manet, he provided a continuous spirit of challenge from within, which in the end opened the doors to a new art and a new mood of realism in painting.

DEGAS

Edgar Degas is one of the great solitary figures of the Impressionist movement, distinguished by temperament and technique from such painters as Monet, Renoir and Pissarro, but nevertheless capable of presenting a powerful opposition to the dullness of nineteenth-century academicism. His pictures, chiefly figure paintings worked in the studio, lacked the spontaneity shown by some of the other Impressionists. For Degas did not share their enthusiasm for outdoors painting. In fact he regarded as simplistic their dependence on it as a means to a new form of expression. Despite these differences, however, Degas contributed much to the richness of Impressionism, his portraits, figures and interior scenes providing a uniquely intimate view of contemporary life – an alternative to the landscape vistas and scenes of open-air recreation favoured by many of his fellow painters.

"What an original fellow this Degas, sickly hypochondriac, with such delicate eyes that he fears losing his sight, and for this very reason is especially sensitive and aware of the reverse character of things. He is the man I have seen up to now who has best captured, in reproducing modern life, the soul of this life."
Edmond de Goncourt

Horses before the Off, 1862
48 × 61 cm (19 × 24 in)
LOUVRE, PARIS
The racecourse was Degas's primary outdoor subject, and one he reworked time and again. Even at this early stage he was experimenting with pictorial composition: the group of riders in the foreground lead the viewer's eye out of the frame on the right-hand side.

Carriage at the races, 1870–3 *(right)*
36 × 55 cm (14 × 22 in)
MUSEUM OF FINE ARTS, BOSTON
In this painting, which was exhibited in the first Impressionist exhibition of 1874, interest concentrates on the figures; Degas rarely studied landscape for its own sake.

Edgar Degas was born on 19 June 1834 into a very wealthy banking family. He detested both his Christian name and aristocratic surname, de Gas, which he commuted to one word. His father came from ancient Breton stock and was proud of his long lineage. His mother belonged to the Musson family, members of which had emigrated to New Orleans and made a fortune in trade.

Edgar was a withdrawn, defiant and caustic youth. He was well-educated in classics and history, and in later conversations with his future colleagues would often display an unpleasant streak of intellectual arrogance. On leaving school he started to study law but showed no real inclination for his profession and soon obtained parental permission to become a painter. In 1855 he entered the Ecole des Beaux Arts where he was considered a rather obstinate pupil, disdainful even of Ingres who did, however, succeed in inspiring Degas with a sense of the supreme importance of drawing. To broaden the scope of his art education, Degas left the school and travelled to Italy where he spent three years studying the old masters in the museums, copying paintings and drawing the landscape. Despite his dislike of the Ecole des Beaux Arts, Degas long remained friends with the contemporary classical masters and in the early 1860s was still considered by them to be a prodigious talent. His painting of 1863–4, 'Young Spartans wrestling', was in the great tradition of French history painting so much favoured in official circles. His early work was very severe and almost wholly classical, so it was a great disappointment to his teachers when, after 1862, Degas began to consort with the arch rebel Manet

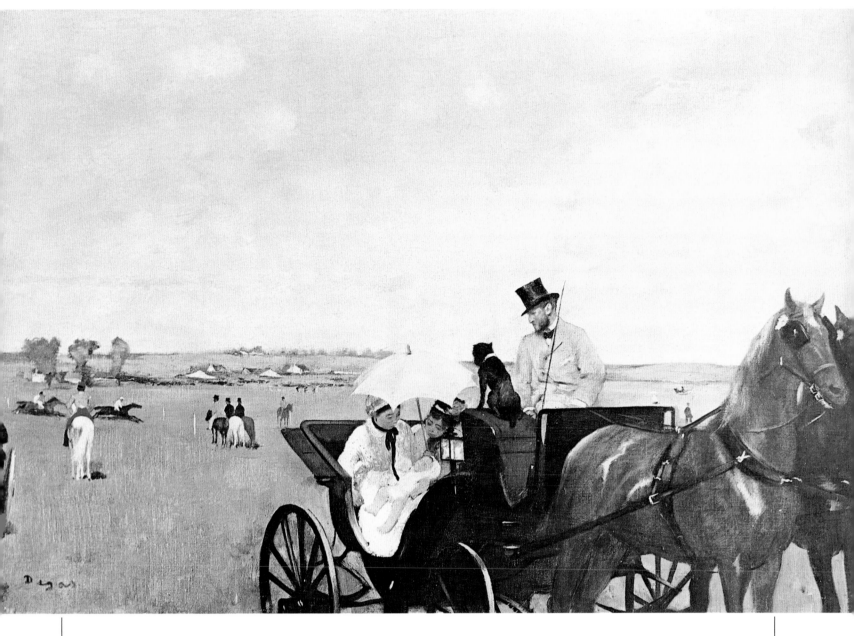

and to show an interest in the vogue for Japanese art which was sweeping France. Through meeting Manet and Henri Fantin-Latour, Degas became involved with other painters of the Batignolles group (see page 112) and entered the discussions on painting which took place regularly at the Café Guerbois.

This sudden change of attitude left him in disgrace with the establishment artists who had such a high respect for his draughtsmanship, and although he rarely agreed with anything that was said at the Café, he was tarred by the brush of the avant-garde. But Degas liked to maintain his independence and as a result of his superior education and sharp wit was always able to express his mind and amuse his listeners. The arguments could become very heated and after one violent exchange between

Manet and Degas both men returned paintings which they had previously given to each other in friendship. However, this breach was soon healed and their friendship survived the fierce atmosphere of debate at the Café. Degas's father could not understand his son's attraction to the Batignolles group and wrote to him trying to encourage him to return to the teaching of Ingres. 'One must recognize that if painting is destined to be reborn in this century, Ingres will strongly have contributed to its Renaissance by showing those who understand him which is the path to follow towards perfection, or rather by stimulating those who were capable of attaining it.' He could not have been more wrong.

In 1873 Degas visited his mother's family in New Orleans where he painted a fine group portrait of his uncle and cousins at work in their trading house. At

various times of his life he travelled, visiting Spain, Morocco, Belgium and Holland among other places, but his subject matter remained almost exclusively Parisian. In 1862 he first really began to immerse himself in contemporary subject matter and to this period belong paintings of the race-courses on the edge of Paris, where Degas studied the animals, the riders and the spectators. He only made sketches on the spot and memorized the scenes, committing the ideas to canvas when he returned to the studio. This method of working was the result of his traditional academic training and very much against the freer manner of working of Monet, Sisley and Pissarro. He treated Monet's great reliance on open-air painting with disdain and regarded it as puerile.

Degas was one of the important moving forces behind the Impressionist exhibitions. He particularly disliked the term 'Impressionist', bestowed on the group by a hostile critic, and argued successfully against its adoption by the artists themselves. The title of 'Société Anonyme', used by the group for the first exhibition in 1874, was originally his suggestion. Despite frequent arguments with the other painters, he missed only one of the group exhibitions, in 1882. Degas championed the cause of maintaining exhibitions independent of the Salon but tried to prevent them from becoming too formalized. He was disappointed by Manet's consistent refusal to show with the group and also fell out with Monet and Renoir when in later years they decided to return to the Salon in an attempt to achieve public acceptance. Despite his abrasive manner, however, he could be an encouraging colleague; it was he who in 1874 had seen and remembered the work of Mary Cassatt (see page 36) at the Salon and later invited her to join and exhibit with the group.

After the final impressionist exhibition in 1886, Degas tended to lose touch with the other painters and his reclusion became more pronounced. Unlike Monet, Renoir and Sisley, he was supported by his family wealth and was never fully dependent on selling his work as a means of day-to-day existence. He did not require the support of a dealer and his commitment to the exhibitions was ideological rather than opportunist; he felt seriously that there

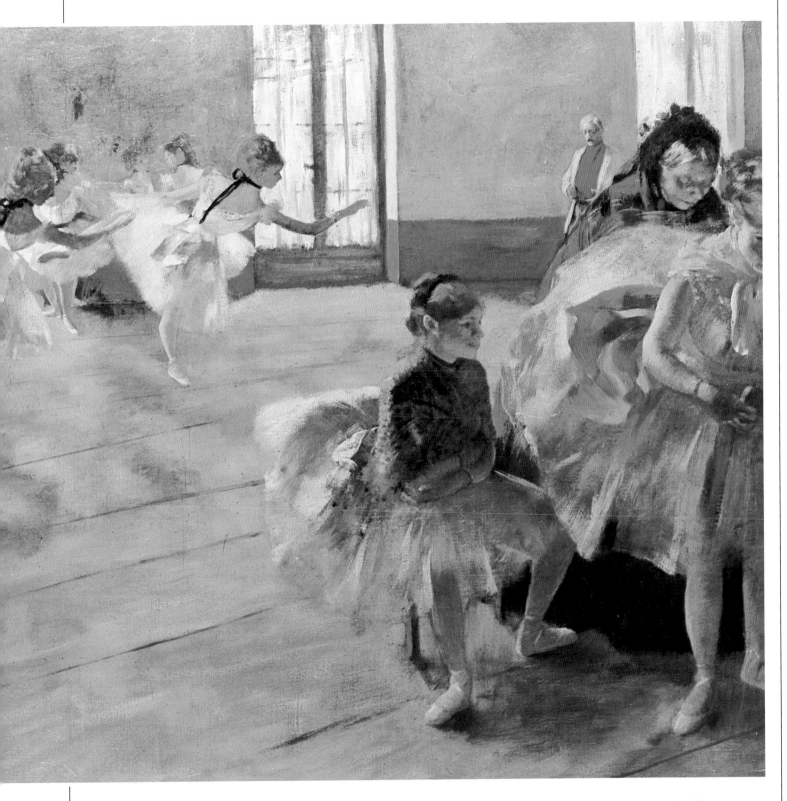

Dancing class, 1877
68 × 103 cm (27 × 41 in)
BURRELL COLLECTION, GLASGOW
It was bold to fill the centre of the composition with empty floorboards, but this unconventional device serves to heighten the visual interest of the work. The picture is nonetheless full of detail, as in the curious twist of the spiral stairs obscuring members of the class, with only the feet of a descending dancer to suggest the full height and perspective of the room.

73

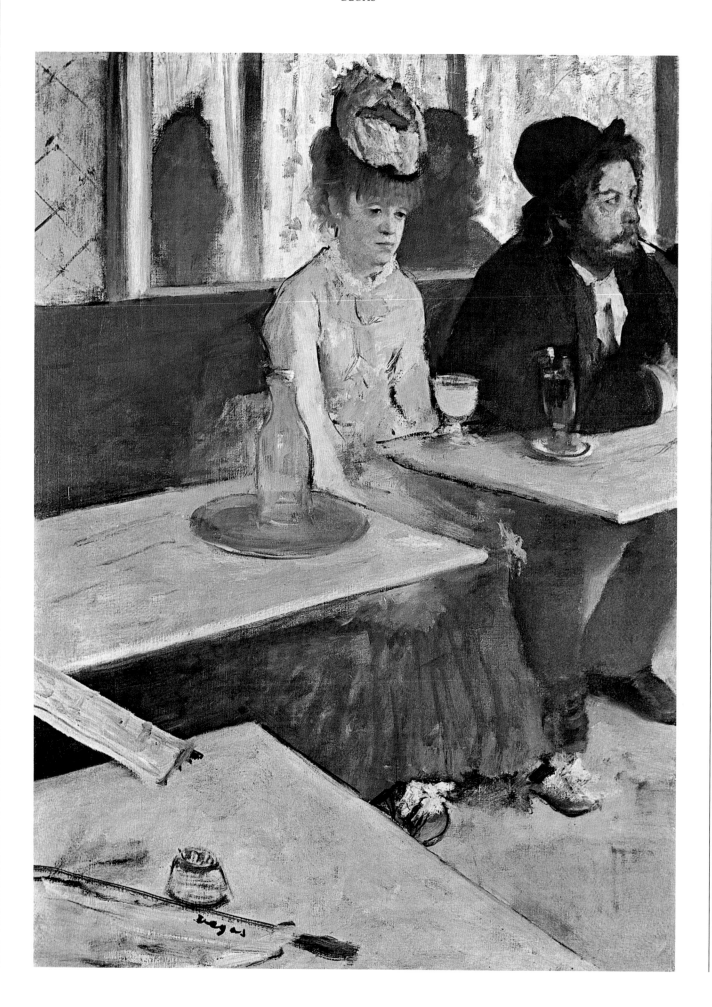

Absinthe, 1876 (*opposite*)

76 × 68 cm (30 × 27 in)

LOUVRE, PARIS

The subjects of this picture were both friends of Degas, the actress Ellen Andrée and the bohemian painter Marcellin Desboutin. The setting was the Café Nouvelle-Athènes, which in the mid-1870s superseded the Café Guerbois as a popular meeting place for the Impressionist painters. Degas has created pictorial interest by placing the subjects off-centre and breaking up the foreground of the picture into the angled planes of the white marble table-tops.

Mlle La La at the Cirque Fernando, 1879

117 × 77.5 cm (46 × 30½ in)

NATIONAL GALLERY, LONDON

Mlle La La could perform amazing feats of strength, such as here being hoisted to the ceiling gripping the rope with her teeth alone. Degas was always alert to the dramatic impact of an unusual perspective and in this work he is able to utilize the spectator's viewpoint to magnificent effect. Seen from below, the body of the acrobat is foreshortened and isolated against the strong red ceiling. The ribbed vaulting cleverly increases the sense of height and upward motion.

should be an alternative to the official channels by which artists were recognized and introduced to the picture-viewing public.

Degas's choice of subject matter is now familiar and seems wholly characteristic. As well as the racecourse, favourite subjects were circuses, music halls and the ballet. In all these motifs, Degas was seeking to observe the human figure in motion; he had a great passion for capturing a sense of movement. He also loved music and a view of the orchestra pit in a theatre was a particular fascination. But in his lifetime little was known of Degas's activity as a painter, since he rarely emerged from

his studio other than to make sketches or to enter the discussions with the fellow artists at the Café Guerbois. He disliked formality and ceremony and deliberately chose to keep himself in isolation. He was taken by many of his contemporaries for a dandy and a dilettante, but this was a mistaken interpretation of his behaviour and they failed to understand the complete seriousness with which Degas approached his painting.

The subject of ballet dancers had appealed to Degas ever since the early 1870s and it is a motif now closely associated with him. Most of his dancers are seen not at the formal performances, but

Portrait of Diego Martelli, 1879
110 × 100 cm (43 × 39 in)
NATIONAL GALLERY OF SCOTLAND, EDINBURGH
*Portraiture was a major part of Degas's work and
commonly the sitters were close friends or members of
his family. Even in a portrait, Degas would contrive to
show the subject from an unexpected viewpoint. Diego
Martelli, an Italian journalist and art critic, is posed as if
unconscious of the painter. The left-of-centre
arrangement is carried through in his own line of vision
which extends beyond the confines of the canvas rather
than being directed back towards the viewer.*

in rehearsal or simply at practice classes. It was
almost as if Degas wanted to get to the very heart of
their talents and abilities, which was not possible
when they were on stage and the auditorium full.
Instead, he sought out the dancers behind the stage
and portrayed them as they really were, noticing the
poor ill-nourished bodies of the girls of the *corps de
ballet*, their dirty linen and their cast-off shoes.
There was nothing romantic about their coarse
naivety nor did he seek to idealize them into some
classical unreality. He observed their movements
and their musculature, the patterning of their limbs
in formal and informal poses. Later in the century,
when working in pastel, he became almost obsessive

about their movements and positioning, concentrating time and again on the same themes. The sense of subject began to interest him less and less, as everywhere he chased movement, line and colour. 'The dance class', which again was not executed on the spot but worked at laboriously in his studio, illustrates his typically determined and planned attitude to painting. What is supposed to appear as an accidental glimpse is in fact a complete compositional exercise in perspective and placing of the figure.

'Absinthe' is a very different but equally typical example of the work of Degas. Again the perspective is all important; the figures are off centre and

Jockeys in the rain, 1881
47 × 63.5 cm (18½ × 25 in) pastel
GLASGOW ART GALLERY AND MUSEUM
The qualities of pastel drawing fascinated Degas and it was a medium he used more frequently over the years, developing a convenient method for preliminary studies into a source of technically complex, major works. Here he exploits the vibrant colour and chalky texture of the medium to atmospheric effect. The fine slanting lines representing the rain are a direct result of the influence of Japanese prints, a formal pictorial device successfully borrowed and adapted by Degas to suit his own style.

The laundress, 1882
81 × 65 cm (32 × 26 in)
PRIVATE COLLECTION
The light falling on the mundane objects of her task gives the laundress a romantic warmth not normally associated with her occupation. This is another of Degas's recurring themes, demonstrating his concern with the usually unnoticed side of life and giving a glimpse into the private understairs world of working women.

there is a large empty space at the front. There is also no attempt to idealize or to condemn, for Degas was a painter with neither a sense of humour nor a moral message.

Like the other Impressionists, but in his own particular way, Degas sought simply to observe. He was not strictly a realist because there was a heavy leaning towards abstraction in some of his later work. He was notably influenced by the clear patterned colouring of the Japanese prints which had found such popularity in France after their introduction in the early 1860s, and photography was another new art form of which Degas quickly

realized the possibilities. From photographs he gleaned the compositional devices of blurred focus, distorted perspectives and images cut off by the edges of the frame, and these elements were brilliantly translated via his own style and technique adding a uniquely individualistic viewpoint to the majority of his compositions.

Some of the boldest work by Degas springs from his keenness to explore novel pictorial possibilities. Perhaps the most striking of all his compositions was 'Mlle La La at the Cirque Fernando'. Here again the figure has been placed off centre, this time to suggest height and distance above the spectator.

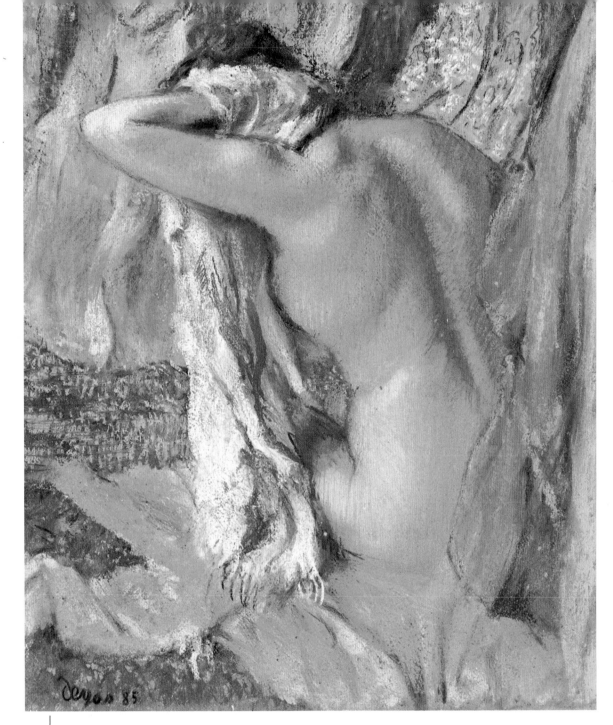

After the bath, 1885

64 × 50 cm (25 × 20 in)
PRIVATE
COLLECTION

When a series of works on the theme of women washing was shown in the final Impressionist exhibition of 1886, the critics and public denounced them as obscene, ignoring the technical virtuosity ever present in Degas's work. Degas rejected their concentration on the intimacy of the subject matter: 'My women are simple, decent people, concerned with nothing other than their physical activity.' This detachment from the emotive quality of the image did not prevent Degas from achieving a sensuous appreciation of colour and texture, superbly translated in pastel.

This painting was shown in the fourth Impressionist exhibition in 1879, and it is easy to see why a public used to well-constructed classical compositions in sombre colours was aghast at the sight of such a painting, its novelty complemented by the free and vigorous landscapes of Monet and Pissarro on the surrounding walls.

Degas also brought his experimentation to the field of portrait painting. Like Manet, he worked very seriously at his portraits using technical devices to convey as far as possible an immediate impression. Diego Martelli was an art critic from Florence who defended the Impressionists in print and tried to win converts among the Italians. In Degas's portrait of him (see page 76), the sitter is placed off centre and seen from above, which forces the eye towards him to a much greater extent than if he had been set squarely in the middle of the canvas. Degas made novel use of different perspectives, much more than any other of his Impressionist colleagues, most of whom remained severely traditional in this field. The manipulation of picture planes and perspective was to become a much more dominant theme in the post-Impressionist work of van Gogh, Gauguin and Cézanne.

After 1886 Degas began to concentrate on much

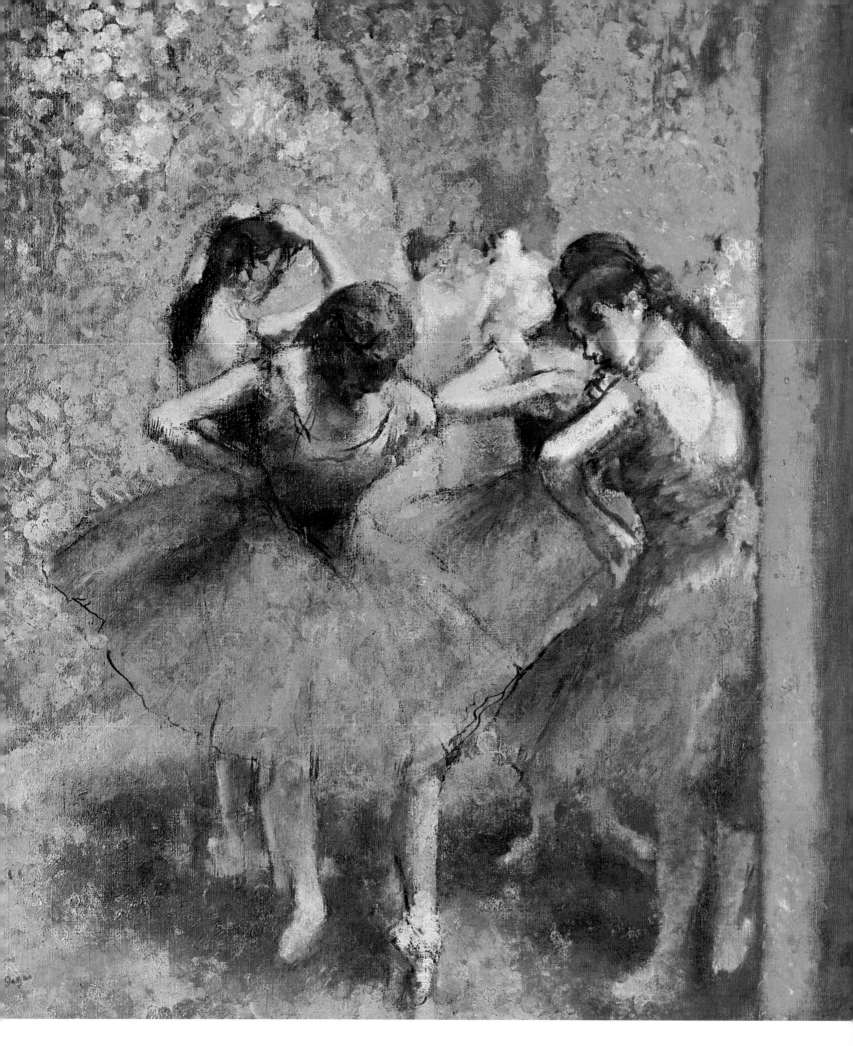

more intimate subjects and less ambitious overall compositions. Because his eyesight was beginning to fail, he tended to use pastel in preference to oil paint and favoured much brighter colours. In his paintings of dancers, he often showed them from unusual viewpoints and sometimes only sections of the body, such as the legs or shoulders, are depicted. At other times he would paint the dancers all together, mixing the figures to form a curious harmony of limbs, as in 'Dancers in blue'.

The most important motif in the works of his later years was the intimate theme of women washing themselves. There is an air of the voyeur in many of these later pastels, as Degas would depict a woman lying or crouching in the tub, washing her hair, or drying herself after a bath. All these compositions use the games of perspective that Degas had developed in the 1870s, and as he worked on through the 1880s the images combined these devices with brilliant colour and a vigorous roughness of surface. The distortion of perspective was deliberately employed to suggest the voyeuristic element which Degas admitted was part of his aim – as though the subject was being seen through a keyhole. In his youth Degas had been much praised for his draughtsmanship and, in a curious way, these later studies of women in the nude continue in a classical tradition. No longer, however, are they given grandiose titles such as 'The goddess Diana at her bath', but instead they could be appreciated simply for what they were – brilliantly executed studies of nudity in its most natural and unselfconscious phases. At the eighth and final Impressionist exhibition in 1886, Degas, now aged 52, put on show a series of these pastels which even then were extremely shocking to the public. In fact he con-

tinued to produce unconventionally posed nudes as long as his failing sight would allow.

By the late 1880s Monet, Pissarro and Sisley had all moved away from Paris; Renoir was even further removed, not only in a geographical sense but also detached from the Impressionist movement as a whole. Of the great motivators of the 1870s it was Degas who remained in Paris working in his studio and in his independent and solitary way producing a side to Impressionism that was unique and emphasized his separation, but which with calculated effort captured the element of spontaneity that had been the characteristic of Impressionist painting.

Degas lived until 1917 but towards the end of the century his sight increasingly failed, so that for the last years of his life he was hardly able to paint or draw at all. Instead he turned to sculpture and, through the medium of touch, produced a series of works on his favourite themes of ballet dancers and horses that rank with his paintings as a tribute to his tireless pursuit of a sense of movement in flesh. He continued to live in Paris in almost total isolation, hardly ever meeting with his friends of the earlier years, for they too were either old and infirm or living too far away to keep in touch, and a number of his colleagues had died. In 1912 Degas was moved from his house in the rue Victor Masse to make way for a new programme of building development, a disruption from which he never properly recovered. He died on 26 September 1917, as he had lived, a lonely and retiring bachelor.

Throughout his life Degas remained a truly independent artist, refusing to involve himself heart and soul with the Impressionist movement. He was always convinced of his own ways and preoccupied by his obsession with draughtsmanship. He

Dancers in blue, 1890
85 × 75 cm (33 × 29½ in)
LOUVRE, PARIS
Young corps de ballet *dancers waiting in the wings are practising final steps or checking their costumes. It is a quiet and sensitive moment before the noise and excitement of the performance. Although the rich*

reds and greens are densely massed to convey the warm, crowded atmosphere of a small space backstage, Degas still concentrates closely on providing the correct anatomical line. There is a special quality to the work which neatly balances an almost abstract sense of light and colour against a finely drawn appreciation of form and volume.

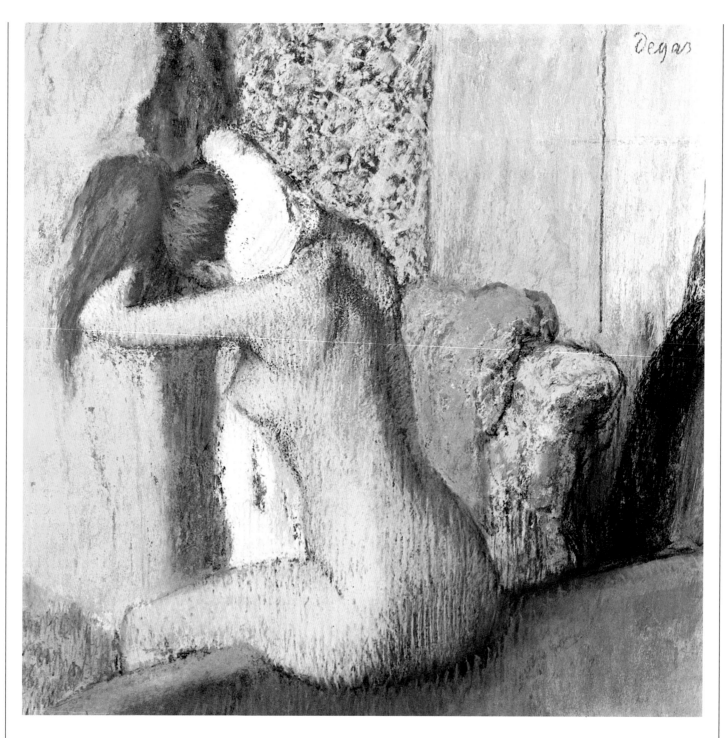

After the bath, 1898

62 × 65 cm (24½ × 25½ in)

LOUVRE, PARIS

With failing eyesight, Degas found the sharp colours and controlled strokes of pastel more manageable than the lengthier process of mixing and applying paints, but by experimenting with the medium he nevertheless developed a remarkably versatile and technically innovative command of its potential. By means of hatched strokes and densely overlaid colours he clearly defines the contours of the woman's body but in the background adopts a looser approach to the fabrics.

nevertheless made a totally unique contribution to the scope of the movement with his pictures of the interior life of Paris; not the fields and the changing seasons or the busy street scenes, but modern life as it was backstage, in the bathroom or behind closed doors. He also contributed greatly to the determination of the Impressionists in the 1870s, when artists of the new movement were struggling so hard to achieve the recognition they believed was their due. As near the end of his life he wryly observed to a younger painter boasting of his own success: 'Ah, in my time, Monsieur, we did not *get on*.'

GAUGUIN

For Paul Gauguin the influence of
Impressionism was to spark off a decision
which led to one of the best-known
legends in the history of modern painting.
His interior vision, so often removed from
the circumstances of his daily existence,
led to a uniquely personal style of imagery
capturing the charm of an exotic
environment free from 'civilized'
distractions. But in fact, Gauguin never
broke free. Despite the power of the South
Seas paintings, they also show the sadness
of a self-imposed exile that ultimately left
the man, if not the artist, still divided
between two worlds.

Paul Gauguin was born on 7 June 1848 in Paris, the son of Clovis Gauguin, a journalist, and Anne Cazal who was of a Spanish family which had settled in Peru. This family connection prompted a move to Peru in 1851, to escape the political upheaval in France which resulted in the establishment of the Second Empire. The journey to Peru before the building of the Panama Canal was very long and arduous. Clovis Gauguin died during the sea voyage and the rest of the family, Paul, his mother and his only sister, spent the next four years living with relations in Lima. When in 1855 they returned to France, they lived with Clovis's brother Isidore Gauguin in Orléans, south of Paris, and here Paul Gauguin's childhood proceeded on the normal pattern for a middle-class boy of his time. At the age of 17, he entered the merchant navy as a pilot's novice and in the first year set sail for Rio de Janeiro. In these two long journeys of his youth lay a pattern to be repeated later in his life.

The Jena bridge, Paris, 1875
64 × 92 cm (25 × 36 in)
LOUVRE, PARIS
Beginning his artistic career while working as a stockbroker, Gauguin was not encumbered with a formal academic training and was particularly open to the influence of the Impressionist painters. This early work shows a typically Impressionist choice of subject matter – the Seine in winter – which was continually studied by Sisley, Monet and Pissarro. However, Gauguin has not yet mastered the sophistication of colour achieved by these more practised painters.

Cattle watering, 1886 (*right*)
79 × 65 cm (31 × 25½ in)
GALERIA D'ARTE MODERNA, MILAN
Painted in Brittany, this work shows the lyrical Gauguin at his best. The tones and colours blend into a chromatic harmony, marking the beginning of his departure from Impressionism as taught to him by Pissarro.

In 1868, Gauguin left the merchant navy for the regular navy but within three years tired of the mariner's life. In the meantime his mother had died and his sister had married and emigrated, leaving Gauguin at the age of 20 with no immediate family in France. He took up a position with a firm of stockbrokers in Paris; their offices were in the rue Lafitte, a street which coincidentally contained a number of art galleries. Gauguin visited these in the company of Emile Schuffenecker, a former office colleague with a strong interest in painting who himself also became an artist, later working with Gaugin at Pont Aven. Until this time Gauguin had shown no more than a passing interest in painting and as yet had certainly showed no practical ability. He made excellent progress as a stockbroker and established a sound social and financial position. In 1873 he met and married a Danish girl from Copenhagen, Mette Sophie Gaad; she was of good family and this liaison was considered most respectable for the rising young businessman.

As a result of meeting Emile Schuffenecker and through his increasing familiarity with the paintings exhibited in the galleries of rue Lafitte, in 1874 Gauguin began to paint largely as a self-taught, Sunday painter. Through Schuffenecker he met Pissarro, the kindest and most generous of the disparate group of painters known as the Impressionists; Pissarro's friendship and advice were to be an important influence on Gauguin. As a man of means, Gauguin was able to afford to buy paintings and as he became acquainted with others of the Impressionist group, he began to collect their works. In 1876 he entered one of his own pictures for the official Salon; the work was accepted but this was the one and only time he approached the Salon.

By 1879, Gauguin had considerable responsibilities; with a wife and three children – Emile, Aline and Clovis – to support he maintained his job but continued to paint with enthusiasm. Holidays were spent with Pissarro's family at Pontoise to the

north of Paris. In 1880 Gauguin took the important step of renting a studio to pursue his work more expansively and it was in this year that he first exhibited with the Impressionist group at their fifth independent exhibition. This pattern continued through the next two years and in January 1883, apparently without warning to his family, Gauguin abandoned his career as a stockbroker and decided to concentrate on painting full time. At 36 years of age he was effectively beginning a new life. His diary records his resolve: 'From now on I will paint every day.'

At this time Gauguin had yet to find his own style of painting and his works very much reflected the influence of the Impressionists – of Pissarro in particular. But by the autumn of 1884 Gauguin was beginning to feel the repercussions of his decision to take to painting as a career. He had been unsuccessful in selling his work and was running short of money. Under pressure from his wife, who by now had four children to care for with the birth of the

youngest child Pola, he agreed to take the family to Copenhagen where he took a job as a representative for a French firm, makers of canvas blinds and tarpaulins. Although he continued to paint he was unhappy with the new situation. He soon quarrelled with his wife's family, who felt that Gauguin had neglected her and undermined her social standing. He put on an exhibition of paintings that was closed down after five days because there was no public interest in his work. In June of 1885, escaping from the frosty atmosphere created by his wife and her family, Gauguin returned to France taking his younger son Clovis and moved from Paris to Dieppe on the north coast, and subsequently to London in search of patronage and sales. By the winter of 1885 he was back in Paris where he supported himself by working as a billposter, earning a meagre 5 francs a day. Though virtually destitute, he did not lose heart. He continued to paint and exhibited in the eighth and final Impressionist exhibition of 1886. In June he put Clovis, who was a sickly child and a

Washerwomen at Arles, 1888

73 × 92 cm (29 × 36 in)

PRIVATE COLLECTION

In 1888 Gauguin spent a few months with Vincent van Gogh at Arles, during which they worked closely together. Van Gogh wrote to his brother Theo of Gauguin's 'very beautiful painting of washerwomen', later describing the finished work as 'better than I imagined it would be.' Gauguin did not respond to the bright light of the Mediterranean area which so excited van Gogh and in essence this work still has the feel of his Brittany paintings about it.

St Peter's Bay, Martinique, 1887 *(left)*

54 × 89 cm (21 × 35 in)

NY CARLSBERG GLYPTOTEK, COPENHAGEN

Bright colour and luminosity spread through this early work of exotic isolation, painted during Gauguin's first visit to the French West Indies. Gauguin has brought the vision of Impressionism far away from Paris and the Seine valley to the open simplicity of the island surroundings. However, there are as yet no signs of the decorative ordering of composition that was to characterize his work once he became fully absorbed in the native way of life in the South Seas.

constant source of worry, into a boarding house in Paris and travelled alone to Pont Aven in Brittany.

Gauguin's first visit to Brittany marked an important change in his career, the point when he was able to break away from the influence of Pissarro and develop an original style. Together with the painter Emile Bernard, whom he first met at Pont Aven, Gauguin moved away from the objective discipline of Impressionism. Between 1886 and 1891 he spent several periods in Brittany and his work shows a gradual exploration of more organized composition, symbolic motifs and a broad, flat, patterning approach to the application of colour. Having absorbed Impressionism with a professional thoroughness, Gauguin moved into his own style with an equally strong commitment. The Breton way of life provided a number of recurring motifs, such as the women in distinctive local costume, and these were gradually knitted with an almost mystical

Old women of Arles, 1888
73 × 91 cm (29 × 36 in)
ART INSTITUTE OF CHICAGO
Gauguin's gradually developing style, like that of van Gogh's, featured an expressive departure from the reality of colour and form, using these elements only as the starting point for a highly personalized composition.

The Belle Angèle, 1889 (right)
92 × 72 cm (36 × 28 in)
JEU DE PAUME, PARIS
Angèle Satre was the Breton wife of the innkeeper with whom Gauguin stayed at Pont Aven in 1889. She sat for the portrait, which he wanted to give her as a parting present, but she refused it as she found it strange and frightening.

Degas, however, greatly admired it and bought it at the auction sale held by Gauguin in 1891.

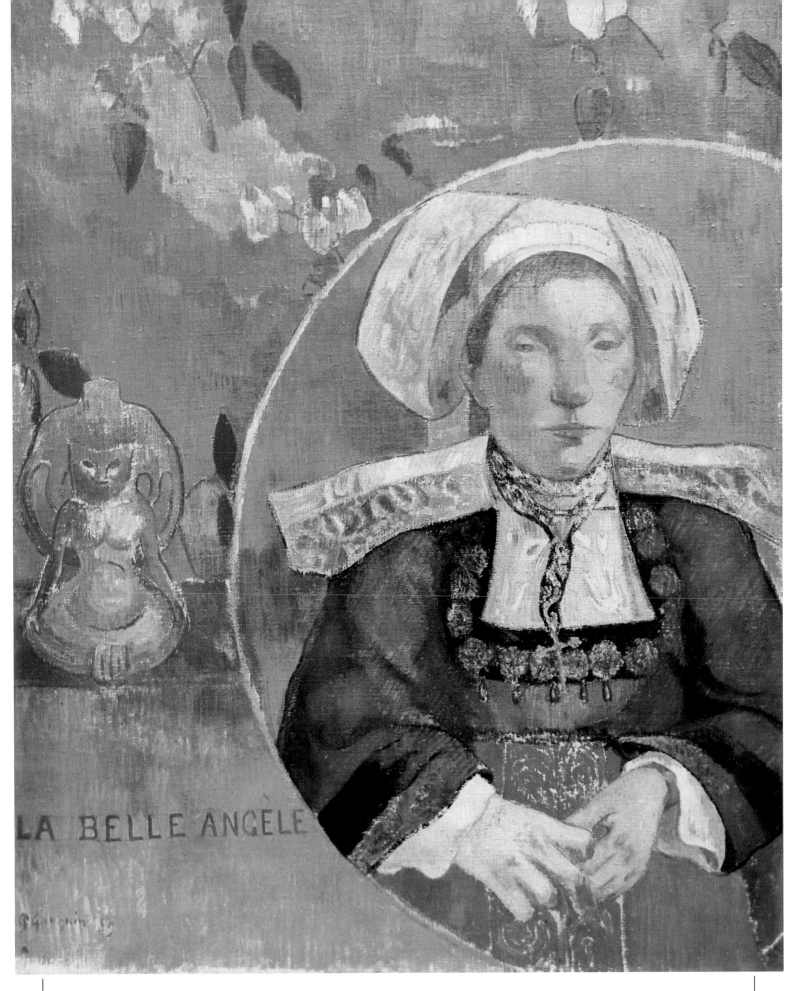

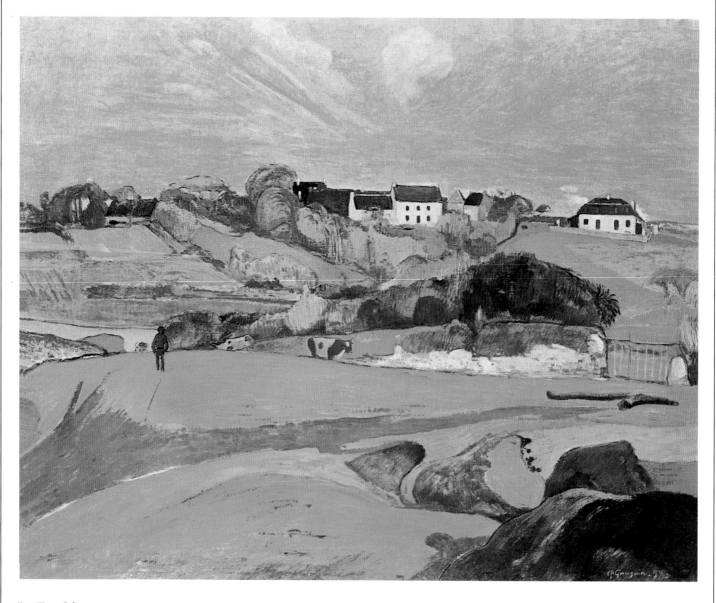

Le Pouldu, 1890

73 × 92 cm (29 × 36 in)

NATIONAL GALLERY OF ART, WASHINGTON

Around Gauguin in Brittany there assembled a group of painters who came to be known as the Pont Aven school. Working in Pont Aven and the nearly village of Le Pouldu, Gauguin and his friends developed a style characterized by simplification of the picture plane into blocks of bright colour. This painting is a typical example; although the subject is the local countryside, there is no attempt at naturalistic rendering. The influence of this style is also seen in the early works of Bonnard and Vuillard.

sense of religious symbolism which produced some strikingly original compositions.

Returning to Paris in the autumn of 1886, Gauguin avoided meeting with Pissarro, whom he feared would be disapproving of the new turn his work had taken. At this time he was first introduced to van Gogh, but the acquaintance was passing as Gauguin was suffering from malnutrition and exhaustion and so had to spend two months of the winter in hospital.

Recovering from this setback, Gauguin became determined to resume his travels. He sent Clovis back to the family in Copenhagen and in April 1887 set sail for Panama, intending 'to live as a native', as he wrote to his wife on the eve of his departure. His great dream was to be able to pursue his painting amid a simple, uncluttered life, far

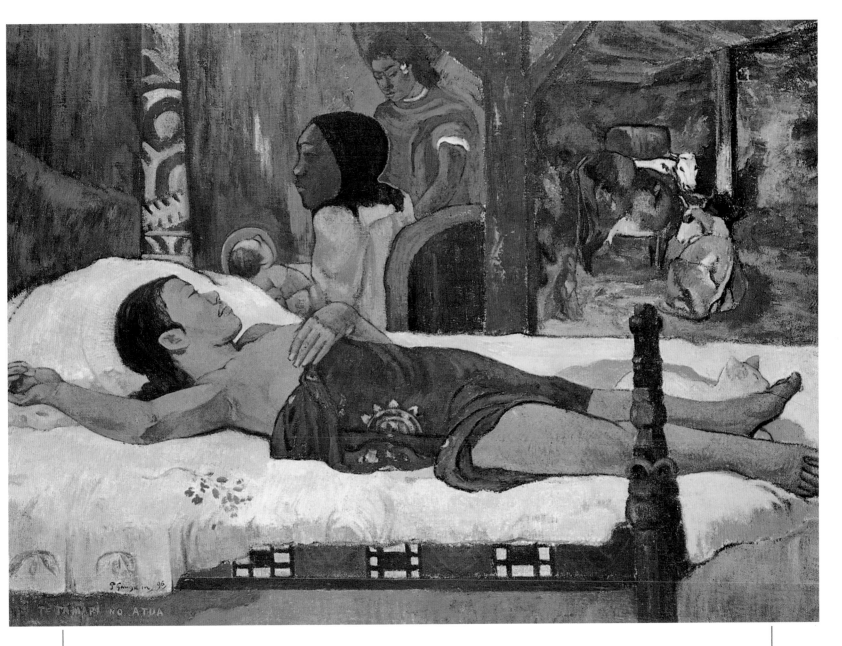

TE TAMARI NO ATUA

removed from the demands of Western civilization, but his arrival in Panama did not offer the transition he expected: he worked for only a month as a labourer on the building of the canal before being fired. Moving to the French West Indian island of Martinique he managed to produce some remarkable work which interpreted the lessons learned in Brittany in the light of his new, exotic surroundings. However, after two months on the island he fell ill and returned to France in the autumn of the same year, having worked his passage home. He was taken in by Schuffenecker and spent the winter in Paris.

In February 1888 Gauguin returned to Pont Aven and again became absorbed in the local atmosphere. He stayed there until October when he travelled back to Paris for his first one-man exhibition, which

Nativity, 1896
96 × 126 cm (38 × 50 in)
BAVARIAN STATE COLLECTION, MUNICH
While in Pont Aven Gauguin was fascinated by the region's complex sculptures depicting the life of Christ and other Bible stories. He had earlier translated traditional Christian subject matter into his own peculiarly modern manner of painting, but here he adapts the story of Christ's nativity to a Polynesian setting, reinterpreting it with a curious combination of the sophisticated idiom of his own decorative painting style, and the primitive simplicity of his chosen environment.

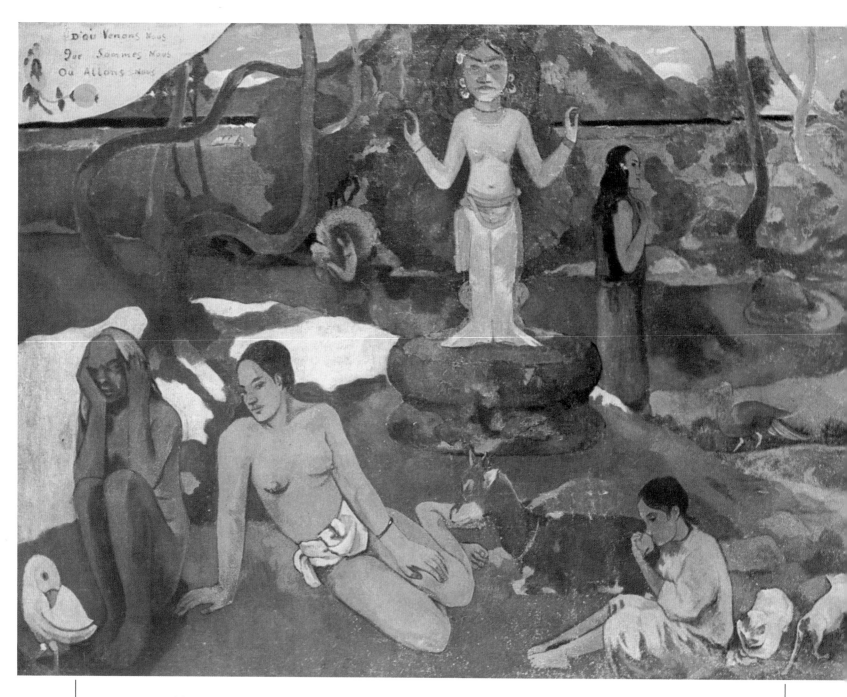

was organized by Vincent van Gogh's brother Theo and included paintings from the periods spent in Martinique and Brittany. After the exhibition, which was not a great success, Theo sent Gauguin to stay with Vincent in Arles and for a while the friendship and collaboration between the two painters gave rise to a highly productive period. However, both men were volatile characters, van Gogh particularly so, and the visit was cut short when on Christmas Eve there was a violent quarrel. Gauguin returned immediately to Paris where he remained until April 1889, when he was once more attracted to Pont Aven. Finding there that former haunts had become very crowded, he moved with his colleague Paul Serusier to Le Pouldu, a village a little further

down the Brittany coast from Pont Aven.

By the winter of 1889–90 Gaugin, now aged 41, had again turned his mind to faraway travel and tried to persuade Schuffenecker and Bernard to accompany him to Madagascar, with the intention of founding a 'studio of the Tropics'. This plan was abandoned and Gauguin spent the summer at Le Pouldu and returned for the winter to Paris. Early in 1891 it was suggested to him that life would be easier and cheaper in Tahiti than in Madagascar. He took up this idea with enthusiasm and began to raise money for the trip, gaining 10,000 francs by an auction of work. This sum was more than enough to start him on the venture. In February he paid a swift visit to his family in Copenhagen and back in Paris

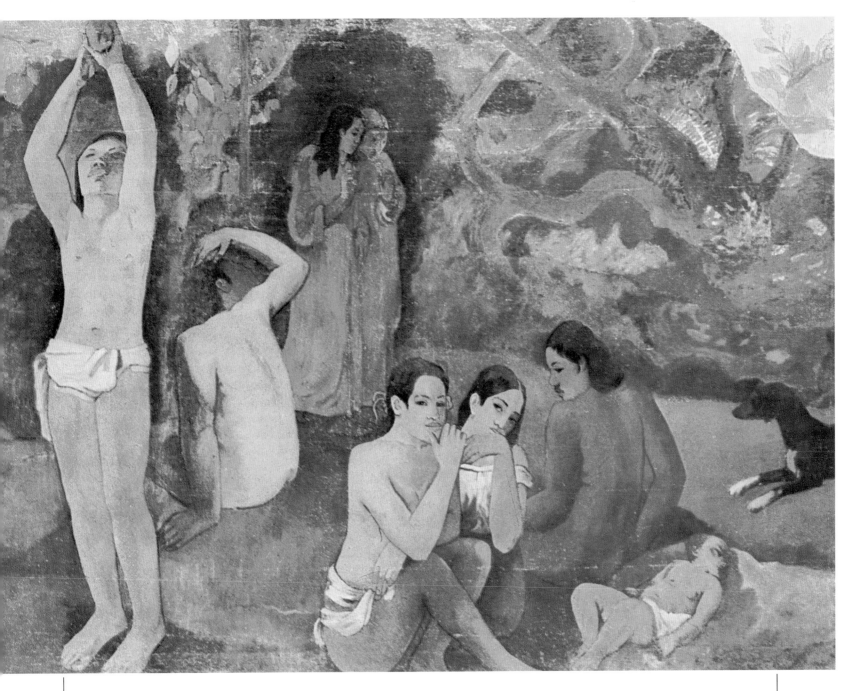

Where do we come from? What are we? Where are we going? 1897

139 × 375 cm (55 × 148 in)

MUSEUM OF FINE ARTS, BOSTON

This is Gauguin's most ambitious composition, a work full of symbolic meaning about the confusion of his life and the isolation of his chosen position. Worn down by illness and deeply distressed by news from home of the death of his daughter Aline, Gauguin brooded on suicide. He conceived this work as a final statement and later wrote of it: 'I believe that this canvas not only surpasses all the preceding ones but also that I will never do anything better or even similar to it. Before dying I put into it all my energy, such a painful passion under terrible circumstances, and a vision so clear without corrections that the haste disappears and life surges up.'

The suicide attempt which followed was a failure but the symbolic elements of the work trace, from right to left, the passage of life from birth to death and the mystery of its significance. The distortions of scale and patterning of shape and colour are an equally deliberate and powerful evocation of the theme.

was treated to a farewell banquet at the Café Voltaire, where some thirty artists and writers presided over by Mallarmé had gathered to wish him well.

On 4 April 1891 Gauguin sailed from Marseilles and, travelling by way of Australia, landed on Tahiti at Papeete in June. From there he moved to the district of Mataëia where he began the life he had dreamed of for so long, living simply among the natives. He became immersed in the customs and habits of his new environment which he recorded not only in his paintings, but in a diary and the fictional work *Noa Noa*. Gauguin worked happily for nine months until March 1892, when the climate proved overwhelming to a man of 44 unaccustomed to the heat. He fell ill and in his misery asked the French governor of the island to repatriate him, but the unexpected sale of a painting for 400 francs renewed his funds and his enthusiasm, as did a portrait commission. Gauguin decided to remain a while longer in Tahiti.

In Gauguin's absence from Europe his wife had organized an exhibition in Copenhagen and in December 1892 the Tahitian works were first put on display in Paris. But by midsummer of the following year Gauguin was longing to return home. His wife sent him 700 francs from the sales of his paintings and he took the opportunity to buy his passage back to France. With the help of friends he settled once more in Paris, subsequently sharing his lodgings with a Javanese girl known as Annah. He had met her in the streets of Paris and doubtless saw in her the attraction of the supposed idyll he had left behind. He neglected his family, sending them nothing when he received an inheritance from his uncle's estate in 1893, but he paid a short visit to Copenhagen in the following year before going back to Brittany.

By 1895, Gauguin had decided to return to the South Seas. Another auction at the Hôtel Drouot netted only a few hundred francs, but with this he paid his passage to Tahiti where he arrived in July of that year. He set to work building himself a native-style house on the west coast of the island but despite this determined attempt to settle, the next two years were not a happy time. Gauguin suffered from loneliness and from physical illness. Often he gave way to despair, but through it all he continued to paint. Early in 1897 he was admitted to hospital and in May he learnt of the death of his daughter Aline, news which affected him deeply. In the depths of despair he painted his great symbolic picture 'Where do we come from?' (see page 92–93). A suicide attempt in February 1898 put him in hospital again.

On leaving hospital Gauguin took a job in the colonial administration of the Bureau of Public Works. Although his pictures were being sold in France through the dealer Vollard, prices were still very low. In 1899 Gauguin got into trouble with the local authorities for protesting against treatment of the natives. His life, with frequent illness and lack of funds, was very difficult and he spent long periods without painting. In 1901 he moved to a different island in the hope of living more cheaply and free of interference from the authorities, but he was ill almost constantly throughout the year. His paintings of this period acquired a sad lyricism, reflected in titles such as 'Nevermore'. He wanted to return to France, but was dissuaded by a friend who argued that the legendary quality of Gauguin's reputation was at last beginning to pay dividends.

"I even believe that salvation lies only in the extreme; any middle road leads to mediocrity."

Red flowers, 1898
94 × 73 cm (37 × 29 in)
METROPOLITAN MUSEUM OF ART, NEW YORK
There is a sense of calm and tranquility about this rich painting which belies the restlessness of Gauguin's life. The composition is flat and deliberately spread across the canvas in the manner of Japanese print work.

Nevermore, 1897

54 × 115 cm (21 × 45 in)

COURTAULD INSTITUTE, LONDON

This wistful and moody picture born of Gauguin's increasing depression is an amalgam of all the features which came to characterize his work: flattened perspective, unrealistic colour and patterned space decorated with curved shapes and scattered with flower motifs. For the viewer, both the painting and its title are full of half-comprehended symbolism inviting further study.

"The young people who come after us will be more radical and you'll see that in ten years we will appear to have been extreme only for our own period."

In 1903 Gauguin was in trouble again for his protests on behalf of the natives and this time he was given a gaol sentence. He planned to go to Tahiti to appeal against the judgement, but before he had a chance his health weakened seriously and he died on 8 May 1903. So ended a sad but brilliant life, in which an absolute imperative to continue forced him to move on, often in despair of the present but always hopeful for the future.

In 1885 Gauguin had written: 'Above all don't sweat over pictures; a great emotion can be transplanted immediately; dream over it and look for its simplest form.' This pursuit of simplicity, in life and art, were his continual motivation. Divided from his family by his sense of commitment, lonely and living in exile from his friends, Gauguin never lost faith in himself. Late in his life, he wrote to the Symbolist painter Odilon Redon: 'My artistic centre is in my brain and nowhere else, and I am strong because what I do is in me.' This noble sentiment was to some extent betrayed by the circumstances of his life, in which a willingness to travel in search of the ideal seemed to leave his cherished vision of simplicity always just beyond the horizon.

JONGKIND

Johann Barthold Jongkind is important as
one of the forerunners of the
Impressionist movement and it is in that
role that he is best known and
remembered. Edmond de Goncourt, the
novelist and critic, drew attention to
Jongkind's contribution to painting in his
review of the 1882 Salon: 'One thing
strikes me in this exhibition; it is the
influence of Jongkind. Every landscape
which has any merit nowadays derives
from this painter, makes use of his skies,
his atmosphere, his familiar elements; that
strikes me immediately and it has not yet
been mentioned by anyone.'

Tall ships in harbour, c. 1855
43 × 62 cm (17 × 24 in)
RIJKSMUSEUM KRÖLLER-MÜLLER, OTTERLO
Jongkind revived the Dutch tradition of open landscapes and seascapes but in a newer and freer form, which caused Signac later to describe him as 'the first Impressionist'. He painted chiefly along the coast of Normandy, where he swiftly transferred his immediate impressions of a scene to canvas.

Overschie, 1856 (*opposite*)
41 × 55 cm (16 × 22 in)
MUSEE DES BEAUX ARTS, DOUAI
In the late 1850s Jongkind returned to paint the canals and gothic buildings of his native Holland.

Jongkind was born in Holland on 3 June 1819, in the same year as Courbet, the seventh of the ten children born to Gerrit and Wilhelmina Jongkind. His father was a minor civil servant who moved from job to job, and while Jongkind received a peripatetic and fleeting education which he did not much enjoy, he considered himself to be brighter than the other children. His elder brothers followed the same career as their father but for Johann, it was decided that he should become a lawyer's clerk. This did not please the boy who preferred to idle his time away sketching on scraps of paper. When his father died in 1836 Jongkind, at the age of 17, was able to escape from the job he disliked and benefiting from the indulgence of his mother, entered the

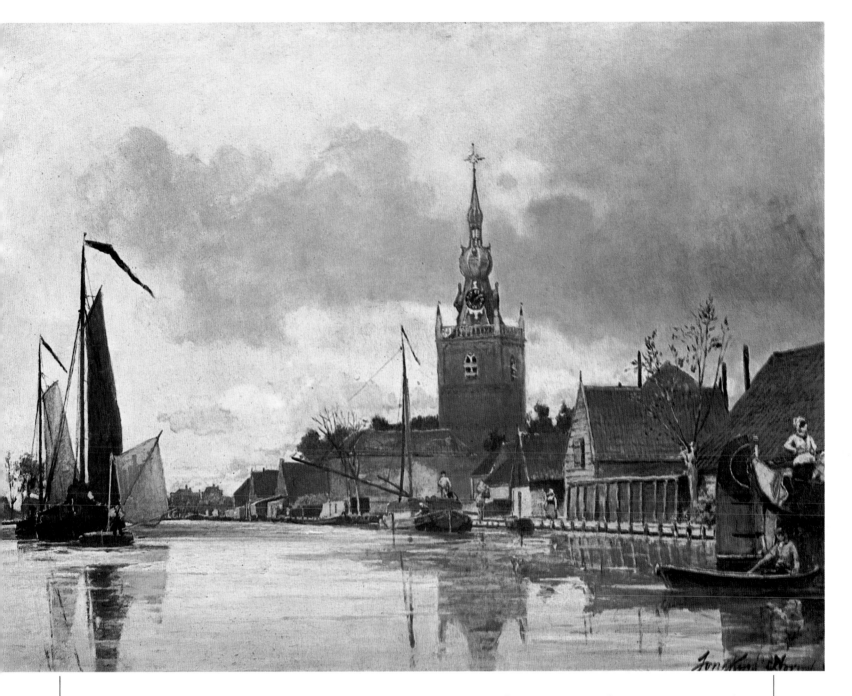

drawing academy of Andreas Schelfout in The Hague. In 1837 Jongkind was called for military service but not enrolled, so he continued to live at home and attend his classes during the daytime. Two years later, through his master Schelfout, he was introduced to the private secretary of Prince William of Orange, the heir to the Dutch throne. This subsequently proved a felicitous introduction, for in 1843 he was given a generous grant of 200 florins which enabled him to stay on at The Hague academy. In later years, several works by Jongkind were among Prince William's collection.

In 1846, as a result of a further recommendation from Schelfout, Jongkind was given another grant for the purpose of going to study in Paris under Eugène Isabey, a renowned marine painter. There he met many young artists who had yet to make a name for themselves – Troyon, Rousseau and other members of the Barbizon school. During the summers of 1848 and 1849 he made trips to Normandy and Brittany. These working visits, a familiar exercise for young painters, were to continue for the rest of his life. Here he learnt to paint the sea and the sky which remained his principal subject matter throughout his career.

Official recognition was not slow in coming, for in 1848 Jongkind exhibited his first work in the Salon, a seascape which lacked much of the maturity and poise of his later paintings but in terms of subject matter essentially set the pattern of his

The beach at Sainte-Adresse, 1863

30 × 57 cm (12 × 22 in)

LOUVRE, PARIS

This is an outdoor sketch which Jongkind would work up into an oil painting on returning to his studio. Although only a sketch, it illustrates the elements that would be the basis of Impressionism – swift, bold strokes and clear, direct colour.

lifelong theme. In spite of this early success life was precarious for the young artist, although the grant from Prince William continued until 1852. Sometime in 1852 Jongkind was fortunate enough to meet a dealer, Père Martin, who bought some of his work and acted on his behalf for many years. Though a quiet and solitary character, Jongkind was readily accepted into the impecunious world of the struggling young artists who exhibited their works in Martin's gallery and he enjoyed more success than some of his colleagues, receiving a third class medal at the Salon in 1852.

After his grant from Prince William expired Jongkind fell badly into debt and took to moody bouts of heavy drinking. In 1855 his Salon entries were refused and as he was also disappointed with his reception at the Exposition Universelle, he left France to return to Holland. There he lived nomadically, moving between Amsterdam and Rotterdam, often in a state of deep despondency which was only worsened by the death of his mother soon after his arrival in Holland. Locked in black moods and self-doubt, he painted less and pined for Paris, though at the same time refusing to leave Holland. In a letter to Martin he wrote, 'While working in Paris one experiences something found nowhere else, something which always makes for the best. There criticism is a help, even poverty is a help.' During these difficult years the money Martin sent from sales of paintings in Paris was the income which kept Jongkind alive.

For five years Jongkind remained in Holland painting the scenery of his native land: the windmills and the boats; the frozen canals and the skaters; the landscape by moonlight or daylight, as he chose. In 1856 Martin sold over 200 paintings and watercolours which had been left behind in Paris, but the total of 2,873 francs raised by this sale did not last for long. Impoverished and depressed, Jongkind seemed to be fading away. In 1860 Monet wrote to Boudin, 'The only marine painter that we have, Jongkind, is dead for art; he is completely mad.' Monet had not, in fact, actually met Jongkind at this time. It was after his return from Holland that they met, in 1862, when Monet acknowledged the older artist in more generous terms: 'His painting was too new and in far too artistic a strain to be then appreciated at its true worth.'

In 1860 a group of artists including Cals, Troyon and Rousseau gave paintings to raise money for Jongkind. Under the guidance of Martin many others donated works and in the end a sum of 6,000 francs was raised. Cals was sent to Amsterdam to fetch Jongkind back to Paris. He paid off the debts and, despite losing Jongkind to several drinking bouts on the way back, successfully delivered him to his friends. Jongkind's return to Paris was the beginning of a happy period. Martin, his dealer, introduced him to M. and Mme Fesser, a couple who became useful friends and patrons. The years of the 1860s became the time of peak performance for Jongkind. During his forties he completed work that showed the best of his spontaneity and freshness.

Mme Fesser, a Dutchwoman married to a Frenchman, was to look after Jongkind for the rest of his life, providing him with comfort and security. His relationship with her was obscure and from 1870 he

The Inn at Balbins, 1869
PETIT-PALAIS, PARIS
Jongkind usually painted coastal scenes but on his travels around France he would often take the opportunity to paint the peasants in the countryside. His style, similar to Corot's, was to be an important influence on Pissarro and Sisley.

was part of a curious *ménage-à-trois*, until M. Fesser's death in 1875, after which he and Mme Fesser spent most of their time travelling together around France while he painted the local landscapes. Jongkind once remarked of her, in Monet's presence, 'She's not my wife, she's an angel', and indeed she was in many ways a guardian and benign influence to Jongkind. Together they fled to Nevers during the Franco-Prussian war of 1870–1 and then returned after the war to Paris. On the death of M. Fesser in 1875, his son took over the family affairs and bought a property in Normandy where he housed his mother and the artist with whom she spent so much time. During these years Jongkind's reputation grew, with such works as 'Port scene' and 'Rue des Francs Bourgeois' which were very typical of his style. He was at last able to achieve the stability and security in his domestic life which for so long he had lacked.

Jongkind was held in high esteem by Monet and other painters so it is a little surprising that he was not invited to exhibit in the first Impressionist exhibition in 1874. Monet in later life spoke well of him. 'He completed the teachings that I already had from Boudin. From that time on he was my real master and it was to him that I owed the final training of my eye.' But by this stage of his life, Jongkind was perhaps beyond his best, his bouts of heavy drinking were becoming more frequently interspersed with periods of non-production. Despite this, in his final years his work found a steady stream of buyers. In 1882 he had a highly successful one-man show at the gallery of the dealer Detrimont. In 1883 at the sale of the estate of Théophile

Bascle, who had long collected Jongkind's works, paintings originally bought for a few hundred francs were reselling for several thousands, much to the artist's pleasure.

From 1880 Jongkind's health had begun to fade. Now in his sixties, he lived almost permanently with the Fesser family at Côte St André in Normandy, where he became a well-known figure in the village. His bouts of heavy drinking and erratic behaviour became more frequent and on one occasion while on his travels, in Grenoble, he ate a whole duck, bones and all, for a dare. In 1887 the mayor of Côte St André did not invite Jongkind to a large banquet for fear he might disgrace himself. By the late 1880s Jongkind's sight was failing and he painted less in oils and more frequently in watercolour, an easier and fresher medium. In January 1891 he suffered a stroke which left his right side paralysed and from which he never recovered. He died on 9 February aged 71.

Jongkind was a great artist, above all, in the eyes of his fellow painters. It is easy to underrate his quiet influence on the young Impressionist painters for he was not a leading member of the group, but with his fleeting, splashy, fresh style he showed the way that others were to follow. In the use of colour he remained conservative but in the application of paint he taught many lessons, not least to Monet, and through him to Pissarro and Sisley. As early as 1863 the critic Castagnary had recognized the importance of Jongkind's example: 'This Jongkind, he is an artist to the tips of his toes. I find in him a true and rare sensibility, and in him everything finds refuge in the impression.'

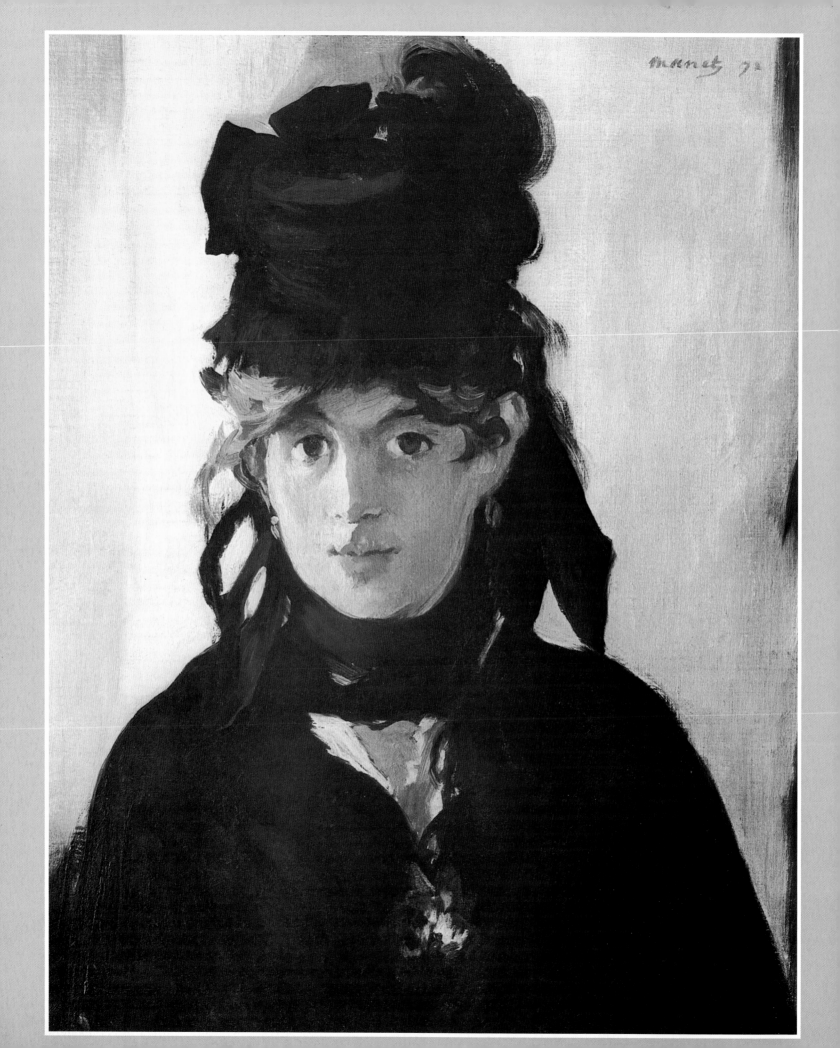

MANET

Manet was one of the major forces behind
the development of Impressionism.
He was never in the strict sense of the
word an Impressionist, yet his presence
dominated the whole movement from
1860 until his death in 1883. It could
almost be argued that the heart of
Impressionism lay not in the haphazard
organization of the independent group
exhibitions, but in the Café Guerbois
where Manet held court in the early
1860s, and where all the young painters
came to listen to the man who was, in the
public eye at least, the 'enfant terrible' of
the Parisian art world.

Portrait of Berthe Morisot, 1872
55 × 38 cm (22 × 15 in)
PRIVATE COLLECTION
*This portrait of the artist's sister-in-law and fellow painter,
Berthe Morisot, displays Manet's great ability to create a
deep effect by simply contrasting light and dark. Strong
dark patterns are created by the shapes of her dress and
hat, and slight variations in tonal value give shape to her
features with the greatest delicacy.*

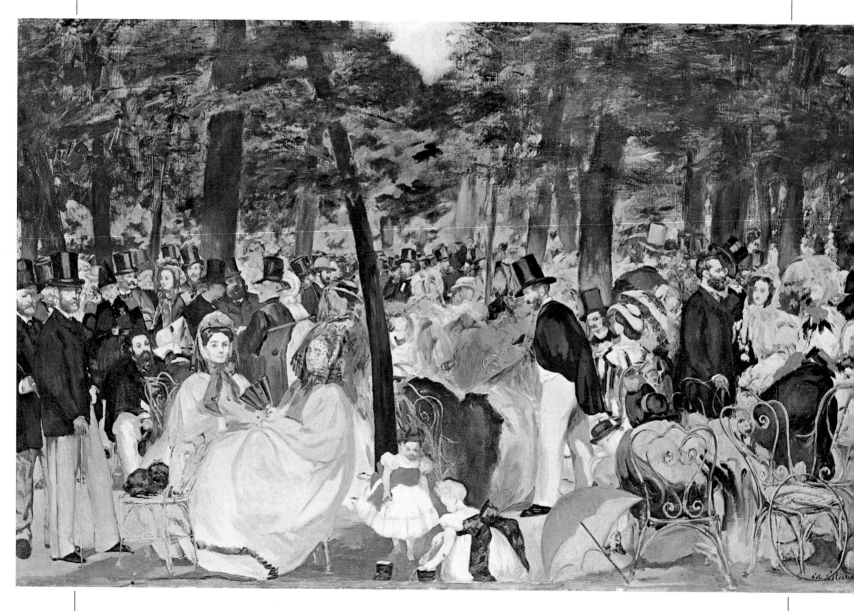

Music in the Tuileries, 1861

79 × 119 cm (31 × 47 in)

NATIONAL GALLERY, LONDON

Fifteen years before Manet painted this picture, the writer Charles Baudelaire had written of 'the painter who will know how to draw out of our daily life its epic aspect and make us see in colour and design how we are great and poetic in our neckties and polished boots.' Manet was the first artist to rise to this challenge and this thoroughly contemporary work was not only a celebration of modern life in the mid-nineteenth century but a record of the artistic world in which Manet lived.

Manet was born on 23 January 1832, the first son of Auguste Manet and Eugénie-Desirée Fournier. The Manets were an affluent family of the *haute- bourgeoisie*. Auguste, at the age of 34, had already become chief of personnel at the Ministry of Justice and was a distinguished senior civil servant. At the age of seven, young Edouard was sent to school in Vaugirard, then a suburb of Paris, where he was not particularly happy. At 10 he started at the Col- lège Rollin, where he showed a precocious talent by decorating his notebooks and was allowed to take special classes in drawing. Auguste Manet wanted his son to study law when he finished school, but Edouard was set on going to art school. In

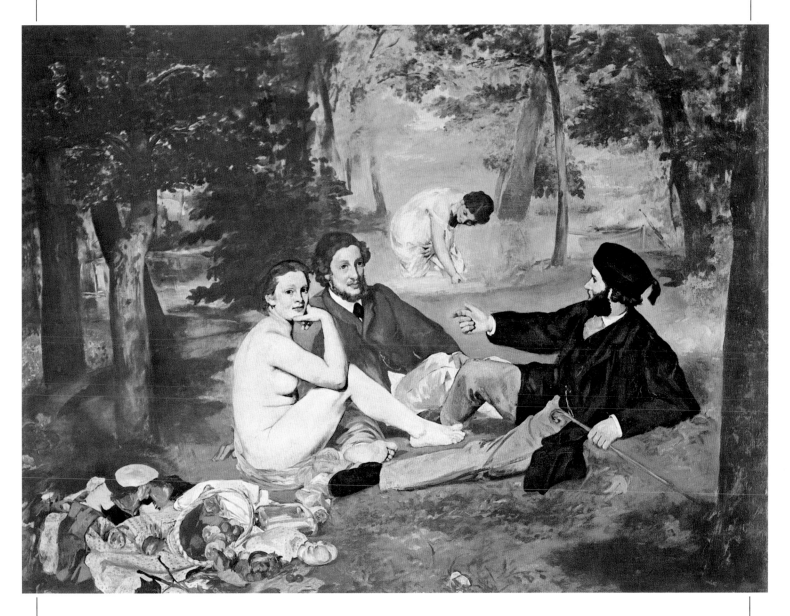

fact, he did neither. He started on a naval career but failed his entrance examination for the Naval Academy. Failed candidates were allowed to sit again after six months at sea, so in December 1848 Manet, aged 16, sailed to Brazil aboard the *Havre et Guadaloupe*. Despite the experience of this trip, he failed the examination again on his return in June 1849.

By this time his father had given up any hope of encouraging his son into a career in law and so he was allowed instead to enter the studio of Thomas Couture. At the same time he studied in the evening at the Académie Suisse and when he had the chance travelled to Fontainebleau and painted with the Barbizon artists. Manet was not satisfied

Luncheon on the grass, 1862–3
214 × 270 cm (84 × 106 in)
LOUVRE, PARIS
The inspiration for this work came from a Venetian painting of the late sixteenth century and the composition is based quite closely on a work by Giorgione, but the feel of the picture is unmistakably nineteenth century. It was, however, considered outrageous to place a female nude, unidealized and rather plain, in a modernized setting among fully-dressed men. The public were scandalized, and Napoleon III pronounced the painting indecent.

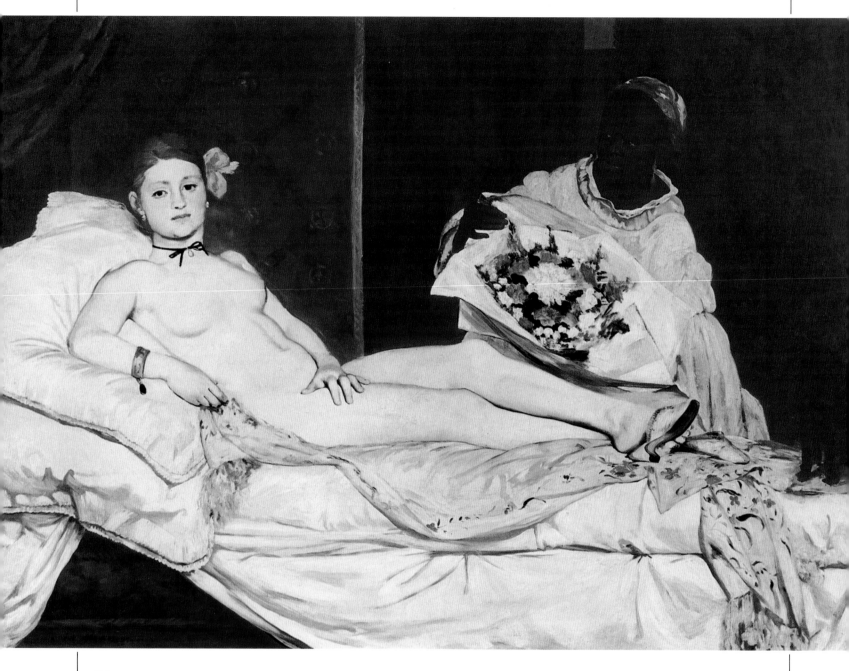

Olympia, 1863

130 × 194 cm (51 × 76 in)

LOUVRE, PARIS

After the shock of 'Luncheon on the grass', this portrait left the public even more uncomprehending and outraged. It shows Manet's penchant for borrowing from the Old Masters – the pose is loosely based on Titian's 'Venus d'Urbine' – but both the pictorial elements and technical treatment are uncompromisingly modern. The stark contrast of light and dark shapes is typical of Manet's personal style, as is the flat tone and fresh colour of the girl's flesh, and the model, boldly staring at the viewer, is far from the classical ideal of beauty demanded by academic standards.

with the teaching of Couture, but continued to study with him until 1856 and even after that was accustomed to ask him for advice. Couture was a competent artist between the extremes of the classicism of Ingres and the romanticism of Delacroix.

During his studies with Couture Manet visited Italy in the company of his younger brother Eugène, to study in the museums. In February 1856 he made an expensive trip which took him to Belgium, Holland, Germany, Austria and Italy. In Holland he was particularly taken with the work of the seventeenth-century painter Franz Hals, whose delicate portraits with their subtle contrasts of light against dark were a great influence on Manet. On

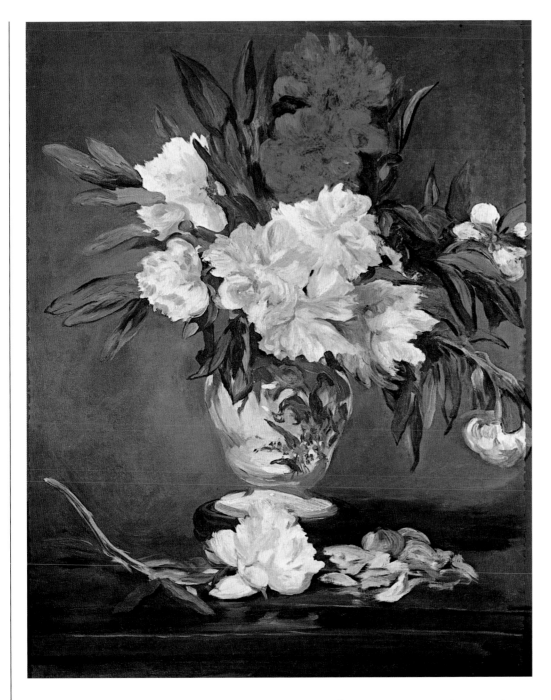

Peonies in a vase, 1864
93 × 70 cm (37 × 27½ in)
LOUVRE, PARIS
Manet painted a series of flower pictures during 1864–5, of which this is perhaps the central piece. Peonies had only recently been introduced to Europe and were regarded as a luxury item. Manet grew them in his garden at Gennevilliers. Their exuberant colour and indeterminate, fully-blown shapes formed the perfect motif for his sensuous brushwork.

his return to Paris Manet continued to study in the Louvre where in 1857 he met the artist Henri Fantin-Latour; the two painters formed a lasting friendship.

In 1859 Manet made his first entry to the Salon; the painting, entitled 'Absinthe drinker' was refused, though Delacroix voted in its favour. Despite this rejection Manet was now embarked on his career as a painter. Because of his parents' wealth he was able to rent studios as and where he pleased. His affluent position enabled him also to afford the indulgence of painting as he pleased and although he was always very keen to win acceptance at the Salons, it was not because he needed the success as

a means of material support as was so much the case for Monet and Renoir in their turn. In 1861, two works that Manet submitted to the Salon, 'Portrait of Mme Manet' and 'The Spanish singer' were both accepted and he was awarded an honourable mention for the latter. This gave him every reason to believe that his career was about to develop promisingly, but in fact he was rarely accepted at the Salon again and over the next 20 years gained a reputation for being a thoroughly dangerous and pernicious influence. This attitude on the part of the art establishment and the public came to be a continual disappointment to Manet throughout his career. He never ceased to believe that the Salon was the

The balcony, 1868–9

169 × 155 cm (66½ × 61 in)
LOUVRE, PARIS

The figures posed for this painting were all friends of the artist. To the left is Berthe Morisot, at the back the painter Antoine Guillemet and to the right the violinist Fanny Claus. The painting was shown in the Salon of 1869 and, after her visit to the private view of the exhibition, Berthe Morisot wrote to her sister: 'I found Manet with his hat on the back of his head and looking distracted. He begged me to go and look at his picture because he did not dare to do so himself. He laughed, looked worried, swearing all the time both that it was a very bad picture and that it would be very successful.' In this Manet was disappointed, as the critics were no kinder to his work than they had been in previous years.

The painting was later bought by the artist Gustave Caillebotte and became part of his collection bequeathed to the national museums at his death.

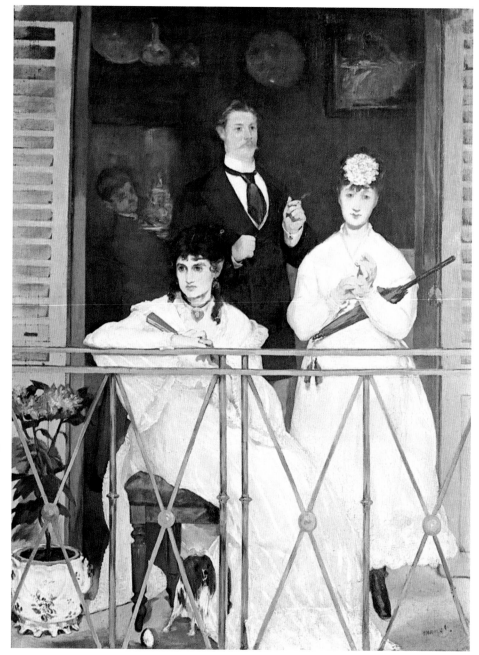

battleground in which a young artist should establish himself and he deliberately eschewed direct association with the independent gestures of the Impressionists, never participating in their group exhibitions.

It was in 1863 that Manet's reputation as a revolutionary artist became firmly established, on the basis of a single work. Along with other paintings submitted to the Salon jury, he included a canvas entitled 'Luncheon on the grass' (see page 105), which was rejected amid howls of outrage from the jury. In fact, the public were given a chance to see the work because Napoleon III allowed, as a sop to the many indignant artists who had been rejected by the Salon, an alternative exhibition known as the Salon des Refusés in which Manet's painting was automatically included.

It is easy to see how shocking Manet's composition must have appeared to the picture-viewing Parisian public. A picture showing a naked woman sitting nonchalantly between two men dressed in modern clothes was taken as an outrageous insult to the great classical works it appeared to be aping. Not only was the subject found distasteful, but the relatively free manner in which the work was painted caused offence. Some critics were scornful, others mocking, but all failed to appreciate the painting and the critical reaction sometimes displayed an unreasoning hostility. 'Imagine Goya had travelled to Mexico', wrote Paul de Saint-Victor,

Boating at Argenteuil, 1874

30 × 97 cm (12 × 38 in)

METROPOLITAN MUSEUM OF ART, NEW YORK

Succumbing to pressure from his younger colleagues to follow them in their choice of open-air painting, Manet nevertheless produced a picture which shows his preoccupation with figures rather than with landscapes. Despite the open-air setting, he completed the picture in his studio, and it is in striking contrast to Monet and Sisley's views of the same scene.

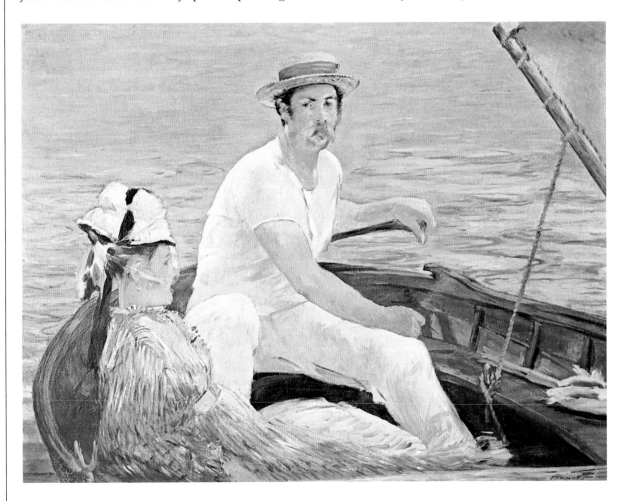

'and running wild in the pampas covered the canvas with squashed cochineal.'

Manet's other great painting exhibited in the same year was 'Music in the Tuileries', a tribute to the desire of the writer Baudelaire (whom Manet had met in 1860) for pictures of modern life. An active spirit and independent attitude was visible in these works which, if not displaying the exact painterly approach which would become Impressionism, served to make Manet a hero in the eyes of young painters who were also facing up to the conservatism of the Salon. By presenting pictures of such striking modernity, Manet was challenging the whole aesthetic creed of the establishment which maintained that history painting on the grand scale, of subjects from long ago, should remain the primary occupation of artists in the present.

It was also in this year, 1863, that Manet was married, to a young Dutch girl, Suzanne Leenhoff. He had known her since 1852, when she had been engaged to give piano lessons to his younger brother. At that time, she had given birth to an illegitimate child whom she publicly claimed to be her brother, but it has never been satisfactorily established whether or not Manet was the father of the baby. The marriage took place on 28 October in Holland.

Despite his lack of success at the official Salon, Manet became well-known in Paris as a result of the Salon des Refusés and his paintings were also

exhibited at the Galerie Martinet in the Boulevard des Italiens. Following his notoriety in the previous year, in 1864 he had two unusual and inoffensive works accepted at the Salon, 'Christ with angels' and 'Episode at the bullfight'. These were more conventional in theme, though presented in a manner which did not compromise towards academic stylization. But in 1856 Manet returned to the centre stage of controversy with 'Olympia', a thoroughly modern rendering of female nudity. This painting, though accepted by the Salon to stave off a repeat of the events of 1863, was hung in a poor position too high to be closely viewed. This did not deter the crowds from pouring in to see it, drawn by the storm of adverse criticism which it aroused in the press. Some critics, however, allowed it guarded praise. Pigalle wrote: 'He who laughs last laughs longest. M. Manet has fired his pistol shot and all the wide open ears of the crowd have heard his name. If he were to take time in the future to clean and "tie up" his works, you would see the public marvel at this same painter who has startled them so much.' Emile Zola wrote two articles in support of Manet for his newspaper *L'Evénement*, and was sacked as a result of strong objections from subscribers to the journal.

The acceptance of 'Olympia' did not signal a change of fortune. In 1866 Manet had two further paintings refused by the Salon but in 1867 he sent nothing, preferring instead to give his own private exhibition outside the Exposition Universelle. He put on show about 50 paintings and the crowds again poured in to scoff at the quaint, flat images with their contrasting tones of light and dark colour. Manet could afford such gestures, even if they served only to amuse the crowds. Thereafter his works were generally accepted at the Salon, but almost invariably they were badly hung. In 1869 he showed 'The balcony', for which the model for the female figure in the foreground was the Impressionist painter Berthe Morisot. Public reception was still lukewarm, and one critic said of this group portrait, 'His painting has about as much interest as a still life.'

Throughout the years of the 1860s, the young painters of the avant-garde who had yet to make their names regarded Manet with great awe and respect. They used to gather at the Café Guerbois where Manet would be the focus of attention, discussing matters of art and aesthetics with anyone who cared to join in. The young painters found the café discussions of great importance. Looking back on their influence, Claude Monet later described the prevailing tone: 'Nothing was more interesting than these discussions, with their perpetual clashes of opinions. There one breathed in the spirit, one was encouraged to sincere and disinterested research; enthusiasm grew from week to week and supported one as definitive ideas took shape. One emerged with a stronger will and thoughts sharpened and clear.' Some people noticed, however, that Manet tended to make statements for effect and a less generous evaluation of his performance was given by the painter Jacques Emile Blanche: 'His controversial sentiments about his art were no more than amiable juvenilities. He spoke like an amateur "communard" in the Revolution.'

From 1864, Manet had rented accommodation in the rue des Batignolles, and for some time he and

"The moment has come for the public to be convinced, enthusiastic, or disgusted, but not dumbfounded. Manet still belongs in the field of discussion, but no longer of bewilderment."
Armand Silvestre

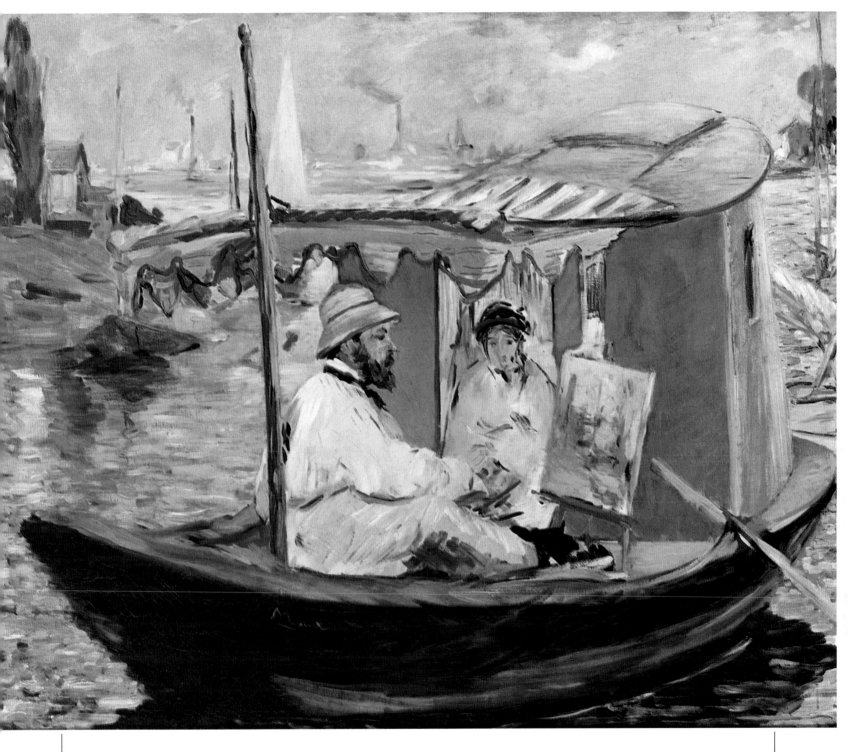

Claude Monet in his floating studio, 1874

80 × 98 cm (31 × 39 in)

NEUE PINAKOTHEK, MUNICH

*The closeness of the Impressionist group during the early
years often produced some engaging pictorial records of
their common interests and pursuits. Here Manet
depicts his younger colleague painting on the Seine in the
boat which Gustave Caillebotte had helped to convert
into a studio. The looseness of the composition and lack
of fine modelling in the figures are unusual for Manet
and show the impact of Monet's influence during the
summer of 1874.*

The Grand Canal, Venice, 1875

57 × 48 cm (22 × 19 in)

PRIVATE COLLECTION

In the year following his stay with Monet at Argenteuil Manet travelled to Venice, where he painted a dazzling work with Impressionist techniques. Swiftly executed, the picture is alive with light and colour and the perspective, so close to the waterline, is emphasized by the tall poles and the prow of a gondola just protruding into the picture from the right-hand side.

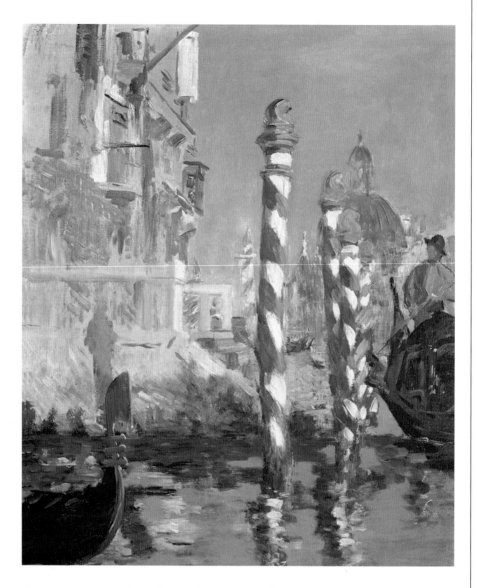

the young artists who gathered around him were designated the 'Batignolles group', a title which neutrally acknowledged their common aims and interests and their increasing separation from the official channels of public taste. A well known group portrait painted by Henri Fantin-Latour showed Manet flanked by Monet, Renoir and Bazille with, among others, the writer Emile Zola. This arrangement of the figures tends to underline how Manet was seen as the natural but unofficial leader of the group.

Manet was undoubtedly identified with the avant-garde at the period when Impressionism was taking shape, but his work of the 1860s has a distinction and clarity which sets it apart from the open-air landscapes that Monet, Sisley and Renoir were painting. By his style and technique, Manet kept himself very much apart from the main thrust of the new movement, but because he was so much better known and owing to the force of his personality, he came to be seen as the key figure in the early days of Impressionism. He was regarded by the public as the evil genius of the modern movement and consequently, as Impressionist influence gathered pace in the 1870s, he was very much associated with it. This was hardly surprising, as much of the picture-viewing public was lacking in discernment and tended to lump together anything that did not conform to the dry academic standards of the well-known Salon painters. Nowadays, with better information and the benefit of hindsight, it is possible to distinguish easily between Manet, who was predominantly a figure painter trained in traditional studio techniques, and Monet, Sisley, Pissarro

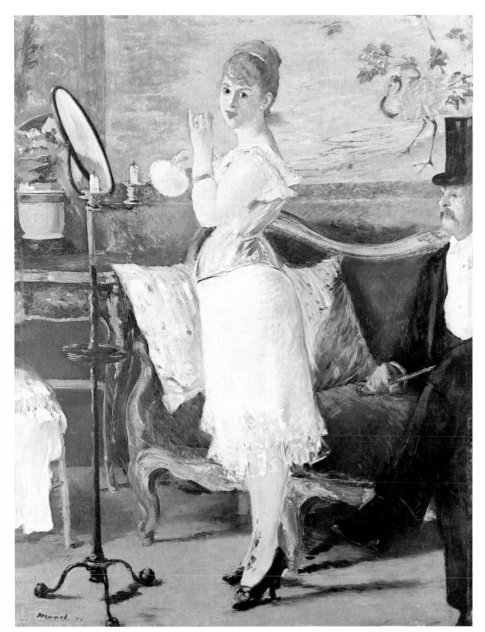

Nana, 1877

150 × 116 cm (59 × 46 in)

KUNSTHALLE, HAMBURG

Emile Zola, the writer who was a close friend and colleague of the Impressionist painters, was engaged between 1871 and 1893 on a series of novels known as the Rougon-Macquart cycle, chronicling the fortunes of a series of related characters in various levels of contemporary French society. In L'Assommoir, published in 1876, he introduced the character of a young girl named Nana, whom he planned to make the main subject of his next novel in the sequence, and who would turn to prostitution and meet a tragic end. It is assumed that Manet based his painting on this character, although the picture predated publication of Zola's Nana. Once again his expression of the less salubrious elements in society offended the Salon jury and the picture was rejected.

and, in the early years, Renoir, who shared a common interest in landscape and a free style of open-air painting. Degas, of all the major Impressionist artists, comes closest to following the example of Manet.

The Franco-Prussian war starkly divided the 1860s from the 1870s in the minds of Parisians, the disruption affecting all areas of their lives. Manet remained in Paris through the period of war and occupation, enlisting in the National Guard, though he had sent his family to safety in the south of France. When peace and order were restored he turned his mind again solely to painting. He travelled to Boulogne and along the Channel coast in the early years of the 1870s. The dealer Paul Durand-Ruel was taking an interest in his work and bought about 25 paintings from him in 1872. In 1873 he ex-

hibited 'Le bon bock', his first painting to be received at the Salon with real enthusiasm for many years.

In 1874 Manet was invited to join the group of painters involved in the first Impressionist exhibition, but declined because he still felt that the Salon was the place in which an artist should really prove himself, despite the fact that he had already made the gesture of exhibiting independently. Degas, in particular, did not take his refusal well: 'The Realist movement no longer needs to struggle with the others. It is, it exists and it must declare itself apart. There must be a Realist Salon; Manet does not understand that. I think he is a great deal more vain than he is intelligent.'

While remaining aloof on the matter of the exhibitions, Manet remained very close to all the Impressionist painters. In the 1870s he was himself

noticeably influenced by the younger painters, by Monet in particular. In the summer of 1874 he went to work with Monet at Argenteuil on the Seine north of Paris. There his young disciples won him over to their enthusiasm for painting in the open air and there Manet became, if only briefly, an Impressionist painter in the same sense as Monet and Renoir. Such works as 'Monet painting in the floating studio' and 'Boating at Argenteuil' are some of the most wonderful Impressionist pictures ever painted. In the same year Berthe Morisot, whose painting Manet very much admired and which was clearly influenced by his own style, married his brother Eugène. Manet was to paint her several times and was very fond of her both personally and as a subject for his figure compositions and portraits.

Manet's palette was considerably brightened by his experience of Argenteuil and he continued to paint in the same way when, in 1875, he visited Venice with his wife. But as far as the public were concerned, his new style was even worse and a view of Argenteuil shown at the Salon of 1875 provoked one critic to say: 'The master is at the stage of a student of twenty.'

Throughout the 1870s Manet continued to paint and to exhibit at the Salon whenever he was

In the café, 1878 (*opposite*)
77 × 83 cm (30 × 33 in)
OSKAR REINHARDT COLLECTION, WINTERTHUR
Manet's café scene is directly comparable to Degas's 'Absinthe' (see page 75), and he used the same female model, the actress Ellen Andrée. Her companion is the engraver Guérard and the scene is the Brasserie Reichshoffen in Paris. Unlike the moody composition created by Degas, Manet's rendering is fresh and alert.

Waitress serving beer, 1878–9
77 × 65 cm (30 × 26 in)
LOUVRE, PARIS
This glimpse of café life is also part of the tradition fostered by Degas and Toulouse-Lautrec, but Manet's style is distinct in both treatment of subject and handling of paint. The casual quality of the moment is emphasized by the jumble of seated figures, while the waitress is naturally the focal point of the composition.

admitted, but even when refused, he devised ways of showing his work publicly, either with a dealer or by displaying the paintings on the walls of his own studio. In 1877 he exhibited 'Nana' in Giroux Ani's shop on the rue des Capucines and the crowds queued for hours on the pavement for a chance to look at it. His studio exhibitions, however, were the cause of his having to find a new place of work in 1878, because his landlord refused to renew the lease due to the unruly behaviour of the public who came to view. In 1879, Manet wrote to the Prefect of the Seine and the President of the Municipal Council with suggestions for decoration of the newly rebuilt Hôtel de Ville in Paris. He proposed to paint it with scenes from the public and commercial life of the day, but he received no answer to his letters. 'Boating at Argenteuil', which he had painted in 1874, was eventually exhibited at the Salon of 1879 and once again Manet's work was the subject of ignorant and hostile criticism, although J. K. Huysmans was generous in his praise, saying, 'Alas, there are so few paintings like this one in this fastidious Salon.'

In the same year Manet was very ill with what he believed was rheumatism and he received treatment for two months in the hospital at Bellevue. The illness was probably what is now diagnosed as locomotor ataxia, a wasting disease affecting muscle coordination, and it plagued him for the rest of his life and was to cause his early death.

In the late 1870s Manet produced some wonderful works showing scenes in café interiors, which were a great influence on both Degas and Toulouse-Lautrec. 'In the café' and 'Waitress serving beer' are paintings full of richness in both colour and composition. Manet always worked in a carefully planned way starting from a canvas primed with white rather than with a dark ground, which is why his paintings are so strongly luminous. Dark and light colours were applied in carefully formulated and contrasted zones, even in the very earliest works, and his technique followed the same principles through the 1870s although the paint was applied with greater liberality. The hostility of the critics in the early days was not only aroused by the subject matter of the paintings, but also by the simplification of form and the abrupt juxtaposition of colours. Zola explained Manet's approach to painting as 'an arrangement of strokes both deliberate and delicate which at a few paces, give a startling texture to the picture.' The use of this system gave to the surface a tension which united the whole of the composition in a shimmering brilliance. This can be seen in the late masterpiece 'Bar at the Folies-Bergère' which is a very closely constructed painting. Most viewers concentrate on the central figure because her eyes are looking straight out from the canvas; they fail to notice the true object of her attention, the man reflected in the mirror to one side. Many of Manet's figures are unshadowed and therefore seem to lack well-rounded form, but he used this device to bring them forward to the viewer's eye, not to flatten out the perspective.

In 1880 Manet had to undergo further treatment for his illness and for three months in the summer he rented a house at Bellevue to be near the hospital where he was receiving hydrotherapy. Mme Manet comforted him as he grew more and more impatient with the doctors, whom he complained of as ignorant country folk not qualified to treat him. At this time he continued to paint though his subject matter was necessarily restricted; he worked mainly on still-life arrangements of fruit and flowers but had many great projects in mind. The cures of Bellevue did not work well, however, and his health continued to decline.

Manet's mother in the garden at Bellevue, 1880
82 × 65 cm (32 × 26 in)
PRIVATE COLLECTION
Manet stayed at Bellevue, near Paris, during the summer of 1880 while he was attending the local hospital and taking the waters in an attempt to improve his health. His movements were necessarily restricted, but this did not prevent him from making some wonderful studies of his garden in which the figures, like this profile view of his mother, were presented against a background of lush green hues vibrating in the bright sunlight.

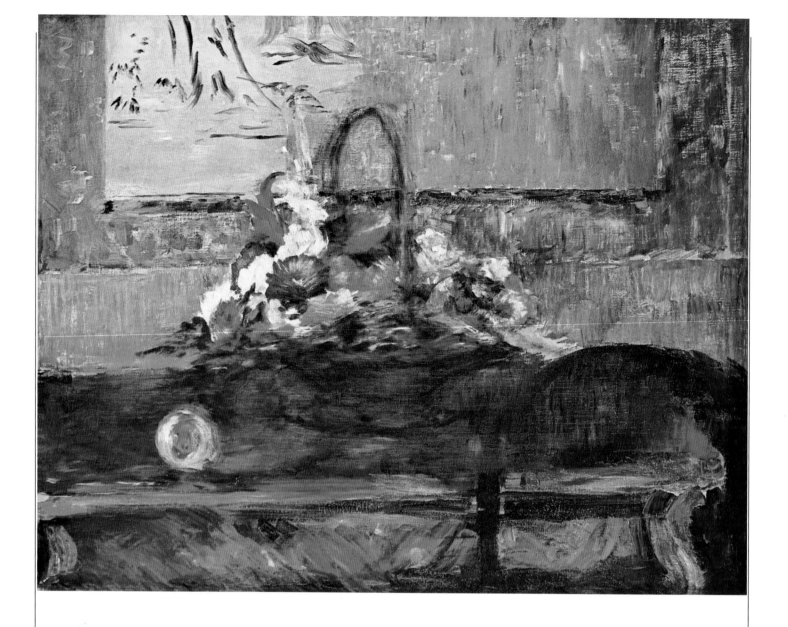

In December 1881 Manet finally achieved official recognition when he was awarded the Legion of Honour. This gesture was marred by the fact that the President of the Republic, Grévy, refused to sign the nomination and Manet himself was not overjoyed by the award. Of Niewerkerke, President of the Ecole des Beaux Arts who was responsible for recommending artists for government awards, Manet bitterly remarked in a letter to the critic Ernest Chesneau: 'He could have made my fortune, but it is too late now to undo the damage of twenty years without success.'

By the end of the year Manet was suffering badly from his illness. He became cantankerous with his wife and friends and not believing himself to be really ill, complained all the time of his inability to paint as he wanted. Nevertheless, he was able to complete 'Bar at the Folies-Bergère' and it was sent

A basket of flowers, 1880
65 × 82 cm (26 × 32 in)
PRIVATE COLLECTION
Simple still lifes became an important part of Manet's output when his illness prevented him from attempting more ambitious works, but he was attracted to flower subjects throughout his career.

The model for the 'Bar at the Folies-Bergère', 1881 *(right)*
54 × 34 cm (21 × 31 in)
DIJON MUSEUM, DIJON
In the interests of realism, Manet hired a barmaid to come into his studio as a model for his final great masterpiece 'Bar at the Folies-Bergère'. This fine portrait of the young model is worked in pastel. Manet used it often in his final years as it could be handled more quickly and conveniently than oil paint.

to the Salon of 1882, together with 'Spring'. Both were well received, but when 'Waitress serving beer' was put on display at the Palais des Beaux Arts in Lyons it was greeted with a hail of sarcasm. It was taking the provinces a little longer to come to terms with a painter whom the Parisians had only recently accepted.

In the summer of 1882 Manet rented a house at Rueil on the bank of the Seine outside Paris; but apart from some pictures of the garden and a few still-life compositions, he was unable to paint very much. By 1883 he was bedridden and on 20 April

his left leg was amputated, but this failed to provide any improvement in his condition and he died on 30 April at the age of 51. He was buried at Passy just outside Paris and among his pallbearers were Monet, Fantin-Latour and Emile Zola.

Even after his death, Manet's greatness as a painter was only slowly recognized by the establishment. In 1889, Monet and Renoir organized a public subscription to buy 'Olympia' for the State, but after it had been purchased from Manet's widow it was not accepted for the Louvre but hung instead in a less prestigious position in the Luxembourg.

Bar at the Folies-Bergère, 1881 (far left)
96 × 130 cm (38 × 51 in)
COURTAULD INSTITUTE, LONDON

Manet struggled against increasing disability to complete this painting. It is a marvellously grand still-life as well as a sensitive study of the young woman.

The sophistication of the perspective is the most striking element. To the right, reflected in a mirror, can be seen the object of the barmaid's attention providing a second, and alternative, portrait against the background of the busy café. It is gradually apparent that the man depicted only in reflection would have a position corresponding to that of the viewer, with the barmaid looking directly at him.

Spring, 1881
73 × 51 cm (29 × 20 in)
PRIVATE COLLECTION

Manet commenced a series of paintings to personify the seasons as beautiful young women, but only two of the proposed four were completed.

Today it is one of the most prized possessions of the Louvre. Even the painters who had known Manet and admired him were slow to appreciate his genius fully. Just before his death, Degas wrote of him, 'He was a much greater painter than even we thought.'

Throughout the 1860s Manet had bombarded the Salon with works of such startling modernity that there were very few people at the time capable of appreciating them. In many ways Manet's constant and public battle with the Ecole des Beaux Arts and the Salon was as important for the development of Impressionism as any other element which contributed to the movement. Manet's reasons for pursuing his struggle alone were to some extent due to the vanity of which Degas accused him, but also showed how he was trapped in the traditional world of French art and could not envisage an era when the official Salon would cease to be the important testing ground it had been for so long. The final word, however, belongs to Manet himself, who with great prescience chose as the motto for his bookplates the Latin words *Manet et Manebit*: 'He is here and he is here to stay.'

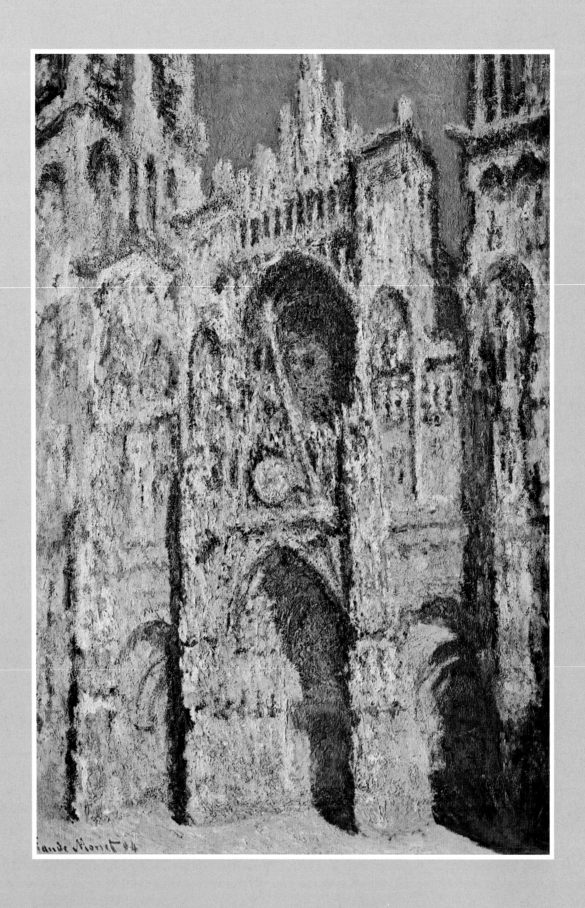

MONET

Monet was in many ways the driving force behind Impressionism and can be seen as the most committed exponent of the movement; the extent, nature and consistency of his work demonstrates his continual search for a newer and better means of expression. In 1888, the critic Félix Fénéon wrote: 'The word "Impressionism" was created for Monet and it fits him better than it does anyone else.' While this comment provides an accurate and precise summary of Monet's central role within the Impressionist group, Cézanne perhaps came closer to describing the essence of Monet's contribution when he said, 'Monet is only an eye, but my God, what an eye.'

Rouen Cathedral, 1894

107 × 73 cm (42 × 29 in)

JEU DE PAUME, PARIS

Of Monet's series pictures, those of Rouen Cathedral are perhaps the most famous. Together they form an extraordinary record of the changing effects of light through the day. By making the façade fill the picture frame, Monet has robbed the architecture of spatial depth and perspective, which displeased some critics. But by this time Monet was established as a major force in French art and many people appreciated this logical and masterly development in his continuing investigation of Impressionist principles.

Claude Oscar Monet was born on 14 November 1840 in the rue Lafitte in Paris, the eldest son of a grocer. In 1845 the family moved to Le Havre in an attempt to improve their fortunes. Here Monet grew up with a special sensibility to the weather which later was an asset in his painting. But his childhood was spent in a family which, while not quite disdaining art, was almost totally ignorant of it. He learned little at school, which he hated, and spent much of the time caricaturing his teachers on the pages of his exercise books. Whenever he got the opportunity he would escape from the school or from his father's shop to draw and sketch on the cliffs, on the beach or in the harbour.

Monet soon became notorious in Le Havre for the speed and accuracy of his caricatures and at the age of 15 had enough connections to be selling the drawings at 20 francs each. He managed to persuade his parents of his desire to become a painter and, because of his immediate success as a caricaturist, in 1856 they allowed him to begin studying art with Jacques François Ochard. Monet used to exhibit his caricatures in a small stationery shop which included a picture-framing service. It was there that he one day met the former proprietor Eugène Boudin. Impressed by Monet's talent, Boudin encouraged him to try painting out of doors, an activity which was unusual in that period when the tradition was for outdoor sketches to be converted into full-scale studio compositions. Monet was at first sceptical but he later wrote: 'Suddenly a veil was torn away. I had understood, I had realized what painting could be. By the single example of this painter devoted to his art with such independence, my destiny as a painter opened out to me.'

In 1859, aged 19 and now firmly resolved to become a painter, Monet visited Paris and the Salon where he was particularly impressed by the free landscapes of the Barbizon painters Daubigny and Troyon. Monet stayed in Paris, against the wishes of his parents, and studied painting at the Académie Suisse, where he first met fellow painter Camille Pissarro. He also frequented the Café des Martyres where Courbet and his colleagues would gather and, in conversations dominated by Courbet, heatedly discuss aesthetic questions.

For the next two years Monet was unable to paint

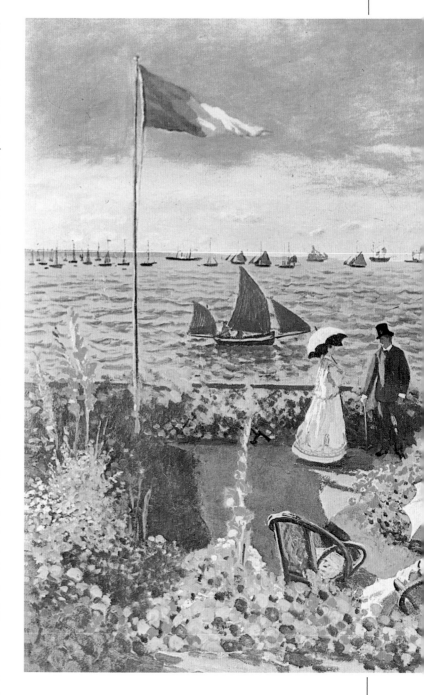

The terrace of Sainte-Adresse, 1866

96 × 127 cm (38 × 50 in)

METROPOLITAN MUSEUM OF ART, NEW YORK

This vibrant picture is an informal portrait of Monet's family at their seaside home in Sainte-Adresse, Le Havre. The seated male figure is Monet's father and the two women are thought to be his Aunt Lecadre and her daughter Jeanne-Marguerite. Though painted in the open air, the picture has a posed quality, lacking the freshness and immediacy of later work when Monet

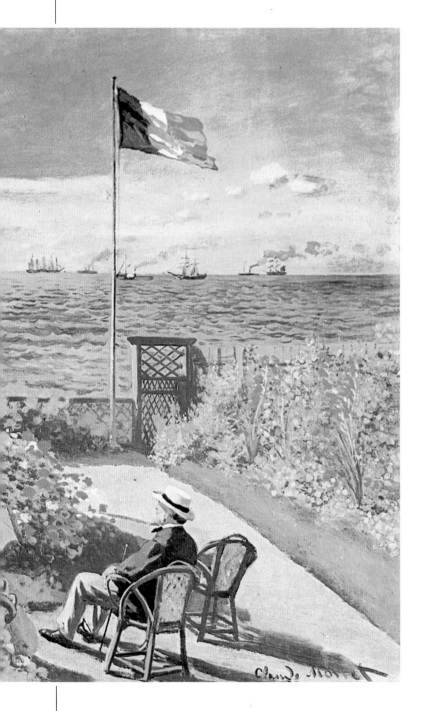

because he was called up for military service which he chose to spend with the Chasseurs d'Afrique in Algeria. In this new location he was very excited by the bright southern light and colour. Early in 1862 he was sent home on sick leave and his father agreed to buy him out of the Army. This enabled Monet to turn once again to painting and in the summer of 1862 he was working, as before, in company with Boudin along the Normandy coast. There he also met Jongkind, of whom he later said: 'He completed the teachings that I had already from Boudin. From that time on he was my real master and it was to him that I owed the final training of my eye.'

In November of that year, this time with the permission of his family, Monet returned to Paris where he entered the studio of the academic painter Charles Gleyre. After the useful advice which he had received from Boudin and Jongkind, Monet found Gleyre's style of teaching insupportable. 'Nature, my friends, is all right as an element of study but it offers no interest. Style you see, style is everything.' It was this sort of remark which had made Monet uneasy under Gleyre's tuition and his attitude was shared by the close friends he had made among his fellow students – Frédéric Bazille, Alfred Sisley and Pierre Auguste Renoir. With Bazille, during an Easter vacation in 1863, Monet worked on outdoor studies in the forest of Fontainebleau, the site made known to them by the paintings of artists of the Barbizon school whom they greatly admired. In 1864, after Gleyre's studio had been closed owing to the teacher's failing eyesight, Monet was accompanied by Bazille, Sisley and Renoir on an extended visit to Chailly-en-Brière, a village in the forest of Fontainebleau, where all four artists realized the value of painting directly from nature and were confirmed in their commitment to this fresh approach to landscape painting.

Only a very few works of the early 1860s survive but by the middle of the decade Monet was beginning to find his way artistically and in 1865 his first work was accepted at the Salon. In 1866 he exhibited again, this time a portrait of his wife-to-be Camille Doncieux, which was favourably received at the Salon and much praised particularly by the writer Emile Zola. Manet, who had only met the younger painter the year before, was rather jealous

recognized the full range of colour perceptible in light on water and the shadows cast by solid objects.

Monet's dedication to painting and his fluctuating fortunes were a constant source of irritation to his family, who were frequently called upon to support him in a lifestyle of which they did not approve, but this visit to the family home seems to have been an unusually happy occasion. In a letter to his colleague Bazille, Monet described the friendly atmosphere and the enthusiasm shown for his work.

of Monet's success, for his own work had been rejected from the Salon and some people, believing he had slightly altered his name to fool the Jury, mistakenly congratulated him on the painting of Camille. Monet's early portraits and large figure paintings, such as the depiction of his family in 'The terrace at Sainte-Adresse', were on the fringe of the Impressionist manner which he was fully to develop in the next few years.

In the late 1860s Monet was again hopelessly impoverished. After the temporary success of 1865–6 he continued his pursuit of an interest in new landscape subjects by painting snow scenes in Normandy. Under pressure from his family, he left Camille, who was by this time pregnant, in Paris and went to stay with his aunt. His son Jean was born in July 1867, during his absence. Monet visited Paris in the autumn of that year and returned with Camille and the baby to Normandy. In 1868 Monet exhibited his paintings in Le Havre; despite interest in the work little was sold and the paintings were seized by his creditors. Dispossessed and without money, he made an impulsive attempt at suicide. Fortunately he was given money by a patron, M. Gaudibert, and by September was able to take a house near Fécamp, where he lived peacefully for a while with his wife and son.

In the winter of 1868–9 Monet began to spend time visiting the Café Guerbois in Paris, where Manet and many painters and writers of the avant-garde gathered. Monet did not say much; the cultural insularity of his childhood could not compare with the urbane and cosmopolitan education of Degas and Manet, who so often dominated the conversation, but he listened intently though preferring to express himself on canvas. By the summer of 1869 Monet was settled in Bougival near Paris. Without funds or materials but aided by Renoir, he worked on the Seine at Argenteuil, where the two friends frequently painted side by side. Here they both painted 'La Grenouillère' a fashionable restaurant and bathing area which appeared in their paintings richly illuminated under a dancing, dappled light. By this time Monet was encountering new problems of visualization and interpretation and it was the manner in which he began to solve them during that summer which would become known as Impressionism.

Whatever Monet's personal satisfaction with his progress as a painter, in 1870 his work was again rejected from the Salon and the Barbizon painter Charles Daubigny resigned from the Salon jury in protest at the treatment of the younger landscape painters. In June of that year Monet and Camille were married, but by September found themselves exiled in London owing to the outbreak of the Franco-Prussian war. Pissarro had also gone to London to escape the effects of the war and through the good offices of the dealer Paul Durand-Ruel, who had staged a London exhibition of contemporary French art, the two painters were brought together again. While in London Monet painted several pictures of the River Thames and the Palace of Westminster but his greatest London pictures were not to be painted until he returned for three consecutive winters at the turn of the century. In this first visit he also took the opportunity to study in the museums of London and was greatly impressed by the paintings of Turner, but later wrote: 'At one time I admired Turner greatly, today I like him much less. He did not organize colour enough and he used too much of it; I have studied him.'

"Renoir is bringing us bread so that we don't starve. For a week no bread, no kitchen fire, no light . . . it's horrible."

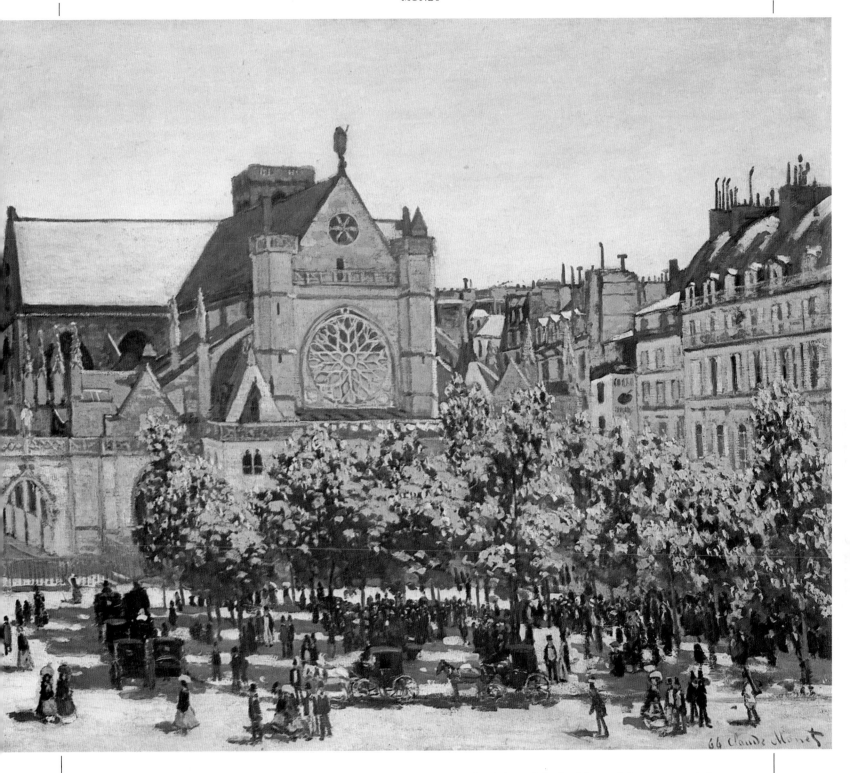

St Germain de l'Auxerrois, 1866

81 × 99 cm (32 × 39 in)

NATIONALGALERIE, BERLIN

Rather than studying the Old Master paintings at the Louvre, the traditional apprenticeship for a young French painter, Monet preferred to turn his easel out towards the streets of Paris, experimenting with the lights of the city. This view of the church façade was painted from a balcony at the Louvre. Beneath the heavily worked solidity of the buildings, Monet treated the foliage in a manner entirely new for the 1860s, but following naturally from the techniques tried in 'Terrace at Sainte-Adresse'. Small brushstrokes of brightly juxtaposed colours hint at the leaves and branches of the trees, while the figures below them are loosely constructed. The impression is of people passing through the square, and of the flickering illumination of sunlight falling through the trees.

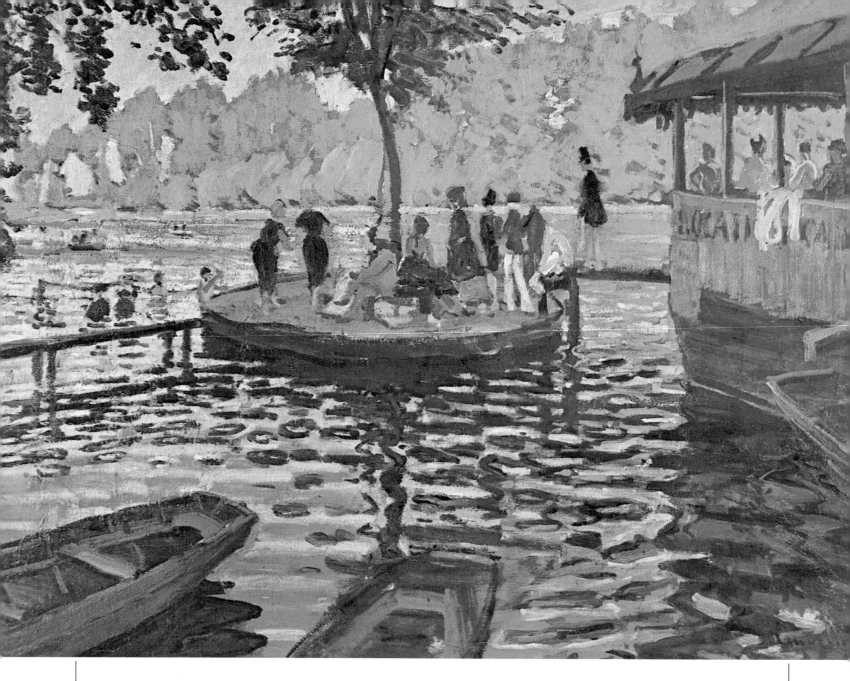

When the war was over Monet travelled back to France by way of Holland and took a house at Argenteuil, where he was to live and work for the next five years. Renoir also came there and both were introduced to the wealthy amateur painter Gustave Caillebotte, who gave Monet much financial assistance. He also helped Monet to build a *bateau-atelier* (floating studio) from which he could paint on the river wherever he liked. All along the Seine, Monet found exactly the sort of subject matter which suited him. Reflections of light on water, the brightly coloured sailing boats and pleasure-seekers, the landscape of the riverbanks – all provided vivid transitory images. He was presented with a world no longer contained by memory but perceived momentarily by the senses in its constantly changing forms. Monet learned to adapt the sizes, shapes and colours of his brushstrokes to the fugitive images of foliage and rippling water as well as the more tangible objects such as boats and bridges. In these paintings at Argenteuil, Monet was using high-key pigments, spirited clashes of colour, dabs, spots and wiggles of paint – whatever he felt was necessary to capture the shapes and colours in front of him. He later explained his manner to a would-be painter, describing it with an almost abstract sensibility: 'When you go out to paint try to forget what objects you have before you, a tree, a house, a field or whatever. Merely think here is a little square of blue, here an oblong of pink, here a small streak of yellow and paint it just as it looks to you, the exact colour and shape, until

"There is always in his painting a praiseworthy search for true tone, which begins to be respected by everyone."
Boudin on Monet

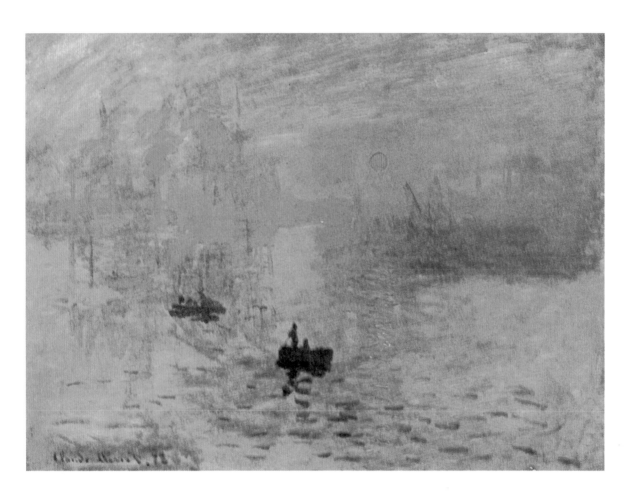

La Grenouillère, 1869 (*opposite*)
73 × 99 cm (29 × 39 in)
METROPOLITAN MUSEUM OF ART, NEW YORK
Working together in the summer of 1869, Monet and Renoir produced almost identical views of La Grenouillère, a fashionable restaurant on the Seine (see page 172). In a letter to Bazille, Monet described how he was carrying 'a dream' of this picture in his mind and explained that Renoir too was fascinated by the subject.

With hindsight, the several different views of La Grenouillère can be seen as the true beginning of the style that became known as Impressionism.

Impression, sunrise, 1872
48 × 63 cm (17 × 25 in)
MUSEE MARMOTTAN, PARIS
The picture that gave its name to the first modern art movement was painted in the grey dawn at Le Havre. The title was given as a variation for the purposes of cataloguing the pictures for the first Impressionist exhibition of 1874; Monet did not intend that it should be seen as a statement about his aim or style in painting. Yet the painting is aptly described as an impression; the tall ships and harbour jetty are barely discernible in the grey mist, the sun casting a fragmented blaze of light. At the time of writing its location is unknown as it was stolen from the Musée Marmottan in 1985.

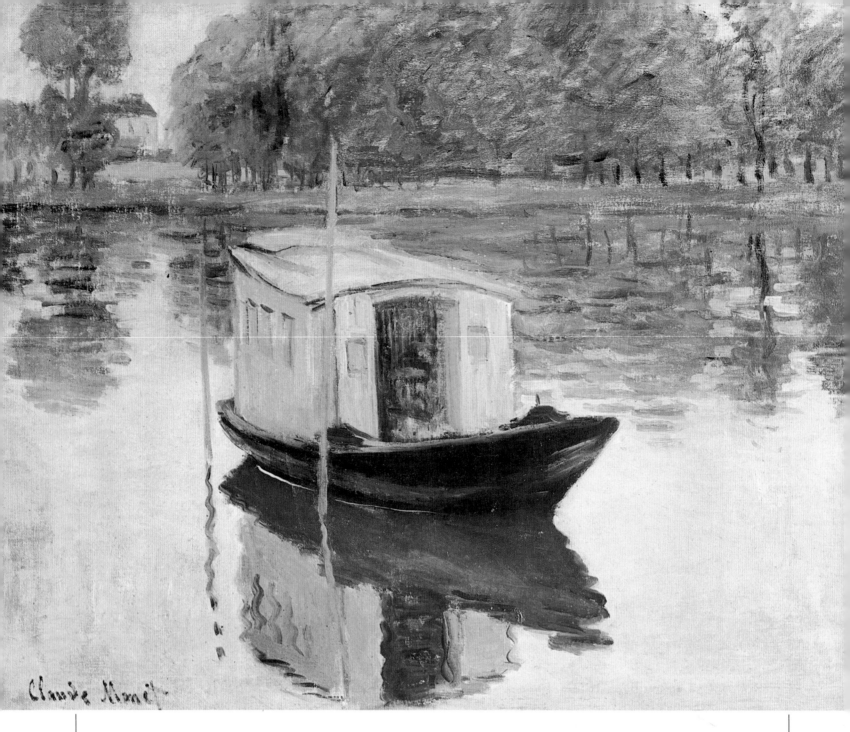

Claude Monet

it gives you your own naive impression of the scene before you.' Monet was not a painter bound up with theory but, as he said, 'I like to paint as the bird sings'; though this to some extent belies the fact that as soon as he decided upon a new scene he was already developing a pictorial solution in his mind.

In 1874 Monet was very closely involved in arranging the first Impressionist exhibition, avidly discussing the organization and detail with Pissarro, Renoir, Degas and the other artists interested in exhibiting their work independently. The exhibition was scheduled to take place before the opening of the official Salon in order to gain as much publicity as possible; in the event it was a failure and there was barely enough money left to cover the costs. It was a painting by Monet, 'Impression: Sunrise', which inspired the critic Louis Leroy, in his review of the exhibition, to use the word 'Impressionists' perjoratively and mockingly, but it was a name that stuck. In later years Monet claimed that the painting's title was of no great significance and that he attached no particular meaning to it.

In March 1875 at Renoir's suggestion Monet joined with Sisley and Morisot in an auction sale at the Hôtel Drouot which was also a great disappointment. Monet's finances remained precarious but he

The studio boat, 1874 *(left)*
50 × 64 cm (20 × 25 in)
RIJKSMUSEUM KRÖLLER-MÜLLER, OTTERLO
Monet's studio boat was built by his friend and fellow painter Gustave Caillebotte, to enable him to paint from the middle of the river. Here the boat is seen moored and it has effectively provided Monet with a still-life composition on a grand scale, but with the water affording the opportunity for a detailed study of reflections. The background is loosely contrived but the boat provides a cohesive image with its strong reflection, as if the two elements were a single structure.

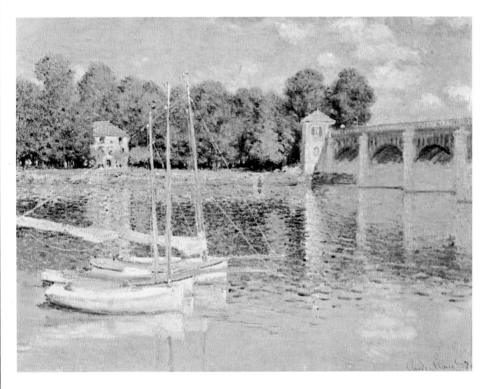

The bridge at Argenteuil, 1874
61 × 90 cm (24 × 35 in)
PRIVATE COLLECTION
At Argenteuil in the mid-1870s, Impressionism as a movement was at its most united and homogeneous. In this work, which is typical of the high point of Impressionism, the scene is full of colour and light shimmering over the water. Broken strokes are used to heighten specific passages of the picture. Although swiftly painted, the work is not slipshod or loosely composed but has a strong sense of organized calm.

continued to paint at Argenteuil, depicting the surrounding countryside and going out in all weathers; 'The bridge at Argenteuil' and 'Monet's garden at Argenteuil' are fine examples of his work from this period. He searched constantly for patrons to buy his works and in 1876 he met Victor Chocquet, who was introduced to him by Cézanne. In the same year the financier Ernest Hoschedé invited Monet to spend the summer of 1876 at his home. The winter of 1876–7 was spent in Paris, when Monet began the famous series of paintings of the St Lazare Station, seen through the steam and smoke of the railway engines.

In 1878 Hoschedé was bankrupted and his collection of Impressionist paintings was sold very cheaply at auction. Monet had settled with his family at Vétheuil, down the Seine from Paris, and in March 1878 Camille gave birth to a second son, Michel. In the summer Mme Alice Hoschedé and her family came to live in Monet's household at Vétheuil. Camille was by this time in ill-health and died in September 1879, leaving Monet with two young children and as impecunious as ever.

All through the 1870s Monet had been exhibiting at the Impressionist exhibitions but was making little headway against an unadventurous public.

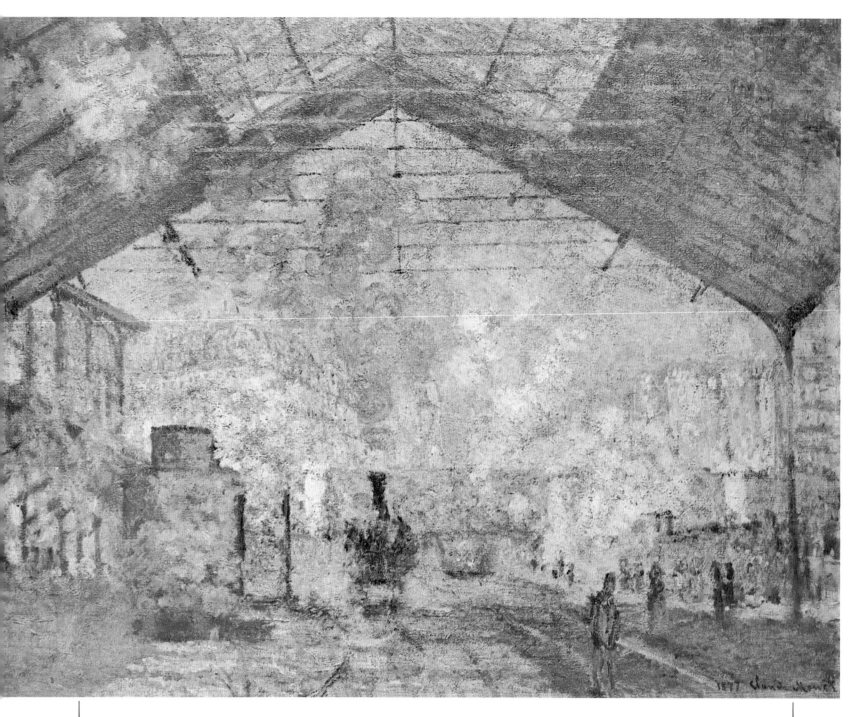

St-Lazare Station, 1877

75 × 104 cm (30 × 41 in)

JEU DE PAUME, PARIS

Monet made a series of studies of the steam engines in the St-Lazare Station, becoming fascinated by the atmospheric effects of sunlight passing into the dense clouds of steam given off by the trains. This provided a whole new set of pictorial images with which to wrestle. In some paintings the steam absorbs light and colour, creating a misty solidity of hues that blot out the background and jumble the traditional perspectives of the work. In others the steam is a veil through which distant details gain a ghostly, shimmering radiance.

Monet was becoming desperate and, in common with Sisley and Renoir, decided once again to resort to submitting work for the official Salon in 1880, in a final attempt to win recognition from the public. As a result of this all three painters quarrelled with Degas, who still stood firm against the Salon, and did not contribute to the fifth Impressionist exhibition. At about this time the dominant theme of Monet's works changed again, from the scenery of the Seine valley to the open views of the Normandy coast. In the spring of 1881 he travelled to Fécamp, a harbour town on the coast north of the Seine estuary, and also painted along the coast at

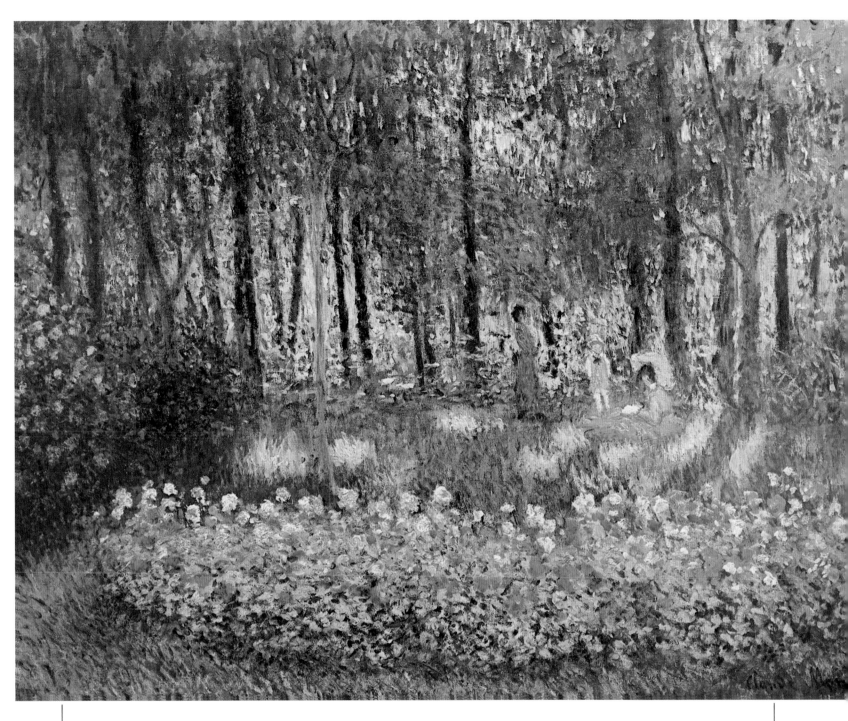

Trouville, where he had not been since the out-
break of the Franco-Prussian war in 1870. His
paintings of this period varied enormously, from
dramatic views of the cliffs to more serene beach
scenes and seascapes. There was a new two-
dimensional quality to some of his paintings, where
he was concerned not so much with depicting the
terrain but with feeling it and expressing it on the
canvas. He often eliminated linear perspective and
recessional devices, such as a human figure or a
building that would create a sense of scale and
proportion; a new patterning of space was develop-
ing on the canvases.

Monet's garden at Argenteuil, 1875

61 × 80 cm (24 × 31 in)

PRIVATE COLLECTION

*This work depicts Monet's wife Camille, their son Jean
and a maid in the garden of their home. During the
period in Argenteuil Monet frequently studied the more
intimate and personalized surroundings of his life, as
well as the broader views of town and countryside.
Renoir, a frequent visitor, also painted Camille and Jean
in this setting and during one visit Manet, too, arrived
and set up his easel beside Renoir's.*

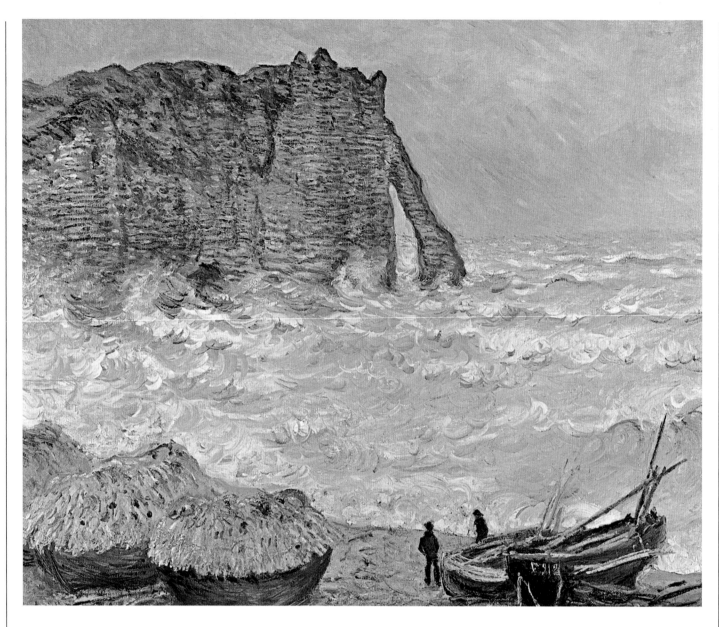

Rough sea at Etretat, 1883

81 × 100 cm (32 × 39 in)

MUSEE DES BEAUX ARTS, LYONS

Like so many painters before him, Monet was drawn to Etretat by the magnificent weighty cliffs with their spectacular arches and stacks marked by horizontal stratification, and he returned there several times between 1883 and 1885. His activity was poetically described by the writer Guy de Maupassant, who watched him painting there: 'Before his subject the painter lay in wait for the sun and shadows, capturing in a few brushstrokes the ray that fell or the cloud that passed . . . I have seen him thus seize a glittering shower of light on the white cliff and fix it in a flood of yellow tones which strangely rendered the surprising and fugitive effect of that unseizable and dazzling brilliance.'

In 1881 Monet moved the family from Vétheuil to Poissy and shortly afterwards moved further along the Seine valley to Giverny, always, however, continuing his painting trips to the coast. In 1888 he went to Etretat, near Fécamp, which had been a favourite haunt of writers and painters for many years. Courbet had painted there and Monet was to develop some of his most spectacular paintings using the wonderful scenery of the steep cliffs, the natural arch at the bottom and the chalk stack standing solitary in the sea and rising to over 70 m (230 ft).

The family were by now settled at Giverny where Mme Hoschedé, now a widow, took care of the household and the children of her own and Monet's marriages. This left Monet free to travel and he took the opportunity to visit many places in Europe in search of different subjects and different conditions of light, atmosphere and weather. With

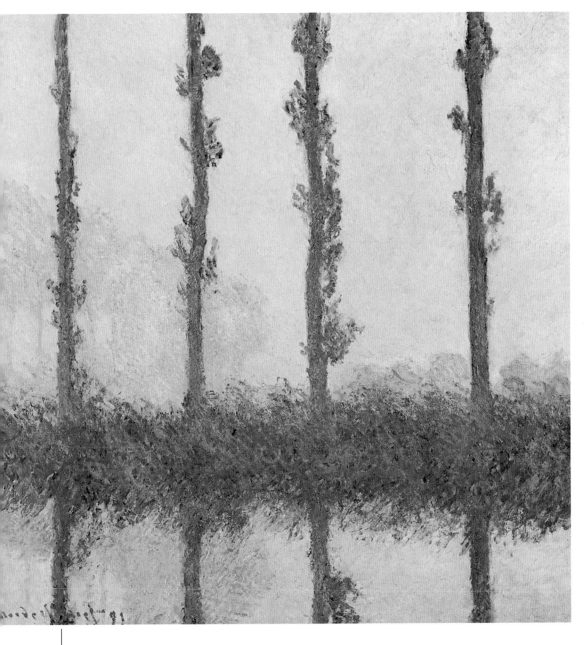

Renoir he travelled to the French Riviera where they worked with Cézanne, and he also made three separate visits to Holland. In Brittany he painted the far westerly coast at Quiberon and Belle-Isle-sur-mer where, in order to catch on canvas the effects of high wind creating a stormy sea, he had to have his easel weighted down with sandbags to prevent it from flying away. The pictures of the Brittany coast blend the sea and the rocks in a wonderful, violent tumult; with the wind and the sky they become almost a unity of swirling motion.

The year 1886 was very important for Monet and the Impressionist movement as a whole, as it marked the development of painting in differing directions stemming from the original Impressionist aims. It was because of the dominance of the painters who came to be known as the 'Post-Impressionists' that Monet declined to submit work to the eighth and final Impressionist exhibition. Seurat had painted and exhibited 'the Grande Jatte' which was a seminal work of Neo-Impressionism (see page 189); Gauguin made his first visit to Pont Aven, the starting point for a new and different school of painting which spawned various associated styles; and van Gogh arrived in Paris which was significant in terms of the idiosyncratic brilliance the influence of Impressionism was to bring to his own development. As far as Monet was concerned, 1886 marked a great relaxation in his work away from the previous turbulence of the Breton scenes. He began to devote attention to some of the more gracious aspects of his surroundings and returned to the lyricism of the Argenteuil period of the early 1870s. Surrounded by his own children and the Hoschedé girls at Giverny, he had at last gained a permanent home after the vicissitudes of poverty.

In 1890 Monet began on the great series of his later works. The first of these was the series called 'Poppies', begun in 1890, and then 1891 the tall lines of poplar trees on the banks of the Epte, the river which ran through the village of Giverny. He made many studies, over and over again, of the same subject in different lights, at various times of the day and in changing weathers. In the poplar scenes he scrupulously attempted to achieve the correct distance between the trees both above the ground and in the reflections on the water. The poplars become fascinating studies of the use of space and light in painting, with the contrast of the stark verticals of the tree trunks and the horizontal band of the bank. Some of these paintings show an abstract fusion of colour in the overall effect. Another important series was of haystacks in a field. These views of rural landscapes are devoid of any human figures and carry no social comment, unlike some of Pissarro's work on similar themes. The haystacks themselves are treated as almost architectural forms and Monet closely studied their positions with regard to the sky, the foreground and the landscape.

Perhaps the best known of the series pictures were the views of Rouen Cathedral, which Monet began in February 1892. In these he trod new ground again, breaking all the conventional rules of composition. The west front of the cathedral became

Houses of Parliament, sun in fog, 1904

81 × 92 cm (32 × 36 in)

LOUVRE, PARIS

Monet's greatest works in London were painted during winter trips over three years at the turn of the century. There he viewed the curving stretch of the Thames between Waterloo and Westminster from his hotel-room window on an upper floor of the Savoy at Charing Cross. This painting postdates Monet's final trip to London and marks a break with his lifelong objective discipline: during the following years he reworked the theme from memory, at the same time as working at Giverny on the great series of waterlily paintings which became his final project.

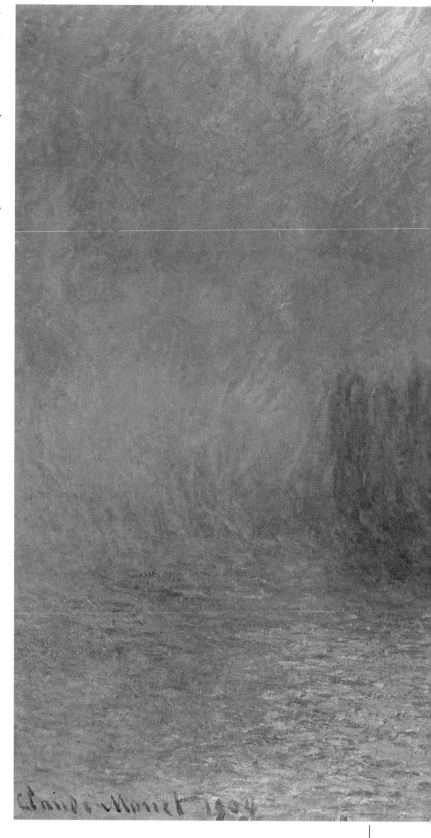

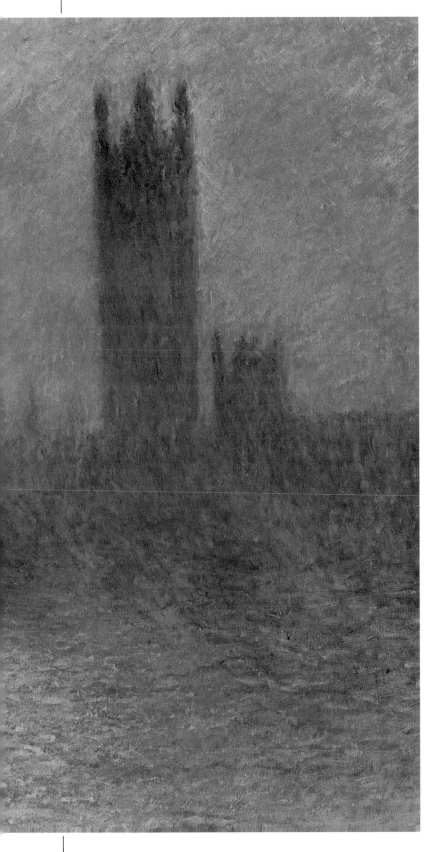

entirely encapsulated in the picture frame, with both the top and bottom of the building cut away in an attempt to isolate the visual image from its surroundings. In painting the cathedral Monet seems to have disentangled an almost transparent film of light from the heavy shadows and stones of the masonry. These pictures were painted all together, different canvases being used to capture morning, afternoon and evening light. In this work of the 1890s Monet was taking Impressionism several stages beyond where Pissarro and Sisley had been content to remain and was attempting to come to terms with new and immediate visual problems. Like Cézanne, who was working at this period in the southern town of Aix-en-Provence, Monet was establishing a method of translating his visual impressions without literary interpretation, in a manner which would pave the way for the abstract art of the twentieth century.

In 1892 Monet, now in his early fifties, married Alice Hoschedé and their happy *ménage* at Giverny continued in comfort, for by this time Monet had become an established painter. Dealers were keen to acquire his work and at last he was beginning to earn the sort of rewards that had been so long denied him. Soon after acquiring his house at Giverny Monet had begun work on redirecting a branch of the Epte in order to create his own water garden. A Japanese-style footbridge was built and

"I advise you to paint the best way you can as much as you can without being afraid to paint bad pictures."

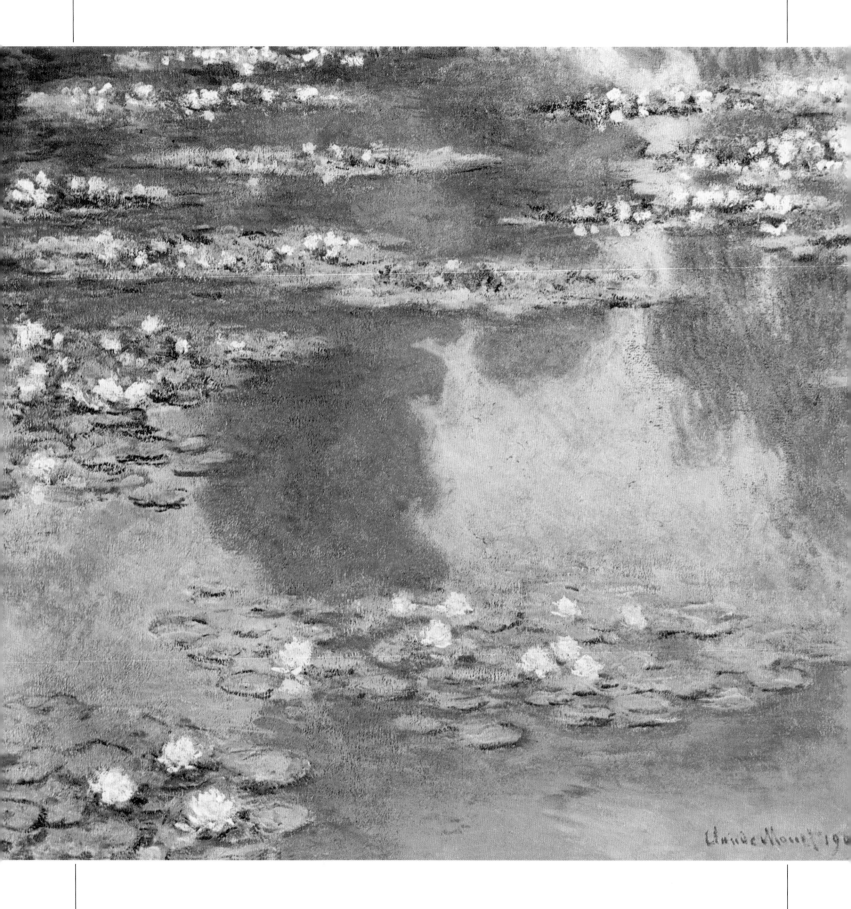

lilies were planted in the totally reconstructed water landscape. It was this water garden that was to prove the almost exclusive subject matter for Monet during the last years of his life. He devoted more time and attention to this one subject than to anything else.

The garden was only finally completed in 1899, until which time Monet continued to travel widely. In 1895 he visited Norway and in 1896 began a projected tour of northern France in which he hoped to take in all his previous favourite locations, reassessing the earlier themes in the context of his mature style. This trip was never fully realized, but before embarking full time on the waterlily series at Giverny, Monet spent three separate periods working on a series of paintings in London. Viewing the river Thames from the fifth floor of the Savoy Hotel and from St Thomas's Hospital on the South Bank, he painted over a hundred works showing in particular the bridges at Waterloo and Charing Cross and views of the Palace of Westminster.

The waterlily paintings were begun in 1899 and continued until Monet's death in 1926. He studied the water garden exhaustively; early works in this series show the bridge and the banks of the pools, but gradually these disappeared as Monet concentrated on the water and the lilies alone. In 1914 he was commissioned by former Prime Minister Georges Clemenceau to decorate an oval room with four enormous curved panels, each devoted to some aspect of the waterlilies. These were installed in the Orangerie of the Tuileries Gardens in Paris in 1927.

Despite his obsession with the water garden at Giverny, Monet continued to travel and acquire new experiences. In 1903, having bought a motor car, he drove with his wife to Madrid to see the paintings of Velasquez in the Prado museum, an ambitious journey for a man of 63 in the pioneer days of motoring. He also made trips to Venice which he described in the telling phrase: 'All Venice is Impressionism in stone.'

In 1911 Alice Monet died and henceforth Monet rarely left his home and garden. Gradually his eyesight began to fail. Although he continued to paint the waterlilies series as long as possible, by 1922 he was almost blind from double cataracts and had to abandon work. An operation in 1923 restored some sight but Monet was losing confidence in his ability to paint properly and grew full of discouragement and anxiety. He died in December 1926, at the age of 86, having lived the longest of all the Impressionist painters. At his funeral, however, were two of the younger artists who had inherited Impressionism: Bonnard and Vuillard helped to carry Monet's coffin to his grave at Giverny.

Looking back over Monet's life, it is amazing to see the volume and variety of his work. From the earliest works of the 1860s he had striven above all else to represent the immediate visual sensations which he felt in front of a subject. He had a horror of theories and felt that painting was a question of direct perception, an instinct for the reality of a specific viewpoint. Many of his motifs are

Waterlilies, 1905

200 × 600 cm (79 × 236 in)
KUNSTHAUS, ZURCIH
The theme of waterlilies occupied Monet's attention for almost thirty years. Slowly they became isolated from the physical surroundings of the garden – the banks, the trees and the Japanese footbridge – until the lilies on the water became a self-contained environment of their own.

"His is a highly conscious art based upon observation and derived from a completely new feeling; it is poetry through the harmony of true colours."
Pissarro on Monet

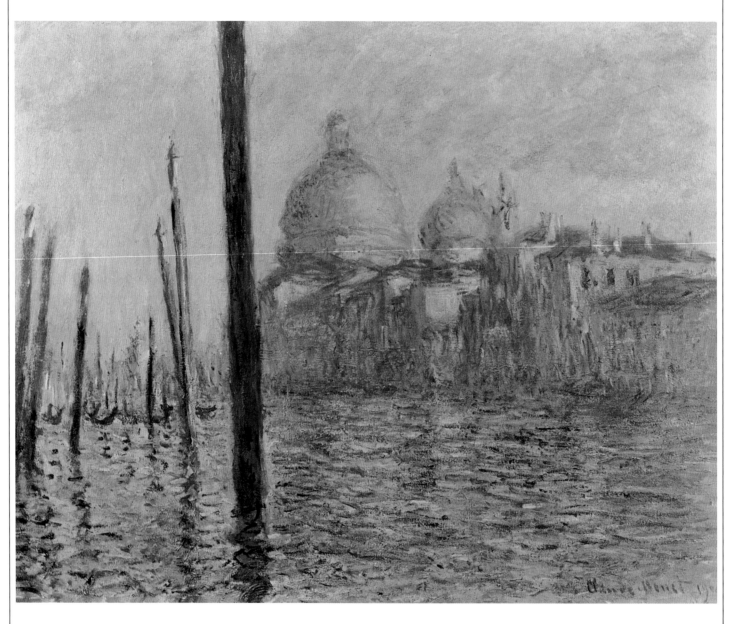

Santa Maria della Salute, Venice, 1908

73 × 92 cm (29 × 36 in)

MUSEUM OF FINE ARTS, BOSTON

Venice was the natural place to visit for an artist interested in light and colour. The great cities of Italy had traditionally been a training ground for many European artists yet Monet, unlike Manet and Renoir, was approaching old age before he made his first and only trip to Venice. Working almost from the water level, as Manet had done before him, he concentrated on the view down the Grand Canal to the east beyond the Salute. The bold lines of the mooring posts rising from the water provide a contrast to the soft impression of the domed buildings in the background, cutting the misty view sharply to create a point of visual focus.

intimately connected with the mechanics of sight: lakes, mirrors, water, snow and steam are recurring images. Monet sought to capture complex visual experiences that pass too quickly to allow people more than a fleeting impression. As early as 1874 the critic Castagnary had understood Monet's aims when he wrote of the Impressionist group: 'They are Impressionists in the sense that they render not the landscape but the sensation produced by the landscape.' Monet realized this principle early in his career and of all the Impressionist artists remained committed to the essential values that had originally stimulated Impressionism: into his old age he continued dedicatedly to trust his visual instincts, painting the landscape he loved just 'as the bird sings'.

MORISOT

Berthe Morisot was one of the most charming painters of the Impressionist movement. Her intimate maternal scenes and pictures of women and children faithfully record contemporary and domestic detail ignored by many of her colleagues. At their best Morisot's paintings rank with Monet and Manet's, a remarkable achievement for a nineteenth century woman considering the obstacles and prejudices of the time. That she successfully overcame such obstacles is a credit to her determination, above all else, to paint well and seriously.

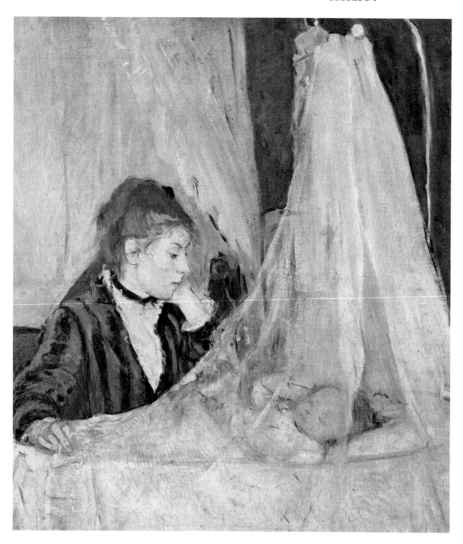

The cradle, 1872

56 × 46 cm (22 × 18 in)

JEU DE PAUME, PARIS

The close relationship of mother and child was a recurring theme for Morisot. In this moving work she depicted her sister Edma (Mme Pontillon) with her new baby daughter Blanche. The delicacy of the brushwork and subtle appreciation of light are most apparent in the handling of the filmy drapery hanging over the cradle. The baby's face is clearly visible but gently veiled beside the detailed treatment of the mother's face, hair and clothing. It is a graceful composition, perfectly balanced and finely realized.

Berthe Morisot was born in January 1841, in the same year as Renoir, in Bourges, a town in central France. Her father was Prefect of the region at the time and also an architect of some standing. As a child she enjoyed a privileged and private education, guided by a succession of governesses employed by the family. She was taught to appreciate literature and to play the piano and at an early age she developed a keen interest in modelling.

As a female child of a *haut-bourgeois* family, it was perfectly acceptable that Berthe should become interested in painting; it was considered a genteel pastime but for women was not generally intended to develop into a serious career. When Morisot made it known that this was her desire, she received considerable encouragement from her family, especially from her mother who from the first took a keen interest in the talents and education of her daughters. In 1857, when Berthe was 16, Mme Morisot arranged for the three sisters, Berthe, Edma and Yves, to take lessons in art from the painter

Chocarne. Yves soon tired of this teaching, but for Berthe and Edma it was a great discovery and the two were to work closely together for the next 12 years, until Edma's marriage in 1869.

After some time with Chocarne they were soon demanding a less conventional teacher and were passed on to Joseph Guichard. When Berthe expressed a strong interest in painting out of doors, rather than the more traditional copying and studio composition favoured by Guichard, he introduced the sisters to the pre-Impressionist painter Corot who was very much taken with them and surprised, in particular, by the strong will of Berthe. Corot demonstrated his technique and encouraged them to copy his own works; he then sent them on a painting trip to Auvers-sur-Oise, in the countryside north of Paris, where Berthe's interest in open-air painting was strengthened by a meeting with the Barbizon painter Daubigny. In 1863, Berthe and Edma moved to a small house at Chou (at various times painted by Pissarro, Cézanne and others)

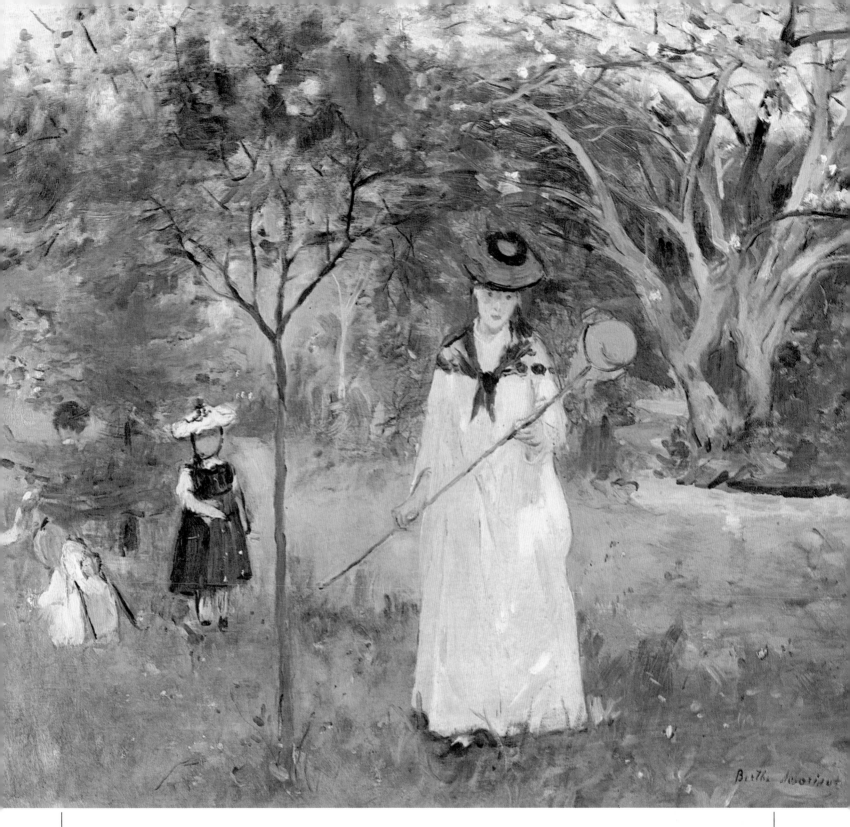

The butterfly catchers, 1874

47 × 56 cm (18 × 22 in)

LOUVRE, PARIS

The contrast of black and white in this work shows the influence of Manet, however, the painting's fresh appeal derives from the fluid brushwork and sketchily drawn image which are typical of Morisot's own style. It is a style which is particularly appropriate to the variety of tone and texture in a garden setting but Morisot was a versatile painter and would modify her technique to catch a particular quality of light and colour: a harbour view, for example, might have a more opaque and even paint surface suited to the open spread of light. This picture again shows Morisot's sister Edma with her children. After her own marriage Morisot's daughter Julie became her favourite subject.

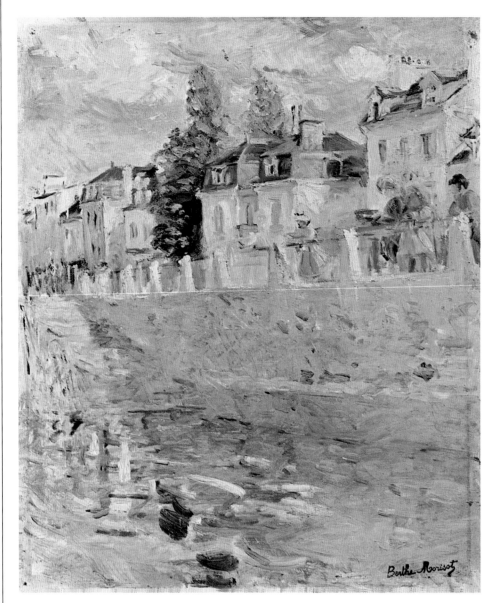

Quayside along the Seine at Bougival, 1883
55 × 46 cm (22 × 18 in)
NATIONAL GALLERY, OSLO
Morisot rarely depicted straightforward landscapes devoid of figures, but this intimate glimpse of a quayside along the Seine reveals a softness and delicacy for the same sort of subject that her fellow Impressionists handled in a much bolder and more open manner.

Woman sewing in the garden, 1881 *(right)*
81 × 100 cm (32 × 39 in)
MUSEE DES BEAUX ARTS, PAU
Morisot's loose brushwork and thinned paint often gave her pictures the lightness of watercolours, though they were painted in oils. The technique is perfectly matched to the charming freshness of this outdoor scene.

between Pontoise and Auvers where they remained for some months. Berthe exhibited in the Salon of 1864 and spent the summer in Normandy.

In 1868, wandering in the Louvre, Berthe Morisot was introduced to Edouard Manet through their mutual friend the painter Henri Fantin-Latour. This was the beginning of a deep, lifelong friendship, further strengthened when Berthe married Manet's brother Eugène in 1874. Manet was very much taken with the confident and able young woman; she in her turn was dazzled by the famous painter notorious for his modernist works and his influence on young artists seeking new experiences of painting. Zola and Huysmans, both eminent critics, referred to Morisot directly as a pupil of Manet but it was a word loosely applied at the time and has been interpreted too strongly by later

historians of Impressionism. She never became his pupil, though in the public eye she was frequently associated with him and his influence on her work cannot be ignored. Morisot was highly conscious of her tendency to be over-influenced by Manet's style and her letters to Edma occasionally expressed her annoyance with this trait.

Throughout her career Berthe Morisot painted the women who were close to her and her intimate surroundings with a charm and subtlety that perhaps only a woman could bring to them. Her sister Edma provided the model for one of Morisot's most charming images of motherhood, 'The cradle', which is a beautiful example of Morisot's unpretentious approach to painting. With Berthe's own marriage in 1874 and the subsequent birth of her daughter, her paintings seemed to keep closely in

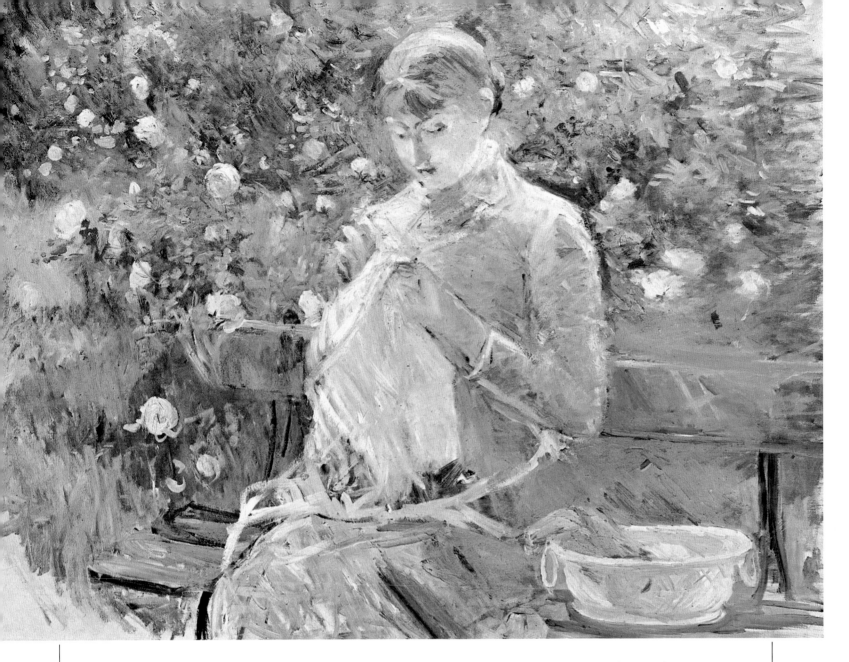

step with her own personal development as girl, wife and then as mother.

The year of the first Impressionist exhibition, 1874, was a very important year for Morisot. She was one of the founding exhibitors in the exhibition showing five of her own works including 'The cradle'. Manet, who himself refused to exhibit with the Impressionists, attempted to dissuade her but she ignored his advice, feeling an unavoidable sense of commitment to the new movement. At the end of 1874 she was married to Eugène Manet, who was supportive of her talent and industry as a painter. Her father had died in the same year but she remained closely involved with her mother and with Edma, who had given up painting after her marriage, and much useful insight into Berthe's life is provided by her correspondence with them.

Berthe Morisot maintained a steady commitment to the Impressionist movement and exhibited in seven out of eight of the independent exhibitions, missing only that of 1879, the year in which her daughter Julie was born. When her former teacher Guichard visited one of the exhibitions and saw her work associated with Impressionism, he wrote a horrified letter to her mother: 'It is not safe to live with madness. They are all a bit touched.'

During the summer of 1878 Berthe travelled with her husband to the Isle of Wight in England, where she painted him often, in works showing simple, everyday scenes. It was one of the major achievements of Impressionism, in which Morisot strongly shared, to convey the humdrum and mundane as suitable subjects for painterly feats of invention in which nothing is taken for granted and all must be

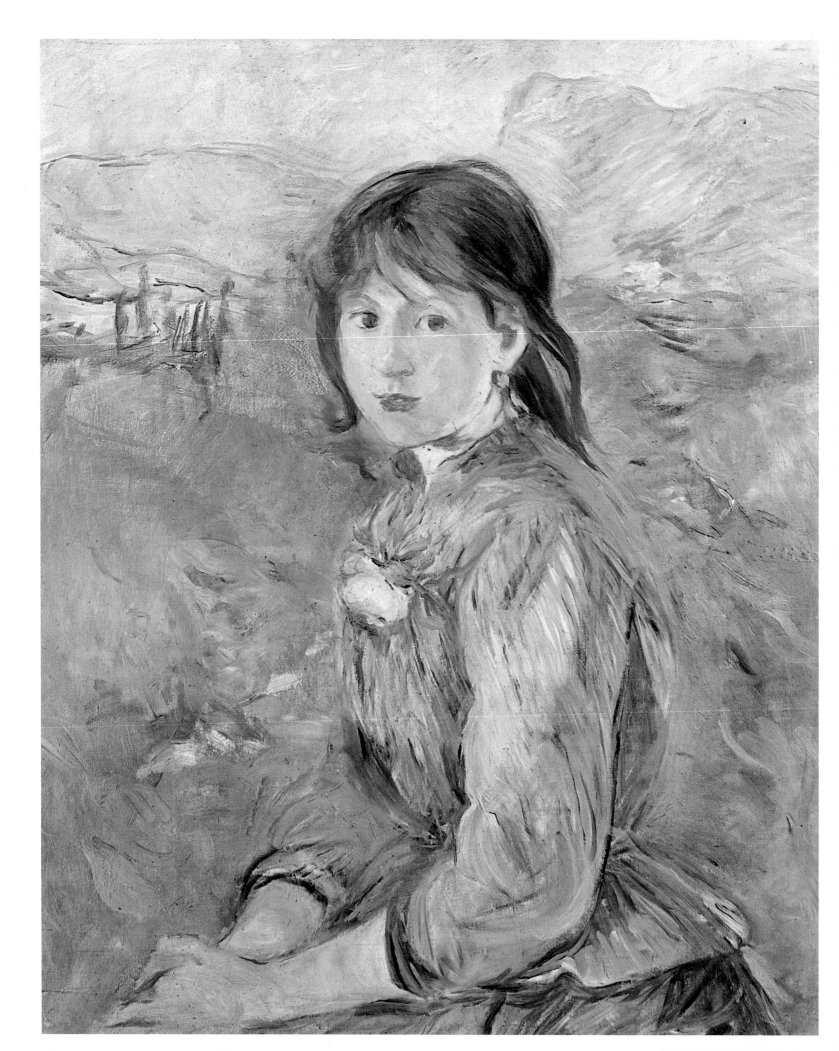

The hydrangea, 1894

73 × 60 cm (29 × 24 in)

JEU DE PAUME, PARIS

This late work shows Morisot still absorbed in the feminine subject matter to which she could bring an intimacy and sympathy of touch that gave the pictures a broad appeal, and still remaining true to the original Impressionist principles of the 1870s.

Little Nizzarda, 1888–9 *(left)*

62 × 52 cm (24 × 20 in)

MUSÉE DES BEAUX ARTS, LYONS

The background is vaguely sketched and of secondary importance in this painting as Morisot concentrates on the subject of the portrait, describing her with vigorous but sensitive brushwork. This captures both the image and the atmosphere with rapid, confident strokes. The fabric of the blue dress attracts light like rippling water, setting off the face which, though lacking fine detail, is both descriptive and expressive.

discovered afresh by the viewer. The birth of her daughter gave Morisot endless opportunities to express her own joy and excitement at the sight of a child growing up in the world.

Throughout the 1880s and early 1890s Morisot returned time and again to the same themes and motifs, but she never lost her freshness of approach. Her teacher Guichard had complained that she tried to do in oil what should only be attempted in watercolour. Perhaps he was right in principle, but his conventional viewpoint failed to appreciate the benefits of her unorthodox technique. There is a splashiness about her work which is reminiscent of watercolour, a medium she also used in its own right, but this manner adds much to the fleeting charm of the moment snatched from time.

In 1891 Eugène Manet died and his widow, with her only daughter, retired to Le Mesnil, the house they had recently bought near the village of Juziers north-west of Paris. There she continued to paint steadily . From the late 1880s she had developed a particular friendship with Renoir and he made portraits of both Berthe and Julie. In May 1892, at the age of 51, Morisot was given her first solo exhibition at Boussod et Valadon, dealers in Paris, and more exhibitions followed, particularly in Brussels where her work was extremely popular. For the next few years she continued to lead a full life, travelling, painting and looking after her daughter, but this was sadly cut short by an illness which developed in January 1895. After only a brief period during which she was bedridden, Berthe Morisot died on 2 March 1895.

Though she died at the comparatively young age of 54, Berthe Morisot had achieved much both as a woman and as a painter. She combined a happy family life with a dedicated career which put her on level terms with the greatest painters of her age. Shortly before her death, she wrote in a notebook: 'It is a long time since I have hoped for anything and the desire for glorification after death seems to me an excessive ambition; mine would be confined to seeking to capture something of the passing moment, oh, only something.' She had captured many of those moments and in doing so had already made sure that to be remembered long after her death was not, after all, such an excessive ambition.

PISSARRO

Pissarro, born a decade before Monet, Renoir and Sisley, appears almost as the father figure of the Impressionist group. Mary Cassatt said of him: 'He was such a teacher, he could have taught a stone how to draw correctly.' Moreover his encouragement of Gauguin, Cézanne and Seurat, who all in their various ways represented the gradual dispersion of Impressionist principles, shows how ready he was to consider and absorb different ideas without feeling threatened. His constant struggle for recognition, or even to make enough money to feed his family, never shook his devotion to painting. He was rewarded by the respect and affection of all the other artists and their appreciation of the beauty and serenity of his work.

Peasant girl with a stick, 1881

81 × 65 cm (32 × 26 in)

LOUVRE, PARIS

Degas described Pissarro's peasant women as 'angels who go to market'. This picture is painted with broad brushstrokes, and filled with colour and light, as if to radiate Pissarro's affection for the countryside and its people.

Camille Pissarro was born on 10 July 1830 on St Thomas in the Danish Virgin Islands. His father was a Danish Jew who had settled in Bordeaux and then emigrated to the Caribbean. His mother had been a widow with two daughters, Delphine and Emma, before marrying Frédéric Pissarro and was also a practising Jew. The family remained for some time in the Caribbean and Pissarro's early education was at the local school and in the homes of his parents. At the age of 11 he was sent to boarding school in France, at Passy in the suburbs of Paris, where the headmaster M. Savary discovered his artistic talent and encouraged Camille to draw and paint. The school vacations, if he did not return to the Virgin Islands, were spent with his paternal grandfather or uncle, both of whom lived in Paris.

In 1847 Pissarro returned to Charlotte Amalie, the capital of St Thomas, and joined his father in business. The family business was a small entrepreneurial affair which did not greatly interest Camille, but he felt a duty to his family and his father. He continued to draw and paint but he was very isolated and could rely on no instruction other than that of his own imagination for guidance. However, he developed a friendship with a Danish painter living on St Thomas, Fritz Melbye, and in 1852 the two men decided to make a trip together to Venezuela. In November they arrived in Caracas where Pissarro was to remain for the next two years, mixing with the local intelligentsia and making trips into the surrounding jungle of the Orinoco basin to paint. The years in Venezuela were a highly unconventional artistic education for a painter in the nineteenth century and it was perhaps here, in the bright sunlight and exotic colouring of the jungle, that Pissarro learnt much that would be of importance to him in later years.

In 1855, after returning for a short while to St Thomas, Pissarro decided to leave his career in commerce and try to make his way as a painter. He returned to Paris and stayed with his relatives; shortly afterwards his family returned from the Caribbean and settled near Paris at La Muette. On arriving in France, Pissarro was very much impressed by the developments in French painting from which he had been isolated during the years spent abroad. He was deeply affected by the work of

Pontoise, 1868
55 × 86 cm (22 × 34 in)
KUNSTMUSEUM, MANNHEIM
In the 1860s Corot had been the strongest influence on Pissarro. This is apparent in the air of luminosity and realism of this work, although the free manner of the brushwork shows Pissarro developing his own style.

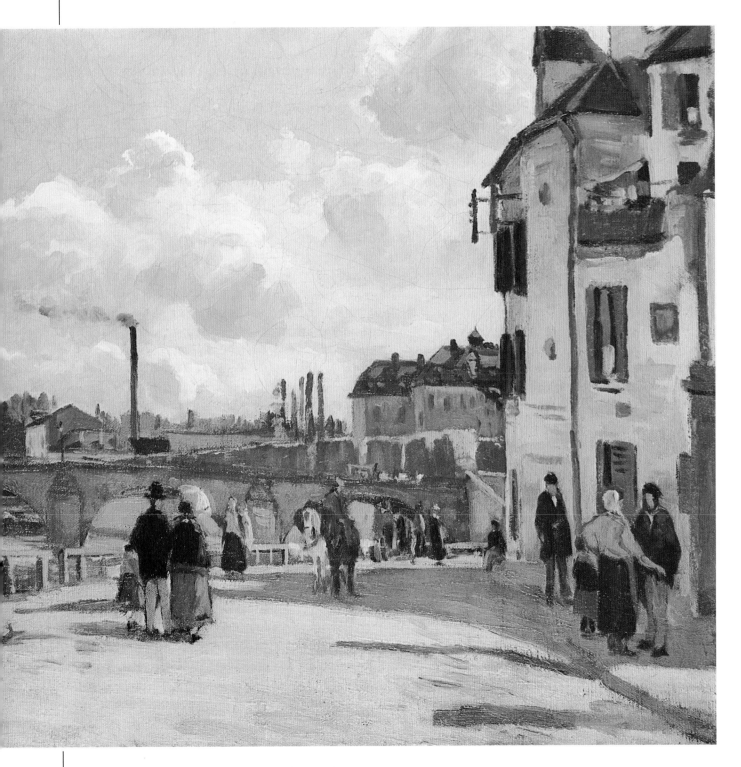

"We were always together but what cannot be denied is that each of us kept the only thing that counts, the individual sensation."

Courbet, on show in a special pavilion at the Exposition Universelle, and the best work of Corot and Delacroix which was available to view at the official Salon. Pissarro was working in a variety of studios in Paris, especially that of Anton Melbye, the brother of his friend Fritz Melbye from St Thomas. At the Ecole des Beaux Arts he received useful advice from Corot: 'Don't look for a formula, don't be influenced by facile pupils, don't decide proportions in advance; in a word, learn to see yourself and work without a preconceived system.' After the years of isolation, Pissarro benefited much from the opportunity to exchange ideas with fellow artists and the advice of masters such as Corot, who was at the forefront of a new interest in landscape painting which was permeating French art.

Pissarro's character was complex and he was involved with many interests not directly reflected in his paintings. He read widely, in particular left-wing and anarchist political theory; the works of Saint-Simon and the Russian exile Prince Kropotkin were an important influence. His decision to become a painter was as much the expression of a natural desire as a deliberate act of distancing himself from the bourgeois values of his family. He became in many senses the mainstay of the Impressionist movement. It was he who drew up the charter for the first Impressionist exhibition in 1874 and he was the only artist to exhibit in all eight of the Impressionist exhibitions. It is also from his full correspondence, in particular with his son Lucien, that much of our understanding of the loosely defined movement has been derived.

In the 1850s Pissarro only slowly learnt the craft of painting and it did not come easily to him. In South America with Fritz Melbye he had been following the typical European tradition of topographical painting. The academic training he received at the Ecole des Beaux Arts was at the hands of the Ingriste painters Lehmann and Picot. Little work of this period survives but after 1860 Pissarro came to be increasingly influenced by Corot, although he failed to catch Corot's sense of light and many of his paintings of this early period are heavy with browns and greys. They do, however, show a sense of construction and well-judged contrasts of light and shadow. After meeting Manet in 1866, Pissarro began to lighten his palette and on moving to Pontoise, a village to the north of Paris, began to paint pictures specially for exhibition in the Salon. The work was much admired although Pissarro tended to emphasize the importance of the landscape over and above what was expected by normal Salon standards, for it was still regarded as the least important subject for painting.

Early in 1860 a young servant girl called Julie Velay was taken into service by the Pissarro family. Camille occasionally asked her to model for him and the two soon began a liaison that was much disapproved of by Pissarro's parents. But despite their disapproval Julie left service and went to live with Pissarro, although they did not marry until much later. In 1863 she bore a son, Lucien, who would also grow up to become a painter. Pissarro was slowly beginning to meet all the young artists in Paris who were to be of importance in the coming years. He was a little older than most of these colleagues but prepared to keep company with anybody of interest. Early in the 1860s he made a great friend of a wealthy man and amateur painter Ludovic Piette, who in the years to come was often to help him out of financial embarrassment or give him a home when he had nowhere else to go.

At this time Pissarro was still only beginning to find his style and he was selling very few paintings. At the death of his father in 1865 he inherited no money to speak of; all remained with his mother to whom he often had recourse to ask for help. A daughter, Jeanne Rachel, was born in the same year and the expenses of caring for a family forced Pissarro to pawn his property despite an allowance from his mother. He followed the habit of so many painters which was to live in Paris in rented accommodation during the winter and then to move out along the Seine into Normandy during the summer. It was in the winter of 1866–7 that he first began to attend the evening *soirées* at the Café Guerbois where he got to know Sisley, Monet and Bazille.

In the summer of 1867 Pissarro began to discuss with Monet the possibility of organizing an alternative exhibition to the Salon but the project came to nothing chiefly through lack of finance, a problem which was to dog Pissarro for the rest of his life.

The road to Rocquencourt, Louveciennes, 1871
51 × 77 cm (20 × 30 in)
PRIVATE COLLECTION
When Pissarro escaped to London during the Franco-Prussian war of 1870–1, he was able to study at first hand the work of the English landscape painters Turner and Constable, who had earlier explored the fugitive effects of light and colour which were to become the main preoccupation of the Impressionists. This is one of the first pictures painted after his return to France.

"You are right my dear Duret, we are beginning to make ourselves a niche. We meet a lot of competition from certain masters, but must we not expect these differences of view, when we have succeeded as intruders in setting up our little banner in the midst of the crowd?"

C. Pissarro. 1872

Pissarro and Monet were becoming very close friends and Monet took over from Corot as the strongest influence on Pissarro's work. Although Père Martin, who acted as Jongkind's dealer, was taking some of his work the financial position remained extremely difficult for Pissarro and he was forced to take a job painting blinds and shop signs in an effort to make ends meet.

In 1869 Pissarro moved with his family to Louveciennes west of Paris, where he painted his earliest Impressionist works. When the war with the Prussians came Pissarro sought refuge with his friend Piette at Montfoucault in Brittany, leaving his furniture and paintings behind at Louveciennes. He wanted to join the army but his Danish nationality disbarred him. His second daughter was born in

154

The road into Voisins, 1872 (*left*)
46 × 55 cm (18 × 22 in)
LOUVRE, PARIS
The deepening perspective of a tree-lined road was one of Pissarro's favourite subjects. He painted many of the villages in the area known as the Ile de France, where he lived almost all his life. The straight road disappearing into the distance provided a conventionally balanced and centred construction to the picture, the vertical stress of the tall, gaunt trees matched by their horizontal shadows thrown across the roadway.

Banks of the Oise, Pontoise, 1877
38 × 55 cm (15 × 22 in)
PRIVATE COLLECTION
The River Oise at Pontoise was almost as important to Pissarro as was the Seine at Argenteuil to Monet. He returned time and again to capture the flow of life along its banks. Like Monet, Pissarro was conscious of the changes which industrialization was bringing to the countryside. A recurring motif in his views of Pontoise is the factory chimney rising above the river, a symbol of a new way of life coming to the villages.

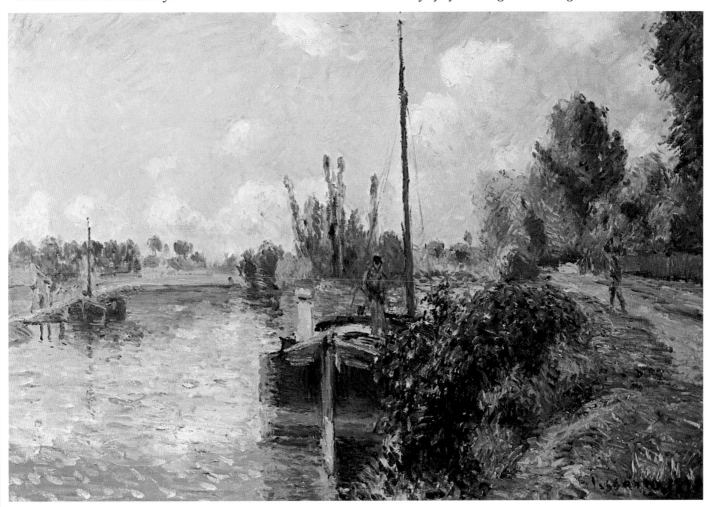

October but died a fortnight later. After this the family fled to England until the war was over.

It was through his association with Monet that Pissarro really developed into an Impressionist painter. By 1870 Pissarro had grown confident in his style and during the next few years produced some of his best work. He was open to the influence of those around him, but as in later life he wrote to Lucien: 'We were always together but what is certain is that each one of us maintained the only thing that mattered and that was our individual sensation.' Pissarro developed his own distinctive style, notwithstanding the influence of Monet, and from a remark written in one of his sketch books of the period it can be seen that he had a very real understanding of what he meant by Impressionism.

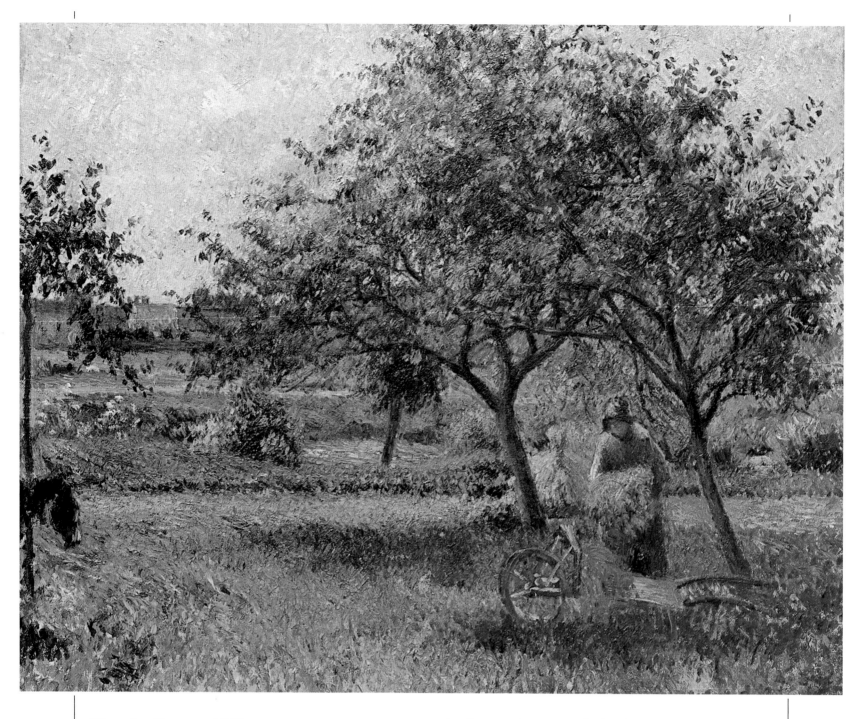

The wheelbarrow, 1881

54 × 65 cm (21 × 26 in)

LOUVRE, PARIS

In the 1880s Pissarro gave increasing attention to the peasants who worked the land that he had painted so lovingly but, as here, he would often merge the landscape and figures, an effect emphasized by the evenness of the paint texture. The small, heavy brushstrokes weave a surface pattern through the image which, amid the controlled harmony of yellows and greens, suggests the subtle shadows and light movement in the grass and trees.

In Pissarro's view, 'A landscape should be seen through a completely transparent vapour in which the colours fuse hesitantly one with the other.' He saw the world as though it were not in tangible form but actually made of light and colour. The challenge of atmospheric conditions intervening between the eye and the object viewed provided the starting point for many Impressionist landscapes.

Pissarro's greatest Impressionist period was from 1869 to 1880. In that time his style underwent several changes but his subject matter remained more or less constant. In the beginning he would apply paint smoothly, sometimes breaking into

small irregular patches, but slowly Pissarro began to paint more thickly with larger brushstrokes and intermittent use of the palette knife, as in 'Winter in Pontoise'. After 1876 he adopted two styles which were almost interchangeable. Short curving brushstrokes intertwined around the forms to enliven the surface of the picture; this style he used chiefly when depicting more modernist subjects, such as factories on the banks of the Oise. In the broader landscapes he adopted a more granular style, overlaying colours to build up a heavy, distributed texture, for example in 'The footpath at Chou' or 'The Hermitage at Pontoise'.

Red roofs, 1877

54 × 66 cm (22 × 26 in)

LOUVRE, PARIS

Four years later than Cézanne's 'House of the hanged man' (see page 42), Pissarro has used a similar kind of flattened perspective which conceals the depth of the composition and creates a densely textured spread of colour from edge to edge of the canvas. The painting has a rich tactile quality and displays Pissarro's sophisticated control of pictorial elements.

Peasants guarding their cows, Pontoise, 1882
65 × 81 cm (26 × 32 in)
PRIVATE COLLECTION
This theme appeared in Pissarro's earlier work but here the figures have come to the fore and the landscape is relegated to a supporting role. Pissarro avoided the overt social comment that van Gogh, for example, was eager to convey in his early paintings in Holland, and he neither idealized the peasants at work nor exaggerated the harshness of their lot in life.

Ile Lacroix, Rouen, 1888

44 × 55 cm (17 × 22 in)

PRIVATE COLLECTION

This extraordinarily enigmatic and haunting image is the result of Pissarro's attempts, in the late 1880s, to combine the atmospheric effects beloved of the Impressionists with the analytical technique of divisionism invented by Seurat. The choice of subject places subtle demands on the divisionist principles; the gradations of tone and colour are minutely balanced among the mass of dotted brushmarks. Pissarro has used an essentially ordered technique to describe the soft chaos of foggy weather. The effect is markedly different from the highly stylized results of Seurat's use of the method.

159

When Pissarro fled to England during the Franco-Prussian war he settled in south-west London, first at Weston Hill and then in Upper Norwood. While in London he met the Parisian art dealer Paul Durand-Ruel and through him discovered that Monet, too, had sought refuge from the war in England. As well as painting about a dozen magnificent works depicting the London suburbs, Pissarro also found time to visit the museums where he took a particular interest in the work of Constable and Turner, and of the landscape painters of the Norwich School.

At last he and Julie Velay were married, in a registry office in Croydon, in the London suburbs, on 1 June 1871. At the end of the month they were able to return to Louveciennes where they found that their house had been requisitioned by the Prussians and pillaged. M. Ollivon, a municipal councillor, had managed to save 40 out of the 1500 canvases, which represented about 20 years' work. Pissarro applied for war damages but was eventually awarded only 835 francs. In November 1871 Julie gave birth to their second son, Georges; Pissarro decided to move from Louveciennes and established himself with his family at Pontoise, on the river Oise which was a large tributary of the Seine. In 1872 Cézanne came to live with Pissarro and his family and the two men worked very closely together for the next couple of years. They had first met at the Académie Suisse in the early 1860s and they developed a close and lasting friendship.

Pissarro was beginning to find a few purchasers for his work but they were the same isolated individuals who bought the work of the other Impressionist painters. The banker Arosa and the singer Faure were his most dependable patrons but also the critic Théodore Duret to whom Pissarro later recommended Monet's work: Pissarro was a man of great generosity who was always keen to help his friends as much as possible and he never tried to keep patrons or buyers to himself.

Monet and Pissarro still had in mind the idea that their colleagues might come together in a society or guild of painters which could become independent of the highly capricious and partial decisions of the Salon jury. It was an idea that had never got off the ground in 1867 but by 1873 the group of painters

Unloading wood at Rouen, 1896
54 × 65 cm (21 × 26 in)
PRIVATE COLLECTION
The bustle and turmoil of the ports were a great attraction to Pissarro in the 1890s. He painted at Le Havre and Dieppe and on the river at Rouen, trying to capture the feeling of modern commercial life as it was lived from day to day. These works are a complement to Pissarro's elegant pictures of the Paris boulevards with their fashionable strollers, the two themes showing both sides of the modern industrial society that France was rapidly becoming.

''*If we observe the totality of Pissarro's work we find there, despite fluctuations, not only his extreme artistic skill, but also an essentially intuitive pure bred art. He was one of my masters and I do not deny him.*''
Gauguin

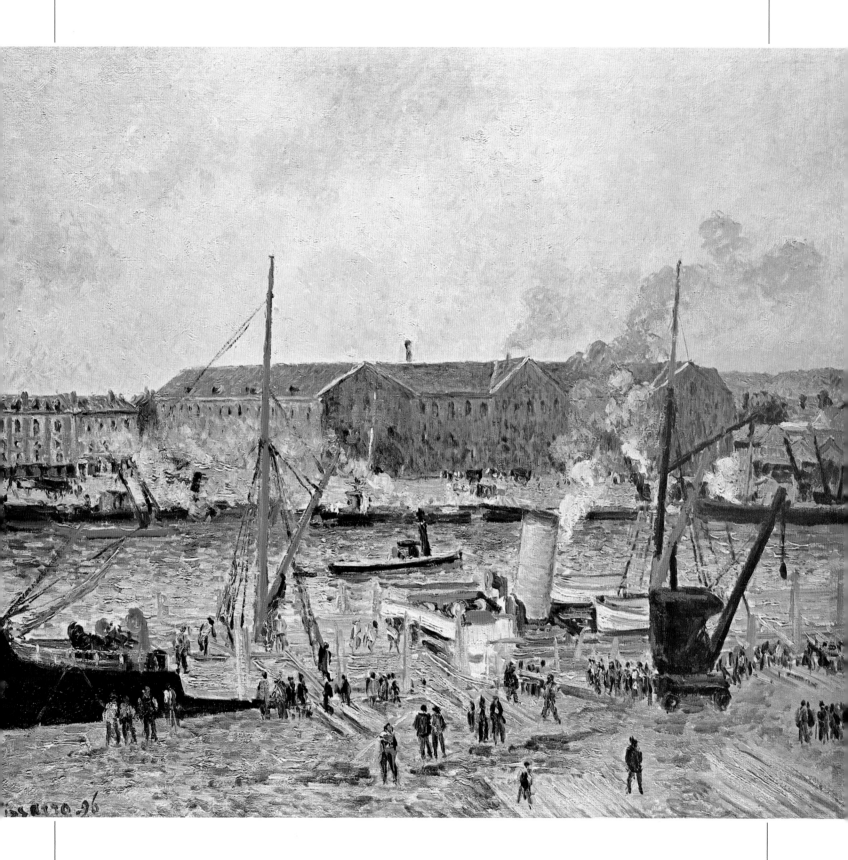

was keener on the idea and the climate was more favourable. Pissarro drew up the charter of the 'Société Anonyme des artistes, peintres et graveurs etc' under which name the so-called first Impressionist exhibition was held, a critical and financial disaster which was a resounding disappointment to all the artists involved.

Times were not easy for Pissarro. His daughter Jeanne died in April 1874; another son Félix was born in July and there was hardly enough money to feed the family. In August Pissarro took his wife and children to stay with his friend Ludovic Piette at Montfoucault, where he remained except for short visits to Pontoise until the spring of 1875. Pissarro joined with the exhibitors in all the Impressionist shows of the 1870s but with no better results. Only a small group of devotees bought his works and were it not for the kindness of Piette and the restaurateur Murer, who gave dinner to artists of the group in his restaurant in the Boulevard Voltaire in Paris every Wednesday evening, Pissarro and his family may well have starved. Mary Cassatt, who was of independent means, tried to find him American buyers and Murer organized a lottery with the prizes all works by Pissarro, in order to try to gain some extra income for the poverty-stricken painter.

Piette died in 1878 which was distressing to Pissarro in that he lost a good friend and patron. In November his family was expanded again by the arrival of a fourth son, named Ludovic Rodolphe. Some dealers flirted with his work but even Père Martin abandoned him. In 1879, in an attempt to pay off his debts, Pissarro invited Murer and the wealthy amateur painter Caillebotte to buy five paintings each at 100 francs. Pissarro found a considerable admirer in the young stockbroker Paul Gauguin, who had been buying his work for some time. Gauguin came to spend the summer of 1879 at Pontoise and it was largely due to Pissarro's encouragement that Gauguin finally gave up stockbroking and took to painting full-time.

By 1880 Pissarro had passed through his major Impressionist phase. Over the next ten years his style was to alter quite considerably, especially after the sixth Impressionist exhibition in 1881. He began to move away from landscape painting and to

The kitchen garden, Eragny, 1897
60 × 73 cm (24 × 29 in)
PRIVATE COLLECTION
Pissarro eventually settled at Eragny, north-west of Paris, which became his base for the last years of his life until his death in 1904. This painting of his kitchen garden under a cloudy sky is typical of the unpretentious nature of his art.

concentrate more on genre and figure painting. The emphasis of his work lay in studies of peasants at work rather than the landscape in which they worked. Instead of the wide open horizons of the earlier landscapes, he tended to place the horizon line high up on the canvas and flatten the perspective, very much in the manner of the Japanese artists whose work had become very fashionable in Paris. Pissarro also took his subject matter into the village market place and created a sort of rural equivalent to the music-hall and café scenes of Degas and Toulouse-Lautrec.

After 1885 Pissarro, largely through the influence of his son Lucien, began to flirt with the new divisonist theories of Seurat and Signac, the style known as Neo-Impressionism (see page 193). During the years of his involvement with this new movement, Pissarro's production dropped dramatically and it would seem that he never truly understood the principles involved or came to grips with an art form that was in the main too rigid and disciplined for his own more instinctive approach to painting. He wrote to Lucien about this in 1889: 'I am looking for a means of replacing the dots; at the moment I am not achieving what I want. The manner of execution is not swift enough for me and does not respond simultaneously with the feelings within me.'

By about 1890 Pissarro seems to have abandoned Neo-Impressionism as an unsatisfactory experiment and he altered his style again, returning very much to the manner of the 1870s almost as if he were giving a summary of the aims and achievements of the early years. At a time when Monet and Cézanne were pushing the boundaries of art even further, Pissarro was beginning to mark time. Yet again, however, his subject matter changed and there were two main threads to the work of his later years. Because of an eye disease that began to develop in the late 1880s, he was no longer able to paint out of doors and so he began to observe the passing hours and seasons over the countryside from an upper room in his studio at Eragny-sur-Epte north of Paris. The other major theme of the final years brought forth the wonderful town- and city-scapes of Rouen, Dieppe and Paris. Once again, it is apparent from the perspective of most of these works that the height of the viewpoint above the scene depicted

corresponds to Pissarro working indoors at an upper window. He wrote to Lucien that his aim was 'to give an idea of the movement, of the life, of the atmosphere of a port filled with steamboats, bridges and roads.'

The same attitude was adopted in Paris where he painted the Seine and the bustling new boulevards of the city built by Baron Haussmann. Pissarro became the painter of the modern city on a grand scale, giving the overall view that was the external equivalent of the intimate interior scenes of Degas. 'I am enchanted with the idea of painting the streets of Paris which people call ugly but which are so silvery, so luminous and so lively . . . It is the modern idiom in full.'

In 1880 when Pissarro was still living at Pontoise the dealer Durand-Ruel, backed by the Union Générale insurance company, was beginning to buy again and prospects looked brighter. In 1888 Durand-Ruel gave Pissarro his first one-man show but, like Sisley, Pissarro was not so popular with the buyers as Renoir and Monet proved to be. Pissarro continued to struggle, with another daughter born in 1881, to look after his large family and was always considering novel means of making money. Durand-Ruel, who was bravely attempting to carry the whole Impressionist movement on his shoulders, was continually in financial difficulties and could never really afford to pay Pissarro large sums for his work so that he was falling deeper and deeper into debt.

In 1884 he moved to Eragny-sur-Epte where he was to remain for the rest of his life and in August of that year his youngest child, Paul-Emile, was born. The trials of his life went up and down throughout the 1880s according to whether Durand-Ruel was more or less successful. The experiment with Neo-Impressionism was not popular with the dealer and did not help him to sell Pissarro's paintings. In September 1887 Pissarro made contact with Theo van Gogh, the art dealer brother of the artist, and persuaded him to take some of his work.

In 1891 Pissarro underwent an operation for the eye trouble from which he had been suffering since 1888 and was unable to paint for some time. His ailment was to continue to be a source of irritation for the rest of his life. During his later years, Pissarro

began once again to become involved with anarchist politics. He read widely the works of such authors as Jean Grave and Proudhon and subscribed to the Socialist newspaper *Le Prolétaire*, but never became involved in any direct activity although he was very nervous when his friends Grave and Félix Fénéon were involved in a famous anarchist trial in 1894, known as the Trial of the Thirty.

Towards the end of the 1890s Pissarro played off Durand-Ruel against another leading dealer, Bernheim Jeune, and in 1901 he managed to sell nine

February sun over Bazincourt, 1893

65 × 81 cm (25 × 32 in)
RIJKSMUSEUM KRÖLLER-MÜLLER, OTTERLO

Pissarro struggled with the post-Impressionist technique of divisionism for several years but though he was attracted by its apparent scientific authenticity, he found it impossible to come to terms with its lack of spontaneity. In the early 1890s he abandoned it and attempted to move forward once again, as he later put it trying 'to regain what I had lost and not to lose what I had learned.' This painting shows the remnants of his divisionist period in the small patches of colour applied with a regular texture, but the effect of the weak winter sunlight is beautifully captured with the visual sensitivity characteristic of his earlier work.

canvases to Durand-Ruel for 24,000 francs. His work was at last beginning to provide him with a decent living, although he did not live long enough to become a rich man. His wife Julie, however, who survived until 1926, was able to enjoy some of the financial reward that had so eluded them during her husband's lifetime.

In 1903 Pissarro was sharing his time between the Channel ports of Dieppe and Le Havre working on another series of marine paintings with which he had been occupied for the past ten years. Late in

September he took part in a pilgrimage to Medan on the first anniversary of Emile Zola's death and this proved tiring for a man of over 70. On returning to Paris where he was to rent an apartment for the winter, Pissarro had to take to his bed and on 13 November 1903 he died peacefully.

Late in life Pissarro wrote to his son Lucien, who had by this time become a successful painter himself: 'Happy are those who see beautiful things in modest surroundings or where other men see nothing. Everything is beautiful, all that matters is

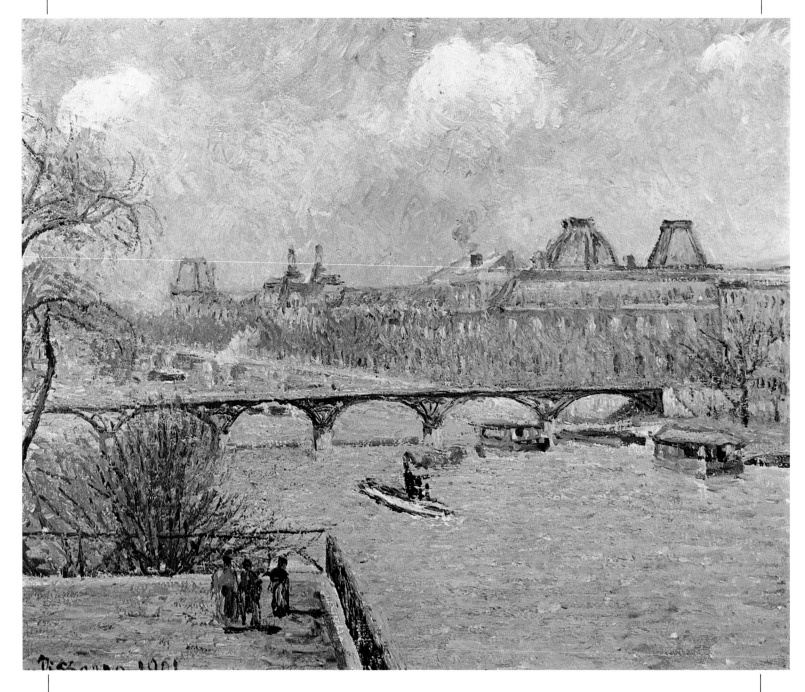

View of the Seine, 1901
46 × 55 cm (18 × 21 in)
PRIVATE COLLECTION

Towards the end of his career Pissarro used to take an apartment in Paris during the winter, devoting his attention to the subject matter of the city. In this painting, the fluid brushstrokes build up an effect of hazy colour – the hallmark of his painting in the final years.

to know how to interpret it.' Throughout his long and remarkably diverse painting career, Pissarro was constantly striving to find new ways to interpret and present the beauty of the world around him. He was always open to new ideas, ready and willing to offer advice to young painters. His generosity was considerable, even when he himself had so little. A letter to Murer, written in the late 1870s, expresses the struggle of his poverty-ridden life, but underlines his devotion to painting: 'What I have suffered is beyond words; what I suffer at the actual moment

is terrible, much more than when I was young – full of enthusiasm and ardour – convinced as I am now of being lost for the future. Nevertheless, it seems to me that I should not hesitate, if I had to start over again, to follow the same path.'

Of the many fine tributes that have been paid to Pissarro as a painter, he is perhaps best remembered in the words of the English artist Walter Richard Sickert, who wrote in 1923: 'Pissarro remains the painter for those who look at rather than those who read about painting.'

The Louvre on a snowy morning, 1902
65 × 81 cm (26 × 32 in)
NATIONAL GALLERY, LONDON
Pissarro painted this view of the Louvre from across the Seine several times at the end of his life in an attempt to capture it under the changing influence of time and season. It is the same stretch of the river appearing in the 'View of the Seine' (pictured opposite) of the previous year. Pissarro had always enjoyed the effect of snow, which so altered the overall view and cast up new lights and colours across the city or the countryside.

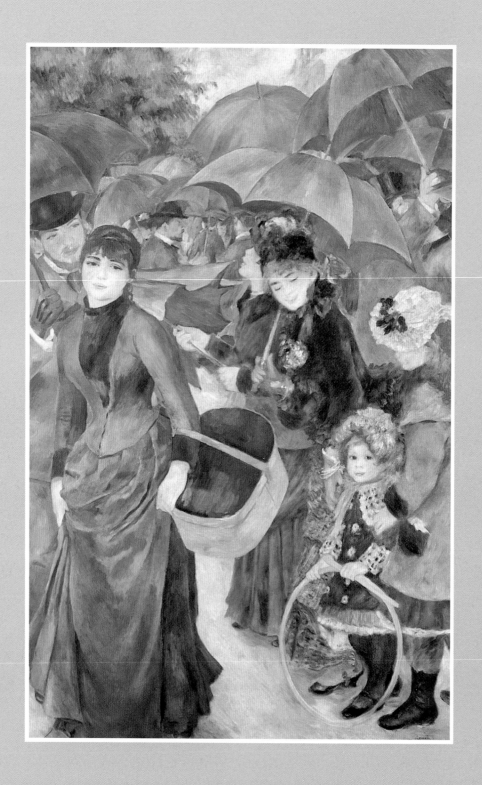

RENOIR

Of all the great Impressionist painters
Pierre Auguste Renoir is perhaps the most
loved and least understood. His pictures
reflect a sumptuous existence where life
seems only good and bountiful. Even
compared to the work of his
contemporaries, his colours are more
ebullient and his figures fleshier. Yet he
was probably the most conservative of all
the Impressionist painters, and seems in
many ways to have closer links with the
eighteenth century than the nineteenth.
He was less theoretical, more relaxed and
a more natural painter than many of his
colleagues, but was nevertheless prepared
to join in their struggles.

The umbrellas, 1884
180 × 115 cm (71 × 45 in)
NATIONAL GALLERY, LONDON

Tone dominates over colour in this work, perhaps more
than in any other by Renoir. The complex framework of
curved planes formed by the umbrellas almost blocks out
the sky and the painter's eye level is the same as that of
the figures, bringing the viewer in among the crowd. The
perspective is condensed; the figures jostle together and
seem to spill from the edges of the canvas. There is a
slight dryness of brushstroke and paint application which
tends to reduce the richness of colour but provides an
interesting, densely textured composition.

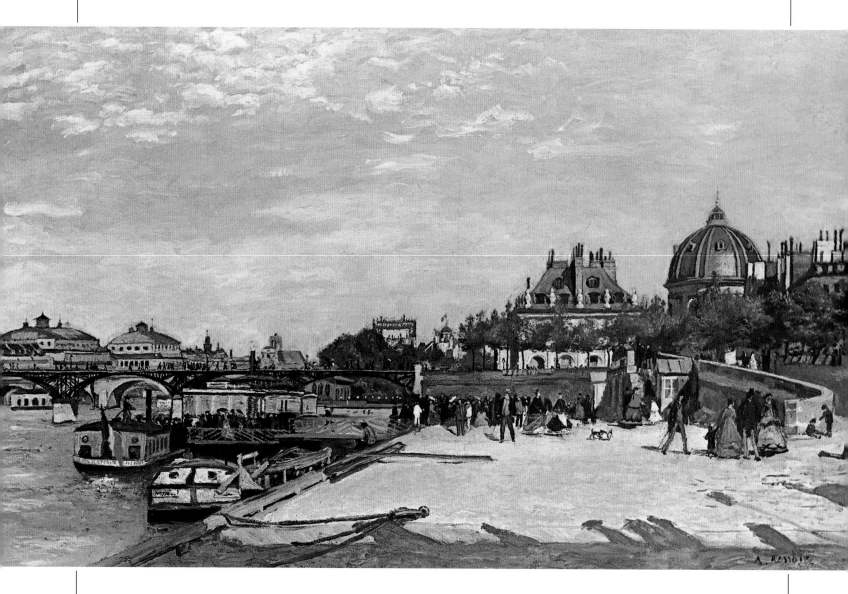

Pierre Auguste Renoir was born on 25 February 1841, in Limoges in the south-west of France. His father, Léonard Renoir, was a tailor, the son of a boot maker and a man of very modest means. In 1844 the family moved from Limoges to Paris in order to seek a better living and settled on the rue d'Argenteuil in the Carousel *quartier* in the vicinity of the Louvre. Renoir never returned to the city of his birth. He grew up in the streets of his Paris neighbourhood where he soon developed a relaxed and joyful approach to life; he made friends easily and was a spontaneous talker and joker. His attitude to life was later reflected in the bright, singing colours of his paintings. Although he had a poor childhood and in adulthood lived through much poverty before eventually enjoying material success,

one of his favourite phrases was 'There are no poor people', as if he regarded poverty of means to be no excuse for poverty of spirit.

As a child Renoir was always scribbling and drawing at school. He also showed a great talent for singing and was taught by the musician Charles Gounod, master of the chapel at the Church of St Roch in the centre of Paris, who tried to encourage him into a musical career. Unfortunately the hard material circumstances of his family forced Renoir to leave school at the age of 13 and to stop his music lessons. He began an apprenticeship as a porcelain painter with the eventual ambition of entering the famous factory at Sèvres. He soon showed an easy skill and great talent for the craft but would often escape to the Louvre to look at the paintings. There

Alfred Sisley and his wife, 1868
105 × 75 cm (41 × 29½ in)
WALLRAK RICHARTZ MUSEUM,
COLOGNE
*Even at this early stage of his career,
Renoir's figure compositions display his
talent at its most expressive and
uninhibited. This double portrait of
Sisley and his young wife is full of the
richness of colour and brushwork that
developed fully in Renoir's work of the
1870s. Renoir frequently worked closely
with Sisley during the 1860s and they
remained lifelong friends.*

**Le Pont des Arts and the Institute,
1868** (*opposite*)
61 × 100 cm (24 × 39 in)
NORTON SIMON FOUNDATION, LOS
ANGELES
*Renoir was very much influenced by his
colleagues in the 1860s, particularly by
Monet, and this untypical early work
shows how he was attempting a similar
style in composition and technique. This
type of subject matter also became
increasingly rare in Renoir's work, as he
devoted his time almost exclusively to
figure studies.*

he became enraptured with the great French pain-
ters of the eighteenth century, in particular Boucher
and Fragonard. The master of the porcelain factory
advised Renoir's parents that he was too good to be
decorating porcelain and ought to be allowed to
train properly as a painter. But when in 1858
machine-colouring supplanted hand-painting at
the factory and Renoir found himself out of work,
his parents could not afford tuition fees at an
artist's studio. Renoir had to continue to support
himself and became occupied with painting decora-
tive domestic goods, such as fans and window
shades.

Encouraged by the advice of his employer at the
porcelain factory, Renoir determined to take up a
serious study of painting. He worked vigorously at

copying and analysing the works of previous French
masters. His favourite paintings were 'Diana bath-
ing' by Boucher and 'The swing' by Fragonard; the
subjects of both these works were to reappear later
in some of Renoir's best paintings. By 1862 he had
scraped together enough money to allow him to
enter the Ecole des Beaux Arts, where he worked in
the studio of Charles Gleyre along with Claude
Monet, Frédéric Bazille and Alfred Sisley. Gleyre,
who was a very able painter and by the standards of
the time a tolerant enough master, was occasionally
strained by the independence and enthusiasm of his
pupils. On one occasion he was sarcastic about
Renoir's efforts, commenting: 'I suppose you paint
because it amuses you.' Renoir's reply was direct and
simple: 'Why else do you think I'm here if not

La Grenouillère, 1869

66 × 81 cm (26 × 32 in)

NATIONALMUSEUM, STOCKHOLM

La Grenouillère was a popular restaurant situated on a barge moored on the Seine, much frequented by the young Parisian bourgeoisie during their leisure time. Monet and Renoir both painted the scene from this particular viewpoint. The influence of Monet is again strong in this painting, especially in the colourfully flecked and broken surface of the water, an element unusual in Renoir's work.

because I enjoy it?' Enjoyment of his art was fundamental to Renoir. He loved painting more than anything else in life.

Renoir was easily led and gladly accompanied Monet, Sisley and Bazille on a painting trip to the Forest of Fontainebleau in 1864. This was suggested by Monet, who already had great enthusiasm for the practice of painting out of doors, and while Renoir was less impressed by the concept initially, he quickly became converted by the experience to Monet's point of view. Much of Renoir's work at

Claude Monet reading a newspaper, 1872

61 × 50 cm (24 × 20 in)
MUSEE MARMOTTAN, PARIS
Renoir has used blocks of light and dark colour very much in the style of Manet, with the pale tones of face, hand and newspaper opposed to the dark blues of the background, but the treatment is much more painterly. The feel of the brush hovers over the picture surface and the smoke emerging from Monet's pipe and billowing upwards lends itself fully to the loose curves of the brushstrokes on the canvas.

this time was darkly coloured but advice from the Barbizon painter Narcisse Diaz encouraged him to paint more colourfully and expansively. Diaz, who felt that Renoir would be a painter of consequence, allowed the impoverished student to buy paint and canvas on his own account, as otherwise Renoir was too poor to buy materials for himself. In order to keep himself going he would take any routine commissions that came his way, which often meant such humble tasks as decorating a cupboard or doing small caricature portraits.

In 1865 Renoir returned to the Forest of Fontainebleau in company with Sisley. At Marlotte, where they stayed, he met Pissarro and Courbet. In the Salon of that year Renoir chose to enter himself as a pupil of Courbet but later, after seeing works by Manet at the Exposition Universelle in 1867, he tried to free himself from the influence of Courbet whose heavy use of paint laid on with a palette knife did not offer the delicacy and subtlety that was to be a feature of Renoir's paintings.

Renoir spent most of 1868 in Paris and his

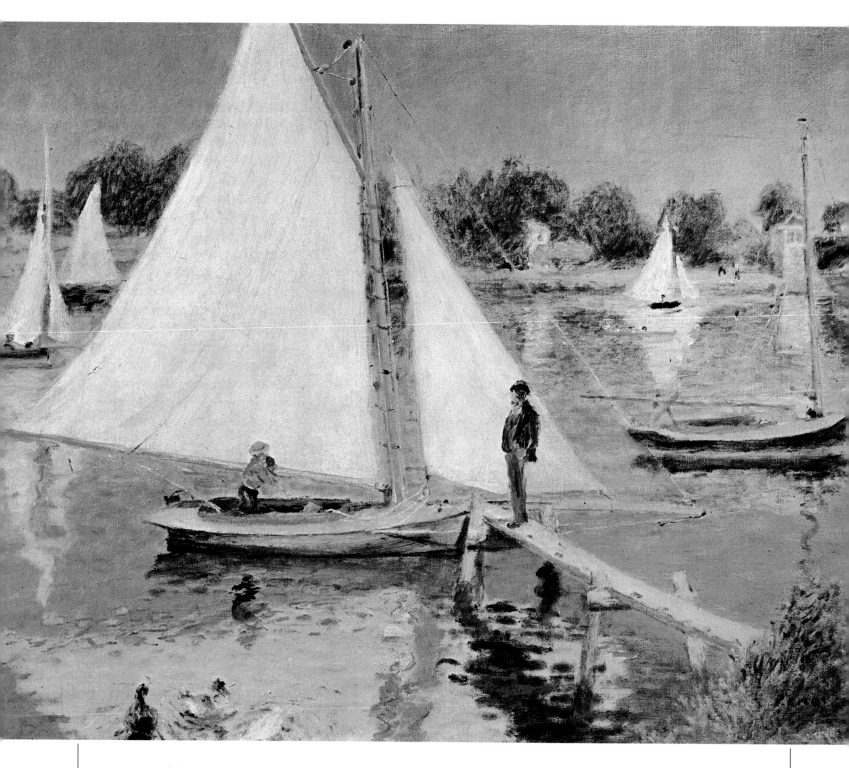

paintings of the city, for example 'Le Pont des Arts and the Institute', show the influence of Monet and the initial traces of what would come to be seen as the early style of Impressionism. During this time Renoir lived in the studio of Bazille, who as the son of a well-to-do bourgeois family was very comfortably off and frequently had to help out his less fortunate colleagues. But even this arrangement was too expensive for Renoir and he had to retire from Paris to his parents' house in Ville d'Avray. These were very difficult times and remembering them

later Renoir said, 'I would several times have given up if Monet had not reassured me with a slap on the back.' Whenever they had enough money to buy materials they would paint like men possessed, working along the banks of the Seine at Argenteuil and Chatou, and it would frequently happen that both men were painting the same subject at the same time. 'La Grenouillère' was a favourite weekend haunt for young Parisians and it provided the two painters with one of the first major subjects typical of the Impressionist movement – a view of

Madame Alphonse Daudet, 1876
47 × 37 cm (18½ × 14½ in)
LOUVRE, PARIS
*After 1876 Renoir became increasingly
popular as a portrait painter and was able to
give free rein to his interest in the human
figure. Commissioned by the writer
Alphonse Daudet, this portrait of Mme
Daudet has a softness that captures her
warmth and femininity, qualities which are
emphasized by the rich colouring and
glowing light.*

The Seine at Argenteuil, 1873
(*opposite*)
50 × 65 cm (20 × 26 in)
PORTLAND ART MUSEUM COLLECTION,
OREGON
*This picture shows Renoir in full command
of Impressionist technique. Colour and light
are the major elements of the picture,
centred around the huge expanse of white
sail and its lively, vivid reflection in the
water below. The plain white shape is
broken into a host of transitory
fragmentations of colour.*

young people relaxing by the water in sunny
weather. It was a theme to which Renoir often
returned and which also inspired Seurat.

During the Franco-Prussian war of 1870–1,
Renoir was drafted into the Cuirassiers and al-
though he did not see any action, being stationed
far south in the Pyrenees, he had little opportunity
to do any painting. He returned to Paris during the
period of the Commune and was one of the few
painters to remain in the city during the troubles.
He cared little for the political upheavals and was

chiefly concerned that he should be able to resume
his work without interruption.

After the war in 1873 the dealer Paul Durand-
Ruel began to buy Renoir's paintings and this steady
source of income enabled him to rent a studio at 35
rue St Georges. His work was refused at the Salon,
as had happened in previous years, and it was this
that chiefly caused Renoir to take an interest in the
scheme proposed by Monet and Pissarro for an
independent exhibition. In the event, Renoir
became closely involved and was not only treasurer

Madame Charpentier and her children, 1878
154 × 190 cm (61 × 75 in)
METROPOLITAN MUSEUM OF ART, NEW YORK
*The publisher Georges Charpentier first bought a
painting from Renoir at the largely unsuccessful auction
of Impressionist works at the Hôtel Drouot in 1875. He
became a valuable patron to Renoir, both directly and in
respect of his influential social position by which he was
able to promote the young artist and introduce him to
other buyers. It was partly through his influence that this
portrait was hung in the Salon of 1879, bringing Renoir
much acclaim.*

but also served on the hanging committee of the
first Impressionist exhibition in 1874. The exhi-
bition was financially a disaster and seemed to
arouse nothing but hostile criticism, but of the few
paintings that were sold several were by Renoir.
The lack of profit from the exhibition prompted
Renoir to dream up the idea of holding an auction
of paintings at the Hôtel Drouot. Monet, Sisley and
Morisot joined him in this venture, which once
again proved disastrous. But there was one particu-
lar benefit, in that the auction attracted the
attention of a modestly well-to-do customs official,

Victor Chocquet, who became a great supporter and patron of the Impressionist artists. Chocquet particularly admired the work of Renoir and commissioned a portrait of himself and his wife standing beneath a painting by Delacroix which formed part of Chocquet's collection. Renoir, who had admired Delacroix from an early age, was very flattered to receive such a commission. Renoir's preference for painting portraits and figure scenes enabled him to get by more easily than some of his fellow Impressionists, as this type of subject matter was more likely to lead to commissions than landscapes.

The luncheon of the boating party, 1881
128 × 173 cm (50 × 68 in)
PHILLIPS COLLECTION, WASHINGTON
Some of the characters in this picture are well-known members of the Impressionist circle, most notably the painter Gustave Caillebotte seated on the reversed chair and Aline Charigot, who later became Renoir's wife, posed with the dog in the left foreground of the painting.

Venice in the mist, 1881

45 × 63 cm (18 × 25 in)
PRIVATE COLLECTION
In this work the final elements of Renoir's truly Impressionist period can be seen. Unusual atmospheric conditions were always seized by the Impressionists as an opportunity to create novel pictorial images. Here the mist is set on fire by the sun bursting through, causing the rapidly sketched figures of the gondoliers to be set against a dramatic and oddly inappropriate backdrop.

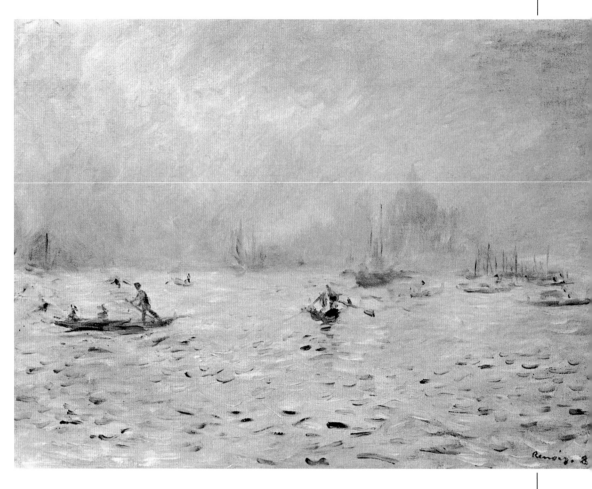

Renoir soon came to rely heavily on Chocquet for support and would write to him and other patrons, such as the publisher Georges Charpentier, begging for money. Charpentier gave him money and also important commissions for portraits of his family, the most significant of which, 'Mme Charpentier and her children', became Renoir's first genuine public success at the Salon of 1879.

Throughout the early 1870s Renoir was still working closely with Monet, along the Seine and particularly at Argentenuil, producing paintings that were very much in the typical Impressionist landscape tradition. But as Renoir became noticed in the mid 1870s, at the Impressionist exhibitions and elsewhere, he began to receive some commissions for portrait work and group scenes not only from devotees of the Impressionist movement such as Chocquet and Charpentier but also from other

sources. 'Mme Daudet' is an example of a commissioned portrait. But despite such work, Renoir was not really earning enough to support his lifestyle. He even considered resorting to exhibiting in the Salon as a way to gain a wider reputation. After the third Impressionist exhibition in 1877 he organized another auction sale but the results were as disappointing as before. He also persuaded the critic Georges Rivière to found a magazine called *L'Impressionniste* which he hoped would combat the hostile and derisive attitude of existing journals.

Renoir exhibited at the Salon in 1878 and did so again in the following year, with some considerable success. For this, he was unpopular with many of his colleagues, who felt that he had betrayed the movement, but Renoir had his reasons as he explained to Paul Durand-Ruel in 1882: 'I would like to tell these gentlemen that I am not going to

Blonde bather, 1882

90 × 63 cm (35 × 25 in)

PRIVATE COLLECTION

In the early 1880s Renoir reverted to the more traditional themes and preoccupations of seventeenth- and eighteenth-century painting. The influence of the Flemish painter Rubens can be seen in the concentration on the fleshiness of the nude figure, but the colour shows Renoir's individual approach, where the whiteness of the flesh is emphasized by the blue sea and golden hair. The figure is, however, isolated in time and place. Though this is far from an academic interpretation of the subject, she has been given the timeless quality of a classical ideal.

give up exhibiting at the Salon. This is not for pleasure, but as I told you, it will dispel the revolutionary taint which frightens me . . . it is a small weakness for which I hope to be pardoned.' Renoir was in fact a highly conservative man by inclination and became more so as regards his subject matter and style in the early 1880s.

In 1880, when he was almost 40 years of age, Renoir met a young model Aline Charigot, whom eventually he was to marry. However, at the beginning of their friendship Renoir was enjoying his energy, freedom and bohemian lifestyle too much to commit himself immediately. In 1881 he took a trip to North Africa and on his return moved swiftly to Italy, where he travelled through Florence, Naples, Rome and Venice. During this Italian trip Renoir made close study of the work of the Italian masters and it filled him with many doubts

about the validity of the Impressionist style to which hitherto he had been so attached. Also, as Aline was living on his money in Paris, financial success was becoming an imperative. Renoir then travelled south to Palermo in Sicily, where he painted a portrait of the composer Richard Wagner, who agreed to only one sitting of 25 minutes. On his way back, Renoir stayed with Cézanne at L'Estaque in southern France and worked there until he contracted pneumonia. On the orders of a doctor he returned to Algiers for a few months to regain his strength and was then able to go back to Paris where Aline had been waiting for him.

The seventh Impressionist exhibition took place in 1882, but Renoir refused to exhibit with Gauguin and Pissarro, whom he felt were becoming too unorthodox in their aims. Gauguin had complained of the conservatism of the work to be included in

the exhibition, and Renoir was unsympathetic to Pissarro's range of political and artistic interests. 'The public does not like that which smacks of politics and at my age I do not wish to become a revolutionary', Renoir wrote to Durand-Ruel.

Renoir now began to develop a more refined and somewhat more traditional style. He concentrated on the human form, producing such works as 'Dancing in the country' and 'Dancing in the city', and perhaps his most famous work of all, 'The umbrellas'. This helped his reputation with the buying public and also with Durand-Ruel, who gave him a one-man show in Paris. These new developments in Renoir's work showed his admiration for Ingres and the masters of the eighteenth century. Landscapes appear rarely among his paintings of this period and his concentration on the human figure was often in the form of many different studies of nudes preparatory to his great painting of 1887, 'Bathers', a final statement by Renoir that he had moved away from the Impressionism of the 1870s. He turned his back on the reliance upon nature which had characterized much of his earlier work and which continued to be of supreme importance to Monet, Sisley and Pissarro. He did not, however, neglect natural models entirely but adopted a somewhat ambivalent attitude: 'How hard it is to find exactly the point at which imitation of nature must cease in a picture. The painting must not be too close to the model and yet we must be conscious of nature.' But later in life he made a remark that seems to confirm the essential conservatism of his

Dancing in the country, 1883 (*this page*)
180 × 90 cm (71 × 35 in)
PRIVATE COLLECTION
Dancing in the city, 1883 (*opposite*)
180 × 90 cm (71 × 35 in)
PRIVATE COLLECTION
This pair of paintings was commissioned from Renoir by the dealer Paul Durand-Ruel. In accordance with his renewed interest in traditional painting methods, Renoir made a number of preparatory sketches. His grounding in Impressionism is apparent, nevertheless, in the free use of colour and light.

approach: 'I discovered about 1883 that the only worthwhile thing for a painter is to study in the museums.' From an old man who had been involved in one of the most important artistic and aesthetic revolutions, this remark somehow seems not to ring true, but Renoir did take very seriously his study of the old masters, particularly those of the eighteenth century, and it may well be that he felt that he had learnt more of value from them than he had by studying nature and working in the open air with his young friends.

In 1885 Aline bore a son Pierre. Renoir worked again with Cézanne and also at Essoyes, south-east of Paris, Aline's home town. The final Impressionist exhibition was held in 1886, but Renoir once more refused to take part in spite of the entreaties of Pissarro and Seurat. Instead he chose to exhibit with a new dealer, Georges Petit, who was staging an 'International Exhibition' in his gallery. At the same time Durand-Ruel exhibited over 300 Impressionist paintings in a show in New York, 32 of which were by Renoir, and they were generally well received, although described in a review in the *New York Sun* as 'lumpy and obnoxious creations'.

In the following years Renoir continued to work on the human figure as his main subject. He did not restrict himself to nudes but took pleasure in depicting women in their many roles, as beautiful and sensuous girls, as mothers and providers. For example, 'Woman feeding her baby' (see page 182), shows Renoir turning to the same sort of themes as Pissarro in some of his pictures of peasant women.

"Around 1883 a sort of break occurred in my work. I had gone to the end of Impressionism and I was reaching the conclusion that I did not know how either to paint or draw. In a word I was at a dead end."

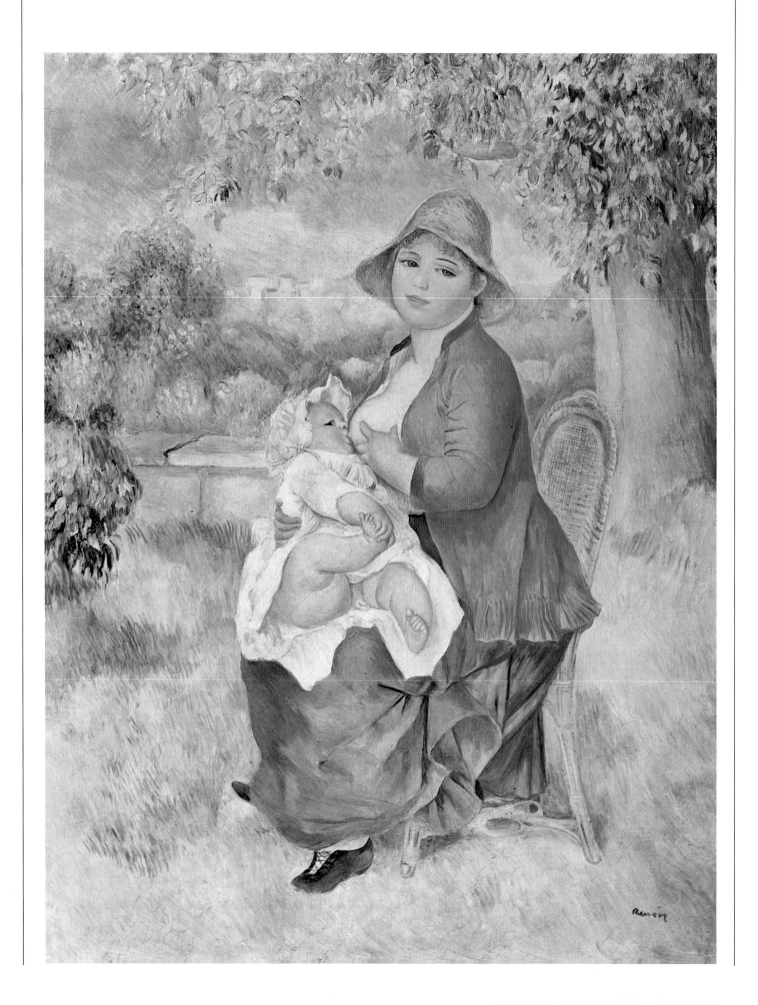

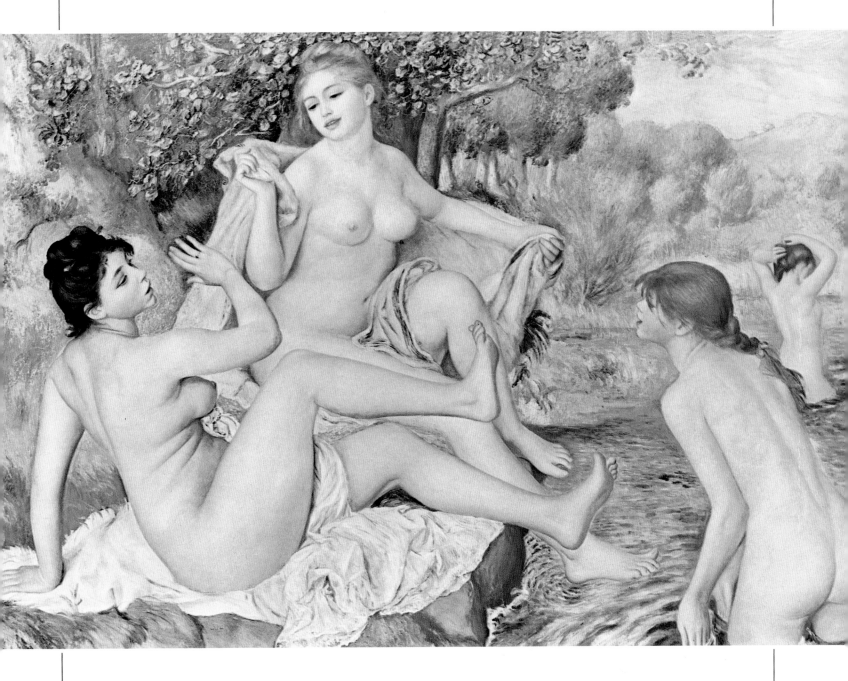

Woman feeding her child, 1885 *(left)*

26 × 19 cm (10 × 7½ in)

PRIVATE COLLECTION

The theme of mother and child which was so well-treated by the female Impressionists Mary Cassatt and Berthe Morisot is here stiff and rigid. Renoir worked hard to build up the right image by means of preparatory drawings and sketches, but in doing so has lost the freshness of the idea. The background seems detached from the figures and it does not have the natural atmosphere of earlier Impressionist works.

Bathers, 1887

115 × 170 cm (45 × 67 in)

PHILADELPHIA MUSEUM OF ART

Although the background is full of colour and painted with Renoir's typically broad brushstrokes, the central figures show an attempt at classical composition. The models were posed artificially in the studio, the background being added from memory and not from immediate observation. During this period of his work, Renoir seemed to fall into a disappointing compromise, unable either to abandon the influence of Impressionism or to submit to the full discipline of traditional painting.

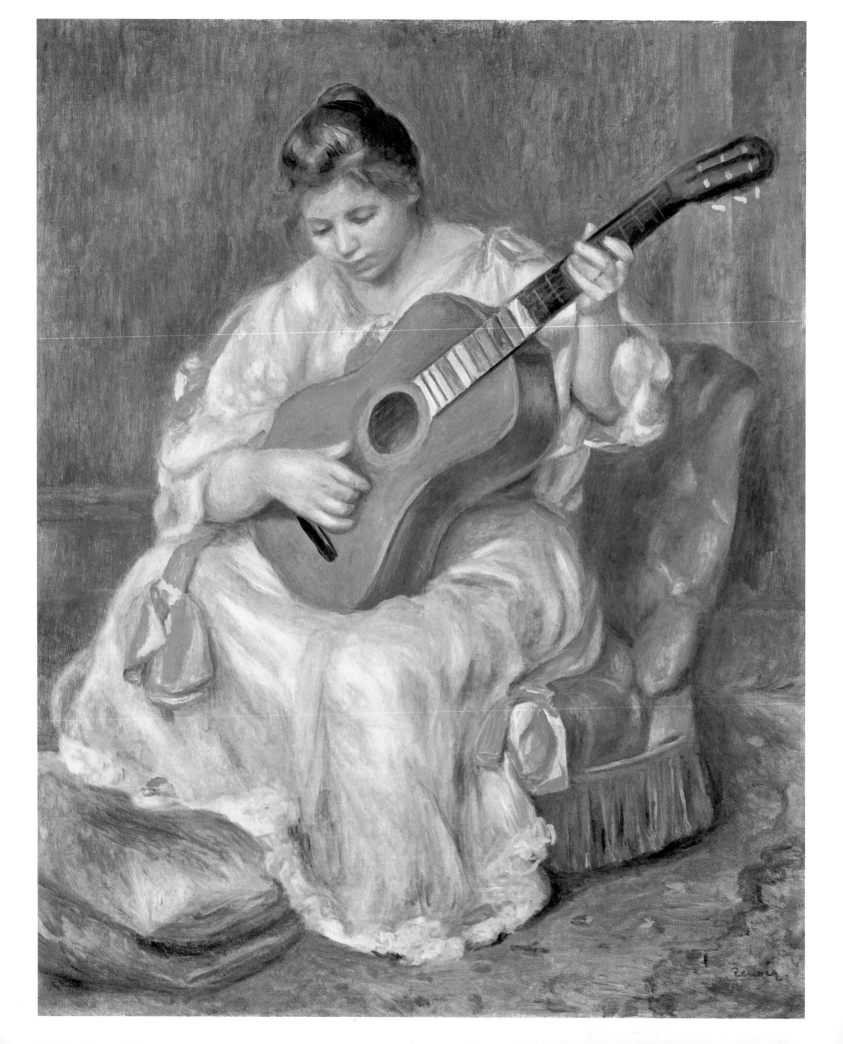

"I have a horror of the word 'flesh' which has become so shop-worn. Why not 'meat' while they are about it? What I like is skin, a young girl's skin that is pink and shows that she has good circulation."

In 1888 Renoir suffered a case of temporary facial paralysis, an affliction that was to trouble him in the last years of his life. Although he moved away from the other painters in terms of the manner of his painting, he never lost their friendship and was able to work with them and live among them. In 1889 he joined with Monet in a campaign to buy Manet's famous painting 'Olympia' to be presented to the Louvre, a project which was eventually achieved.

Renoir eventually married Aline on 4 April 1890 and Jean Renoir, a second son, was born in 1894 and lived to become a famous film director. In 1892, after a large retrospective exhibition of over a hundred works which was a great success, Renoir felt confident enough to write to Durand-Ruel, 'I think I have deserved a bit of success because I have worked so hard.' In fact the exhibition was a major turning point in his career and for the rest of his life he was successful with few financial difficulties.

In 1893 his wife's niece, Gabrielle, came to live with the family and became the most frequent of Renoir's models during the later years of his life. She was probably the model for 'Young girl with a Guitar' among many other compositions. In 1894 on the death of Gustave Caillebotte, Renoir was appointed executor of his will which necessitated persuading the government to accept the Caillebotte bequest of his whole collection of Impressionist paintings. These were not finally hung until 1897, in the Luxembourg palace.

In the mid 1890s Renoir became seriously afflicted with arthritis and had to walk with the support of two canes. Over the next few years he visited various spas and watering places in Europe in a vain attempt to find a cure for this affliction. Renoir was by this time a painter very much in demand: many dealers were clamouring for his work and would often be sold works which were little more than preparatory sketches or amusing compositions of his children. Museums and exhibitions in Europe and America were beginning to acquire and exhibit his paintings. The Secession Group in Vienna showed several works in 1903 and in St Louis in the United States, he was one of the most popular artists in the Universal Exhibition.

After 1900 Renoir's health began to deteriorate further. The bronchial trouble from which he had suffered since 1882 worsened. In 1908 he suffered from a severe hernia and in 1912 a stroke deprived him temporarily of the use of his arms and legs. In fact he was never able to regain properly the use of his legs and had to be driven in a wheelchair or carried in a sedan chair. At the beginning of the new century Renoir had bought a house at Cagnes, near Cannes in the south of France and gradually as he grew more infirm he spent more of his time there. He would be carried to wherever he wanted to paint and then Coco, his youngest son born in 1901, or his niece Gabrielle would prepare the palette for him and then insert the brush into his hands which by now were crumpled with arthritis. Renoir claimed to be very happy during the last years of his life because now he had nothing to do but to paint, which he still enjoyed more than anything else.

Young woman playing the guitar,
MUSEE DES BEAUX ARTS, LYONS
In this painting Renoir has finally broken away from his experiment with structural and plastic formalities and once more his brush runs free with fluidity and suppleness. The figure acquires a density and depth of form which places her most convincingly in her surroundings.

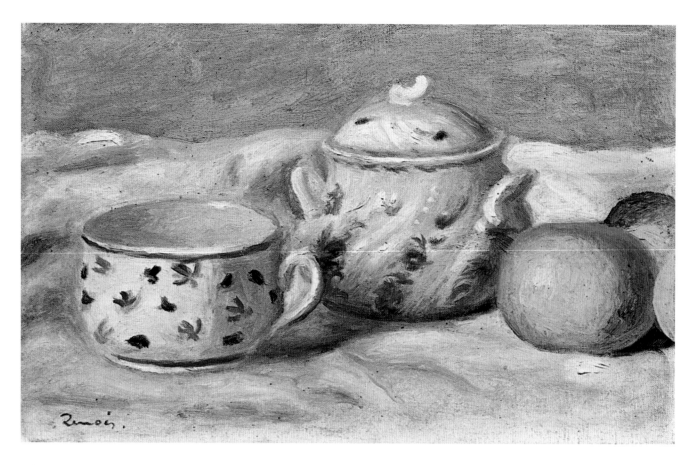

Still life, 1904

21 × 32 cm (8 × 12½ in)

PRIVATE COLLECTION

Towards the end of his career Renoir concentrated on smaller and more intimate compositions in contrast to the large-scale works of the 1880s. In this less ambitious work Renoir is nevertheless able to display his sensitivity to the minute nuances of colour in the simplest of objects. Subtle tints enliven the white areas and the blue shadows form a bold contrast to the orange fruit.

Renoir died on 3 December 1919 in his house at Cagnes. He had been a great craftsman, something of which he was particularly proud. 'Painting is no dreaminess; it is first of all a handicraft and it should be done as the work of a good craftsman.' But he is remembered also as one of the great colourists of the nineteenth century. In 1919, shortly before his death, he was invited to witness the hanging of his portrait of Mme Charpentier at the Louvre, where he was treated with great respect. Afterwards he commented: 'If I had been presented at the Louvre thirty years ago in a wheelchair I would have been swiftly shown the door. One has to live a long time to witness such changes. I have had that chance.' It is the key to Renoir's appeal that a willingness to make changes caused him to marry together his Impressionist experiences and his great love of earlier, more traditional styles. It is a tribute to his personality, too, that in rejecting Impressionism to that extent, he nevertheless retained the affection and respect of his colleagues and from his early struggles contrived to create a peaceful, successful and satisfying life.

SEURAT

Georges Seurat was of the second
generation of Impressionists, associated
with the original group and championed
by Pissarro. In his brief career he
nevertheless quickly developed a
technique of painting which represented a
strict analytical revolt against the more
expressive qualities of Impressionism.
Seurat sought to translate the sensations
of colour and light by a rigorous, almost
scientific discipline, however, the impact
of this new departure failed to gather its
full momentum owing to his death at the
age of only 32. Pissarro, despite his early
enthusiasm, found Seurat's divisionist
technique inimical and eventually
limiting, and it is difficult to tell what its
development might have been had its most
dedicated exponent survived to have a
living influence on a third generation of
painters.

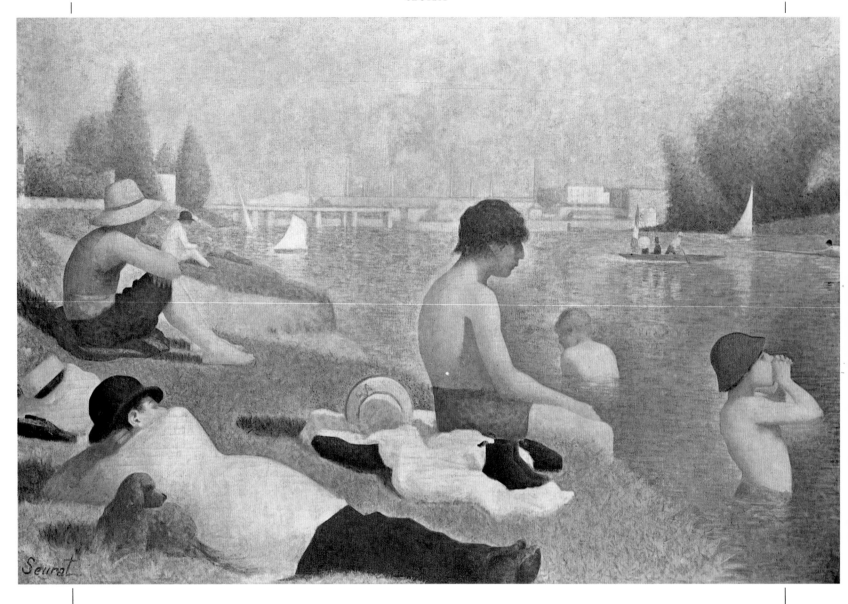

Bathers at Asnières, 1883–4

200 × 301 cm (79 × 118½ in)

NATIONAL GALLERY, LONDON

This was the first of Seurat's large compositions which were to make him such a figurehead of the movement away from Impressionism. It is painted with short and deliberate strokes, with blocks of light and form calculatedly spread across the canvas. The studied indifference of the central figure seems to underline Seurat's attempt to concentrate on form above content as the strength of the picture. A great deal of preparation went into planning the composition, with many outdoor sketches and studies of models in the studio finally put together on the large canvas. In this first of his major works Seurat had not yet developed the full theory of divisionism, but the painting was partially reworked in 1887, when divisionist passages were introduced.

Seurat was born on 2 December 1859 in Paris, the third of the four children of Antoine Seurat and Ernestine Faivre. His father was a stockbroker and investor who himself owned a large amount of stock, so Seurat was able to enjoy the benefits of a wealthy family and never had to worry about financial matters. His education was unremarkable, given the privileged class into which he was born, but at an early age he showed a precocious interest in the arts. His uncle, Paul Faivre, would take him to the Louvre and also to the smaller galleries which sometimes showed the works of the new radical painters, the so-called Impressionists. At 15 Seurat was allowed to go to special evening classes in drawing, where he made a great friend in the fellow painter Edmond Aman-Jean. In 1876 he started work at the Ecole des Beaux Arts where he studied in the classes of Henri Lehmann, a celebrated

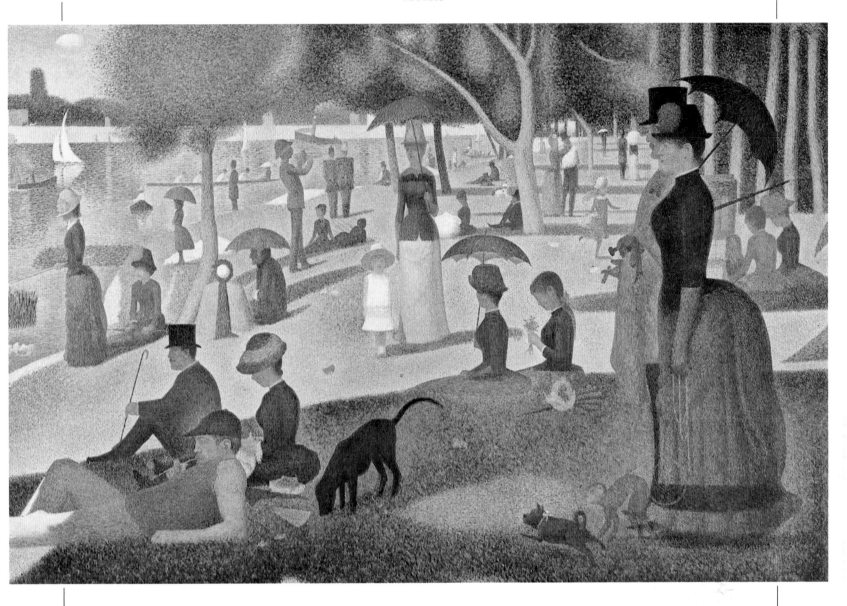

classical painter in the manner of Ingres, who insisted on great attention to line and drawing rather than colour. Seurat was only a mediocre pupil who in the opinion of Lehmann showed no great promise.

In 1879 Seurat rented his first studio in Paris and in the same year visited the fourth Impressionist exhibition, which made a considerable impact on him. In the spring of 1881, after completing his military service, Seurat spent a lot of time travelling with his friend Aman-Jean, visiting the places along the Seine and in Normandy where the Impressionists had been painting for many years. Seurat was also deeply influenced by the work of Delacroix, who as a romantic painter had been the very opposite of Seurat's master Lehmann. He read Delacroix's journals and wrote lengthily on his ideas of colour and form.

The official Salon still dominated as the testing

Sunday afternoon on the Ile de la Grande Jatte, 1884–6

206 × 306 cm (81 × 120 in)

ART INSTITUTE OF CHICAGO

This, Seurat's monumental divisionist work, incorporated his new discoveries about contrasting and complementary colours, the technique of painting with tiny dots emphasizing that light contains a vibrant mixture of pure colours. The moment is frozen: the figures are statuesque. Seurat chose his subject not for its emotional or social import but simply as the starting point for an ambitious exercise in painting, where light, shape and colour are given their supreme pictorial importance. Every detail was observed and recorded over a long period of time and given a place in the composition. Initially Seurat produced a detailed study at one-third the size of this, the final version.

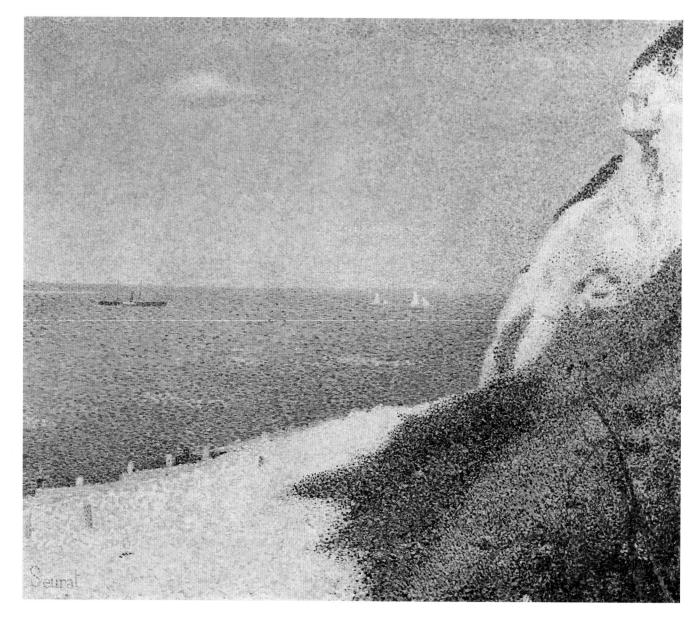

ground for a young artist and Seurat sought acceptance for his paintings of Parisians at leisure, but was refused. In 1883 he devised the first of his great canvases on this theme of leisure; he worked on 'Bathers at Asnières' for almost a year, making many preparatory drawings and sketches. It was ready for submission to the Salon of 1884, but again Seurat met with rejection. This refusal of so large and important a work prompted Seurat and several other colleagues to form the Société des Artistes Indépendants, which was very much based on the earlier plans of the older Impressionists to group together for independent exhibitions. In this way, ten years after the first Impressionist exhibition, Seurat and his colleagues set up the Salon des Indépendants, an alternative to the official Salon in which an artist's work was admitted on payment of an entry fee; there was no jury selection.

Undaunted by the refusal of 'Bathers at Asnières', he began to plan the painting which now tends to be seen as his master work: the great canvas called 'Sunday afternoon on the Ile de la Grande Jatte'. This work was begun in 1884. The summer of 1885 was spent on the Channel coast where Seurat painted many marine views and developed more fully his theories of divisionism, which led to the reworking of the 'Grande Jatte' in a markedly more formalized manner. The term divisionism refers to the division of colours into pure pigments; a technique of painting in which small touches of pure hues are gradually built up together on canvas to create an effect known as optical mixing, in which the dots of colour appear to merge into secondary hues and tones. This method, which is also called pointillism, required a gradual and lengthy approach to a painting, rather than the

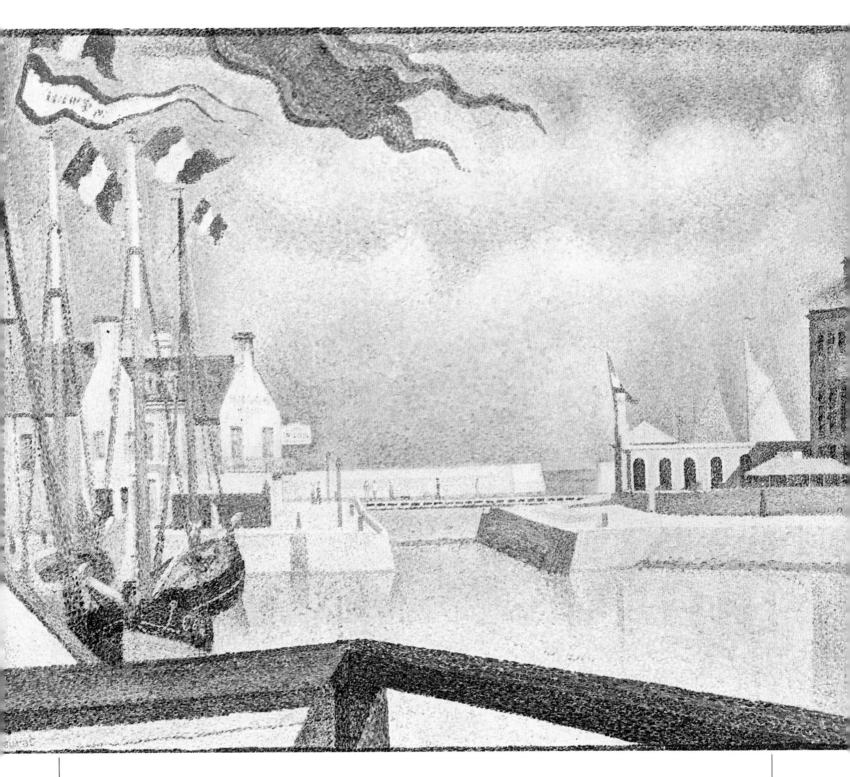

The beach at Bas-Butin, 1886 (*opposite*)
67 × 78 cm (26 × 31 in)
MUSEE DES BEAUX ARTS, TOURNAI
A shimmering hazy atmosphere has been created by the use of densely applied dots. Painting the sort of subject made acceptable by the Impressionists, Seurat's technique presents a timeless scene rather than the fleeting moment of Impressionism, when even the boats at sea seem frozen in a permanent picture.

Sunday in Port-en-Bessin, 1886
66 × 82 cm (26 × 32 in)
RIJKSMUSEUM KRÖLLER-MÜLLER, OTTERLO
Seurat's concentration on form and not content gives his work an air of artificiality which is necessarily more marked in the landscapes than in the indoor scenes. This work, although a beautiful symphony of shape and colour, has none of the freshness or vitality of an impressionistic treatment of the same subject.

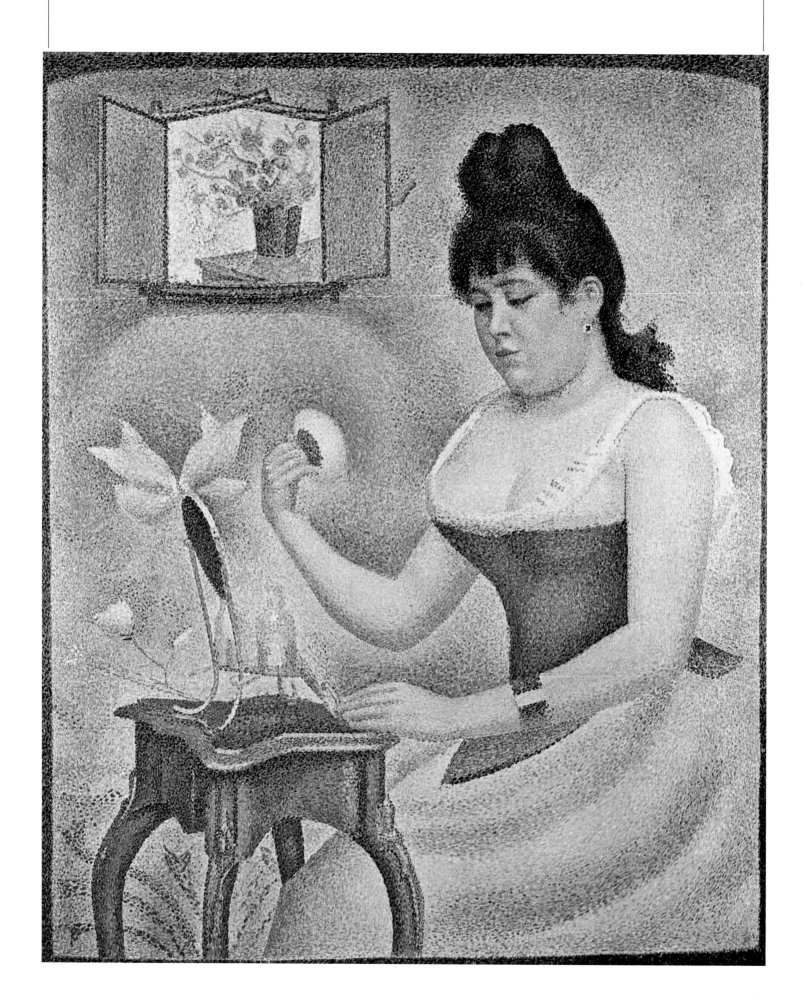

rapid execution appropriate to Impressionism. In the many preparatory drawings and colour sketches which Seurat made for his major works he was following the long-established principles of studio composition, but applying them to a completely revolutionary style of pictorial arrangement. His great obsession was to infuse his paintings with as much light as possible; this factor was indeed a direct legacy of Impressionism, but Seurat was trying to organize and predict precisely the effects of his use of colour.

The critic Félix Fénéon met Seurat in 1885 and took up the cause of the new art form, in the following year naming it as Neo-Impressionism in a review written for the Brussels art journal *L'Art Moderne*. To the painters and critics of the avant-garde, Seurat seemed to offer a sense of continuity and direct development from Impressionism. He was invited to exhibit in Brussels and divisionism gained a foothold in Belgian art. After another summer spent at Honfleur and other locations on the Channel coast, Seurat's work in the Salon des Indépendants of 1886 was a great success. In the same year Seurat took his ideas a stage further by actually painting the frames of his pictures in the divisionist manner, in order to give them a complete unity and harmony. As a result of his popularity and the high regard in which he was held, his influence penetrated to painters older and more experienced than himself. Even Camille Pissarro, one of the leading and most committed of the Impressionist painters, took up Seurat's style for a while.

Seurat's life became increasingly busy, divided between painting and exhibiting his work. He kept the habit of travelling to the coast during the summer and spending winters in Paris. In the late 1880s he began work on two canvases which again expanded the range of his subject matter, 'The models' and 'The can-can', the one an austerely formal figure composition, the other a wild and exotic eruption of colourful characters.

In 1889 he began to live with a young model by the name of Madeleine Knobloch. This liaison was kept secret for fear of family disapproval. When Madeleine became pregnant and bore a son, christened Pierre Georges, Seurat became even more secretive and withdrawn, living virtually as a recluse and emerging only to take part in exhibitions. The birth of the child was kept even from Seurat's mother, who would have been deeply shocked that her brilliant, rich and handsome son had fallen for the charms of a lowly model. Seurat was considered the *beau idéal* of his generation. His old friend Aman-Jean said of him, 'He resembled the St George of Donatello. . . . He was beautiful'; and the sculptor Carabin described Seurat as 'an apostle with the head of Christ'.

Early in 1891, Madeleine was again pregnant but before the birth of the second child, a completely unexpected tragedy occurred. On Palm Sunday Seurat felt in the peak of health and was preparing work for exhibition, but by Maundy Thursday he had fallen very ill. In desperation he arrived at his mother's house with the pregnant Madeleine and the infant Pierre Georges. By the morning of Easter Sunday Seurat was dead of diphtheria.

Towards the end of his life Seurat had been angered by press reports which he felt gave him insufficient credit for developing the theory of divisionism. In a curious correspondence channelled through Fénéon, he argued with Signac about the role that each had played; he perhaps never acknowledged adequately the extent of Signac's contribution, but it is undoubtedly true that Seurat had developed the original theories himself. Seurat was not greatly given to definitive statements about his art. In one sense, the paintings themselves are his manifesto, but in 1890 he wrote: 'The purity of the element of the spectrum is the keystone of

Young woman powdering herself, 1889–90
95 × 79 cm (37 × 31 in)
COURTAULD INSTITUTE, LONDON
This late work displays the fully controlled effect of divisionism. It reflects a strong sense of linearity which is

due to the carefully defined contours of each element, rather than to the actual use of line. The model is Seurat's common-law wife Madeleine Knobloch, whose existence was carefully concealed from his family and friends. Hence there is no hint of intimacy in the picture.

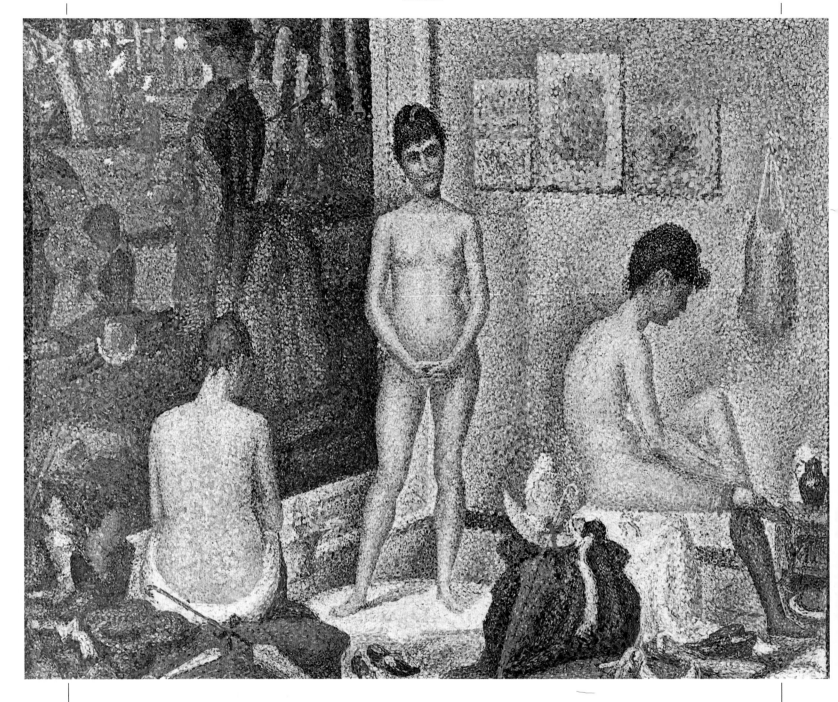

The models, 1888
39 × 48 cm (15 × 19 in)
PRIVATE COLLECTION
This, the smaller of two versions of the same
composition, shows a looser style of painting often seen
in Seurat's preparatory studies. The dots of colour are
enlarged, giving a more fluid and less clear image. This
technique, combined with the informal poses of the two
seated models, partly belies the very tightly constructed
order of the composition, and the carefully chosen detail
in the clutter of studio props against the background of
Seurat's masterwork. The figures are reminiscent of
classical French painting.

technique. Since I first held a brush, I had been
looking, with this basis in mind, for a formula of
optical painting.' But in addition to this declaration
of the fixedness of his aim, he also said, 'One cannot
develop a school without offering many great
works.' Sadly, the brevity of his life denied him the
chance to fulfil this criterion, yet the early maturity
of his work established divisionism as a deliberate
and unique contribution to the vocabulary of the
visual arts and despite its disciplinary character, it is
as personal in its expression of post-Impressionist
possibilities as is the flamboyance of van Gogh's
brushwork or the South Seas vision of Gauguin.

SIGNAC

Paul Signac was among the generation of painters following in the wake of the Impressionist movement. At the time of his birth, Manet had already shocked the Paris art world with his controversial paintings and Monet, Renoir and Sisley were art students learning to trust their own instincts rather than the academic dogmatism of their teachers. With Seurat, Signac helped to develop the analytical colour theory of Neo-Impressionism, but outliving his young colleague by many years, Signac witnessed the many more radical changes brought to painting by French artists of the early twentieth century. By the end of his life Signac had become a survivor from a completely different age.

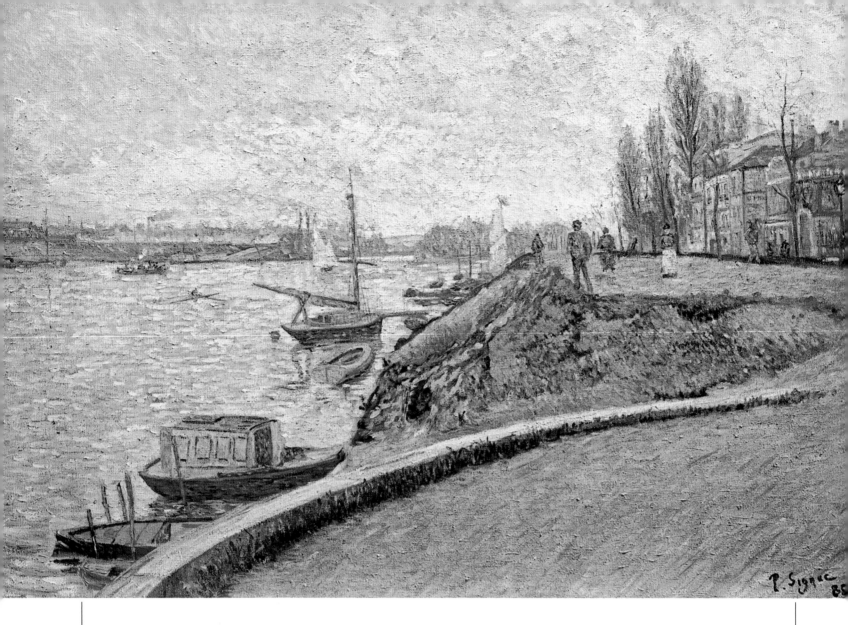

The Seine at Asnières, 1885
73 × 100 cm (29 × 39 in)
PRIVATE COLLECTION
Even though Signac became a leading figure of one of the major movements of post-Impressionism, it was from the original Impressionists that he learned to paint. The subject and technique of this painting are in the direct tradition of Impressionism.

The hatmaker, 1885 *(right)*
100 × 81 cm (39 × 32 in)
PRIVATE COLLECTION
Although painted in the same year as 'The Seine at Asnières', this is evidence of a radical change in Signac's work. He has departed from the fresh technique of Impressionism into a more ordered and stylized form of composition.

Born in Paris on 11 November 1863, Paul Signac was the only son of Jules Signac and Héloïse Dandon. His father was an affluent saddle- and harness-maker and though of the artisan class he was able to put his son through a good secondary education and encouraged his talent for drawing, a pursuit of which he himself had always been fond. As a young man Signac was much taken with the works of the Impressionist painters, as yet still unpopular with the public at large. At the 1879 Impressionist exhibition, Signac, aged 15, went along to view and also tried to copy some of the works, in the manner of many young artists in the past learning their skills from the paintings of the old masters. He was evicted by Gauguin who was angered by such a retrogressive approach and told Signac rudely, 'We don't copy here, mister.'

In 1880 Signac's father died and his mother moved to Asnières, on the Seine just outside Paris.

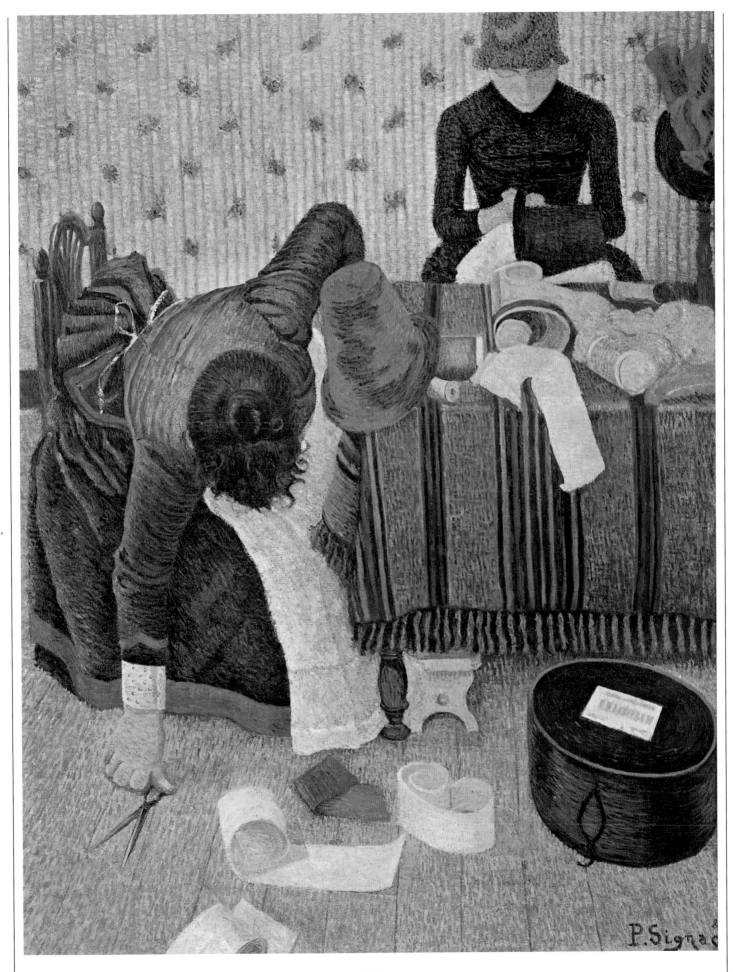

This had been a location where the Impressionists had been painting for many years and Signac was often to return to the subject matter of this riverside area. Signac began his artistic apprenticeship with the classical teacher Bin, a former winner of the academic Prix de Rome. But he did not stay long; he valued his independence and resented the authority of his teachers. His earliest paintings, attempts to imitate the Impressionist style of Monet, date from a period at Port-en-Bessin on the Normandy coast in 1882. For several years he painted in the manner of the artists of the independent movement – Monet, Pissarro and Sisley – as he was full of admiration for their work. He had no financial worries, being well provided for by his father, and was able to paint as he wanted without caring for sales or public approval; a fortunate position enjoyed by few of the leading Impressionists. Studying hard to improve his technique and moving among fellow painters, he met the painter and patron Gustave Caillebotte, who taught Signac how to sail and passed on to the young artist a passion which was never to desert him. Signac was never far removed from boating places on the sea or on the river. He won many regattas and owned some 30 boats during the course of his life. His work reflected this passionate interest and many years later a young pupil, Lucie Cousturier, was to say; 'Signac's art was born from the water and water identified his genius.'

Signac had literary as well as artistic ambitions. He moved among artists and writers in café circles

The lighthouse at Portrieux, 1888

45 × 64 cm (18 × 25 in)
RIJKSMUSEUM KRÖLLER-MÜLLER, OTTERLO
This highly static rendering of a coastal view, in which the wind does not blow and the sea does not ripple, is in direct contrast to Impressionist works on similar subjects.

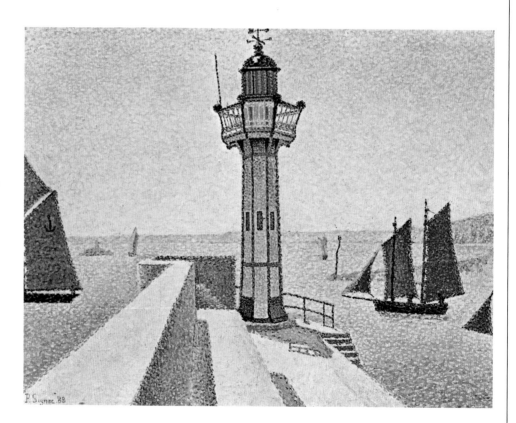

The Côte d'Azur, 1889
66 × 87 cm (26 × 34 in)
GEMEENTEMUSEUM, THE HAGUE
The analytical quality of divisionism, although destroying the transient immediacy of the painter's observation, could nevertheless convey a powerful evocation of mood. In this work the colours create a strong sense of the intense and stifling heat of midday.

and wrote cabarets for the Chat Noir nightclub. Later in life he published his *Aide-Memoire Stendhal-Beyle*, a serious work dealing with an author he loved and admired intensely. In 1884, at the exhibition of the Société des Artistes Indépendants, Signac first met Georges Seurat. This was a highly important meeting of two fertile minds. By 1886 Signac had ceased to be an Impressionist and had moved with Seurat into the camp of the Neo-Impressionists; he enthusiastically developed the technique of divisionism in his own work, the use of many individual spots of pure colour to create harmony of shape and form, and was keen to discuss and contribute to a formalized theory of the application of colour. Seurat was the dominant and more confident artist of the two, but Signac's allegiance

to and promotion of the new manner of painting was an important aspect of its spreading influence.

The eighth and final Impressionist exhibition, at which Signac showed two paintings, was held in 1886. Though only 22, he was very much respected by his fellow painters, even those who were considerably older and more experienced. He was able to paint in an unhurried and carefree manner, showing increasing interest in the scientific techniques of his art. He was closely involved with the works of Charles Henry, a theoretician who was attempting to formulate a precise definition of colour values in terms of their ability to produce particular psychological effects.

The great influence of Seurat was lost with his early death in 1891. In 1892 Signac built himself a

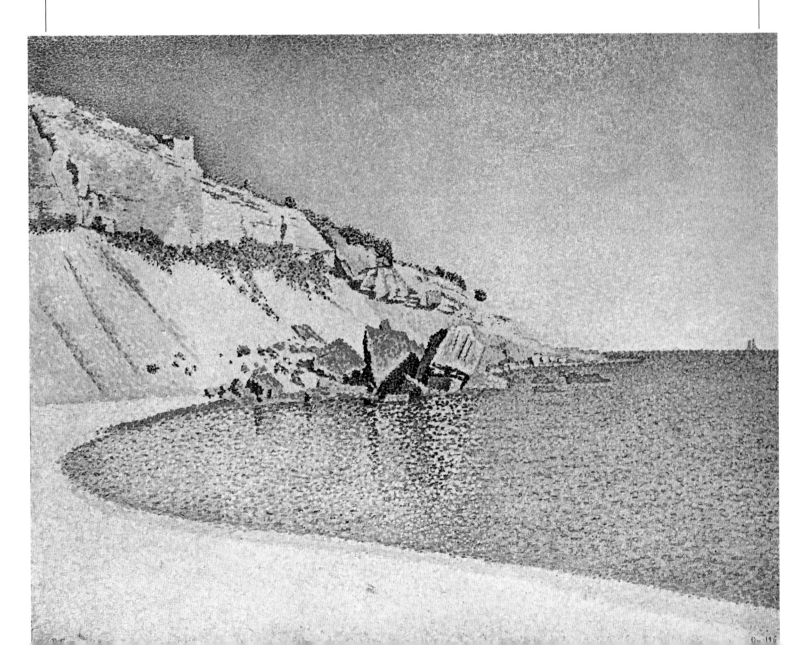

Saint Tropez, customs officers' footpath, 1905
73 × 92 cm (29 × 36 in)
MUSEUM OF PAINTING AND SCULPTURE, GRENOBLE
After about 1900 Signac adopted a broader form of divisionism, expanding the brushstrokes into small squares resembling the tessellated surface of a mosaic. In this painting he applies the technique to a non-naturalistic scheme of colour using vibrant, heavy tones.

house at La Hine near St Tropez, a town which he was to paint frequently over the years, and on 7 November of that year he was married to Berthe Robbes. He continued to paint freely but also devoted much time to socialist and anarchist politics, contributing articles and illustrations to magazines. But despite his interest in revolutionary activities, by the age of 30 Signac had become a well-balanced, comfortable man of means. He travelled across Europe, painting as he went – views of Venice, Constantinople, the Low Countries and Brittany. He was always busy with some political scheme or other but contrived at the same time to lead an active social life despite his association with left-wing politics.

After 1894 he began to exhibit at the Galerie des Néo-Impressionnistes which had been set up by Antoine de la Rochefoucauld. His paintings, still adhering to the Neo-Impressionist style, included landscapes, seascapes and some charmingly intimate studies of women and interior scenes, for example 'Woman doing her hair'. Signac's paintings always sold well though he never really needed the money. Towards the end of the 1890s he began to move away from the tiny pinprick manner of divisionist brushwork towards applying colour in large rectangular blocks, resembling mosaic in their overall appearance.

By 1914 he had changed again, abandoning oil painting to a large extent and preferring instead the more fluid medium of watercolour. 'Painting in oil is a severe struggle; watercolour is a light-hearted game,' he said in 1918. Some of his late watercolours show a fleeting and momentary style of expression that harks back to the days of Jongkind and Boudin, in almost direct contrast to the severely analytical works of Neo-Impressionism. In 1927, never quite forsaking his literary bent, Signac

published a study of the life of Jongkind.

Towards the end of his life Signac was seen rather as a hangover from a previous artistic generation, an elder statesman of French art but no longer producing work of great relevance. He lived long enough to witness a large retrospective exhibition in his honour, held in 1934 at the Petit-Palais in Paris, but perhaps more pertinent at the time was the exhibition 'Seurat and his friends: the development from Impressionism', an indication of the historical place of the movement in which Signac had so vitally participated. By the summer of 1935 Signac was very ill; at the age of 72, it seemed as if he had lived beyond his time. He died on 15 August 1935 after a full and productive life.

Signac was an egotistical but very able man, a curious contradiction between a bourgeois and a radical. In 1914 he had stood aloof from the conflict of World War I refusing to fight because he believed in the importance of the individual. He was a man of great sensitivity and generosity; he often looked after the children of his friends and helped to pay for their education. He was also an original and provocative critic of both art and literature. His great paintings of the sea, infused with a sense of playfulness of light on water prompted the critic Félix Fénéon to say: 'Of this chromatic opulence which appears in the canvases of Paul Signac, decorating bold and rhythmic compositions, it is perhaps reasonable to say that he is one of our heroes in the field of painting, a Poussin, a Lorraine.'

Perhaps living so long beyond the impetus of that early, inventive period did damage to Signac's reputation. Unlike Seurat, he does not have that tantalizing aura of the unfulfilled genius, but his life's work is a testament to the immense fertility of the later years of the nineteenth century.

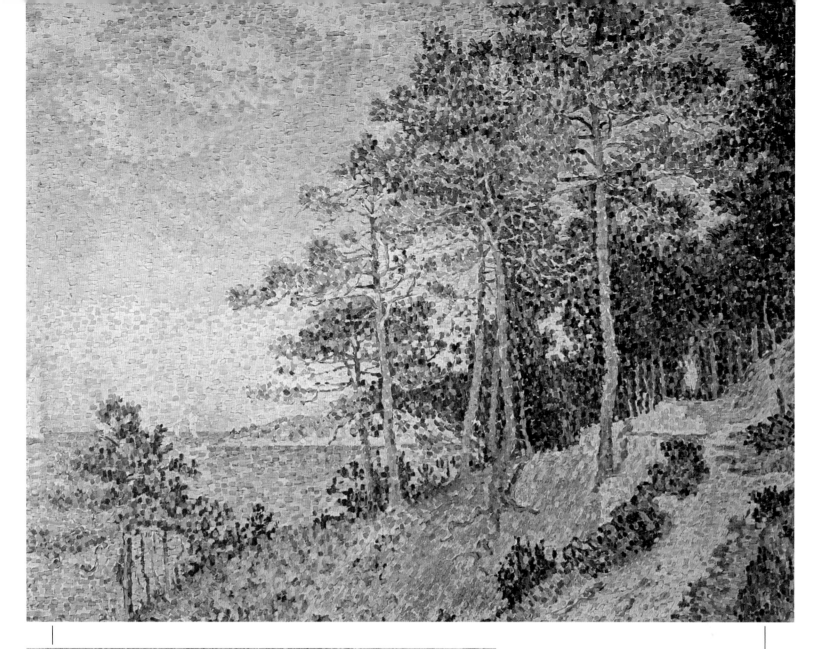

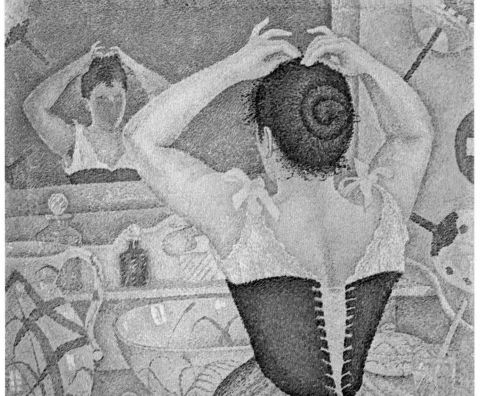

Woman doing her hair, 1892
70 × 59 cm (27½ × 23 in)
PRIVATE COLLECTION
In his interior scenes Signac tended to conform to the favoured post-Impressionist technique of flattening the perspective, so that although there is a mirror reflection here, it does not add to the sense of depth. The picture has the feeling of graphic work patterned across a page and is an interesting contrast to Seurat's similar composition 'Young woman powdering herself' (see page 192).

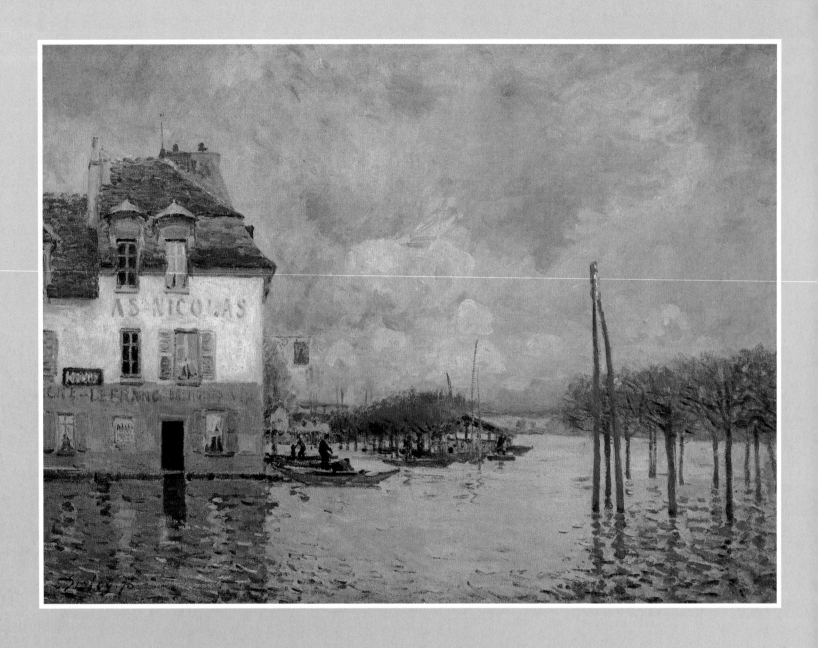

SISLEY

Alfred Sisley could perhaps be called the archetypal Impressionist. Like Monet, he remained true to the spirit of the original movement, but whereas Monet constantly pushed at the boundaries of his painting and lived to experience new styles of art emerging around him in the twentieth century, Sisley continued to paint as he had in the early days of the development of Impressionism, and, at his death in 1899, could rightly be viewed as one of the most consistent exponents of late nineteenth-century landscape painting.

Floods at Port-Marly, 1876

60 × 81 cm (24 × 32 in)

LOUVRE, PARIS

Sisley lived all his life along the banks of the great rivers in the vicinity of Paris. As happened every year, the riverbanks would burst and this provided Sisley with the opportunity for some of his best work. The flood water, half-submerging trees and houses, created a completely new perspective in the most familiar of landscapes. The scene was perfect for an Impressionist painter preoccupied with transient effects. Part of the impact of Sisley's flood pictures lies in the knowledge that this is a passing and truly unique view, soon to be changed as the floods subside.

Alfred Sisley was born on 30 October 1839 in Paris, although his parents were English. His father, William Sisley, was born in Manchester and came from a rising commercial family. His mother, Felicia Sell, came from a refined and urbane London family. She was cosmopolitan and sophisticated enough to fit in well in Parisian society when her husband moved there in the course of his work. He made a sizeable fortune in business, selling artificial flowers particularly to the South American market. Such affluent middle-class parents were able to provide their son with a serene and untroubled youth. Alfred's elder brother Henri died in childhood and his two younger sisters were his constant early companions. Both married young, the elder, Emily, to a M. Rivallon and the younger, France-Aline, to a doctor who lived in the Pyrenees. Alfred saw little of them in his adult life and despite the hardships he was to suffer, never turned to them for financial assistance.

Although Alfred Sisley developed into a highly non-conformist painter by official standards, this in no way implied a rebellious nature. He was a good schoolboy and attentive pupil. In 1857, at the age of 18 he was sent to England by his parents to become fluent in the English language and to gain experience in the cotton business, as preparation for what his parents expected would be a commercial career. Sisley spent four years in England but during that time showed no great inclination towards a career in commerce and preferred to spend his time in art galleries whenever he had the opportunity. In the museums of London he was particularly taken by the landscapes of Turner, Constable and Richard Parkes Bonington, all of whom were to be a much greater influence on the development of Impressionism than the French painters of the same period. When Sisley returned to Paris early in 1862 he made clear to his parents that the trading practices which he had been studying in England did not interest him as a career; he made it known that what he really wanted to do was to become a painter. William and Felicia Sisley raised no objection to their son's request and sent him to study in the studio of the painter Charles Gleyre.

Gleyre was a competent painter mainly working in the classical manner of David but his style was softened by the anecdotalism popular among his contemporaries. As a painter he kept his distance from nature and was totally uninterested in landscape painting except as a background to figure compositions. At the studio Sisley formed a particular friendship with three other young painters – Claude Monet, Pierre Auguste Renoir and Frédéric Bazille. Gleyre's discipline was rigorous and soon the four students, who were by no means rebellious by nature, found the conditions irksome and the nature of the lessons not conducive to their taste. In the spring of 1863 Sisley and his three friends began to paint together as a group, independently of Gleyre's tuition. They were keen to work in the open air and to study the particular subjects that fascinated them. They objected to the form of teaching which held that painting was a methodical art proceeding by certain set rules which simply had to be learnt and carried out in order to produce a perfect painting. Instead they wanted room for self-expression and development. Following the example of the Barbizon painters, Sisley went with Monet to Chailly-en-Brière on the edge of the Forest of Fontainebleau in order to paint in the open air.

The four painters were from very different backgrounds. Sisley was a wealthy man and could afford to paint as he pleased. So too Bazille, who was enrolled as a medical student but preferred painting to his medical studies. Monet and Renoir were by no means of the same social class or affluence but it did not disturb the camaraderie of the group as they learned to paint together. None of Sisley's work from the early 1860s has survived so it is impossible to make a judgement, but the consistency of his later style suggests that these early works were the training ground in which he slowly discovered the scope of his creative talents.

As well as painting at Fontainebleau Sisley would, with one or two friends, make expeditions along the Seine valley and into Normandy in search of subjects to paint. During the winter he rented a studio in the Avenue de Neuilly where Monet and Renoir, who could not always afford such luxuries for themselves, often came to work if they were not lodging with Bazille. The summer of 1864 was very similar to that of the previous year, with expeditions

into the countryside surrounding Paris. In 1865 Sisley and Renoir took rooms in Marlotte, on the Seine south of Paris, where they were soon joined by Monet and Camille Pissarro, a slightly older painter of similar taste whom they had met the previous winter in the Café Guerbois, a popular meeting place where many of the young avant-garde painters gathered to discuss art and aesthetics. Here Sisley painted two works which he exhibited in the Salon of 1866. Sisley was not a revolutionary and he showed no aggressive hostility to the Salon which was the natural place for any young artist to exhibit if he wanted to establish a reputation, although in 1867, after he had works rejected by the capricious Salon jury, Sisley signed a petition with Renoir and Bazille for a Salon des Refusés such as had been organized by Napoleon III in 1863.

Landscape near St Cloud, 1865
125 × 205 cm (49 × 81 in)
PETIT-PALAIS, PARIS
This unusually large-scale work for Sisley is an early attempt to come to terms with the bright sunlight in a broad, open space. Although the result is a little clumsy and heavy-handed, it shows that Sisley was already addressing himself to the particular problems of landscape painting that would come to dominate his artistic life.

The Canal St Martin, 1870

50 × 65 cm (20 × 25½ in)
LOUVRE, PARIS

This painting marks a breakthrough in Sisley's style, as if he had finally found his element in the great expanses of sky and water split by the vertical planes of the houses along the canal bank. He rarely recorded details of his technique or painting method, but a surviving undated letter stresses his interest in the broad spread of natural light in landscape. Sisley described the sky as giving the landscape depth and movement, adding, 'I always begin a picture with the sky.'

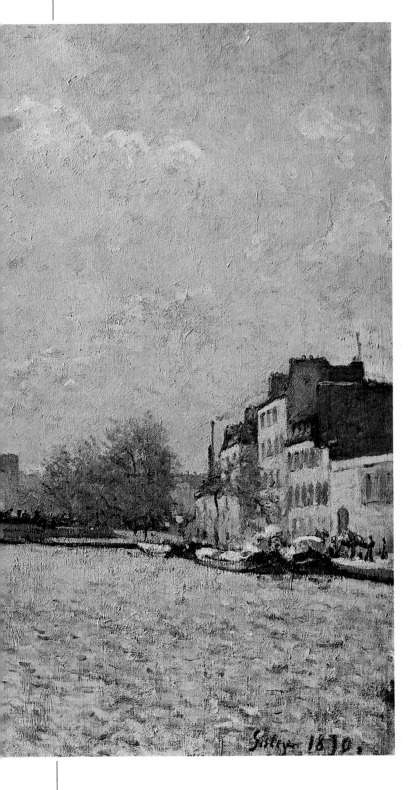

During the 1860s life was good for Sisley. He was in the prime of life, wealthy, ambitious and good company. When in 1866 he married Marie Eugénie Lescouzec, a Parisian girl by whom he subsequently had two children, Pierre and Jeanne, this did not greatly alter his lifestyle as he could well afford to support a family and to continue with his painting. He would spend the summers in Normandy or Fontainebleau and the winters in Paris where in the evenings he would attend the gatherings at the Café Guerbois, to talk and argue with his colleagues. Emile Zola, who was often to be seen at the Café Guerbois, spoke of the assembled company with respect: 'They form a group which grows each day. They are at the head of the movement in art and tomorrow one will have to reckon with them.' Prophetic and bold words in 1868 but in fact, Zola was to be proved right. In 1869 Sisley's work was again rejected at the Salon but in 1870 it was accepted. The vagaries of Salon rejection depended considerably on the jury, which was made up of established painters and changed each year. The fortunes of the young Impressionists often depended on Charles Daubigny, a Barbizon painter who favoured their work but was not always able to convince the other members of the jury of their merits.

By 1870 Sisley had been painting for almost eight years but unfortunately very little of the work from this early period is known to us because only eight landscapes and four still-life compositions survive. Of the landscapes, none as yet show the great talent which was to blossom in the 1870s, as Sisley began to work harder and with more confidence. Although Sisley's great sensitivity to the effects of light was already apparent, it was in a muted, subtle form compared with Monet's bolder approach to light and colour at this time. It is not clear how so much of Sisley's early work came to be lost, since he was not in the same straits as Monet, for example, who frequently overpainted his early canvases because he could not afford fresh material. After 1872, however, when Sisley had been taken up by the dealer Paul Durand-Ruel, his work had a much better chance of survival once bought or exhibited, even if he was still only able to earn relatively small sums for his paintings.

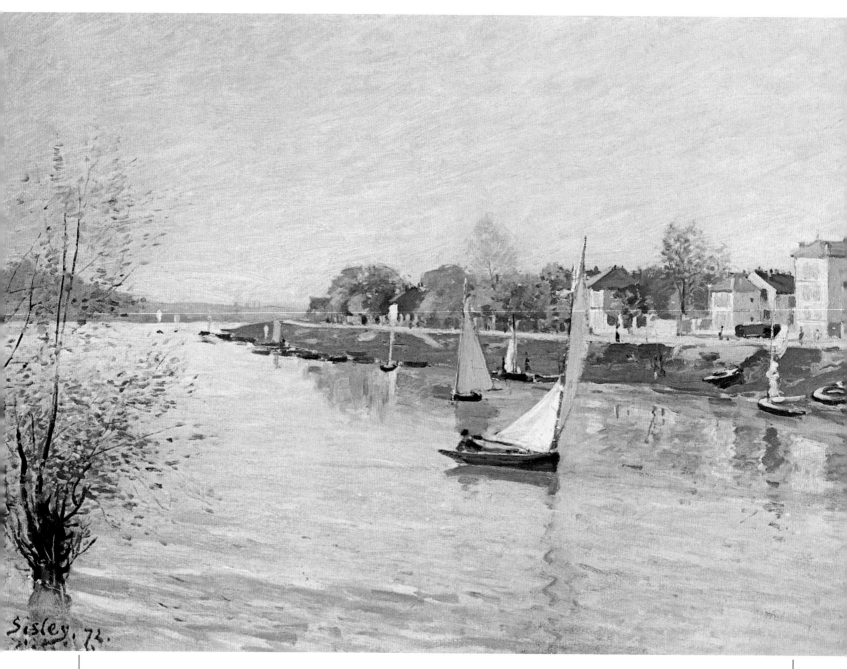

"Because the sun softens some parts of the landscape and sharpens others it has a material effect on nature which should be rendered materially on canvas."

The Seine at Argenteuil, 1872
50 × 73 cm (20 × 29 in)
PRIVATE COLLECTION
Argenteuil was probably the most frequented of the riverside locations favoured by the Impressionists and recorded in their paintings. Like his colleagues, Sisley has delighted in the glittering reflections on the water's surface, but the colours he uses to capture the scene are typically more muted and harmonious than those in Monet's vibrant impressions of Argenteuil. Sisley's picture seems to reflect a golden, autumnal light rather than the distinct, clear hues of high summer.

The years of the Franco-Prussian war, 1870–1, were a time of great crisis for many in France, but for Sisley most acutely because the war ruined his father's business so that the artist could no longer rely on financial support from his family. Like Monet, Pissarro and Renoir, from this time on Sisley had to support himself on the sales of his work as a painter. The collapse of his business destroyed Sisley's father who died shortly afterwards, a broken man. These events were a rude shock to Alfred Sisley, who had hitherto been protected from many of the difficulties that beset his less fortunate colleagues, but it did not in any way discourage him from his chosen career or influence him to change his style in order to court greater popularity. The sad effect of his loss of fortune was that it changed the affable young man over the years into a shy, retiring and at times morose recluse. His cheerful disposition became clouded with anxiety as he often had to beg admirers and fellow painters for money. It did not make him an aggressive or bitter man, but he gradually lost the open-hearted friendliness of his youth. Unlike Pissarro or Monet who had never known wealth, Sisley found it difficult to come to terms with poverty.

During the Franco-Prussian war Sisley moved to Louveciennes close to Paris and Versailles, where Renoir was a frequent visitor as both colleague and family friend. Sisley painted pictures of the village in all seasons and in varying weather conditions, and also returned in later life to paint the same scenes again. Another favourite location for painting was the forest at Marly just north of Louveciennes and this region was the subject of some of his finest work of the 1870s. In 1871 Paul Durand-Ruel held an exhibition in London of new French art, which included one painting by Sisley. It was not, however, until 1872 that the painter and the dealer actually met and Durand-Ruel began to buy Sisley's work on a regular basis. This continued until 1877 when Durand-Ruel, owing to his brave support for the young artists in the face of public indifference, went bankrupt and was not able to begin buying again until 1880. During the years 1871–3 Sisley painted in and around Louveciennes and along the banks of the Seine at Bougival and Argenteuil. He could easily travel into Paris and was able to keep in touch with his colleagues and also offer them the hospitality of his home. Pissarro and Monet spent long periods along the Seine in Normandy and the three painters often worked together on the same subjects.

In 1874 the first Impressionist exhibition was held. Sisley, now in his mid-thirties was one of the prime movers for such an exhibition, although not closely involved in the organization, and exhibited five works, suffering with his colleagues the scorn and derision of the press and the myopic public.

Wheatfields near Argenteuil, 1873
49 × 73 cm (19 × 29 in)
KUNSTHALLE, HAMBURG
Forsaking the river for the land, Sisley has produced a work of unusually strong contrasts. Bright blocks of colour and heavily worked paint textures successfully convey the different elements of the landscape.

Louveciennes, road to Sèvres, 1873

54 × 73 cm (21 × 29 in)

LOUVRE, PARIS

The early work of the Impressionists, while adopting a revolutionary approach towards colour and light, still maintained the traditional principles of formal composition. Sisley, who was perhaps the least adventurous Impressionist in pictorial terms, never challenged the established rules of perspective. The long line of trees flanking the roadway as it narrows into the distance provides a simple, conventional structure within which Sisley takes advantage of a soft patterning of light and shade, set against a clear, open sky.

After the exhibition the collector Armand Faure paid for Sisley to visit England where he stayed in London and produced several wonderful paintings of the city and of Hampton Court.

On his return to France, Sisley moved northwards from Louveciennes and settled for three years at Marly-le-Roi. Here he was able to paint the great floods of 1876, with the shimmering water totally altering the normal perspective of the landscape. In an attempt to alleviate his precarious financial situation he joined with Monet, Renoir and Berthe Morisot in an auction of paintings held at the Hôtel Drouot. This was a total disaster and the police had to intervene when the crowd turned hostile. The few buyers of Sisley's work, apart from Durand-Ruel, were the amateur collector Victor Chocquet, the critic Théodore Duret and the affluent fellow

painter Gustave Caillebotte. For the pictures that sold, the highest price paid was 300 francs for Sisley's 'Molesey Weir: Hampton Court', though this was a poor sum by comparison with Salon prices. Sisley exhibited in the second and third Impressionist exhibitions of 1876 and 1877, which fared little better than the inaugural exhibition of 1874. Despite the fact that he was at the height of his powers as a painter during the 1870s, Sisley was finding it almost impossible to reach the buying public.

Chased by creditors Sisley left Marly-le-Roi in 1877 and settled in Sèvres. His existence now depended on the generosity of his friends and a few patrons; the publisher Georges Charpentier and the Parisian restaurateur Eugène Murer were virtually his only sources of credit. At his restaurant in the

Molesey Weir: Hampton Court, 1874

50 × 75 cm (20 × 29½ in)

NATIONAL GALLERY OF SCOTLAND, EDINBURGH

Sisley visited England in 1874 following the failure of the first Impressionist exhibition. In London he was temporarily distracted from his interest in pure landscape by the sights and atmosphere of an unfamiliar city. This close study of water gushing over the weir at Hampton Court is in contrast to his normally placid river views, and the turbulent movement of the water itself becomes the dynamic focus of the work.

Boulevard Voltaire, Murer would welcome Pissarro, Sisley and other impecunious painters every Wednesday evening for dinner. While painting such beautiful works as 'Street scene in bright sunlight', Sisley was having to write letters to friends begging for money.

In 1879 Sisley decided against exhibiting in the fourth Impressionist exhibition but thought instead of attempting once more the official Salon. To Duret, Sisley tried to justify the decision: 'Our exhibitions, it is true, have served a purpose; they have made us known and as such have been very useful, but I do not feel we should isolate ourselves any longer. The time when we can carry as much prestige as the official exhibitions is still a long way off.'

Both the paintings submitted by Sisley were rejected from the Salon and his situation grew worse when he was ejected from his house in Sèvres by the bailiffs. Charpentier swiftly sent him some money which enabled Sisley to rent a new apartment and continue to paint. In 1880 he moved again, to Moret-sur-Loing south of Paris and close to Marlotte. Apart from a brief stay at Sablons nearby he was to remain there for the rest of his life. He frequently painted the town of Moret and its principal architectural features, the church and the bridge, in all weather conditions and at all times of the year. Soon after moving to Moret he wrote to Monet in an effort to persuade him to live there too, for 'the houses are quite cheap.'

Having abstained from two more of the Impressionist exhibitions Sisley rejoined the group for the seventh exhibition in 1882, in which he showed 27 works, almost all of which belonged to his dealer Durand-Ruel, with whom he had been contracted since 1880. After the exhibition of 1882 Monet and Durand-Ruel were keen to alter their tactics and planned to produce individual rather than group shows. Sisley attempted to resist their move but as Durand-Ruel owned so many of the paintings he was in a position to do as he pleased. In 1883 he produced individual exhibitions for Boudin, Renoir, Pissario, Monet and Sisley. Sisley's exhibition contained some 70 works and was not a great success. He wrote sadly to one collector, a Dr Bellio, 'All is not well in the life of a landscape painter.'

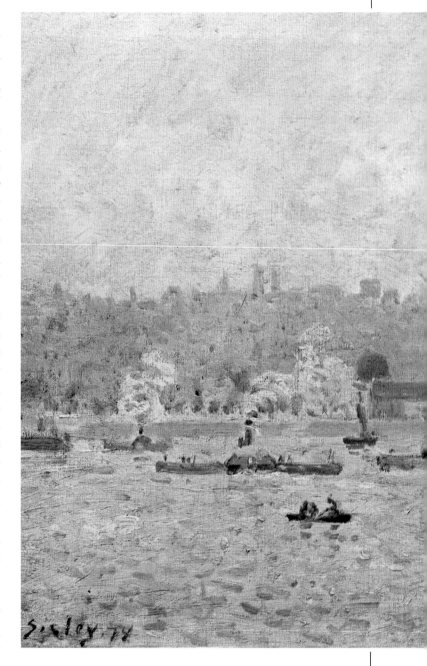

The Thames at Charing Cross Bridge, 1874
33 × 46 cm (13 × 18 in)
PRIVATE COLLECTION
St Paul's Cathedral rises as a hazy landmark above a clutter of boats passing the bridge at Charing Cross. Sisley was at his best when painting water reflecting the light of the sky. Here, with the very subtlest of green and blue tones, he merges the foreground and background of the painting into a charming composition of flecked and misty beauty.

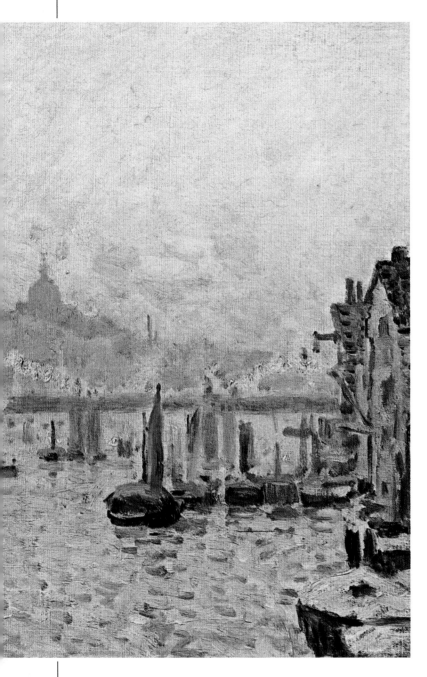

"Is there anything more full of movement than the sky, the blue sky with its beautiful white clouds? It is the spell-binding movement of waves on the sea."

During his short stay away from Moret in 1884 at Sablons, Sisley frequently painted the canal which joined the Loing to the Seine. Although Dr Bellio and Murer were buying his work the financial situation remained precarious: Durand-Ruel was paying him a constant but small sum but in 1885 even this dried up when the dealer had temporarily to stop buying paintings due to the collapse of his backer, the Union Générale insurance company. Nevertheless he still had an enormous amount of stock which could be sold. An exhibition in London contained 80 works by Sisley and paintings were also sent to Boston, Berlin and Rotterdam. The benefit of these activities to the painter, however, was moral rather than material. In November 1885 Sisley wrote a despairing plea to Durand-Ruel: 'By the 21st I shall be without a penny again, I must pay the butcher and the baker and then there is the winter to get through.' Durand-Ruel gave some help but there was little he could do until he was able to sell the work of the Impressionists regularly. In 1886 Sisley ignored pleas from Gauguin and Degas to exhibit in the eighth and final Impressionist exhibition. Instead he remained in Moret plodding away at his painting, never giving up hope of the official recognition which would establish him.

Durand-Ruel managed to organize a very successful exhibition in New York in 1886 and this encouraged him to begin buying again, so that in May 1888 he was able to put on a large exhibition in Paris of the work of Renoir, Pissarro and Sisley. From this exhibition the French government bought 'September morning', an accolade which so encouraged Sisley that he began to make arrangements to take French nationality until the procedure became too costly; it was not until 1898 that Sisley became a French national.

Durand-Ruel was doing his best for Sisley and in 1889 gave a whole New York exhibition to him alone but unlike Monet and Renoir, who at this time began to find a wider buying public, Sisley was still struggling to find a market. Associate membership of the Société National des Beaux Arts, a mildly avant-garde group, gave him the opportunity to exhibit in a semi-official capacity in Paris every year. This increased his optimism, but had little

more definite effect. But Sisley was never prepared to give up. He had phases of renewed vigour, as described by Pissarro who had lunch with him on 13 April 1889 and wrote the next day to his son Lucien: 'I met Sisley yesterday. I had not seen him for at least two months. He seems so happy at the moment he is floating.'

During the 1890s, however, now in his fifties, Sisley acquired an air of resignation. He quarrelled with Durand-Ruel over prices and turned instead to the dealers Boussod et Valadon, but was actually painting less and less. Although living in more comfort in Moret he was not making money and as Pissarro wrote again to Lucien, in 1895: 'Monet, he sells, very expensively; Renoir, Degas, they sell don't they? I remain with Sisley as the tail of Impressionism.' The writer Gustave Geffroy stayed in Moret in the mid-1890s and he wrote that Sisley 'seemed to sense that never in his life would a ray of glory come to shine on his painting.' Sisley began to feel truly disheartened after the dealer Georges Petit had organized a large retrospective exhibition in 1897, which included about 150 of Sisley's paintings. Many friends attended, there were isolated good reviews, but the public and press ignored the exhibition and not a single work was sold.

Sisley travelled to England for a few months in the autumn of 1897 and stayed at Penarth, near Cardiff in Wales, where he painted the only seascapes of his career. By this stage he was painting very little and on returning to Moret he was no more than a shadow of the confident young man of the 1860s who had felt the whole world was before him. In October 1898 his wife died and his friend Dr Viau diagnosed that Sisley himself had cancer of the throat. Early in 1899 he knew he was going to die and summoned Monet to his deathbed to commit to him the care of his children. Sisley died on 28 January 1899 and was buried shortly afterwards in the cemetery of the church at Moret which he had so often painted. The funeral was attended by Monet, Renoir, Pissarro and many others who had known and admired him.

Alfred Sisley's art, like his life, was a blend of moderation and modesty. There was a logic to the development of his style. He did not seek to surprise or cause the sense of outrage that was for years the

typical response to Impressionism. Despite the crisis in his personal circumstances occurring midway in his career, his work shows a remarkable unity over the years from the very earliest works in the 1860s through to the final painting at the end of the century. It consists almost exclusively of landscapes, apart from a handful of still-lifes and interiors. He did not choose his subjects for any picturesque or anecdotal reason but deliberately to give a view of the rural world as it changed from season to season

Street under snow, Louveciennes, 1874

47 × 56 cm (18½ × 22 in)
COURTAULD INSTITUTE, LONDON

The changed pattern of a landscape when seen under snow provided a fascinating pictorial challenge for the Impressionists. It was a favourite subject for Sisley, Monet and Pissarro and all were keen to capture the subtle combination of hues reflected in a snowy white surface. Sisley worked outside so often and so persistently to capture scenes like this, that his face would sometimes become paralysed with cold.

or from hour to hour. Like Monet he made meticulous studies of the same subject over and over again in which he sought to depict the changing play of sunlight and weather on the objects before him. Sisley's work is not haphazard or intemperate but carefully constructed with deliberate use of perspective and technical devices. He would use short separate strokes for the ground or leaves and blend the brushstrokes together in the sky. As he wrote to the critic Tavernier in 1892, 'I am for

diversity of techniques in the same picture. Objects must be rendered so as to indicate their individual textures. In addition and above all they must be enveloped in light as they are in nature.'

Sisley was clear-thinking and deliberate in everything he painted, consistent not only in his style but also in the content of his paintings. With rare exceptions his work is confined to Normandy and the Seine valley and it may well be that this localized interest was enforced by his inability to

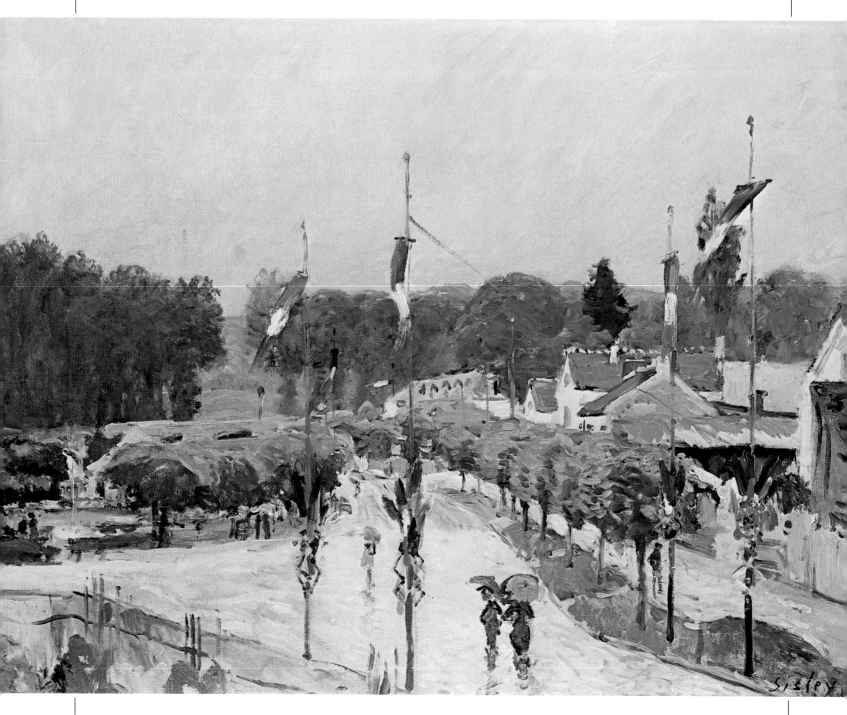

Bastille day in Marly-le-Roi, 1875
54 × 73 cm (21 × 29 in)
PRIVATE COLLECTION
A day of celebration is subdued by rainy weather, but
for Sisley this provides an unusual and interesting
composition. The watery uncertainty of the atmosphere
merges and blends the buildings, trees and passers-by.
Many colours are reflected from the glistening streets,
and the hanging flags become vibrant dashes of colour.

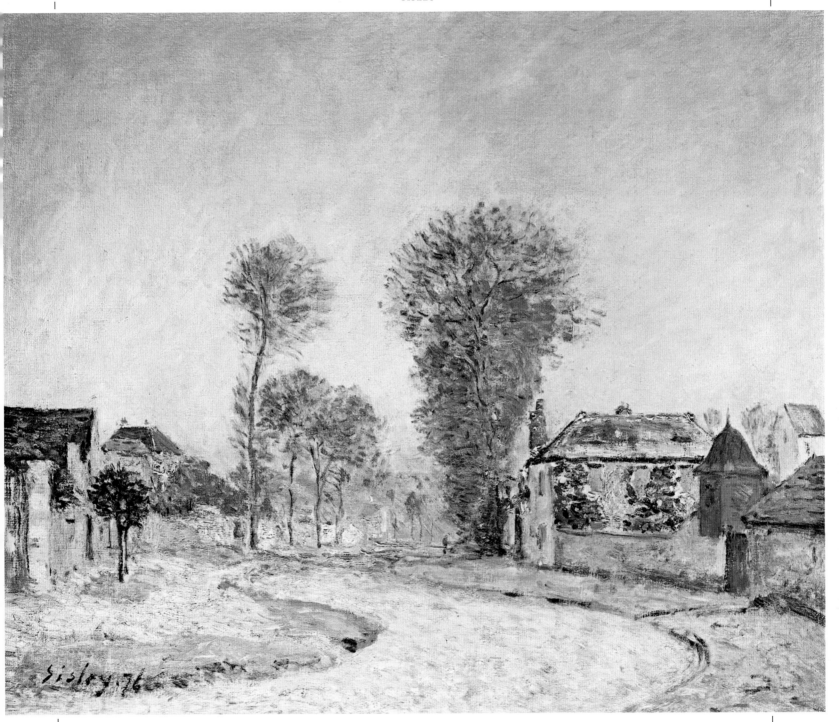

Street scene in bright sunlight, 1876

46 × 55 cm (18 × 22 in)

PRIVATE COLLECTION

With the midday sun highlighting all the true colours of the view, Sisley has exploited the golds and greens which contribute to the mellow richness of the scene. This painting clearly illustrates how the development of Impressionism freed landscape painters from the constraints of academic traditions of colour and form.

Moret-sur-Loing, 1892 *(overleaf)*

81 × 65 cm (32 × 25½ in)

PRIVATE COLLECTION

Sisley painted Moret, where he finally settled, from many different viewpoints and under varying lights and conditions of weather. Unlike Monet, Sisley did not conceive his paintings as great series of works analysing every aspect of a particular motif. He painted simply as he saw, concentrating on his own local world.

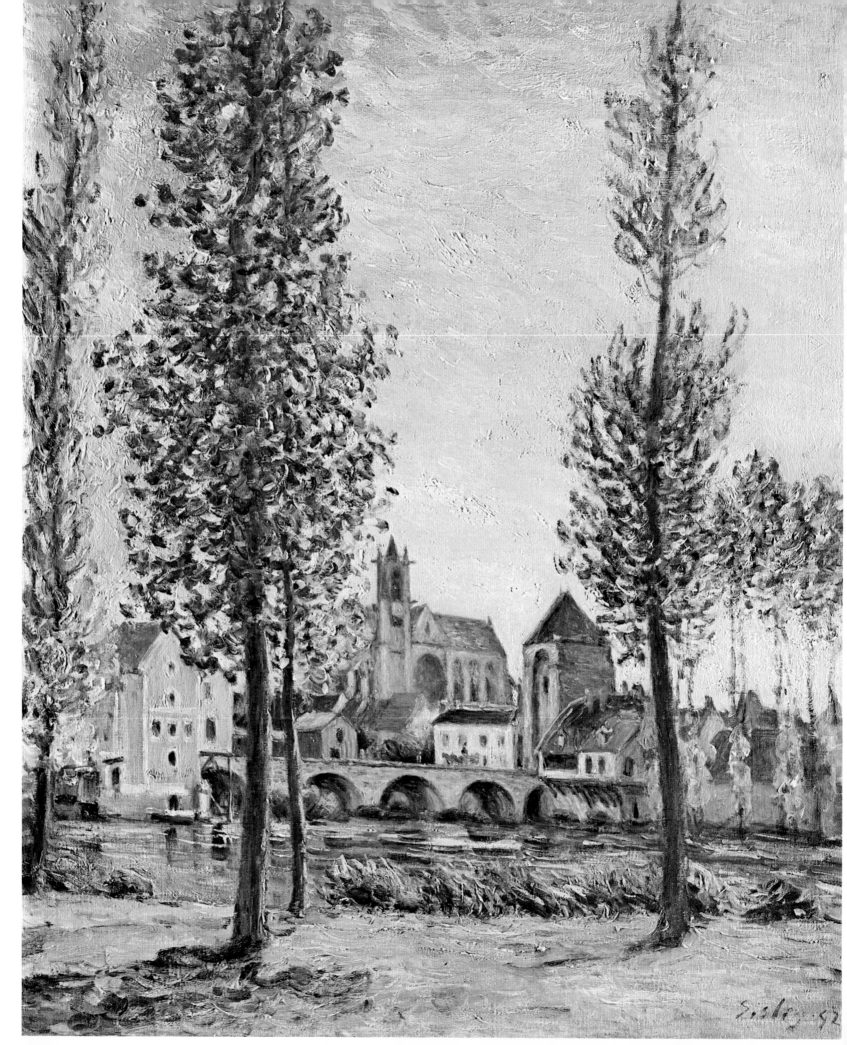

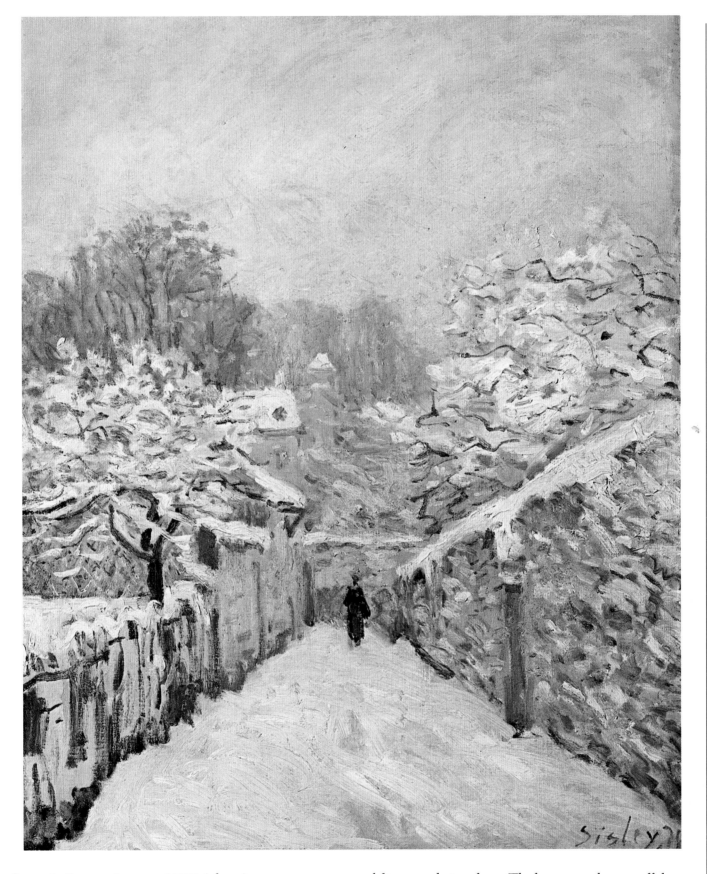

Snow in Louveciennes, 1878 (*above*)
61 × 50 cm (24 × 20 in)
LOUVRE, PARIS
Like the sunlit 'Road to Sèvres' (see page 210), this simple view with its central perspective offers Sisley a delicate study in colour. The hazy grey sky sets off the brighter triangle of snow in the foreground, and there is a clever balance of warm pink and cool blue tints. The tiny dark figure acts as a focal point, drawing together the receding planes and fine linear detail.

The church at Moret-sur-Loing, 1893
65 × 92 cm (25½ × 36 in)
MUSÉE DES BEAUX ARTS, ROUEN

This church appears in many of Sisley's Moret pictures: here he celebrates its imposing mass under an effect of strong sunlight and shadow, and animates the image with vigorous brushwork. Sisley has carefully studied the relative colour values to catch the subtle modulations between the brightly lit and shaded areas of the church walls.

afford to travel through Europe. Yet his art lost nothing by being restricted mainly to the landscape of northern France. Sisley deliberately avoided the bustling street scenes of Paris often painted by Pissarro and Monet, preferring instead the silent, figureless landscapes of the countryside as it changed through the seasons. Sisley was probably the least adventurous of the Impressionist painters but, within the limits which he set himself, he was arguably the purest of them all.

TOULOUSE-LAUTREC

Count Henri de Toulouse-Lautrec was one of the more colourful characters in the artistic world of late nineteenth-century France. He was rich, mischievous and dissolute, and endowed with extraordinary ability as a painter. His pictures show the brilliance and glitter of the 'fin de siècle' world, ranging from the casual 'frisson' of brothel scenes to the excitement and energy of the circus and the music hall.

Born on 24 November 1864 at the family ancestral home Hôtel du Bosc in Albi, in the south-west of France, Henri was a member of one of the most distinguished of French families, descended from the Emperor Charlemagne through the semi-royal counts of Toulouse. As a child he enjoyed the typical education of a member of his class; he was privately educated at home by a governess and great stress was laid on the outdoor activities becoming to a young nobleman. Since the time of his grandfather it had become natural for the young members of the family to learn to draw, so the young Henri was encouraged when he showed early artistic talent. His grandmother once remarked 'If my grandson kills a game bird it provides him with three pleasures: shooting, eating and drawing.'

At the age of 13, Henri de Toulouse-Lautrec's happy and privileged life was changed radically when he suffered two broken legs in a riding accident. He never properly recovered from the breaks because they revealed a genetic abnormality in the bone cells – a result of too much interbreeding over the years. His parents, in fact, were first cousins. The result of the accident was that while the rest of his body grew, his legs did not and they remained the size appropriate to a boy in his early teens. When fully grown, Lautrec was no more than 1.37 m (4½ ft) high, yet his torso and head were those of a normally developed man. As a result he presented a rather comic figure and was always keen to try and distract attention away from his appearance.

Dance at the Moulin Rouge, 1890 (*opposite*)
115 × 150 cm (45 × 59 in)
PRIVATE COLLECTION
The informal atmosphere of the popular Parisian
nightclub is well rendered by Lautrec's rapidly sketched
figures and semi-transparent areas of colour.

At the Moulin Rouge, 1892
123 × 141 cm (48 × 55½ in)
ART INSTITUTE OF CHICAGO
Here, the strong line of the balustrade and the
incomplete form of the figure in the foreground heighten
the viewer's sensation of passing into the Moulin Rouge.

About a year before his accident, in 1878, Lautrec had begun to study painting seriously and following the accident, during his long convalescence at Nice, he was able to devote much time to drawing and experimentation. His first real teacher was a deaf-mute called Pinceteau, who was subsequently replaced by Bonnat and Cormon. Lautrec was able to have the best teachers made available to him; although his disability prevented him from being able to participate fully in the aristocratic life which was his inheritance, there were compensations in coming from such an important family. From quite early in his studies, he showed a keen interest in contemporary avant-garde artists, such as Manet, rather than in following the classical tradition of his teachers. A glimpse of his feeling for art is given in a letter of 1881, written to his mother: 'I have tried to draw something real, not something ideal.'

Already separated from the conventional way of life of his family, Lautrec began deliberately to lose touch with it. He moved to Paris and mixed in Bohemian artistic circles. He was determined to become a successful artist, as again he expressed it to his mother: 'I am leading a Bohemian life and find it difficult to accustom myself to such a milieu. Indeed, one of the chief reasons why I do not feel at my ease on the Butte Montmartre is that I am hampered by a host of sentimental ties which I must absolutely forget if I want to achieve anything.' By charm, wit and ability Henri was gradually accepted into the new world of his choice. He visited the studios of Manet and Degas, whom he much admired, but though learning from their work he

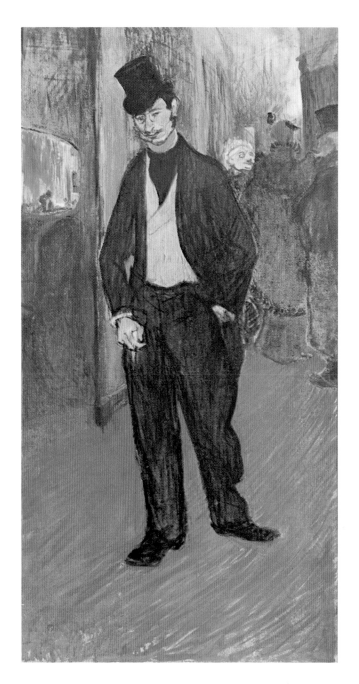

La Goulue entering the Moulin Rouge, 1892
(*opposite*)
80 × 60 cm (31 × 24 in)
MUSEUM OF MODERN ART, NEW YORK
Louise Weber, whose stage name was La Goulue, was the favourite among Lautrec's 'demi-monde' women. She is seen here entering the Moulin Rouge with all the sophistication of a queen, flanked by her female companions. Lautrec painted and drew her in many different poses and costumes.

Dr Tapie de Celeyran, 1894
110 × 56 cm (43 × 22 in)
MUSEE TOULOUSE-LAUTREC, ALBI
The doctor, who was Lautrec's cousin, is seen here entering the theatre of the Comédie Française. The picture suggests the essential loneliness of a man spending time in the company of actresses, dancers and prostitutes. The strong and unrealistic red which dominates the composition contributes to the heavy moodiness of the work.

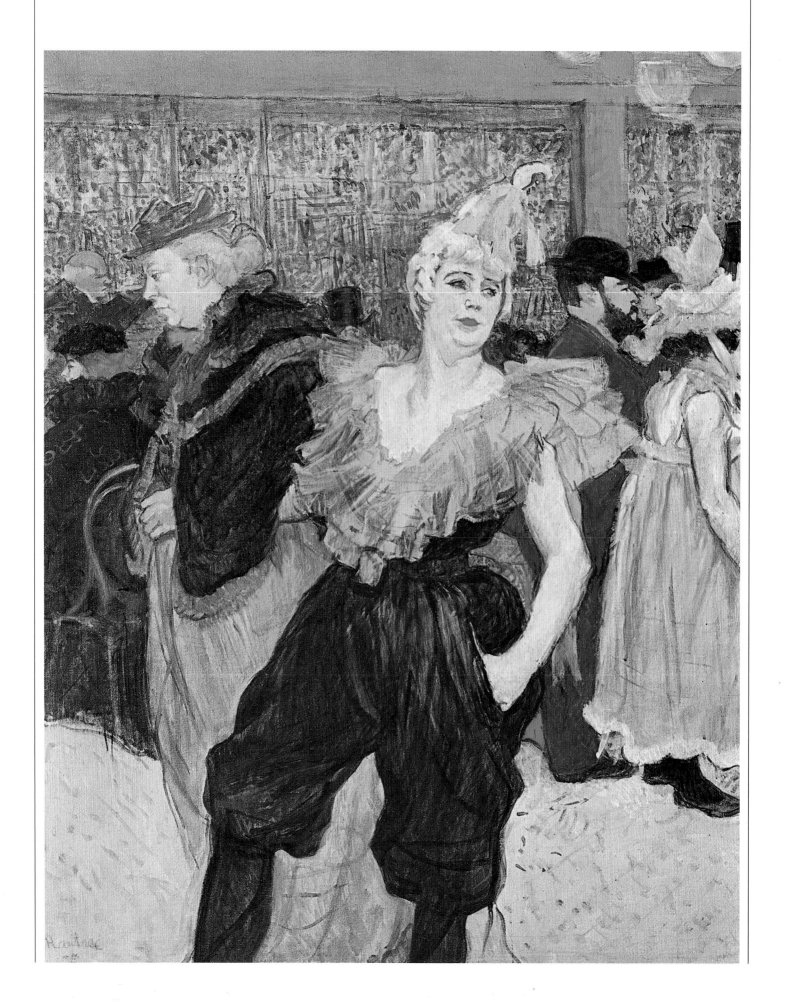

Cha-U-Kao, 1985 *(opposite)*

77 × 55 cm (30 × 22 in)

REINHART COLLECTION, WINTERTHUR

Cha-U-Kao was a French dancer who cultivated a fashionable Japanese image and was famous in the Parisian cabarets of the late nineteenth century. She also acted as a burlesque clown and is here depicted in semi-theatrical costume. The painting is full of sensitive colour harmonies – soft yellows, browns and pinks – that seem to create an almost tranquil moment in the frenetic atmosphere of music-hall life.

Madame Poupoule at her dressing table, 1899
(overleaf, left)

60 × 40 cm (24 × 16 in)

MUSEE TOULOUSE-LAUTREC, ALBI

This atmospheric and intimate picture suggests the reverse side of the outward gaeity of Paris nightlife. The opposition of colours in the strong, rather raucous blues and yellows contributes to the sense of a discordant mood. It is not a comfortable image, but the dense texturing of the brushwork and careful gradations of colour show Lautrec at the height of his artistic control.

The English barmaid at the Star, Le Havre, 1899
(overleaf, right)

41 × 33 cm (16 × 13 in)

MUSEE TOULOUSE-LAUTREC, ALBI

This rapid sketch, a combination of painting and chalk drawing, has a remarkable freshness despite the fact that it is a late work from the period when Lautrec's life and health were already in decline. In an attempt to combat his alcoholism and physical degeneration, friends and relatives persuaded him to visit coastal resorts like Le Havre where he painted this, but it was too late to undo the damage done to his health.

remained apart and original in his own form of execution. Perhaps more closely than any of the other artists following up the innovations of the Impressionist movement, he fulfils the writer Baudelaire's hopes for the painter of modern life who should grasp that 'the transient aspects of observed reality form the basis of all enduring artistic values.'

By 1885, at the age of 21, Lautrec had forsaken his academic masters and was learning from the Impressionists. By 1888 he had achieved his mature style which was to stay with him for the rest of his short life. His talent naturally lent itself to swift and captivating works, grasping the excitement of the changing spectacles of a circus performance or the languorous atmosphere of a brothel. His early work in cabarets and music halls, depicting the dancers and singers on stage and in their rich recreational environments, was deliberately bold and anti-academic. Lautrec was greatly influenced by Seurat's and Signac's studies in colour and realized that colour could deeply affect the mood of a painting. He therefore deliberately used blues and greens to create a melancholic mood, or oranges and reds for a lively effect. He also made conscious use of flattened planes in the picture, a device learned from Japanese art and used by many of the other artists of the time, in particular Gauguin and Degas.

More than any other artist of this period Lautrec captured the essence of Parisian urban night life. He was not in the least concerned with the type of subject matter favoured by Monet and Pissarro; he gave no thought to the rural aspects of Impressionism or the notion of painting in the open air. Instead he immersed himself in the seedy glamour of everyday life, at the bar, in the circus or with actresses behind stage. It is all observed without moral comment and with a sense of humour which was not apparent in Degas's paintings of similar subjects. Like Degas, Lautrec's method of achieving his apparently spontaneous compositions was to make innumerable sketches on the spot and return to the studio to develop the final work, hiring models as necessary to help him perfect the poses of the figures. He also became a master of graphic arts, producing fine prints and lithographic posters.

From 1888 Lautrec moved right away from the mainstream of Impressionist painting. He would cut

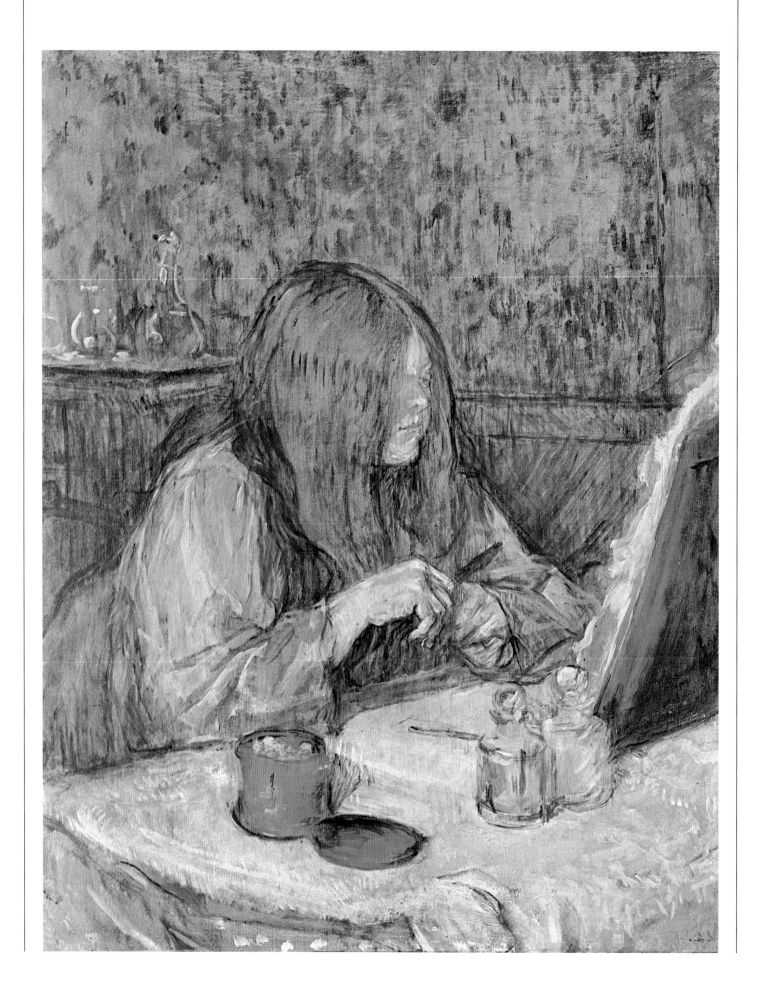

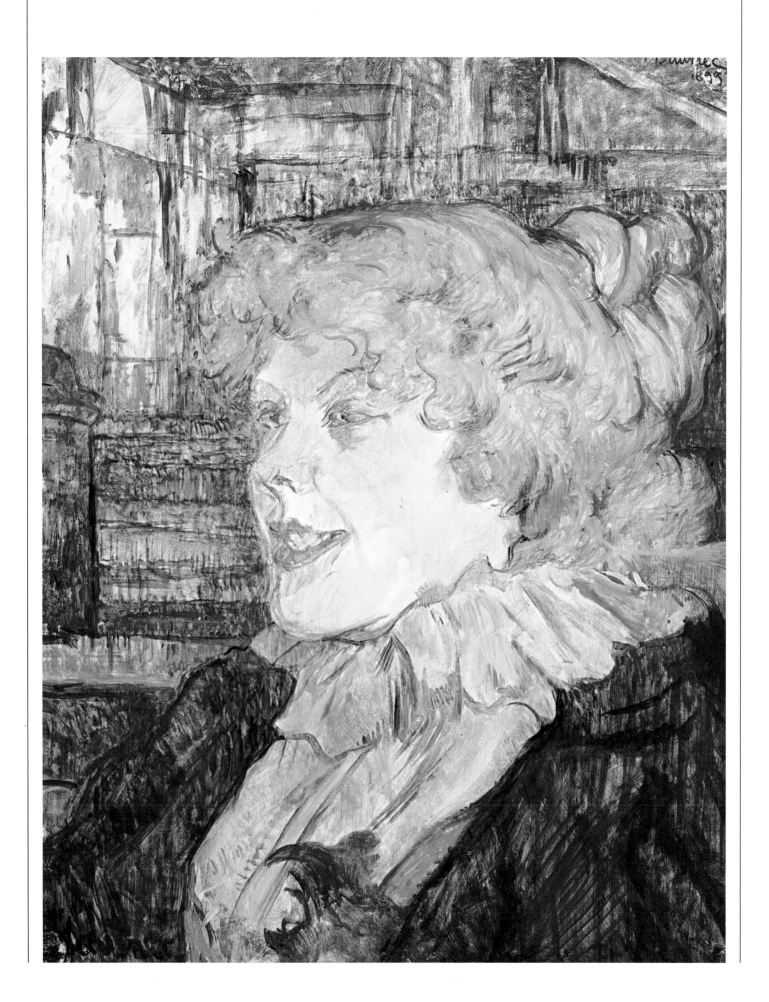

Jane Avril dancing, c. 1893

101 × 75 cm (40 × 29½ in)

PRIVATE COLLECTION

Jane Avril was the subject of a wonderful poster created by Lautrec and the continuing popularity of that image has made her perhaps the best-known of his many models. In this painting she is seen in the same pose as that used for the poster, here isolated from her surroundings. The looseness of the brushwork emphasizes the sense of movement.

away objects at the edges of a picture to give a higher sense of movement and immediacy, or bring a jumble of tables and chairs to the front of a painting; in theatrical scenes he would bring the action on stage to the front and put the audience in the background. Becoming the dispassionate observer, looking at performers and audience with equal clarity, was a central theme of his art. He moved in a different milieu from that of the major Impressionist artists, selling his paintings through private dealers and doing commercial work for the press.

Because of the subject matter he had chosen in a deliberate attempt to escape from the comfortable aristocratic background of his childhood, Lautrec led an increasingly dissipated and Bohemian life. He deliberately threw himself into the joys and sorrows, the material pleasures and physical sordidness of his surroundings and he often drank to excess to hide his embarrassment about his appearance, as he made his way through the world of music halls and brothels.

Lautrec had never been strong owing to his accident and to his genetic history, but his lifestyle put an additional strain on his health. Moreover, despite the great zest for life which is displayed in his paintings, he was actually a sad and lonely man. By 1897 both his mental and physical health were beginning to break down. In 1898 he was subject to a brief attack of madness and in 1899 suffered a complete mental breakdown and had to spend four months in a sanatorium. In December 1899, after

recuperating at the family home in Albi, he returned to Paris and the fancy-dress world of his paintings, again taking to heavy drinking. His work inevitably suffered as a result and he lost the bold swinging line which had given so much strength to his earlier pictures. He retained his strong sense of the distribution and manipulation of colour within a painting but the ability to hold the picture together with a stroke or a gesture eluded him. In March 1901 he suffered a second breakdown and died that same year, on 9 September, at the age of 37.

Almost all Lautrec's work is in direct contrast to the easy middle-class world of town and country evoked by the leading Impressionist painters, yet it was from them that he learnt much about the use and application of paint. However, he developed a more artificial, racy pictorial idiom suitable for the expression of his vision of the twilight world in which he had chosen to live. Most importantly he had acquired an idiosyncratic pictorial sense that saved his work from becoming mere reporting of the occasion depicted. Some of his characters seem almost to float in a vacuum divorced from their background.

A sad and brilliant figure, Lautrec portrayed his surroundings with a vividness which still appears fresh after almost a century has passed. He had achieved, as all the Impressionists in their various ways attempted, the most immediate evocation of the transient, fleeting moment of observed reality, captured forever in tangible form.

VAN GOGH

Vincent van Gogh's extraordinary temperament produced the most distinctive of the legacies of Impressionism. Like Gauguin, he has become a legendary figure, neglected during his lifetime and subsequently hailed as one of the greatest painters of his own or any other age. That his life should end in suicide might seem the inevitable outcome of a tortured and intimate vision which produced so many vigorous paintings within a relatively brief career. But from his many letters to his brother Theo, a more complex picture emerges of a man who came late to painting but who grasped it with a persistent and lucid curiosity, trying to collect his whole experience of life and art in his colourful expressions on canvas.

Vincent van Gogh was the eldest son of a minister of the Dutch Reformed Church, born on 30 March 1853 in the village of Zundert in North Brabant. Four years later in 1857 his younger brother Theo was born, for whom he maintained a lifelong and intense affection. The young Vincent received a typical middle-class education during which time he showed no aptitude for or interest in either drawing or painting.

At the age of 16, in 1869, Vincent obtained a job with the international art dealers Goupil and Co in The Hague through an uncle with some influence in the firm. With this appointment Vincent's family expected him to be embarking on a secure professional career. In 1873 van Gogh was sent to work for Goupil's dealership in London, and from there to Paris. While in London he experienced his first

The potato eaters, 1885
82 × 114 cm (32 × 45 in)
VINCENT VAN GOGH MUSEUM, AMSTERDAM
Van Gogh's early work in Holland was focused on the daily life of ordinary people, in particular on the poverty of agricultural labourers. To his brother Theo he wrote, 'I have tried to emphasize that those people, eating their potatoes in the lamplight, have dug the earth with those very hands they put in the dish.'

Moulin de la Galette, 1886 *(right)*
46 × 38 cm (18 × 15 in)
GLASGOW ART GALLERY AND MUSEUM
The Moulin de la Galette on the top of Montmartre was a favourite subject for the Impressionists, at that time still a rural location though now engulfed by modern-day Paris.

Self-portrait, 1887

44 × 37 cm (17 × 14½ in)

VINCENT VAN GOGH MUSEUM, AMSTERDAM

*Van Gogh rapidly developed his own highly individual
style of brushwork, influenced by both Impressionism
and by the principles of Seurat's divisionism, but
interpreted without theoretical analysis to produce these
long, slashing strokes of bright colour. The whole texture
of the work is built up by the pattern of circulating brush
strokes, drawing attention towards the central features
of the portrait and giving the work great force and
vigour.*

Interior of a restaurant, 1887 (*opposite*)

45 × 56 cm (18 × 22 in)

RIJKSMUSEUM KRÖLLER-MÜLLER, OTTERLO

*This painting is clearly influenced by the divisionist
theories of Seurat but the unusually harmonious
colouring seems to prefigure the early work of the Nabis
group, especially the paintings of Edouard Vuillard. The
colours are close in tone and build up a pattern across
the canvas from which the distinct forms of the objects
subtly emerge.*

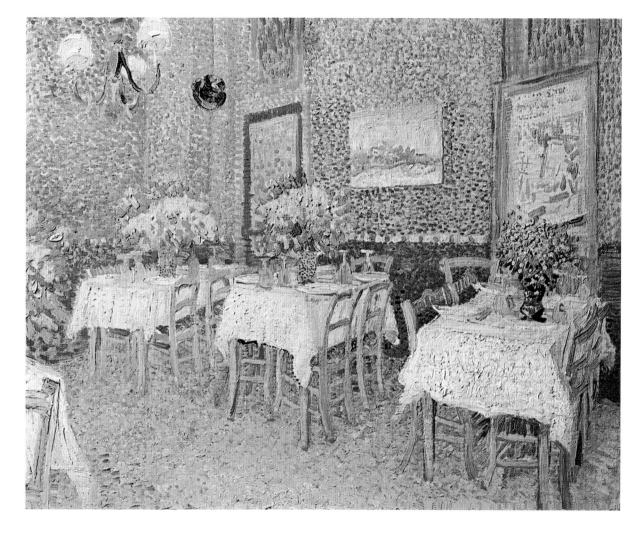

serious unrequited passion for a woman, the daughter of his landlady. This set the pattern for other disastrous relationships with women that contributed to the eventual undermining of his health and sanity. Moving on to Paris, van Gogh took comfort in thorough study of the Bible. The strong religious atmosphere which must have prevailed in his father's home made it perfectly natural for him to turn to the Bible in times of stress and loneliness. His religious fervour combined with an unsuitable temperament for commerce led him to entertain a healthy contempt for the business of art dealing. In March 1876 he was dismissed by Goupil and Co and returned to England. At first he took a job as an assistant teacher at a school in Ramsgate on the south coast, but soon after moved to a school in Isleworth, near London, where he was employed as an assistant master and acted as a lay preacher.

By January 1877, however, van Gogh was back in Holland, working as a book shop assistant in Dordrecht and trying to educate himself further. In May of that year he went to Amsterdam to gain more formal teaching in preparation for studying theology at university, this as a preliminary to

entering the priesthood. In Amsterdam he lived with his uncle Jan van Gogh, a rear admiral. After a year of this life the impulsive van Gogh grew bored with studying the Latin and Greek which were essential prerequisites to theological study at the university. In July 1878 he left and moved to Brussels where he began a course training as a missionary. Later in the same year he went to Borinage, a Belgian colliery near Mons, to work as a lay missionary. During the following months he was so deeply affected by the poverty of the miners, that he gave away all his possessions and was promptly dismissed from his post for displaying fanaticism.

All this time he had been in regular correspondence with his brother Theo and maintained this habit for the rest of his life. Early in 1880 he wrote to Theo: 'I shall take up my pen; I shall sit down and draw; from now on everything is changed for me.' Through his previous experience in art dealing, van Gogh had learned to appreciate painting; his letters to Theo were full of references to artists, and to books which he also loved, but he had hitherto shown no interest in acquiring the practical skills of a painter. His sudden decision to become an artist at

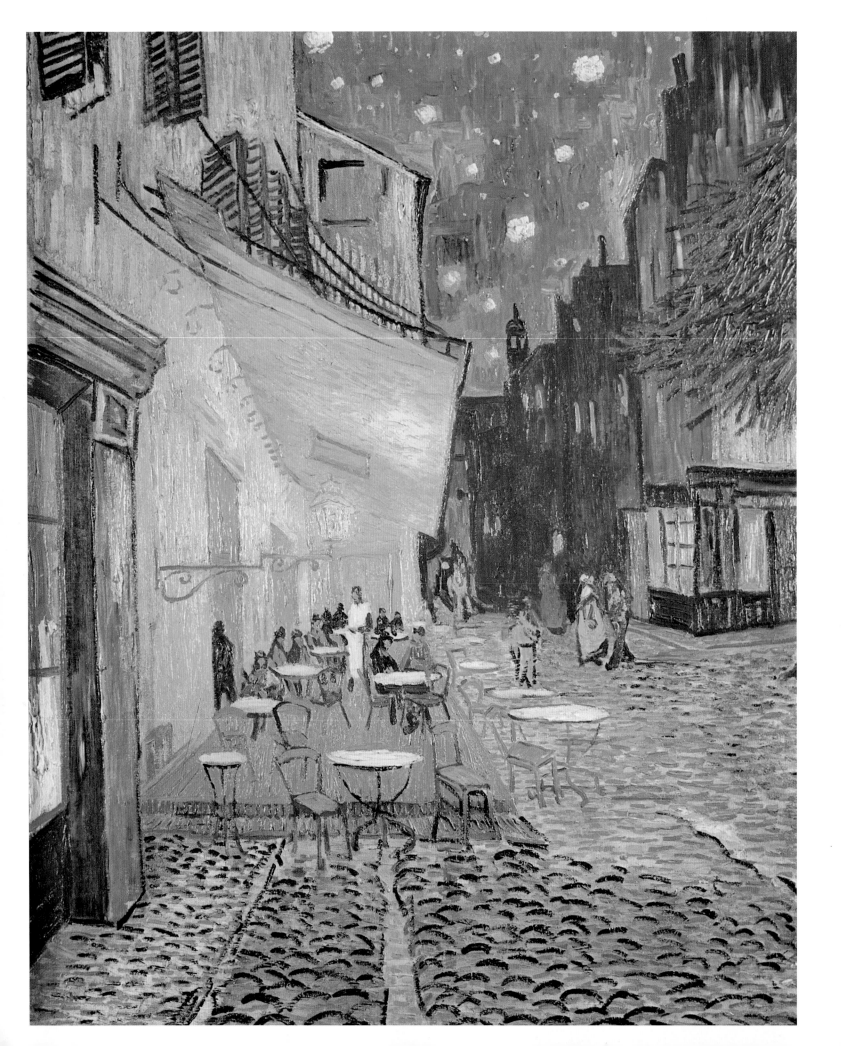

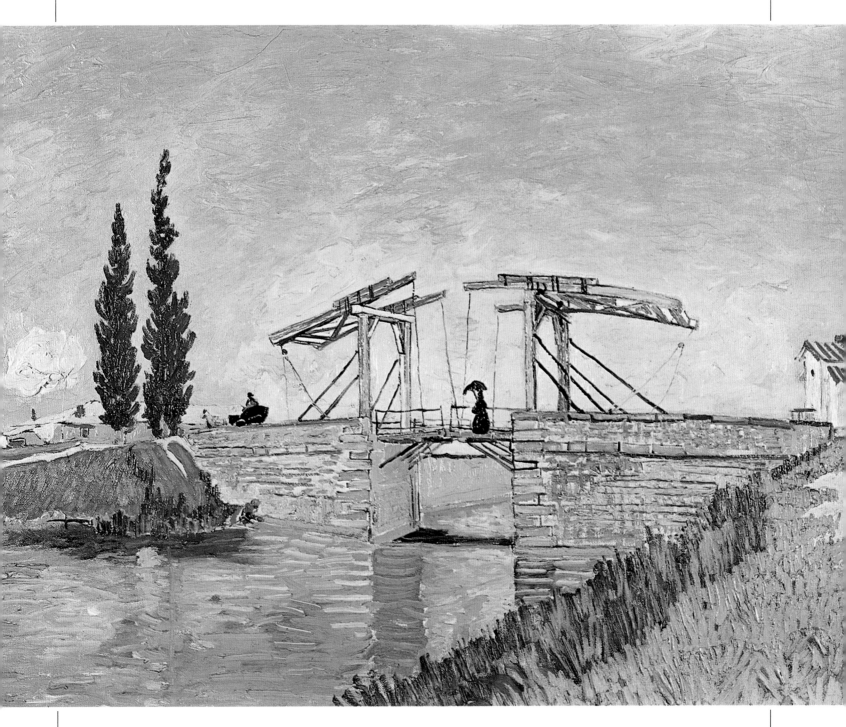

Café at night, 1888 (*opposite*)

81 × 65 cm (32 × 25½ in)

RIJKSMUSEUM KRÖLLER-MÜLLER, OTTERLO

Bright, intense light shines forth from the café in almost menacing contrast to the deep blue of the night sky, which is pinpricked with little balls of complementary yellow fire. The figures become tiny shadowy forms against the light, and the peaceful evening café scene in Arles seems transformed into a frightening vision born out of the artist's turbulent inner feelings.

The bridge at Langlois, 1888

49 × 64 cm (19 × 25 in)

WALLRAF RICHARTZ MUSEUM, COLOGNE

Van Gogh depicted this subject many times and this canvas is one of the later versions. Its ordered composition and careful distribution of colour suggest his emotional stability at the time, in comparison with the harsh strokes and dashing colours of the previous year's self-portrait .

Sunflowers, 1888
95 × 73 cm (37 × 29 in)
VINCENT VAN GOGH MUSEUM,
AMSTERDAM
In the summer of 1888 at Arles, van Gogh painted a series of sunflower pictures and used them to decorate the walls of his rented house. Each painting in the series is conceived as a harmony of similar colours and the intensity of feeling is emphasized by the thick marks defining the separate petals of the flowers.

Wheatfields at La Crau, near Arles, 1888 (*opposite*)
72 × 92 cm (28 × 36 in)
VINCENT VAN GOGH MUSEUM,
AMSTERDAM
This wide open expanse was a very attractive prospect to van Gogh after the flattened views of Dutch landscape painting.

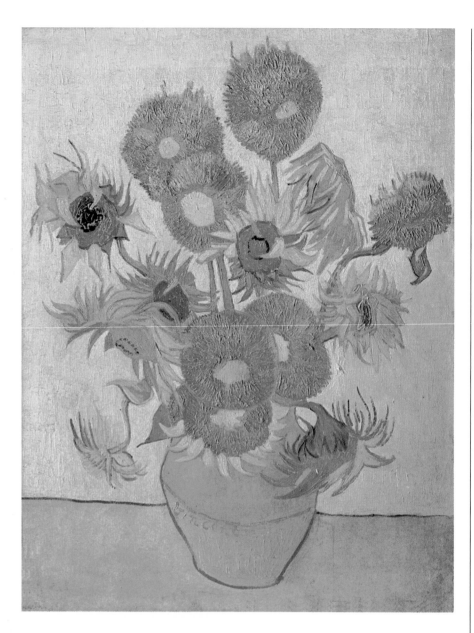

the age of 27 must have surprised Theo, who was now himself working for Goupil, but Theo was used to Vincent's impulsiveness and encouraged him in the new venture just as he had offered support in all Vincent's attempts to find a sense of purpose in life. Van Gogh began to sketch the miners among whom he was still living and also took to copying the work of Jean François Millet, one of the leading Barbizon painters whose work often brought out the brutality in the lives of ordinary labourers rather than a romanticized view of poverty. Van Gogh suddenly found a new freedom and peace of mind. In his letters to Theo he had used the metaphor of a caged bird which felt an instinct to fly but could not free itself of its surroundings. His new vocation seemed to offer a chance to escape to a brighter world.

In October 1880 van Gogh moved away from Borinage to Brussels, where he lived on money provided by Theo. He soon realized how much he had to learn and that his prospects of earning a living as a painter were poor. Because he felt that he was taking too much from Theo, who was by no means a rich man, van Gogh returned in April 1881 to live with his father who had been appointed minister at Etten in North Brabant.

While staying in Etten van Gogh suffered from another passionate but unrequited love affair. He was rejected by his cousin, Kee Vos, and the family were unsympathetic to the pain which this affair caused for Vincent. In a moment of great depression after the collapse of his amorous hopes van Gogh left Etten just before Christmas 1881 and moved to The Hague, where he began to take lessons from the painter Anton Mauve. He had been making clumsy drawings of peasants toiling in the fields near his home; these were full of feeling and strength but he

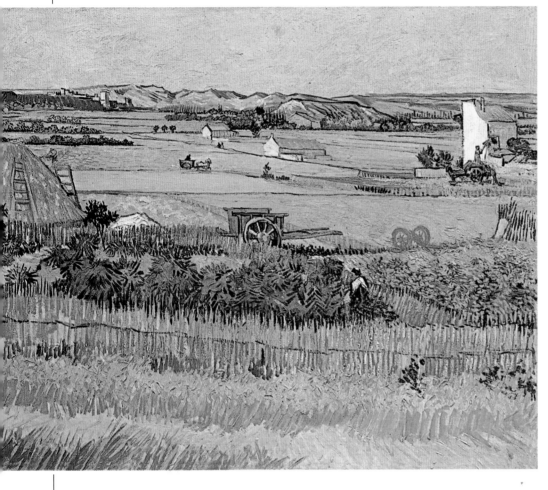

"I think a peasant girl, in her dusty, patched blue skirt and bodice, which get the most delicate hues from weather, wind and sun, is more beautiful than a lady."

was only really successful in capturing the harsh moody landscape. Throughout 1882 Mauve was very sympathetic to the would-be artist but eventually the patience of the volatile van Gogh snapped when, as a discipline, he was instructed by Mauve to copy plaster casts of antique statuary in order to improve his draughtsmanship. He simply refused to do the work and when Mauve was unrelenting in his instruction, van Gogh began systematically to destroy each of the casts. After this outburst he ceased to attend Mauve's classes but continued to live in The Hague, where he concentrated on drawing the poor figures in the streets, the down-and-outs and the suffering, for it was they who attracted him most. Van Gogh's wide range of reading matter included the realistic novels of Emile Zola and George Eliot whose very subjects were those same poverty-stricken people he had been drawing at

Borinage and Etten. All his early work expresses the struggle for life against overwhelming odds.

Early in 1883 he picked up off the streets a pregnant woman called Siet, and for a while they lived together, van Gogh trying to give Siet the warmth and love that he felt she had lacked. Inevitably the attempt was a failure; the financial burden proved too much and both his health and work began to suffer as a result. In October of the same year van Gogh left The Hague and went to spend a few months on the North Sea coast at Drente, an area of lonely moors and fenlands. This isolation soon proved trying to the artist's melancholic disposition and in December he fled back to the security of his father's new home in Nuenen, another town in North Brabant. For the next two years van Gogh lived with his family, studying the peasants working on the land, and all the while

developing his artistic abilities. The culmination of the work of this period was 'The potato eaters' in which he tried to present a down-to-earth view of the hard toil required to gain an honest meal. Of this painting he wrote to Theo: 'I have wanted to give an impression of a way of life quite different from that of us civilized people. Therefore I am not at all anxious for everyone to like it or to admire it at once.'

In the spring of 1885 the sudden death of his father encouraged van Gogh to leave home once again. He travelled to Antwerp, where he joined the Academy but was sent to the class for beginners because of the inadequacy of his drawing. His time in Antwerp was not wasted, though, because he was able to study the work of the seventeenth-century painter Rubens which inspired him to brighten his palette. Late in 1885 Theo wrote to Vincent from Paris and invited him there in order to meet the Impressionist painters who now dominated the avant-garde artistic world.

In February 1886 van Gogh arrived in Paris where he was to remain for the next two years. This was the year of the final Impressionist exhibition and members of the original group had already begun to go their separate ways, but van Gogh's meetings with artists such as Pissarro and Gauguin and fresh acquaintance with the work of the Impressionists stimulated in him a great devotion to colour and an ardent desire to come to terms with it in his own paintings. As a result his palette grew brighter and the tone of his works less serious. He began to paint the scenery of Paris, as in 'Le Moulin de la Galette', and he produced many other works which varied greatly in appearance from those of his Dutch period. The 'Self-portrait' of 1887 shows how van Gogh was quickly coming to terms with what Impressionism had to teach him; he was using shorter touches of the brush and also adopted the stippled divisionist technique of Seurat and Signac. In the short time that van Gogh spent in Paris he absorbed Impressionism and almost as rapidly moved on from it, as he continued to explore the aesthetic world in a manner entirely peculiar to himself. The less earnest approach to subject matter was combined with the influence not only of Impressionism but also of the clear colours and fluid

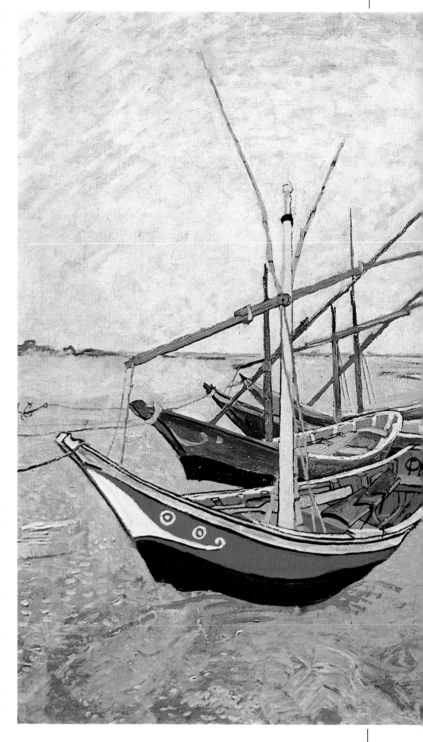

Boats at Saintes-Maries, 1888
66 × 81 cm (26 × 32 in)
VINCENT VAN GOGH MUSEUM, AMSTERDAM
This picture is full of subtle contrasts, combined to enliven a basically simple composition. The lines of the masts offset the heavier forms of the boats and in turn their strong colours stand out against the generally

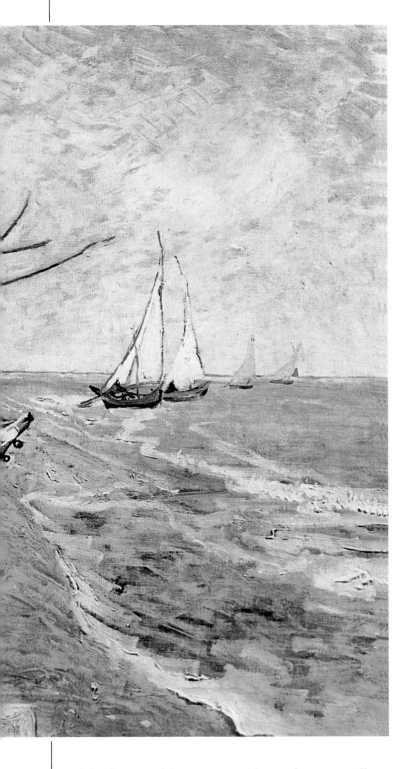

subdued tones of the seascape. The work is unusually open and lyrical. Once again there is an echo of Impressionism in the choice of subject matter – brightly coloured boats on the water – but van Gogh's representation of the scene characteristically shows more emotional strength than, for example, Monet's harbour and river views.

compositions of Japanese prints. He left behind the heavy melancholy of his earlier themes.

After two years van Gogh left Paris, which he was beginning to find claustrophobic, and in February 1888 moved south to Arles in Provence in search of a more peaceful environment and attracted by the brighter and more constant light of the south. Here his work changed again; he moved away from the lighter tone of the Parisian pictures and adopted a moody and individual style in which the colours became more expressive. Van Gogh worked fiercely to capture the atmosphere and sensations of his surroundings, bending lines and playing with the picture image as he struggled to fill his paintings with the deep emotions that he felt; this is shown particularly in 'Café at night', which was turned from a straightforward and peaceful scene into one of deep and almost sinister intensity.

Through the early months of 1888 van Gogh was burning with eagerness to paint in the bright spring light which was an entirely new sensation after the gloomy grey skies of the Low Countries. He was at last beginning to develop a sense of confidence in his own work and sometimes completed more than one painting in a day. The sun dominated his thoughts; yellow became a colour of major importance as van Gogh came to see the sun as the source of all life and power. The symbol which he chose, the sunflower, is one of the best-known and most popular motifs of van Gogh's art.

In May 1888, with money supplied by Theo, Vincent bought a house in Arles and established a studio which he intended should be a refuge for any painter seeking the bright light of the south. In October of that year Theo sent Paul Gauguin to stay with his brother. At first the two painters got on well, but the atmosphere became very strained, contributing to van Gogh's growing instability. In a moment of desperation van Gogh cut off his ear. The following day, 24 December the two painters fell out again and Gauguin returned immediately to Paris, while van Gogh was admitted to hospital, although he was not seriously injured. On recovering and leaving the hospital, van Gogh found that he had developed a great horror of being alone and he began to suffer more acutely from an illness which had been with him for some time. It is

believed to have been psychomotor epilepsy, a neurophysiological disorder. It changed his moods and perceptions but did not affect, in his lucid periods, his ability to paint.

Early in 1889, on Theo's advice, Vincent had himself admitted to the Asylum de St Paul in St Rémy-en-Provence where he was able to continue painting. When he was lucid he painted frantically and with great energy for fear that he might go mad again. His colours become more subdued after the high intensity of 1888 and the melancholic young man of the early 1880s re-emerged in his work.

The rest of 1888 was spent in the hospital at St Rémy. As well as new compositions van Gogh returned very often to copying the works of Jean François Millet, on whose inspiration he had relied so heavily in the early years. He was pleased when Theo, who had recently married, named his first son Vincent in honour of his dearly loved brother; and a further pleasure was that for the first time van Gogh received some favourable press criticism of his work, in an article written by Albert Aurier for the *Mercure de France*. But he had yet to sell a painting and relied entirely on the generosity of Theo in order to exist.

By May 1889 van Gogh was growing tired of the restrictions of St Rémy and on the advice of Theo discharged himself from the hospital and travelled to Paris and then further north to Auvers-sur-Oise. There Theo had arranged for him to stay in lodgings under the supervision of a dilettante painter and collector of Impressionist paintings, Dr Gachet. Van Gogh liked Auvers, where so many of the Impressionists had painted before him; he set to work with renewed enthusiasm, delighted to have fresh subject matter after the confines of St Rémy. Despite the apparent tranquility of this period van Gogh's last pictures reveal violent emotions and, after barely two months in his new surroundings, he attempted to shoot himself with a revolver. The attempt was not immediately successful but Vincent died two days later, on 29 July, from the self-inflicted wounds. He was comforted on his deathbed by Theo, who outlived his brother by only six months. The two are buried side by side at Auvers-sur-Oise.

In 1880 van Gogh had begun his career with the minimum of knowledge and technical skill, but an

Wheatfield with cypresses, 1889

72 × 91 cm (28 × 36 in)

NATIONAL GALLERY, LONDON

As van Gogh's bouts of insanity increased, so too did the forcefulness of his pictures when in his more lucid moments he was able to paint. In this painting the whole landscape, earth and sky, is heavily moulded with brushstrokes and seems to undulate with nervous energy and stress.

"To express hope by some star, the eagerness of a soul by a sunset radiance. Certainly there is no delusive realism in that, but is it something that actually exists?"

Still life, 1889

50 × 64 cm (20 × 25 in)

RIJKSMUSEUM KRÖLLER-MÜLLER, OTTERLO

The mundane elements of van Gogh's daily life were not too base to be treated with his wonderful glowing colours and transformed into bright, dynamic images. Van Gogh has set real, simple objects in a vibrant and unreal world, where the speckled background of red against blue contributes to a sense of the magical and exotic.

iron will forged out of the frustrations and thwarted passions of his life. Van Gogh's was an impulsive contrary nature. His great determination was combined with social ineptitude; the altruism shown in his early missionary gestures and the idea of providing refuge for Gauguin at Arles seems at odds with the egoism and ambition he showed once embarked on his career as a painter. Throughout his sad and turbulent life, in which his incapacity to conform led to such great conflicts, he was continually protected by the ever-present figure of his brother Theo and this fortunate relationship helped to form one of the greatest painters of the nineteenth century.

VUILLARD

Edouard Vuillard is one of the most captivating painters of any age. His intimate portraits, domestic scenes and interiors have a characteristic individualism and an expression of painterly invention that are directly appealing to the visual senses. But like Bonnard, Vuillard was a figure overtaken by history – a nineteenth-century inheritor of Impressionism who was left behind by the rapid progress of art in a new, vigorous century. Nevertheless, both these artists developed the lessons of Impressionism into personal visions of the world which have persistently claimed a place alongside more startling innovations, and it is precisely the intimacy and privacy of Vuillard's world, so subtly and yet colourfully expressed, which make his contribution to the period of post-Impressionism unique.

Edouard Vuillard was born on 11 November 1869 at Chiseaux in the *département* of Saône et Loire. He was of bourgeois stock, his father a retired army officer and his mother the daughter of a textile manufacturer. In 1878 the family moved to Paris and the young Edouard was sent to school first at Rocroy St Léon and then to the prestigious Lycée Condorcet. When Edouard was 15 his father died and his mother, to look after her son and pay for his education, set up a small dressmaking business. Vuillard remained very much devoted to his mother, who later became a frequent subject in his paintings and was a great source of inspiration.

When he was 18 Vuillard considered entering the military academy at St Cyr but was dissuaded by the painter Ker Xavier Roussel, who encouraged him instead to take up studies in painting at the Ecole des Beaux Arts and the Académie Julien. This was a formal education for an artist of the 1880s, but it in no way contributed towards Vuillard becoming a conventional artist. The final Impressionist exhibition had been held in 1886 so that, although still not accepted by the establishment, Impressionism was already beginning to be seen as a movement that had perhaps reached the peak of its development. Van Gogh and Gauguin had already branched away and the younger artists Seurat and Signac were developing the innovative but disciplined style which came to be known as Neo-Impressionism (see page 193). More experimental forms of art were beginning to find a market.

In 1888 Vuillard and Bonnard, together with several other contemporaries, founded a group of artists given the title of the Nabis. The Nabis painters owed much to Impressionism in their use and application of paint. Their ideas of composition were influenced by Gauguin and the Pont Aven school, with which Nabis members Maurice Denis and Paul Sérusier had been directly connected. Like the Neo-Impressionists, the Nabis were concerned with explorations of form and colour; like the Pont Aven school, their subject matter was drawn largely from the mundane and ordinary in their surroundings, though occasionally tinged by symbolic elements which lent an air of mysticism.

In 1891, at the age of 22, Vuillard took a studio in Paris, shared with Bonnard, in the rue Royale.

At about the same time he became acquainted with the literary Nathanson family who published the artistic journal *La Revue Blanche*. Members of this family were frequently painted by Vuillard and they also provided patronage for the young artist, who completed many large-scale interior decorations for them. Another important patron was Joseph Hessel, whose wife became a great friend to Vuillard and frequently sat for her portrait.

Vuillard's life developed a comfortably settled pattern: he lived with his mother in Paris and summers were almost invariably spent in the country with the Nathansons or with the Hessels, who formed the circle of Vuillard's friends and were in effect a sort of extended family. Vuillard quickly made his reputation as a painter and in 1899 was given an exhibition by the dealer Bernheim Jeune, with whom he continued to exhibit until the outbreak of World War I. By the end of the nineteenth century the avant-garde artists in Paris had succeeded in establishing their alternative to the official Salon, an event known as the Salon des Indépendants, and Vuillard was a regular exhibitor. His decorative manner and instinct for subtle combinations of tone and colour produced a body of work with a highly distinctive character and charm. Edouard Vuillard was a quiet and retiring man. His natural timidity and shyness were occasionally broken by great outbursts of temper and he also suffered from a debilitating sort of melancholia which often kept him from working for months at a time. The importance of his mother in his life may have been the main reason why he remained a bachelor, although he was involved in several short-lived love affairs.

As a young painter in the 1890s, Vuillard's almost immediate success was due not only to the patronage and influence of the Nathansons and Hessels, but also to the novel appearance of his work. Unlike several of the other Nabis painters, he avoided religious and anecdotal subjects, preferring instead carefully constructed scenes of Parisian daily life or portraits showing the subject relaxed and in an intimate setting. He began to explore the infinite gradations of colour in all their subtlety; he was neither rigorously theoretical, like the Neo-Impressionists, nor flamboyantly colourful in paint

Darning a stocking, 1891

27 × 22 cm (11 × 9 in)

MUSEE NATIONAL D'ART MODERNE, PARIS

At first sight the heavy patterning here suggests a simplification of the image, but it is a complex construction. In the chequered dress, for example, Vuillard has carefully reproduced, by means of pure patterning, the flow and direction of the fabric and the volume of the figure.

Landscape at Romanel, 1900
42 × 68 cm (16½ × 27 in)
KUNSTHAUS, ZURICH
The depths of this picture are built up by successive planes stepped forward from the sky with the clear-cut effect of a theatre decoration. Landscape was an unusual area of study for Vuillard who generally depicted domestic scenes.

Misia Nathanson and Paul Vallotton, 1899
(opposite)
MUSEE NATIONAL D'ART MODERNE, PARIS
In this double portrait the figures facing in different directions create an enigmatic image. Again, Vuillard constructs the painting around the devices of a strongly patterned shape and a condensed perspective.

as Bonnard became, but his work shows a characteristic sense of both tone and pure colour. In addition to the paintings, Vuillard also executed large-scale decorative works such as those for Dr Vaquez and in all ways showed remarkable command of his medium. Even before the age of 30, he had achieved a precocious sophistication as well as the fame which had been so desperately elusive to the great pioneers of the Impressionist movement Monet, Sisley, Pissarro and Renoir.

At the beginning of the twentieth century the Nabis movement began to fragment as the painters went their separate ways. Bonnard and Vuillard remained close friends, but they ceased to work so closely together. Vuillard continued to live and work in Paris; in 1907 he moved to the corner of the Place Vintimille and later, in 1926, actually moved into the square itself. The park at its centre and the

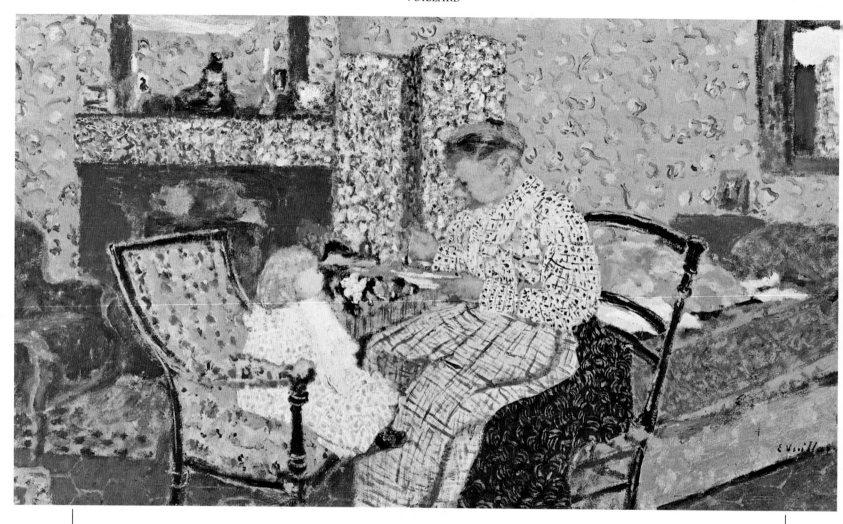

everyday life of the square were to be among Vuillard's most frequently painted outdoor subjects and he treated them with a quality and intimacy that is reminiscent of his interior scenes.

Vuillard's early success stayed with him but as the twentieth century progressed, his unchanging style and privacy of view became less fashionable and his work was less in the public eye. He travelled little, making short visits to London and to Holland in 1913. During the years of World War I he continued to live with his mother, staying in Paris or with the Hessel family at Vaucresson. By the 1930's the historical value of Impressionism was widely recognized and Vuillard, as one of its direct heirs, with Bonnard and Signac came to be regarded as something of an elder statesman of French art. In 1937 he was elected to the Académie des Beaux Arts, which had changed considerably from the stuffy protector of classicism which it had been in the late years of the nineteenth century. In 1938 a large retrospective exhibition was held in Vuillard's honour at the Musée des Arts Décoratifs in Paris. By the time of his death, in 1940 at the age of 72, Vuillard was a figure from a bygone age and his work was regarded by many of the younger painters as retrogressive and reactionary, so far had things moved on from Impressionism.

Vuillard had led a tranquil and withdrawn life which seemed to have extended beyond its time. The security of his mother's home and his deep sense of religious faith, retained from boyhood, were not to be disturbed. Perhaps the temperament that attached him to this security was what prevented him from moving forward with the avant-garde of a new industrial age, when painting was to change so much in response to a changing world. The deeply personal sense of his domestic and local surroundings, portrayed with a powerful sense of colour, light and shade, was not surprisingly outmoded in the years between the two World Wars. In retrospect, however, it is this very individualism and its private glimpses of a lost world that make Vuillard's painting still valued and much-loved alongside the vivid legacy of the earlier Impressionists.

Feeding Annette, 1901
(*opposite*)
MUSEE DE L'ANNONCIATION, ST TROPEZ
Vuillard's mother and sister frequently featured as models for his paintings. He generally depicted them during their relaxed moments at home, sharing a meal or quietly sewing. Marie, Vuillard's sister, married his fellow Nabis member the painter Ker Xavier Roussel and their daughter Annette, seen here with her grandmother, became one of Vuillard's favourite subjects. His many paintings of Annette form a charming record of her young life, from babyhood to young womanhood. This painting is in typical style, a rich, affectionate portrait of everyday family life.

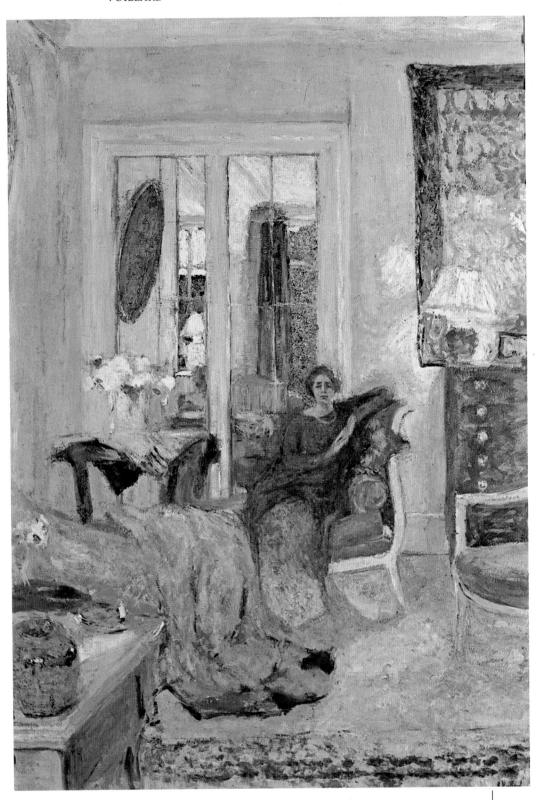

Princess Bibesco, 1912
112 × 81 cm (44 × 32 in)
SAO PAULO MUSEUM
Princess Helène Bibesco was a member of Parisian high society, a hostess to select gatherings of artists, intellectuals and aristocrats. In this painting Vuillard has placed her far back in the overall composition and, although she is the subject of the work, it has ceased to be a simple portrait and has become instead a complex interior view, subtly lit and recessed to create an interesting pictorial scheme.

GALLERIES AND MUSEUMS

The following galleries and museums contain important collections of Impressionist art:

Germany
Wallraf – Richartz Museum, Cologne
Akademie der Kunst, Berlin
Bayensche Staatsgemaldesammlungen, Munich

Switzerland
Kunstmuseum, Basle
Kunstmuseum, Berne
Petit Palais, Musee d'Art Moderne, Geneva
Kunsthaus, Zurich
Winterthur, Sammlung Oskar Reinhart
Sammlung E.G. Burhle, Zurich

Britain
National Gallery of Scotland, Edinburgh
National Gallery of Wales, Cardiff
National Gallery, London
Courtault Institute, London

Netherlands
Stedelijk Museum, Amsterdam
Rijksmuseum Vincent Van Gogh, Amsterdam

U.S.S.R.
Hermitage Museum, Leningrad
Tretjakar Museum, Moscow

Japan
National Museum of Modern Art, Tokyo
National Museum of Western Art, Tokyo

U.S.A.
The Art Institute of Chicago, Chicago
Boston Museum of Fine Arts, Boston
Los Angeles County Museum, Los Angeles
Norton Simon Museum, Pasadena, California
Metropolitan Museum, New York
Museum of Modern Art, New York
National Gallery, Washington
The Philips Collection, Washington

France
Musée Toulouse Lautrec, Albi
Musée Claude Monet, Giverny
Centre National d'Art et de Culture, George Pompidou, Paris
Galerie du Jeu de Paume, Paris
Galerie de l'Orangerie, Paris
Musée de Louvre, Paris
Musée Marmottan, Paris
Musée d'Orsay, Paris
Musée Maison Gustave Courbet, Ornans
Musée Fabre, Montpellier
Musée des Beaux Arts, Rouen
Musée de l'Annonciable, St Tropez

SUGGESTED FURTHER READING

History of Impressionism, John Rewald, New York, 1961.

Post-Impressionism; from Van Gogh to Gauguin, John Rewald, New York, 1962.

Van Gogh, Gauguin and the Impressionist Circle, Mark Roskill, Greenwich, 1970.

A Day in the Country: Impressionism and the French Landscape, Richard Bretell et alia, Los Angeles, 1985.

Frederic Bazille and Early Impressionism, J Patrice Marandel et alia, Chicago, 1978.

Mary Cassatt, A D Breeskin, Washington, 1970.

Cézanne and the end of Impressionism, Richard Schiff, Chicago, 1984.

Image of the People; Gustave Courbet and the 1848 Revolution, Timothy J Clark, London, 1973.

Degas, Ian Dunlop, London, 1979.

Degas; the Artist's Mind, Theodore Reff, London, 1976.

Gauguin and the Port Aven School, W Jaworska, London, 1972.

Jongkind and the Pre-Impressionists, Charles C Cunningham, Northampton, Mass, 1976.

Manet, Françoise Cachinim (intro), Paris, 1983.

Manet and Modern Paris, Theodore Reff, Washington, 1982.

Monet at Argenteuil, Paul Hayes Tucker, Yale, 1982.

Monet's Years at Giverny; Beyond Impressionism, Daniel Wildenstein, New York, 1978.

Camille Pissarro, Christopher Lloyd, London, 1981.

Renoir; his life, art and letters, B Erlich White, New York, 1984.

Toulouse Lautrec, Douglas Cooper, London, 1955.

Van Gogh, Marc Tralbant, London, 1969.

INDEX

Paintings are given in italics.
Italicized page numbers indicate
illustrations.

ACKNOWLEDGEMENTS

Editors: Piers Murray Hill
Isabel Papadakis

Design Manager: Jane Willis

Copy Editor: Judy Martin

Designer: Iain Hutton-Jamieson

The Publishers would like to thank
Virginia Prina of Fabbri Editore
for all her help in collating the picture material.
Special thanks to Judy Martin for all her hard work on the text.

Flags in the rue Montorgueil, 1878 (*page 2*)
62 × 33 cm (24 × 13 in)
MUSEE DES BEAUX-ARTS, ROUEN
*In this vibrant rendering of a Paris street at festival time, Monet has captured a
vivid sense of life and movement; of flags flapping in the breeze and of crowds in
the street.*

256